The BLOCK Reader in Visual Culture

The BLOCK Reader is a collection of essays from the pages of *BLOCK*, encompassing key cultural and critical debates between artists, art and design historians and cultural theorists throughout the last decade

Between 1979 and 1989 *BLOCK* attempted to address the problem of the social, economic and ideological dimensions of the arts in society and offered a challenge to a conventional understanding of art history. Collected together for the first time, *The BLOCK Reader* represents some of the major themes and interests that persisted throughout ten years of publication.

The *BLOCK* editorial board, Jon Bird, Barry Curtis, Melinda Mash, Tim Putnam, George Robertson and Lisa Tickner, lecture at Middlesex University and were all involved in the production of the journal *BLOCK*. They are the editors of the Futures series, published by Routledge. This Reader is edited by the *BLOCK* editorial board and Sally Stafford, who also lectures at Middlesex University.

The BLOCK Reader
in
Visual Culture

London and New York

First published 1996
by Routledge
11 New Fetter Lane, London EC4P 4EE

Simultaneously published in the USA and Canada
by Routledge
29 West 35th Street, New York, NY 10001

Routledge is an International Thomson Publishing company

Typeset in Baskerville by Florencetype Ltd, Stoodleigh, Devon
Printed and bound in Great Britain by Biddles Ltd,
Guildford and King's Lynn

British Library Cataloguing in Publication Data
A catalogue record for this book is available from the British Library

Library of Congress Cataloguing in Publication Data
A catalogue record for this book has been requested

ISBN 0–415–13988–0 (hbk)
ISBN 0–415–13989–9 (pbk)

CONTENTS

CONTENTS

Part II Design history

Part III Cultural theory

ILLUSTRATIONS

CONTRIBUTORS

Jon Bird is Reader in Visual Culture at the School of History and Theory of Visual Culture at Middlesex University.

Barry Curtis is Head of the School of History and Theory of Visual Culture at Middlesex University.

Tamar Garb is Reader in the History of Art at University College London.

Philippa Goodall is Programming Director for Photography at the Watershed Media Centre, Bristol.

Nicholas Green was a lecturer at the School of Art, History and Music at the University of East Anglia, until his death in 1989.

Fran Hannah is Principal Lecturer at the School of History and Theory of Visual Culture at Middlesex University.

Dick Hebdige is Dean of the School of Critical Studies at California Institute of Arts.

Lucy Lippard is a freelance curator and critic, living in New Mexico.

Frank Mort is Reader in Cultural History at the School of Social and Historical Studies at Portsmouth University.

Kathy Myers is an independent television director.

Fred Orton is Senior Lecturer in the Department of Fine Art at the University of Leeds.

Claire Pajaczkowska is Senior Lecturer at the School of History and Theory of Visual Culture at Middlesex University.

Griselda Pollock is Professor of Social and Critical Histories of Art at the Department of Fine Art at the University of Leeds.

Tim Putnam is Professor of the History of Material Culture at the School of History and Politics at Middlesex University.

CONTRIBUTORS

Olivier Richon is an artist teaching Postgraduate Photographic Studies at the School of Communications, University of Westminster.

Martha Rosler is Professor of Photography at Mason Gross School of the Arts, Rutgers University, New Jersey.

Necdet Teymur is Professor of Architecture at METU, Faculty of Architecture, Ankara, Turkey.

Lisa Tickner is Professor of Art History at the School of History and Theory of Visual Culture at Middlesex University.

Judith Williamson is Professor of Cultural History at the School of History and Theory of Visual Culture at Middlesex University.

ACKNOWLEDGEMENTS

BLOCK has reason to be grateful to a very extended list of colleagues, readers and friends – too many to mention here – but we wish to acknowledge all those who contributed to *BLOCK* during its 10-year existence and particularly those contributors whose work we were not in the end able to include due to the practical constraints on the anthology.

We also wish to acknowledge Mike Evans, Fran Hannah, Claire Pajaczkowska and John Walker (past fellow-editors); Peter Green, John Lansdown (successive Deans of the Faculty of Art, Design and Performing Arts); Penny Chesterman (Secretary to the School of History and Theory of Visual Culture); Kathryn Tattersall (our designer); Cath Ward and Rasaad Jamie (for administrative help); and the Arts Council of England for their support.

For the Reader we thank Rebecca Barden at Routledge for her enthusiasm and support of this project.

INTRODUCTION

BLOCK was an initiative that was very much of its time and place: a manifestation of the cultural logic of a newly self-conscious, historicised and politicised initiative in the cultural realm; and a simultaneous allergic reaction to the idealism of academic art history. *BLOCK* was devised by a group of hard worked polytechnic lecturers, all but one art school trained, who met at Hornsey College of Art in the aftermath of the 'sit in'. The mid-1970s was a time when most of the work undertaken by art and design historians in polys was 'servicing' studio areas in art departments. 'Research' was a sporadic activity – there was a limited range of opportunities to publish. Producing a journal seemed a good idea at the time as a vehicle of communication with a small and scattered community of like-minded, Marxist and polemical practitioners and theorists. At Middlesex the initiative was part of a general sense of the need for more autonomy and it accompanied gradual institutional moves, by the same group, towards establishing undergraduate and graduate degrees in art, cultural studies and design history.

BLOCK was inspired by a sabbatical awareness of the close relation between research, teaching and publishing in American colleges. Between 1977 and 1979, when the first issue was published, the editors were engaged in sporadic debates about how such a project could be organised within an H.E. institution, which often turned on minutiae of financial arrangements and degrees of autonomy and responsibility. The facilities seemed to be at hand, there was some goodwill, but it turned out to be a very complicated negotiation. Producing *BLOCK* was labour intensive and drew heavily on the expertise of a recent graphic design graduate, Kathryn Tattersall, whose choices reflect a contemporary interest in Russian Constructivist graphics with a nod to Eric Gill, the typography of 1930s radicalism and the influential work of David King, who designed early issues of *City Limits* and a number of highly relevant catalogues.

It is difficult to recall, even at this relatively short distance in time, the substantial physical and intellectual constraints on production. In 1979, for us anyway, the materiality of journal production involved a great deal of

late night inexpert cutting and pasting on tables in untidy rooms in Muswell Hill and Crouch End. The notorious *BLOCK* typos were as much the result of dropping tiny pre-pasted scraps of paper as inept proof-reading. By the last issue, only 10 years later, it was all done on computer. The pre-1979 intellectual landscape is as hard to recall and in some ways as historically and ideologically remote. The first issue indicates some of the vectors involved in constituting a materialist art history. The fact that we asked John Berger for a contribution demonstrates an intention of furthering the tradition of Marxist art history from Frederick Antal, Arnold Hauser, Max Raphael and Meyer Shapiro, through to the publication in the mid-1970s of the work of T.J. Clark and Nicos Hadjinicolaou. The work of French and German theorists, particularly as they were mediated through the debates on film and cultural theory in *Screen*, was important and *BLOCK* was dedicated to recognising and acclaiming work being done by contemporary political artists, an intention to which we remained impressively faithful, publishing examples of relevant artwork.

By the late 1970s a number of initiatives similar to *BLOCK* had emerged. These included journals – *Red Letters*, *Artery* and *Wedge*; exhibitions like 'Art for Whom' and 'Another Picture', and the 'Art & Social Purpose' issue of *Studio International* (Spring 1976) under the editorship of Richard Cork. Also influential were a number of exhibitions of Russian Revolutionary art – Rodchenko, Mayakovsky at MOMA, Oxford; and 'Art and Revolution' at the Hayward. This revolutionary ethos was inspirational and, seemingly appropriate at the time, it coincided with interests in art and language and a new impetus in photomontage and reflections on the politics of art in the 1930s. The work of the Birmingham Centre for Contemporary Cultural Studies, especially their 'Working' and 'Stencilled' papers, and that of the editors of and contributors to *Screen* and *Screen Education* were fundamental to the reformulating of ideas about art and the politics of representation.

After weeks of deliberation over a title for the prospective publication – with suggestions which included 'Basement', 'Artifax' and 'Exchange and Art' (rejected by *Exchange and Mart* who feared competition should a more commercial editorial policy emerge) – the present title was decided on at the Rodchenko exhibition as suitably agitprop and fundamentalist whilst hinting at subcultural Mod antecedents and a certain formgiving and underpinning potential.

One of the early intentions for *BLOCK* was to publish more student work and to publish material that reflected directly on problems of teaching – pedagogy was regularly addressed in articles but there were disagreements from quite early on about the mode of address, about access and difficulty. Once editing and production was an established and regular activity the editors tended to follow their interests, and something of an 'expert discourse' developed. To a large extent we shared in the difficulty of the time – possibly

the result of trying to say new things, and think politically, in a language heavily dependent upon structuralist and semiotic theories of meaning.

One very material determinant on the continuing existence of *BLOCK* was the problem of distribution. A number of 'alternative' distribution agencies had become established but they often did not seem to distribute and copies entrusted to them had frequently to be repossessed. Editors tended to trust to the boots of their cars and a 'run' around sympathetic London galleries and book shops. Out of London 'Red Star' was an appropriate vehicle. A great deal of time was devoted to correspondence with overseas distributors, some of whom were wonderfully friendly and efficient, others just friendly and some neither. Long suffering subscribers saved us and the index cards became indicative of where sympathetic individuals and institutions were to be found. Readers of *BLOCK* and similar journals tended to meet at conferences, some of which were organised 'in house', and there was a sense of a ragged consensuality and coherence of purpose which was manifest in many other initiatives, particularly in teaching and in the increased frequency of articles submitted.

Inevitably these reflections on the history of *BLOCK* suggest a coherence and unity to a project which, at the time, operated under a fairly loosely formulated set of aims and objectives. The initial stimulus was to try and intervene in the discourses that defined and validated visual culture, particularly the writing of art's histories. The Editorial for the first issue announced our intention to: 'address the problems of the social, economic and ideological dimensions of the arts in societies past and present'. Besides the critical tradition in art history and cultural theory already mentioned, *BLOCK* was also committed to challenging the dominance of the 'canon' and the forms of evaluation of significant 'works' through the critical analysis of the discourses of art: their institutional histories and regimes of knowledge. Feminist theories and the rapidly expanding field of post-colonial studies were fundamental in our attempts to focus on the production of culture within a network of practices and determinations.

Two major themes characterised the analysis of visual culture in the decade of *BLOCK*'s publication. On the one hand were arguments for the understanding of art as a social, material and expressive practice determined by specific forms of production and reception. Social history, institutional critique, the cultural analysis of Raymond Williams and Pierre Bourdieu, and varieties of reception theory and ethnography all contributed to the study of the visual within the broader anthropological formulation of culture as a 'whole way of life'. The other, related, theoretical input came from a combination of work on representation as a structure and process of ideology producing subject positions, and the social disciplining of technologies and regimes of power having real effects upon our lives and experiences. If the latter showed the influence of Foucault, equally important were psychoanalytic concepts, particularly theories of pleasure and the interplay of

meaning and desire in the text and on the reader or viewer. Frequently the subject of debate and controversy, this work investigated the psychic foundation of social subjectivity and the role of culture as the creative imagination's transformation of symptoms into symbols. In response to these developments *BLOCK* attended to an increasingly diversified field of cultural objects and theory, not simply to extend a list, but out of a recognition that issues of cultural legitimacy, intellectual responsibility and political effectivity are constantly being redefined.

Later issues of *BLOCK* evidenced these moves within critical theory and the relation of theory to social and cultural agendas. It is, perhaps, worth reflecting on the fact that the last issue of *BLOCK* as a journal – in 1989 – coincided with a momentary fissure in the political landscape which allowed a glimpse of an alternative 'horizon of possibility' – the dismantling of the Berlin Wall and the collapse of apartheid. We are now in a very different and, arguably, profoundly pessimistic moment, and again the role of intellectuals and the politics of theory are matters for dispute. Identity politics and the cultures of diasporic movements; warnings of global apocalypse and the proliferation of eco-politics; the fragility of the global networks of production and exchange; the impact of information technologies and bio-technologies producing scenarios of cyberbodies and hyperrealities; the uncertainties within the institutions of knowledge and their increasing capitulation to the logic of the corporate mentality – all of these factors attest to a general fear and anxiety, a state of cultural psychosis. Perhaps as we edge fearfully towards the '*fin de millennium*' and stare into the symbolic 'unknown', Gramsci's expression of embattled resistance is the best we can hold on to: 'pessimism of the intellect, optimism of the will'.

Part I
ART HISTORY

INTRODUCTION

BLOCK came out of an art history department but also out of a frustration with what passed for an account of 'art' and 'history' in the modern university. In this it was one more (but early) sign of the times: one more instance of attempts to revise the tired formulas of sensibility-plus-dates in favour of a properly materialist analysis of culture that would redefine the boundaries and priorities of the discipline. *BLOCK*'s editors had come to art history by different routes. Several of us had been to art school and others had read English or history. All of us had had to re-educate ourselves to teach design history, film theory and cultural studies, and had found in those areas not only different procedures, priorities and objects of study but a series of challenges to conventional 'art history'.

Our goals were at once political and intellectual. A materialist analysis of art – or in *BLOCK*'s extended terms 'visual culture' – had to offer an adequate account of particular social practices that were rooted in the historical circumstances of, among other things, particular relations of power. Hence the engagement with the social history of art and with Marxism (where Marxist art history was seen as a critical riposte to the liberal vacuum on questions of power) and hence also the necessary interrogation of Marxist models by feminism (most notably in Griselda Pollock's 'Vision, Voice and Power' in issue 6). This overtly political dimension to *BLOCK* is what dominates some reference to it – the self-parodying 'Take Up A Correct Position' subscription advertisement in issue 9 has been taken as neither 'wholly or even partially ironic or humorous in intention'.[1] But it was. What is often overlooked – and this is not to undercut or undersell *BLOCK*'s rootedness in socialism and feminism – is a continuing and widening strand of inquiry into the whole problem of how to write about (and teach, and value) 'art' at all, and the contribution that might be made to these problems by a range of (chiefly) post-structuralist theories and debates. Lucy Lippard's 'Hot Potatoes' or Griselda Pollock's 'Art, Art School, Culture' or Jon Bird's 'Art History and Hegemony' might be seen as direct engagements with the (repressed) politics and economies of art in the New York art world, in the studio and the art school, and in the public sphere. On the other hand,

Claire Pajaczkowska's 'Structure and Pleasure' and Fred Orton's 'Present, the Scene of . . . Selves, the Occasion of . . . Ruses' offer, respectively, a critical account of recent French structuralist and post-structuralist writings on art (little read in England until the publication of Norman Bryson's selection in *Calligram* 5 years later in 1988),[2] and an exemplary unravelling (via the concept of metonymy) of Jasper Johns' pictorial and emotional strategies in certain works of the 1960s.

Of course these essays have something broadly in common with each other and with *BLOCK*'s enterprise (that tidy and slightly portentous term masks a degree of flexibility and a great deal of dispute). Most of us knew each other and held more-or-less compatible views. The blandness of the alternatives helped to see to that, combined with the extraordinary vituperation that met what were in our view *adequately* historical accounts. (A classic instance, much discussed, would be the hysterical response to David Solkin's catalogue for the Richard Wilson exhibition at the Tate Gallery in 1982.)[3] But this selection shows how diverse our contributions were as well as what they shared.

There is also a certain porousness here. *BLOCK* was not a closed endeavour and could not be. The shape and content of each issue was determined by the best of what was available and what was available depended on factors beyond our control, from the increasing workloads (or 'productivity') of lecturers in the period to the availability of alternative outlets. There is a certain irony in the amount of art history we published given our grumbles about it, which speaks partly to the understated intensity of that engagement. But it should not be overlooked that we would have been more broadly spread across the visual field, with more on media studies and design history, if it had not been for the existence of *Screen* (which trespassed into art history around 1980–1 with articles by Pollock and Clark), *Screen Education* (which published important essays on photography by John Tagg), *Ten:8*, and the advent of *new formations* and the *Journal of Design History*. Questions of post-colonialism and ethnic difference appeared late on ours as on other agendas. Perhaps they would have found more of a place in *BLOCK* if they had not been stimulated by the pioneering work of *Third Text* (from 1987) and found a home in it. (Despite some efforts to solicit work in this area there is nothing lying unpublished in our files.)

But *BLOCK* was not just shaped by its competitors, it was also in conversation with them. That may also seem with hindsight a characteristic of the 1980s. It was a place to join in or answer back from, a platform, for some an hospitable if untidy staging post *en route* to subsequent publication. Terry Smith's articles on Frida Kahlo (issues 8 and 9) were followed by his book on the genesis of American modernism.[4] Fred Orton's book on Jasper Johns was published in 1994.[5] Charles Harrison's, Michael Baldwin's and Mel Ramsden's article on 'Manet's "Olympia" and Contradiction' (issue 5) was a vigorous contribution to the discussion of that touchstone of revisionist art

history, but one so lengthily entailed with other texts in the conversation that we decided, reluctantly, not to include it here. (Marcia Pointon has commented that 'to contribute to the debate on *Olympia* initiated by T. J. Clark in 1980 and pursued in the pages of books and journals from *BLOCK* to the *New York Review of Books* [was] to earn one's art-historical spurs in the competitive lists of Modernist critique'.)[6]

Art history is now, as Donald Preziosi has put it, more Roman than Greek: 'like the Pantheon . . . a vast aggregate of materials, methods, protocols, technologies, institutions, social ritual, and systems of circulation and inventory'. That problematic term, 'the new art history', has found a place in commentaries, curricula and publishing catalogues. Social and contextual histories of one kind and another – formerly exceptions – have come to dominate conferences here and abroad. The standard professional question is no longer 'What's your period?' There are classicists, mediaevalists and modernists but also Marxists, feminists, deconstructivists, cultural psychoanalysts and semioticians. (Most large departments, like zoos, aim to have one or two of everything.) This has taken place against a rumbling and occasionally explosive discontent, protesting at the importation of alien forms of politics and theory on to the virgin territory of the irreducible aesthetic object. And in truth it is a mixed blessing. (We have all heard papers in which garbled accounts of Derrida and Lacan are brought fruitlessly to bear on some hapless ninteenth-century print.) *BLOCK* in 1996 would have to be a very different enterprise from *BLOCK* in 1979. But in the hope that it is still worth looking back, that these articles offer not only moments worth recalling but trails as yet left unpursued, we reprint a selection here. . . .

NOTES

1 Marcia Pointon, *Naked Authority: The Body in Western Painting 1830–1908*, Cambridge University Press, Cambridge, 1990, p. 3.
2 Norman Bryson, *Calligram: Essays in New Art History from France*, Cambridge University Press, Cambridge, 1988.
3 See Neil McWilliam and Alex Potts, 'The Landscape of Reaction: Richard Wilson (1713?–1782) and His Critics', in *The New Art History* (eds A.L. Rees and Frances Borzello), Camden Press, London, 1986, pp. 106–19; Michael Rosenthal, 'The Death of British Art History', in *Art Monthly*, April 1989, pp. 3–8.
4 Terry Smith, *Making the Modern: Industry, Art and Design in America*, Chicago University Press, Chicago, 1993.
5 Fred Orton, *Figuring Jasper Johns*, Reaktion Books, London, 1994.
6 Pointon, ibid., p. 113.

1

HOT POTATOES
Art and politics in 1980

Lucy Lippard

(*From*: Issue 4, 1981)

Every summer I sit down and try again to write about 'art and politics'. Every summer, the more the possibilities have expanded and the changes been frustrated, the harder it gets. Despite years of 'art activism' the two still crouch in separate corners of my life, teasing, sometimes sparring, coming to grips rarely, uneasily and without conclusion or issue. Even now, when many more visual artists are informed about radical politics, when 'political' or 'socially concerned' art has even enjoyed a doubtful chic, artists still tend to think they're above it all and the Left still tends to think art's below it all. Within the feminist art movement as well, polarities reign, although because of its fundamental credo – 'the personal is political' – they have different roots, and different blossoms.

I wrote the paragraph above in the summer of 1977, 2 years before the cusp of 1980 where I stand now. Things have not changed much. Contrary to the popular image of the wild-eyed radical, artists are usually slow to sense and slower to respond to social currents. Yet perhaps in response to the anti-1960s economic backlash that has only recently reached the art world in the guise of punk and/or 'retrochic', it does seem that an increasing number of young artists are becoming concerned with social issues – though often in peculiar and ambivalent ways. I tend to be over-optimistic, and at the moment am obsessed with the need to integrate ivory tower and grass roots, particularly within the 'cultural' and 'socialist' branches of feminism. So I could be wrong, as I was when I hoped for too much from the conceptual third stream around 1970. But first, a little history.

A LITTLE HISTORY

Art and politics as currently defined cannot get together in America because they come from opposite sides of the tracks. Art values are seen by the Left as precisely bourgeois, even ruling-class values, while even the most élitist

7

artists often identify vaguely – very vaguely – with an idealised working class. Or perhaps painter Rudolf Baranik's way of putting it is fairer:

> Art both serves and subverts the dominant class of every society. Even the most passive or subservient art is not the precise carrier of ruling class ideas, though in every way the ruling class makes an effort to make it so.[1]

Art may feel trapped in the ivory tower, now and then complaining bitterly, now and then slumming for a while, but it lets its hair down selectively so only a chosen few can climb to its chamber. Politics has other things to think about and, aside from occasional attempts to knock down the tower, is little concerned with what goes on inside it. At financial crises, politics may solicit money and propaganda from art's liberal conscience, which also provides cocktails and imaginative bursts of energy until 'too much time is taken away from the studio'. Caught in the middle of all this is the socially conscious and sometimes even socially concerned artist.

The American art world, where most of these forays take place, is a curious barnacle on capitalist society that imagines itself an aesthetic free agent. The art world has been wary of politics since the late 1940s, when artists were in danger of being called before the House Unamerican Activities Committee if their work was too comprehensibly 'humanist'. In 1948 a soon-to-be-famous painter and a critic jointly declared that 'political commitment in our time means no art, no literature'.[2] Variations on this position dominated the next 20 years, only a few holdouts insisting that 'painting cannot be the only activity of the mature artist' (though continuing to support the separation between art and politics).[3]

American art subsequently became a world power precisely by severing itself from politics (read Left politics, since the centre and right are just presumed to be 'society' or 'life'). By the late 1950s, the New American Art – abstract, and therefore, paradoxically, far more socially manipulable than representation – sidled forth from the tower to issue internationally impressive 'breakthroughs'. Those who had initially objected to its red range began to like warm colours when these could be paraded as testimony to the glories of aesthetic freedom in a democracy. No one seemed to notice until the later 1960s that artists had lost control of their art once it left the studio – perhaps because the whole experience was a new one. Some American artists were enjoying for the first time a general prestige. In the process of acknowledging that content in art was inseparable from form, many also fell for the next step (offered by critics who had been 'political' themselves in the 1940s) – that form alone was the only possible content for 'important' or 'quality' art. This recipe was swallowed whole in the period between Korea and Vietnam. How, after all, could pure form be political? How indeed. The problem seemed solved as the international *Triumph of American Painting* paralleled the triumph of American multinationals. Again, in all fairness, it

should be noted that the artists themselves were rarely if ever aware of these implications, and when they were, their extraordinary aesthetic achievements could be identified, as Irving Sandler has said, as 'a holding action on the threshold of resistance'.[4]

All this time there was a good deal of banter about the superior 'morality' of American art as compared to European art; yet political morality – ideas affecting culture from the depths rather than on the famous surface and at the famous edges – was all but invisible in the art world. For a while the yacht was too comfortable to rock, even though it was still too small to accommodate the majority of the artist population, not to mention the audience. By the mid-1960s, the small number of highly visible artists who had 'made it' offered a false image of the future to all those art students rushing to New York to make their own marks, and to have nervous breakdowns if they did not get a one-man show within the year (I say one-man advisedly, since the boys suffered more than the girls, who had been led to expect nothing and had had to cultivate personal survival powers).

Throughout the 1960s a good healthy capitalist dog-eat-dog competition flourished with the free-enterprise aesthetic. More or less abruptly, at the end of the decade, reaction set in, taking the form of rebellion against the commodity the art object had involuntarily become. Conceptual art was conceived as a democratic means of making art ideas cheap and accessible by replacing the conventional 'precious object' with 'worthless' and/or ephemeral mediums such as typed sheets, xeroxes, snapshots, booklets and streetworks. This coincided for obvious reasons with the conscientious down-ward mobility of the counterculture and the rhetorical focus of the often academic New Left. It was crowded in the streets in 1970, what with the Blacks, the students, the antiwar movement, the feminists, the gays. Art felt like one of the gang again, rubbing elbows with the masses, fighting a common enemy. After all, despite the élitist fate of their art, artists can easily identify with oppressed minorities whose civil rights are minimal.

But Wait. The enemy looks familiar. It is The Hand That Feeds us. We were picketing the people we drank with and lived off. We were making art in a buyer's market but not a consumer's market. We were full of 'mixed feelings', because we wanted to be considered workers like everyone else and at the same time we were not happy when we saw our products being treated like everyone else's, because deep down we know as artists we are special. What we (art-workers) wanted, and still want, as much as control over our labour power and over the destiny of our products, was feedback, because art is communication, and without contact with its audience it becomes the counterpart of a door handle made on a Detroit assembly line. (I have this vision of a 1990s artist seeing a film of a SoHo gallery in the 1970s and finding herself unable to recognise her own work – just as the factory worker would not be able to distinguish her door handle.)

9

A little dissent goes a long way in the art world. By 1971 the ranks were dissolving back into the white-walled rooms. Pluralism reigned and there was more room at the top. For the most part this pluralism was healthy, though attacked from the right as a fall from grace, too democratically open to mediocrity; and from the left as a bribe, too tolerant of anything marketable, a confusion of the issues. Dissent was patronised, patted on its ass and put in its place. Those who were too persistent were ghettoised or, more subtly, discredited on levels they were never concerned with. After a brief flurry of Women's Art and Black Art shows, the institutions subsided to prepare for a backlash campaign. Yet one thing that the art activism of the late 1960s and the increased (if intermittently applied) theoretical awareness of the 1970s did accomplish was a fairly thorough purge of the 'my art is my politics' cop-out, which encouraged Business as Usual and blocked all avenues (or alleys) to change. We were all aware by then that every move we made was political in the broad sense, and that our actions and our art were determined by who we were in the society we lived in. (This is not to say that most of us cared to think about these insights.) We were also beginning to realise that conceptual art (the so-called movement, not the third-stream medium) had, like the dress and lifestyles of the period, made superficial rather than fundamental changes, in form rather than in content. When we trooped back into the galleries, back to a SoHo already cluttered with boutiques and restaurants its residents could not afford (a far cry from the Artists' Community envisioned around 1968), we bore this new burden of awareness. We could no longer seriously contend that because art tends to be only indirectly effective, artists should be exempt from all political responsibility and go bumbling on concerned only with their own needs. (Yet again, this is not to say that most of us cared to act on these insights.)

IF MY ART ISN'T MY POLITICS, WHAT IS?

One point at which art and politics meet is in their capacity to move people. Even though communication with non-buying or non-writing viewers is an unpopular or unconsidered goal in the high art world, art that has no one to communicate with has no place to go. Contemporary criticism has offered no solid analyses of the artist's exile status, nor any sophisticated notion of art's audience – either present or future/ideal. We might get further faster by asking ourselves as artists and art-workers: Who are we working for? The accepted avant-garde answer has long been 'for myself', and 'for other artists'. These responses reflect the rugged individualist stance demanded of American (male) artists and the fundamental insecurity of an artist's existence in a society that tolerates but does not respect cultural activities and practically denies the existence of cultural *workers*. Reaching a broader public, aside from its populist correctness and aside from the dangers of

aesthetic imperialism, might revitalise contemporary art by forcing artists to see and think less narrowly and to accept ideological responsibility for their products. By necessity, the feminist art community has made important moves toward a different conception of audience. Perhaps this is what Jack Burnham meant when he saw feminism as offering a potentially 'vernacu-lar' art to replace the 'historical' art that has dominated modernism.[5] (My dictionary's first definition of vernacular gave me pause: 'belonging to home-born slaves'.) Although it was still possible in 1977 for *Studio International's* special issue on 'Art and Social Purpose' to ignore feminism, this has been a central concern of the most original feminist artists and writers for some time. Feminist artists are luckier than most in that we have a constant dialogue between a network of intimate art support groups and the rest of the women's movement, which is dealing with non-art issues in the real world. (An example is the current campaign in New York of Women Against Pornography.)

Yet the 'high' or commercial art world's lack of respect for a less than classy audience whose tastes differ from its own continues to be conveyed through its patronising (and, alas, matronising) accusations that any popular work is 'rabble-rousing' and 'crowd-pleasing'. The institutional reception, or lack thereof, given Judy Chicago's monumental and collaboratively executed sculpture *The Dinner Party*, and the overwhelming enthusiasm it has sparked in non-artworld audiences, is a significant case in point. Suffice it to say that the notion that élitism is necessary to the survival of quality is tendered by the same liberals who deny all evidence of repression in America and continue to defend the superiority of a capitalist democracy.

For all the Global Village internationalism supposedly characterising the 1970s, in 1980 most artists are still working for exactly the same economically provincial audience, 'It's a free country'. We are supposed to recognise that personal tastes differ. In the high art world, however, 'quality' is the status quo. It is imagined to be permanently defined by those controlling the institutions. Whilst stylistic pluralism has been encouraged in the 1970s, deeper divergences from the mainstream are still not tolerated. Given the reigning criteria by which lousy art cast in the proper mould or accompanied by the proper prose is consistently hung, bought, approved by the most knowledgeable professionals, the issue of quality seems irrelevant. Since quality comes from art, and not vice versa, the question is, how do we arrive at an art that makes sense and is available to more and more varied people, whilst maintaining aesthetic integrity and regaining the power that art must have to provoke, please, and mean something?

For better or for worse, most people go through life without even wanting to reach the inner sanctums where Art coyly lurks. What the ruling class considers 'low art' or 'bad art' plays a role in the lives of many more people than 'high art', and it is this need that new art is trying to tap. Right now, only the lucky few get 'good art' or are educated to recognise it, or decide

what it is. (Recently feminists, Marxists and Third World artists have been trying to re-educate ourselves in order to avoid seeing with the conditioned eyes of the white capitalist patriarchy.) But are we really so lucky? How much of the avant-garde high art we see gives us profound sensuous or intellectual pleasure? How often do we lie to ourselves about our involvement in the art we have convinced ourselves we should like? How many sensible middle-class people devoted to the survival of 'good taste', as intoned by the powers that be, secretly pine for the gaudy flimsiness, the raucous gaiety of 'lower class' culture? Judging from the popularity of such art from other, more 'primitive' or ancient cultures, of pop art, 'camp' and the whole punk or new wave phenomenon – quite a few.

IS THERE ART POST LIFE?

In the 1970s it became critically fashionable to call art 'post' anything that peaked in the 1960s: 'post-studio', 'post-conceptual', 'post-modernist', 'post-minimalist', even 'post-modern'. (Where does *that* leave us?) Maybe in the 1980s we will just find out that 'beyond' was nothing but a vacuum. Or a void – as in a *tabula rasa*, which is not a bad thing, especially when things need cleaning up as badly as they do now. For some of us who lived through the 1960s and have spent the last 10 years waiting for the 1970s to stand up and identify itself, the 1970s has been the vacuum. It was only in its last three years or so that it got it together to pinpoint an aesthetic of its own, and this it did with a lot of help from its friends in the rock music scene, not to mention SM fashion photography, TV and movie culture, and a lot of 1960s art ideas conveniently forgotten, so now eligible for parole. As we verge on the 1980s, 'retrochic'[6] – a subtle current of content filtering through various forms – has caught up with life and focuses increasingly on sexist, heterosexist, classist and racist violence, mirroring, perhaps unwittingly, the national economic backlash.

(Some parenthetical examples of retrochic in case it has not spread as far as I am afraid it has: An exhibition of abstract drawings by a first-name-only white artist gratuitously titled 'The Nigger Drawings' for reasons so 'personal' he is as reluctant to murmur them as he is to wear black-face in public; this was studiously defended as 'revolutionary' by a young Jewish critic who has adopted a pen-name associated with Prussian nobility. Or a male Canadian rock group called Battered Wives, who could be speaking for all such 'artists' when they explain 'the name is symbolic. It does not mean anything'; the group sings a song called 'Housewife' – 'she's a house-wife/Do not know what to do/So damn stupid/She should be in a zoo'. Or a beautifully executed and minutely detailed 'photorealist' painting called *The Sewing Room* dedicated to some poor soul named Barbara, which depicts a pretty middle-class sitting room in which a workclothed man gorily stabs the lady of the house in the neck.)

12

Some of its adherents seem to see the retrochic trend as a kind of acatatic but dangerous drug not everybody has the guts to try. It has been called a 'DC current that some people pick up on and others don't', that combats 'tokenism' and is 'too hot to handle'.[7] Some retrograde punk artists share with the right wing an enthusiasm for the 1950s, which are seen as the good old days. They are either too young, too insensitive or too ill-informed to know that the 1950s were in fact very bad old days for blacks, unions, women (viz. the crippling and deforming fashions like stiletto heels, long, tight skirts and vampire make-up) and for anyone McCarthy cast his bleary eye on. The earthshaking emergence of rock 'n' roll notwithstanding, it was also a time of censorship in the arts, of fear and dirty secrets that paved the way for the assassinations, open scandals and quasi-revolution of the 1960s.

Punk artists – retro and radical – also trace their bloodline back to pop art and Warhol (though the latter epitomised the scorned 1960s) and to Dada (though it is not fair to blame a socialist movement for its reactionary offspring). The real source of retrochic is probably futurism, which made no bones about its fundamental fascism and disdain for the masses. Violence and bigotry in art are simply violence and bigotry, just as they are in real life. They are socially dangerous, not toys, not neutralised formal devices comparable to the stripe and the cube. So I worry when a young artist whose heart and mind I respect tells me he is beginning to like the reactionary aspects of punk art because he sees them as a kind of catharsis to clear the decks and pave the way for change in the art world. At this point, as in the idealisation of the 1950s, I become painfully aware of a generation gap. The anticipated catharsis sounds like the one I was hoping for in 1969 from conceptual art and in the 1970s from feminist art.

And if retro-punk is too hot to handle, where are all those burned fingers? Most of the hot potatoes seem to have been cooled to an acceptable temperature and made into a nice salad. If Warhol is king of the punk party, the real retrochic heroine should be Valerie Solanas – the uninvited guest, whose *Scum Manifesto* was too hot for *anyone* to handle.

I hope retrochic is not the banner of the 1980s, but merely the 1970s going out on an appropriately ambiguous note, the new wave rolling on and leaving behind an ooze primed for new emergences. I have nightmares about a dystopian decade dominated by retrograde fascist art which, while claiming on one hand to be 'space age social realism',[8] manages on the other hand to be just Right for up-and-coming extremists, for those people who simultaneously jerk off to and morally condemn violence and bigotry. The living-rooms of the powerful, however, will not be hung with blurry photos of gum-chewing, sock-hopping terrorists torturing each other. The establishment's taste in politics and art do not coincide any more than does that of the artists themselves. With a nod to upward mobility, one can probably expect to find hanging over these mantles the same good solid blue-chip

formalism associated with the 1950s and 1960s, which continued to be successfully promoted and sold throughout the 1970s. Inflation encourages such acquisitions, and the SoHo boutique mentality will maintain its strongholds. Or perhaps the art of the 1980s will be a hybrid of the 1970s progeny: impressive acres of coloured canvas and tons of wood and steel functioning as covers for safes full of money and dirty pictures, with give-away titles like *Snuff, Blowupjob, Monument to a Rapist, Faggot Series, Kike I, Kike II, Kike III* and so forth – a charming and all too familiar blend of the verbally sensational and the visually safe.

There is, I am glad to report, another, more hopeful side to all of this, which is subtly entwined with the above. The pivot is an ambiguous notion of 'distancing'. We critics have been talking about 'distancing' or 'detachment' or good old 'objectivity' with admiration since the early 1960s, applying it in turn to pop art, minimalism, conceptual art, and now to performance, video, photography and film. Irony is usually an ingredient, and if we are seeking a *tabula rasa*, irony is a good abrasive. But irony alone, irony without underlying passion, becomes another empty formal device. Today 'distancing' is used two ways, which might be called passive and active. Distinguishing them is perhaps the most puzzling aspect of today's aesthetic and moral dilemma.

The passive artists tend toward the retrochic extreme. They are sufficiently 'distanced' (or spaced out) to see offensive racist or sexist words and images as a neutralised and harmless outlet for any perverse whim; after all, it's only Art. (They are not usually so far gone, however, as to use such epithets outside of the art context – in the subway, for instance.) These artists would subscribe to the formalist maxim 'If you want to send a message, call Western Union', and they tend to have great disdain for old-fashioned radicals (like me) who take such things seriously.

The active artists also use distancing as an aesthetic strategy, but to channel social and personal rage, to think about values, to inject art with precisely that belittled didacticism. Instead of calling Western Union, these artists hope that they will be able to put their message across by themselves. They often use understated satire or deadpan black humour to reverse offensive material and give it a new slant. The younger they are, the rougher they get, and sometimes the cycle reverses itself and it is difficult to distinguish earnestness from insanity.

Passive or active, the crux of the matter is how do we know what is intended? We are offended or titillated or outraged; now we have to figure out whether it is satire, protest or bigotry, then whether the intended content has been co-opted by its subject matter. These are questions that must be asked about much of the ambiguous new art. These are questions particularly important for feminists working against, say, pornography and the violent objectification of women, and for blacks working against racists in liberal clothing.

14

For example, when a woman artist satirises pornography but uses the same grim image, is it still pornography? Is the split beaver just as prurient in a satirical context as it is in its original guise? What about an Aunt Jemima image, or a white artist imitating a black's violent slurs against honkies?

Answers, though not solutions, have just been proffered by two leading and very different practitioners of social irony. Yvonne Rainer, who works from a Brechtian viewpoint, treated sex and female nudity with humour and 'distance' in her films until she realised from audience responses that the strategy was not working. At that point she became convinced, according to Ruby Rich, 'that no matter what techniques surrounded such a depiction, no matter what contradictions were embedded in the presentation, nothing could ever recoup the image of a woman's body or sexuality bared'.[9] Similarly, black standup comedian and pop hero Richard Prior has just vowed publicly to give up a staple of his routines – the word 'nigger'. 'There was a time', he says, 'when black people used it as a term of endearment because the more we said it the less white people liked it, but now it seems the momentum has changed. . . . There's no way you can call a white person a nigger and make him feel like a black man.' Asked why whites are getting so fond of the word, he replied, 'I do not think enough of them have gotten punched in the mouth.'[10]

Distancing, it seems to me, is effective only if it is one half of a dialectic – the other half being intimacy, or approaching, or optimism. You move away to get a good look but then you move back toward the centre where the energy is. This seems to be the position of a number of younger artists whose often para-punk work bears some superficial (and perhaps insidious) resemblance to retrochic. An increasing number are disillusioned with what they have found in art and the art world (including the alternate spaces and the current dissenters): 'Embrace fearlessness. Welcome change, the chance for new creation. . . . There is no space for reverence in this post-earthrise age. We are all on the merit system. The responsibility for validity is the individual artist's. The art critic is dead. Long live art.'[11] To which I would holler 'Hallelujah', but not 'Amen'.

Some young artists are working collectively, making art for specific instal-lations, public places, or for their own breezy, often harsh little shows in flaky impermanent spaces (the model for which may have been Stefan Eins' idealistic if not always fascinating 3 Mercer Street Store, and now his more fully developed Fashion Moda in the South Bronx). One of the most talked-about exhibitions last season in New York was 'The Manifesto Show', collaboratively organised and open to friends, invitees, and off-the-street participation, through which it organically almost doubled in size. There was no single, recognisable political line, but a 'social and philosophical cacophony'[12] of specific statements, rhetoric straight and rhetoric satirised, complaints, fantasies, threats – some more and some less geared to current art attitudes. Distancing techniques were used against themselves in self-

referential hooks into content from art, as in Barbara Kruger's contribution, which began: 'We are reading this and deciding whether it is irony or passion/We think it is irony/We think it is exercising a distancing mechanism/ . . . We are lucky this is not passion because passion never forgets'.

There were also the unselfconscious, atypically straightforward works that said what they meant and meant what they said. And there were Jenny Holzer's dangerously conventional collages of propaganda with lethal reminders built in for anyone who swallows them whole ('REJOICE! OUR TIMES ARE INTOLERABLE TAKE COURAGE FOR THE WORST IS A HARBINGER OF THE BEST ... DO NOT SUPPORT PALLIA-TIVE GESTURES: THEY CONFUSE THE PEOPLE AND DELAY THE INEVITABLE CONFRONTATION ... THE RECKONING WILL BE HASTENED BY THE STAGING OF SEED DISTURBANCES. THE APOCALYPSE WILL BLOSSOM'). The message seems to be Think for Yourself.

THIS UP AGAINST THAT

Those invested in a perpetual formal evolution in art protected from the germs of real life will not like my suspicion that the most meaningful work in the 1980s may depend heavily on that still pumping heart of twentieth-century art alienation – the collage aesthetic, or what Gene Swenson called 'The Other Tradition'. Perhaps it will be only the alienated and socially conscious minority that will pursue this, and perhaps (this demands insane heights of optimism) the need for collage will be transcended. Obviously I mean collage in the broadest sense, not pasted papers or any particular technique but the 'juxtaposition of unlike realities to create a new reality'. Collage as dialectic. Collage as revolution. 'Collage of Indignation'.[13] Collage as words and images exposing the cultural structure of a society in which art has been turned against itself and against the public. Martha Rosler, for instance, sees her sarcastic narratives (book, video, performance artworks) as 'decoys' that 'mimic some well-known cultural form' so as to 'strip it of its mask of innocence'. And the media strategies for public performance used by west-coast feminists Suzanne Lacy and Leslie Labowitz (with the 'social network' Ariadne) juxtapose two kinds of image within the context of street, shopping mall or press conference. The first is an image of social reality as we all know it through TV and newspapers. The second is that image seen through a feminist consciousness of a different reality – for instance looking at the media coverage of the Hillside Stranglers murders in Los Angeles, analysing its sensationalism and demeaning accounts of the victims' lives, then offering an alternative in the form of a striking visual event ('In Mourning and in Rage') and controlling the subsequent media interpretations. The public thus receives, through art, information contrary to that which it sees as 'the truth' and receives it in a manner that is striking

and sufficiently provocative to encourage reconsideration of 'the truth'. Ariadne's media strategies obviously have limited means at their disposal, but their performances have played to audiences of thousands and have an impact only professional artists can bring to bear.[14]

The attraction of a collage aesthetic is obvious when we realise that most of us, on the most basic level, exist in a downright surrealist situation. Consider the position of an artist in a society that perceives art as decoration or status symbol, investment or entertainment. Consider the position of a visionary artist in a society devoted solely to material well-being. Consider the position of a person making impermanent objects of no fixed value in a time of inflation and hoarding. Consider the position of an artist labouring under the delusion that individuality is respected in an age of bland, identical egos. Perhaps most surrealist of all, consider the position of a feminist/ socialist/populist artist in a patriarchal capitalist marketplace.

NOW WHAT?

After the pluralism of the 1970s, the 1980s are going to have to make art that stands out in sharp relief against our society's expectations for art. Artists are just beginning to understand the flood of new media available, after a decade of enchantment with their novelty. Comprehension of 'the nature of the medium' may sound like an echo of formalist dogma, but if the medium is one whose nature is communication – the video, the street performance, posters, comic strips, graffiti, the ecologically functional earthwork, even photography, film and that old but new-for-the-visual-artist medium, the book – then such comprehension may have more impact on audience and on art. We are supposed to have grown up absurd already. Yet through the 1970s I have asked myself why the hell these new mediums were the vehicle for so little socially concerned art. If there is all this rebelliousness and unease among young artists about how the art world treats art (and there is), why are such appropriately outreaching media so little explored and exploited? Why is there such a dearth of meaningful/provocative and/or effective public art? Has distancing gone too far? Have we got carried away? Space-age objectivity over our heads? Over and out?

I hope we are not just doomed to follow the bouncing ball through endless cycles of romanticism/classicism, subjective/objective, feeling/intellect, etc. If the 1960s proved that commitment did not work, the 1970s proved that lack of commitment did not work either. The 1980s decade is coming into a legacy of anxiety, of barely articulated challenge to boringly predictable mainstream art. It is going to have to restore the collective responsibility of the artist and create a new kind of community within, not apart from the rest of the world. The danger on all aesthetic fronts is the kind of faction-alism that already divides the politicised minority within the art world. Too many of us spend our time attacking everyone else's attempts at relevance

17

while paranoically guarding our own suburban territories. There is an appalling tendency to insist on the need for theoretical understanding of the artist's position in a capitalist society and simultaneously to destroy by 'logic' every solution offered. It is all too easy for any intelligent observer to be devastatingly cynical about Marxists making abstractions, artists made vulnerable by working at the same time in communities and in museums, feminists riding the women's movement to commercial success and getting off there. The denial of support to an artist or group who is trying to work out of this dilemma we all share, the questioning about presentation, form, and motivation when it appears that communication *is* nevertheless taking place, all this merely recapitulates the competition that maintains the quality-based 'high art' world.

Merely opportunist as some of it may be, art with overtly social content or effect still poses a threat to the status quo. And, ironically, no group is so dependent on the status quo as the avant-garde, which must have an establishment to attack, reverse, and return to for validation. It is true that most politically aware artists and art-workers would sooner give up politics than give up art. Embedded in the whole question of why more visual artists are not more committed to combining form and content in more interesting ways is the tabu against 'literary' art. Artists emphasising words and ideas over formal success have been seen since the 1960s as traitors to the sacred modernist cause; just as the Dadas and surrealists are not considered serious contributors to modernism even when their *contributions* are considered serious. This sort of prejudice has been blurred by the mists of pluralism, but it remains as subtle conditioning, because visual art is about making things (even if those things have no 'pictures') and this is what visual artists justifiably do not want to give up. In the late 1960s we got sidetracked by the object/non-object controversy. Sheets of paper and videotapes, though cheaper than paintings and sculptures, are still objects. Conceptualism, we know now, is no more generically radical than any other 'ism' but it is no less art.

Another major question we have to ask ourselves as we enter the 1980s is: Why is it that culture today is only truly alive for those who make it or make something? Is it because making art, or whatever the product is called, is the most satisfying aspect of culture? Is it because its subsequent use or delectation is effective only to the extent that it shares some of that intimacy with its audience? Even as a critic, I find that my own greatest pleasure comes from empathetic or almost kinaesthetic insights into how and why a work was made, its provocative elements. So the necessary changes must broaden, not merely the audience, but the makers of art (again a fact the feminist art movement has been confronting for some time over the issue of 'high', 'low', craft and hobby arts). Maybe the ultimate collage is simply the juxtaposition of art and society, artist and audience. Maybe that is what a humanist art is – it comes in all styles and sizes, but it demands response and even imitation. It is alive.

For the vast majority of the audience now, however, culture is something dead. In the 1950s the upwardly mobile bourgeois art audience (mostly female) was called the 'culture vultures'. They did not kill art but they eagerly devoured it when they came upon its corpse. As Carl Andre has observed, art is what we do and culture is what is done to us. That fragile lifeline of vitality, the communication to the viewer of the ecstasy of the making process, the motive behind it and reasons for such a commitment can all too easily be snapped by the circumstances under which most people see art – the stultifying classist atmosphere of most museums and galleries and, in the art world, the personal intimidation resulting from over-inflated individual reputations.

What, then, can conscious artists and art-workers do in the coming decade to integrate our goals, to make our political opinions and our destinies fuse with our art? Any new kind of art practice is going to have to take place at least partially outside of the art world. And hard as it is to establish oneself in the art world, less circumscribed territories are all the more fraught with peril. Out there, most artists are neither welcome nor effective, but in here is a potentially suffocating cocoon in which artists are deluded into feeling important for doing only what is expected of them. We continue to talk about 'new forms' because the new has been the fertilising fetish of the avant-garde since it detached itself from the infantry. But it may be that these new forms are only to be found buried in social energies not yet recognised as art.

NOTES

1 In conversation with the author. In this and other conversations and writings over the years, Baranik has been a rational radical voice in my art-and-politics education.
2 Robert Motherwell and Harold Rosenberg, in *Possibilities*, no. 1, 1948.
3 Ad Reinhardt, *Arts and Architecture*, January 1947. Many of the ideas in this article have their source in Reinhardt's ideas and personal integrity.
4 Irving Sandler, *The Triumph of American Painting*, Praeger, New York, 1970. Max Kozloff, William Hauptman and Eva Cockcroft have illuminated the ways in which Abstract Expressionism was manipulated during the cold war in *Artforum*, May 1973, October 1973 and June 1974.
5 Jack Burnham, 'Patriarchal Tendencies in the Feminist Art Movement', *The New Art Examiner*, Summer 1977.
6 I do not know who coined the term 'retrochic', but it was used frequently during the controversy over 'The Nigger Drawings' show at Artists' Space, NYC, 1979. A classic practitioner is Norman Mailer, who in his 1957 *The White Negro* praised two hoods who had murdered a store owner for 'daring the unknown' in an 'existential' act, and who later said he 'felt better' after stabbing his own wife.
7 Douglas Hessler, letter to the editor of *The SoHo News* (21 June 1979) in response to a piece by Shelley Rice (7 June 1979) which bemoaned the prevalence of 'apolitical sophistication'.
8 J. Hoberman, 'No Wavelength: The Para-punk Underground', *The Village Voice*, 21 May 1979.

9 Ruby Rich, in *The New Art Examiner*'s special issue on 'Sexuality', Summer 1979.
10 Richard Prior, quoted by Richard Goldstein in *The Village Voice*, 23 July 1979.
11 Lauren Edmund, review (in the spirit of) 'The Manifesto Show', *East Village Eye*, 15 June 1979.
12 Peter Frank, 'Guerrilla Gallerizing', *The Village Voice*, 7 May 1979, p. 95.
13 'Collage of Indignation I and II' were the titles of two separate exhibitions of art for social protest, the first a painted-on-the-spot collage in Angry Arts Week, 1967, the second a show of commissioned political posters at the New York Cultural Center and other locations in New York, 1970–1, organised by myself and Ron Wolin.
14 For more on Ariadne, see *Heresies*, no. 6, 1978, and *Heresies*, no. 9, 1980.

2

MAY STEVENS

Lisa Tickner

(*From*: Issue 5, 1981)

ORDINARY. EXTRAORDINARY. A COLLAGE OF WORDS
AND IMAGES OF ROSA LUXEMBURG, POLISH/
GERMAN REVOLUTIONARY LEADER AND THEORETI-
CIAN, MURDER VICTIM (1871–1919) JUXTAPOSED
WITH IMAGES AND WORDS OF ALICE STEVENS
(BORN 1895–) HOUSEWIFE, MOTHER, WASHER AND
IRONER, INMATE OF HOSPITALS AND NURSING
HOMES. ORDINARY. EXTRAORDINARY.[1]

The public and the private worlds are inseparably connected;
. . . the tyrannies and servilities of the one are the tyrannies and
servilities of the other.

(Virginia Woolf)[2]

May Stevens' recent work had not been seen in England until her contri-
bution to 'Issue' at the ICA in 1980. We are probably more familiar with
the 'Big Daddy' paintings which Lucy Lippard discusses in *From the Center*
as images of patriarchal power. ('Big Daddy is watching you, but with total
incomprehension, with his phallic, bullet-shaped, bomb-shaped head, with
his baby fat of useless age, himself a prick with the bulldog – *his* prick –
secure in his lap.')[3]

This series put politics (specifically, socialist and anti-imperialist politics),
together with autobiography, in order to represent something of the mutual
interdependence – for women – of public and private tyranny.

I began to paint my own family background. I painted out of love
for those lower-middle class Americans I came from and out of a
great anger for what had happened to them and what they were

21

letting happen, making happen, in the South and in Vietnam. . . .
I had two recent photographs – one of my father, one of my mother.
They were snapshots, terrible to see, revealing of what life had done
to these people I loved, and what they had done to each other.
The photograph of my mother was too terrible for me to deal with.
I started to paint my father.

My mother, when I was growing up, did not sew, did not cook
well, and did not keep a beautiful house . . . when my brother died
at sixteen and I left home, the long disorientation consumed her
and she was committed to a state mental hospital. Sexism and
classism, male authority and poverty-and-ignorance were the forces
that crippled my mother, the agent in most direct contact with her
was, of course, my father.[4]

The 'Big Daddy' paintings belong very much to the period of civil rights
and anti-draft politics, and this is true both of their references and their
style. By the early 1970s these politics had largely given way to, or had been
reformulated within, different arenas such as that of the emerging women's
movement in which Stevens was now active.

A woman *is* her mother/That's the main thing.

(Anne Sexton)[5]

The photograph – indeed the relationship – that had been 'too terrible
to deal with' became the focus for a double page spread in the first issue
of *Heresies* in 1977.[6] The influence of the women's movement, specifically
of consciousness-raising and the 'personal as political'; the inspiration of
Adrienne Rich's *Of Woman Born*; the demands of an unfamiliar format for
which she adopted a collage of overlapping texts and imagery – all these
seem to have facilitated a rediscovery, around and behind her father's bulk
('can't get that build out of your mind, can you?'), of the mute shadow of
her mother (who 'lost year by year the habit of speaking').

It was the first time that I had ever designed something specifically
for the purpose of a magazine. The idea wasn't just to put in two
photographs from other work I'd done, but to make something that
would suit this publication, which we conceived of as being social-
ist-feminist . . . it was to combine art and politics, and I came up
with the idea of working with the thinking, the life, the work of Rosa
Luxemburg and to combine this with the story of the life of my own
mother. . . . I think the genesis of that was a very ordinary thing,
which made a lot of sense to me at the time, though it is harder
for me to discuss it now. At that time I was so aware of the split
within the women's movement between women of different classes
– so aware that working class women felt that feminism had noth-
ing to do with them, that it was about being a media star, that it

22

was a very bourgeois movement that looked down on women who raised families. That sense was painful to me. I come from the working class and have very strong ties – I want to maintain that connection. . . . So I wanted to use her life, and her very limited circumstances, her limited education and limited possibilities – and juxtapose her – and *combine* her – with Rosa Luxemburg who was such a fantastically successful woman in all of the things that she did.

Many women have . . . split themselves – between two mothers. One, usually the biological one, who represents the culture of domesticity, of male-centredness, of conventional expectations, and another . . . who becomes the countervailing figure . . . (with) a freer way of being in the world.

(Evelyn Reed)[7]

The juxtaposition of Alice and Rosa is not a comparison of 'ordinary' and 'extraordinary' since each, of course, is both; and one point of the comparison is to fracture such terms, especially in regard to women – 'hidden from history', and speaking, publicly, on sufferance or not at all. There are links between these apparently incompatible lives: between the determinants and implications of Alice's private silence (and institutionalising) and Rosa's public voice (her imprisonment and assassination). Neither is Rosa, more familiar in history, a more 'historical' figure than Alice. In tracing her near-obliterated life, May Stevens reminds us of that which 'history' works to erase. It is Rosa who becomes, as it were, a subject for portraiture ('I wanted to bring her close, very intimately close and alive'); and Alice for history painting ('In some way I was trying to get some distance on my mother').

Indeed, it is possible to argue for *Ordinary/Extraordinary* as a kind of history painting[8] transposed to the modern vernacular. Literary allusion, figure composition, social and moral implication, narrative or anecdotal subject matter have been largely rejected by the avant-garde. But Stevens' piece *does* deal with events from the (recent) past which it invests with contemporary significance; it uses both allegorical and narrative devices, albeit in a fragmented and modernist form; it refers to history at the same time as it asks 'what history?', 'whose history?'; and through its juxtaposition of the revolutionary speaker and the mute housewife it remembers 'all of those without names/because of their short and ill-environed lives'.[9]

Whatever is unnamed, undepicted in images, whatever is omitted from biography, censored in collections of letters, whatever is misnamed as something else, made difficult-to-come-by, whatever is buried in the memory by the collapse of meaning under an inadequate or lying language – this will become, not merely unspoken, but unspeakable.

(Adrienne Rich)[10]

MAY STEVENS
ORDINARY.EXTRAORDINARY.

The words of Rosa Luxemburg

Five days before she was murdered she wrote:
'Order' reigns in Warsaw!' 'Order reigns in Paris!'
'Order reigns in Berlin!' This is how reports of
the guardians of 'order' read, every half-century,
from one center of the world historical struggle
to the other. And the exulting 'victors' fail to
notice that an 'order' that must be maintained
with periodic bloody slaughters is irresistably
approaching its historical destiny, its downfall.

Tomorrow the revolution will rear its head once
again, and...will proclaim, with trumpets blazing:
I was, I am, I will be!

The words of Alice Stevens

Once she said, 80 years old, living in a nursing
home, eating the food, waiting for change, forgetting
more each day, sliding toward a slimmer consciousness,
slipping softly away:
Everybody knows me.

Figure 2.1 May Stevens, *Ordinary. Extraordinary.* 1981

Source: Centre page piece produced for *BLOCK*, no. 5, 1981. Reproduced with kind permission of the artist

24

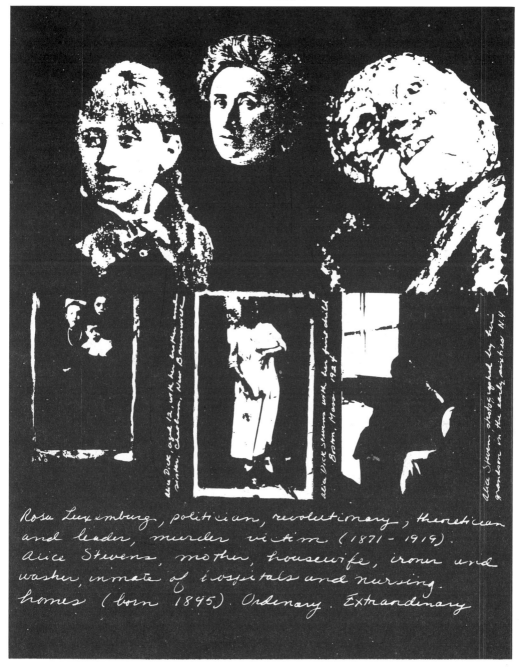

Rosa Luxemburg, politician, revolutionary, theoretician and leader, murder victim. (1871 - 1919). Alice Stevens, mother, housewife, ironer and washer, inmate of hospitals and nursing homes (born 1895). Ordinary. Extraordinary

A redefinition of art, at least as violent in its breaking up of received ideas as the birth of abstraction, is going on. These artists engage in that redefining out of motives deeper than the search for newness or modishness. They have things to say that demand these ways of saying and ways they are still working toward.

(May Stevens)[11]

The use of texts and photographic imagery in the *Ordinary/Extraordinary* series is almost filmic.[12] The reader (it seems the appropriate term) must first scan the overlapping ingredients of a complicated pictorial surface – adjusting between handwriting, printed captions, and different kinds of photographs (official, studio, snapshot) – finding only provisional forms of coherence in the pattern of darks and lights, in an implied narrative sequence, in the nostalgia common to old letters, fashions and faded photographs. We must coax significance (and pleasure) out of a series of juxtapositions deliberately left unharmonised, without commentary, since the artist is looking particularly for forms of expression that will let in certain kinds of everyday experience, and parallel the shifting levels of conscious-ness through which we perceive them.

I think my concept about the whole piece is that something which is sort of visual, aural, suggestive, evocative . . . emerges, and maybe flickers and recedes and comes and goes – glimpses of the meaning and the sequence which you probably have to work at, but which adds up, eventually . . . I feel I learn and experience things very much through a surfacing and disappearing . . . the sense of consciousness that I experience in my daily life all the time is something that I would like to *use* in art . . . I would like to have a sense of different *levels* of consciousness, and of things seeping through, disappearing. That phenomenon is so *real* to me, and so overwhelming, that I'd like to put that in art . . . it seems real, more real than something that's on one level and spelled out and limited and confined. Always in flux and always changing . . . that's my sense of the way things really are – change and uneven-ness, coming and going. That form is the truest form that I can think of, or that I know of, and it's hard to find out how to do that, but that's my sense of form at the moment. And it does come out of the Women's Movement. That has given me some insights into a way of thinking about these things.

The series is partly *about* representations: about their relation to feeling and memory; about their survival, as fragments, through time and handling; by accident or through the artist's processes about the degrading of imagery in different kinds of reproduction – almost a metaphor for the erosions and erasures to which both material objects and memories are subject. The

26

contrast between Alice as a young woman with her baby, and as an old woman in an institution (where she 'gained the ability to speak, but lost a life to speak of'), is no less poignant than that between the 12-year-old Rosa Luxemburg in an archaic studio portrait, and the police photograph of her disintegrating corpse. At the same time it is not a question of reading back through to the 'content', as in a mist. The ingredients are things loved in themselves, finely discriminated ('I love the look of photographs, text, photostat, xeroxes, – and a grey page of text is very beautiful'). They have an old library flavour, of something musty and archaeological, dug out of a damp cellar. They survive from, and stand to us for, the history of the recent past; but they also signify in different ways, bringing some of their old associations with them into new juxtapositions, so that the meanings they produce – or we produce, reading them – are derived neither from the past nor the present alone, but from the new uses to which old ingredients are put. The past is reconstructed in the present (how else, indeed, can it exist?); and new representations draw on associations already in currency (how else are cultural meanings (re)produced?).

Collage is a particularly frank expression of this process (and it is not here the formal synthesis of cubist collage or the visionary 'chance encounter' of surrealism). The elements do not 'cohere' into the harmonious composition of which it is traditionally said that nothing can be added or taken away. On the contrary, they offer a sense of the provisional, of pieces held in tension, with each other and with their own pasts. It is not that aesthetic decisions are not made – decisions about efficiency, significance or pleasure – rather that they are not made to *unify*, or on the other hand, to favour the dream-like or absurd. This is a kind of 'bricolage', as Lévi-Strauss describes the work of the myth-maker, drawing on 'whatever is to hand' (i.e. 'the contingent result of all the occasions there have been to renew or enrich the stock') – speaking 'not only *with* things . . . but also through the medium of things': 'it is always earlier ends which are called upon to play the part of means: the signified changes into the signifying and vice versa'.[13]

Elements from different modes of experience, different systems of meaning (family albums, Edwardian dresses, political pamphlets, private letters, remembered speech, police photographs) – emotionally charged and dense with their original reference – are overwritten and overlaid, 'pieced', to use a female metaphor, in new patterns of association and contiguity: imbricated and interleaved. Like much feminist work it attempts to transform 'a metaphorical tradition and political perspective dominated by the male voice'[14]; to incorporate into the area of legitimate cultural expression a range of traditionally silent positions and speakers; and to assert the interdependence of the conventionally opposed – the public and the private, politics and autobiography. It offers a critique of modernism that also draws on it, addressing itself to a contemporary art practice which it struggles to

transform, on the one hand; and to the concerns of the women's movement – the social construction of gender, the particular oppression of women, the 'personal as political' – on the other. (Not the personal as the private and authentic domain of individual sensation – but the personal as a place of contradiction, of conflicting pressures and desires; a place circumscribed and compromised for women by the operations of hegemonic power.) May Stevens' work, like that of Susan Hiller, Mary Kelly and others working in England, is scripto-visual in form; simultaneously private and political in origin and effect; concerned to reinstate in art a highly charged content which is at the same time subject to organisation and comment; and committed to the self-conscious exploration and manipulation of the processes of representation itself.

> daughters said that they had seen photographs of their mothers as young women, and that the woman in the pictures hardly resembled the woman they called mother. . . . We can see in these snapshots that our mothers left another life to come to the place where we meet them.
>
> (Judith Arcana)[15]

The last point about *Ordinary/Extraordinary* is about motherhood. A great deal of women's work in the last few years has come back round to this ('how to live it or not to live it'). Motherhood as plenitude or loss; as the crucible of femininity; as the relation that triggers every kind of social assumption and confirmation; as the sump into which energies are drained from all other tasks that would require the 'selfishness' of undivided concentration. Women have been Angels in the House of Art – devoted, primarily, to its inspiration and domestic care. *Cultural* creativity is the work of men (who labour and bring forth in female metaphor). 'Mother' and 'artist', even more than 'woman' and 'artist', have been contradictory terms – a distinction enforced by material circumstance, since it was, and is, very difficult to reconcile the demands of both roles as each is currently constituted. As Tillie Olsen has pointed out, 'until very recently almost all distinguished achievement has come from childless women'.[16] (It is a choice that some women are not in a position to make, one way or the other; one that men on the whole are never obliged to make; one that once made can be hard, one way or the other – consider Plath rising to write at four, 'that still blue almost eternal hour before the baby's cry';[17] or Woolf, when *The Waves* was moving well, and 'I had a day of intoxication when I said "children are nothing to this".'[18])

It is a dichotomy that the opposition between Alice Stevens and Rosa Luxemburg might seem to restate (there are a number of references in Rosa's letters to her desire for a child): Yeats' choice between 'perfection of the life or of the work'. But the invisible third term here is the artist herself (artist and mother), who stands between the ghostly figures of Alice and Rosa in *Mysteries and Politics*, who attests to the survival of the martyred revolutionary,

and to the eloquence of the mute housewife, and who in 'rescuing' her mother, constitutes herself, as different.

> And about the mother part of it – in a way I think the whole thing was an attempt to validate my mother's life, and its failure. . . . In some way I was trying to get some distance on my mother, and to bring Rosa closer.

> But poets should
> Exert a double vision; should have eyes
> To see near things as comprehensively
> As if afar they took their point of sight,
> And distant things as intimately deep
> As if they touched them.
> Let us strive for this
>
> (Elizabeth Barrett Browning)[19]

NOTES

1 From the artist's book *Ordinary/Extraordinary*, 'examining and documenting the mark of a political woman and marking the life of a woman whose life would otherwise be unmarked'. Published July 1980. Otherwise uncredited quotations come from discussions at Middlesex Polytechnic, and privately with the author in March 1981. I should like to say how grateful I am for May Stevens' patience and co-operation, and how much I enjoyed the opportunity to learn more about her work.

2 Virginia Woolf, *Three Guineas*, Penguin, Harmondsworth, 1977, p. 162.

3 Lucy Lippard, *From the Center*, E.P. Dutton & Co., London, 1976, p. 234.

4 May Stevens, 'My Work and My Working Class Father', in *Working It Out. 23 Women Writers, Artists, Scientists and Scholars Talk About Their Lives and Work* (eds Sara Ruddick and Pamela Daniels), Pantheon Press, New York, 1977, p. 112.

5 Anne Sexton, 'Housewife', *All My Pretty Ones*, Houghton Mifflin, Boston, 1962.

6 May Stevens was a founder/editor of *Heresies* ('a feminist publication on art and politics') and subsequently a member of the core collective. It was planned from 1975, and the first issue appeared in January 1977.

7 Evelyn Reed, *Woman's Evolution*, Pathfinder Press, London, 1975, p. 247.

8 During the 1970s May Stevens produced three works – *Artist's Studio (After Courbet)* (1974), *Soho Women Artists* (1977–8) and *Mysteries and Politics* (1978) – which she exhibited together at the Lerner Heller Gallery as 'Three History Paintings'. History painting had been traditionally the most prestigious and public genre; the most elevated in academic theory; and the one to which women had least access by reason of training, expectation, and what Cora Kaplan has called the 'taboo on public speech'.

9 Adrienne Rich, 'Culture and Anarchy', *Heresies*, vol. 3, no. 9, p. 92, 1980.

10 Adrienne Rich, *On Lies, Secrets and Silence*, Virago, London, 1980 (first published 1979), p. 199.

11 May Stevens, from a proposal to the Whitechapel Art Gallery for a joint British/American show of feminist political art. This eventually became 'Issue', selected by Lucy Lippard at the ICA, November 1980.

12 In this it is completely different from the hierarchic frontality of the 'Big Daddy'

series, and from such monumental female heroines as *Artemisia*, Stevens' contribution to the corporate 'Sister Chapel', 1978.

13 Claude Lévi-Strauss, *The Savage Mind*, Weidenfeld & Nicolson, London, 1972 (first published 1962), pp. 17–19 *passim*. (I have not been entirely fair to Lévi-Strauss' original intentions. He refers to the artist as 'both something of a scientist and of a "bricoleur"'; and refers rather disparagingly to that 'intermittent fashion for collage' which he sees as nothing but 'the transposition of "bricolage" into the realms of contemplation' (p. 30).

14 Cora Kaplan, Introduction to Elizabeth Barrett Browning's *Aurora Leigh*, The Women's Press, London, 1978, p. 14.

15 Judith Arcana, *Our Mothers' Daughters*, The Women's Press, London, 1981 (first published 1979), p. 165.

16. Tillie Olsen, *Silences*, Virago, London, 1980, p. 31.

17. Ibid., p. 36.

18. Ibid., p. 160.

19. Elizabeth Barrett Browning, *Aurora Leigh* (1853–6), republished by The Women's Press, London, 1978, pp. 200–1.

3

STRUCTURE AND PLEASURE

Claire Pajaczkowska

(*From*: Issue 9, 1983)

INTRODUCTION

This essay was originally written as a paper for the Association of Art Historians' Annual Conference in 1983 where it was given as part of a panel organised by Jon Bird. At the time it seemed that Marxism was already well established as a critical methodology in art history. Nico Hadijinicolaou, speaking from his work on *Art History and Class Struggle*, was a major contributor to the panel and the project of interpreting paintings as visual artefacts produced within a political economy, already part of a long tradition, was then in Britain being carried forward by Tim Clark, Charles Harrison, John Tagg, Janet Wolff and others. The problem was that the critical method of Marxist analysis had tended to override other realities, particularly the issue of the specificity of art as text and the reality of the gendered dimension of the gaze and the imagination. This essay was an attempt to place these issues alongside that of political economy. In hindsight it was impossible to predict that the orthodoxy of Marxism could be so fragile, and that what seemed to be a new 'hegemony' in art history could be a defensive stance against vulnerability within academic and cultural institutions which in many ways continue to shore up the jealously guarded privileges of a self-protective middle class.

However, semiotics is now fully compatible with a cybernetic Imaginary which has severed 'information' from its basis in the mechanics of power. As an endlessly additive pursuit with new definitions of signification proliferating, semiotics is taught as an autonomous discipline within 'communication studies'. The once revolutionary concept of the 'arbitrariness' of the signifier's relation to its referent has now been lost in the dense fogs of postmodernism.

The fate of psychoanalytic and feminist approaches to art may well prove to be similarly compromised by the 'iron laws' of institutional thinking, with the promotion of publishing as the most highly prized index of research.

The attempt to introduce ideas from French structuralism into what appeared to me to be the dogged empiricism of British art history now

seems over-optimistic if not naive. But there are still some interesting and urgent questions raised by the conjecture of theories; the question of how masculinity as a symbolic structure might be central to the meaning and history of art remains unanswered. And the use of psychoanalysis as a method for understanding this structure, meaning and history is still in its infancy. These issues remain a goal for current research.

On re-reading this essay I am struck by the sense of its aspiration towards a kind of control (which might be the mood of the structuralist project but which is more likely a youthful substitute for integrity) and the unalloyed severity of its superego. Most strangely of all, the footnotes seem more interesting than the body of the text.

I was mystified but happy when it was translated and reprinted in *Montage*, a Norwegian journal of the avant-garde, art and theory.

An introduction to and explanation of the most interesting aspects of the structuralist and semiotic methods in art history and the analysis of the image can be found in Jaques Aumont's book *L'Image*, translated and soon to be published by the British Film Institute. The concept of a discourse of looking, which is identified as an 'apparatus', is fully explored and discussed, thereby extending empirical, social and historical analysis into psychoanalytic accounts of subjectivity, identification, memory and desire.

The aim of this paper is partly to introduce and partly to discuss the ways in which semiotic and psychoanalytic theories of art have found points of articulation and intersection, and to suggest some other possibilities for thinking about representation.

The best way for me to understand something is to see how it differs from other things, to see a relation between differences, and this is the way in which I will introduce and discuss these theories, in relation to one another, within a history. By tracing the changes and development of theories of art through the structuralist and 'post-structuralist' paradigms that have emerged over the past 15 years it should become evident that fundamental transformations are taking place in the very conceptualisation of 'art'. I place the 'post-structuralist' in inverted commas because to use it at all entails, for me, a suspension of disbelief: I don't see that the 'post' represents any real advancement on, or progression from, the structuralist paradigm. Insofar as it is used to refer to theories of the subject, as opposed to theories of the text, I think that structural thought, especially that of Marx and Freud, is still the site of the most pertinent, and troubling, questions about subjectivity. However, in following the changes in the conceptualisation of subject and object in art theory through the work of a generation of writers, it is clear that major changes have taken place, and as long as we understand what they mean it does not much matter what they are called.

I have chosen the texts of five writers which are indicative of the kinds of changes that have taken place. In doing this I cannot do justice to the complexity and variety of positions taken by each writer across their work as a whole, but will use the texts of specific moments to build a history which at times confounds chronology. The five texts are Jean-Louis Schefer's *Scénographie d'un Tableau*, Jean Paris' *Painting and Linguistics*, Marcelin Pleynet's *Peinture et 'Structuralisme'*, Guy Rosolato's *Essais sur le Symbolique*, and Julia Kristeva's essays on Bellini and Giotto from *Polylogue*.[1]

IMAGE/LANGUAGE

The enormous resistance to these theories and their way of thinking about art as systems of representation (if you want proof just wonder why so few of these texts exist in English translation whilst the publishing industry keeps bombarding us with 'shock-of-the-new' post-structuralism) is often rationalised as an argument which complains that structuralist theories 'reduce' art to the status of language, denying the specificity of meaning as it exists in the visual image. This argument will be answered firstly by explaining *the way in which* images are subject to being considered as texts (Schefer and Paris) and the problems that arise from this; and secondly how a different understanding of the specificity of imagistic representation can emerge from having worked through the linguistic paradigm. Eventually the polarisation of Image versus Language becomes the comprehension of images in relation to language.

Structural analysis has many origins, in Marx, Freud and Lévi-Strauss as well as in linguistics; Schefer's work, for example, owes much to Lévi-Strauss' analysis of myth although it is explicitly based on Hjemslev's linguistics. And I would also place this contemporary work about the image/language relation within another history, a history of art practice. It resumes the preoccupations of both Soviet Formalism and early Surrealism. The intellectual products of the Formalists are central to the contemporary debate: Eisenstein and Dziga Vertov's film theory, Vladimir Propp on narrative structure, Roman Jakobson on both language and art and who, as early as 1921, pointed out that art history was in dire need of a more rigorous methodology if it was to remain anything more than gossip.[2] This intellectual tradition was the product of a close interrelation of theory and practice, was based on collective forms of organisation, and gave rise to a vital problematic, particularly in relation to cinema where experiments with a new medium and a new revolutionary politics resulted in the creation of some important thinking about the organisation of images into syntactic and narrative forms, and more generally about the image/language relation.

The other tradition, one with striking similarities to the Formalists, was Surrealism; or at least the early surrealism whose true descendants were the Situationists rather than the Salvador Dali phenomenon. Again there was

the interest in film, in using film to work out problems about the way in which meaning is made; there were collective forms of organisation, the interrelation of theory and practice, and political practice. We can find antecedents in Magritte's paintings (one of which is now used as the cover to the paperback edition of Lacan's work), in films like *L'Age D'or* and *Un Chien Andalou*, as well as in the 'paranoia criticism' and the word games recorded in their manifestos.[3]

Within contemporary writing the battle between word and image has been fought for a long time, usually taking the form of an imperialist struggle for ownership of territory, the territory being the power to define academic disciplines. These arguments for the primacy of the image usually come from versions of Merleau-Ponty's phenomenology, or less philosophical and more literary assumptions that are implicit in much art history (Coleridge seems to be a favourite, especially his concept of the 'imaginative faculty'). These arguments claim that the image is a separate and more primary form of communication than language, that it is truer, and that its special truth cannot really be discussed in language.

Others, attempting to incorporate the analysis of visual meaning systems within wider semiological systems, extend their analytic classifications to include images as subsystems of language; such as the work of Eco, Metz and C.S. Peirce. Peirce's classification of a tripartite sign composed of icon, index and symbol which correspond to analogical, metonymic and arbitrary relations of signifier to referent is one which has been used in this way.

I shall return to this battle at several points during the course of the paper, to show that there can be no right answer within the terms of the debate and to suggest how the terms might be changed. But first we must look at the way in which the terms have been set and how the debate has developed.

The *Scénographie d'un Tableau* is a book-length analysis of a single painting: *The Chess Players*, a double portrait by Paris Bordone, a sixteenth-century Venetian painter. Because the painting revolves around the game of chess, the central element, Schefer examines historical material about the conventions of theatre and the concepts of acting and playing for sixteenth-century Venetians. History is the 'context' of the painting as text. In his analysis of the text Schefer divides the painting into its signifying elements and discusses the way in which these elements are assembled through two perspectival systems. The one which organises the left-hand side of the painting; the colonnades and the paving, is constructed through the classic, monocular grid with its diagonals converging at 'vanishing point'. The right-hand half of the painting is a rural scene with a parallel, although different, atmospheric, perspectival system. Each system is characterised by its own lighting; the play of light across the colonnades is different from the light and shade around the trees. A further part of the analysis discusses the doubling and repetition evidenced throughout the painting; the double system of perspective and lighting is repeated with other elements, the chess game has

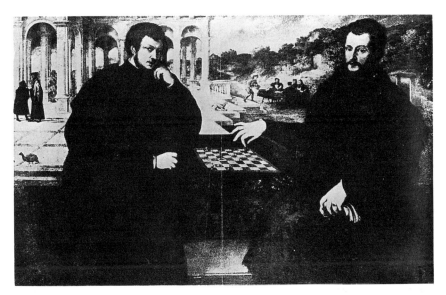

Figure 3.1 Paris Bordone, *The Chess Players* (c. 1700)

Source: Every effort has been made to contact the copyright holder of this picture, formerly housed at the Kaiser Frederich Museum, Berlin. For queries, please contact the publishers.

its other in the card game, the two men on the paving are mirrored by the two women lying in the grass on the far right, the dog and the bird, the shape described by the splayed fingers of the hand holding the chesspiece echoes the shape made by the zig-zag of the paving meeting nature.

The elements he isolates, then, are objects (signifieds), lighting, underlying organisational systems (perspectives), lines (hand and paving stones) or colours. What Schefer considers of analytic importance is the relation between these elements. These are classified as *codes*, and amongst the many codes identified in the painting are the rhetorical, the numerical, the geometric, and the logical. Each code has a number of variants. For example within the rhetorical code, as it operates in the painting, there are a number of tropes: catachresis, hyperbole and metaphor. In metaphorical troping one element is substituted for another within the same relation; for example, the chess game stands in relation to the rest of the painting as the painting stands in relation to the viewer, as a game with conventional and formal rules.

For Schefer, the system of codes with its subsystem of articulation within the codes is a way of specifying the operation of the process of *figuration*, the process fundamental to art, which works to transcribe the iconic mode of signification into a linguistic code, or, in other words, acts as a network which becomes the threshold between language and the world. Figuration

is the way in which the various meanings operative within the codes are transcribed into a representational system, the way in which the contradiction between nature and culture is symbolically and ideologically transcribed into the dual perspectival system of the painting. In positing the antinomy of nature and culture as underlying the system of opposites and doubling within the painting Schefer is drawing rather literally on Lévi-Strauss' analysis of myth, and although this is indisputably one fundamental level of the painting's meaning I want, later, to return to the painting to suggest that there is another underlying system of meaning, equally fundamental, which Schefer has not identified. Nevertheless the book is one to which all subsequent writers on the semiotics of painting refer; it is one of the most rigorous attempts to describe the system of the text in its signifying relations with the viewer.

Jean Paris, in *Painting and Linguistics*, criticises Schefer for his formalism; the *Scénographie*, he claims, is a perfect example of the distortion of the understanding of visual representation by an insistence on the primacy of language, evidenced in Schefer's use of the concept of the tropes of rhetoric, a writerly or spoken form. Paris claims that perception has a double structure, a deep and a surface structure, both of which are to be found in the signifying structures of paintings. The surface structure is the level of 'impression' and the deep structure the level of 'meaning', and these two levels are linked (as in generative grammar) by a transformational mechanism. The transformational mechanism, in visual terms, is *spatiality*, and in paintings we can identify it as the implicit construct described by the looks (or gazes) of the 'characters' within the composition. Such an analysis can only be of relevance to figurative representation, and accordingly Paris analyses a series of Renaissance paintings in order to define his model of the transformational process. He suggests that this generative method 'shifts the emphasis from the sign to its production; from structure to structuration, which allows painting and linguistics to be equated without sacrificing the specificity of either'.

Paris' model is a rather literal transcription of Chomsky's transformational grammar into a dubiously schematised version for the analysis of images; and without going into the debates about the adequacy of Chomskian linguistics as an analytic method for the description of language it is clear that there are some problems with its use as a description of imagistic representation, particularly painting. Given that generative grammar is an advance on structural linguistics (of the Saussurean tradition) insofar as it considers language in terms of sentences, as a syntactic structure (for Chomsky syntax has a deep structure which is linked by a transformational process to the surface structure which is the input for semantics and phonology, meaning and sound) it would seem necessary to think about the 'sentence' of painting. Paris expects this advance in linguistics to be an advance in art history, but does not suggest what a sentence might be in

painting. This is probably because there are no sentences in painting, there is no structural time flow and so no syntactic deep structure. There may be some form of narrative structure in the production of meaning, and the time taken for the viewer to complete the process of meaning may be considerable, but to equate this with the temporality of sentence structures is a nonsense.

It is this question of temporality and syntactic structure which make it impossible to apply the sophisticated and more advanced formulations of film theory to the analysis of still images, although as we shall see, there are areas of common concern (such as identification, fetishism, pleasure as fascination).

The most surprising part of Paris' work is that he is right in being dissatisfied with Schefer's formalism but then goes on to choose a Chomskian generative grammar as his model as if this were to extricate the analysis of visual representation from its domination by linguistics. Paris offers no real advance on Schefer's work; as analytic methods each can only incorporate realist and classical representational forms, and neither theory accounts for the necessity of the structures it describes. Schefer is right in characterising the rules of Bordone's painting as circulating around a system of doubling and repetition, but why is it that repetition has meaning in the fundamental way in which it does? This inability is due to the fact that neither theory has any conceptualisation of the unconscious; Schefer's Lévi-Straussian idea of unconsciousness as the structure itself of mythic thought, as a classificatory system which works on the contradictions of nature and culture, is an idealist concept or at least a very imprecise concept of 'the architectonic of the human mind'. For Chomsky there is no unconscious, and language arises quite simply and autonomously from the genetically inscribed 'Language Responsible Cognitive Structure', the exact anatomical location of which awaits discovery by neuro-physiologists; his separation of competence from performance means that all manifestation of unconsciousness in language is considered as performative variables of an unchanging and ideal linguistic competence.

But what both Schefer's and Paris' methods do do is to consider the complexity of certain kinds of visual representation and to try to deal with that complexity in a rigorous and systematic way.

Marcelin Pleynet starts his essay '*Peinture et Structuralisme*' by stating that Schefer's model is an essential basis for the analysis of all figurative art. Pleynet uses the term figurative to mean the classical monocular perspectival system of representation, within which meaning is made through the fixing of a signifier to a signified. As a form of realism, figurative painting presents no problem for the semiotic analyses, and Pleynet takes as his object of inquiry the minimalist and conceptualist sculptures of some American artists of the 1960s. Modernists such as Sol Lewitt, Robert Morris, Judd, André, and Tony Smith are taken as representatives of a new form of

'painting', one which is supposed to have a closer equivalence to the multi-dimensionality and polysemy of signifying activity. Because modernist art works within decentred, fragmented, spatial relationships rather than with monocular perspectival form, its signifying activity is one which encompasses both *énoncé* and *énonciation*, both object and process.

The argument about the radicalness of modernism is one that crosses many practices; it has its mouthpieces in literature, cinema and theatre as well as in art and the argument is probably familiar to most readers. Pleynet cites these sculptors as examples of the modernist/formalist practice; the artworks, he says, show the rules of their making, they foreground the process of production, the signifiers refer to the conventions of signification rather than to a transcendental signified. But he also argues that these are ultimately empty works, idealist in their negation of a negation, and he suggests that the Americans would have a lot to learn from the study of both dialectical and historical materialism if they want to be involved in a truly materialist practice. So modernist, or non-figurative, work is analysed as having meaning only insofar as it constitutes a transgression of the realist system, but it is interesting to see non-figurative art being treated within the framework of a structural analysis which is usually limited to the analysis of classical realism. In another essay in the collection Pleynet also discusses Matisse and colour, briefly citing Melanie Klein's theories of infancy, and raising issues that I shall return to in discussing the work of Julia Kristeva.

To introduce the transition from the consideration of the text as a system to the analysis of the text in its relation to a reader, the transition from linguistic to psychoanalytic theory, I have chosen the work of Guy Rosolato. Not only because this work is representative of Freudian and Lacanian thought but because it is in itself very good work. In the book *Essais sur le Symbolique*, two-thirds of which are discussions of the possibilities for and difficulties of using psychoanalysis to understand the meanings and structures of art, there are two essays to which I am particularly referring: 'L'Organisation Signifiante du Tableau' and 'Difficultés à Surmonter pour une Esthétique Psychanalytique'. Chronologically these essays precede the work of Schefer, Pleynet and Paris, written in or around 1965, but they are, in the logic of the intellectual trajectory I am describing, a progression from the analysis of textual systems. Rosolato takes as his object of investigation the cultural systems which uphold the incest taboo, the oedipus complex and its central referent the father, the system of genealogy and descent: 'history'; and the differences of the sexes. He explores the way in which these systems operate as symbolic laws through cultural productions such as painting; and through other semiological systems governed by those laws, such as religion, tragedy, authorship, etc.

In the 'Difficultés' Rosolato makes four main points: first that amidst all the forms of psychic organisation the structure of 'perversion' is the most appropriate for understanding the nature of the art object and the pleasure

derived from it. This Rosolato is claiming in contrast to Freud who suggested that the structure of 'neurosis' was the most appropriate, saying that whilst religion was equivalent to obsessional neurosis, and philosophical systems were characteristic of a structure of thinking equivalent to paranoia, the structure of art was hysterical. (I shall return to Freud, hysteria and the artist in my discussion of the Bordone painting.) The most important structure of perversion for understanding art, one which stands as a contradiction to the perversion/neurosis dichotomy, is fetishism, a three-way relation in which a signifier is used to negotiate separateness and identity with an other. The necessity for the concept of fetishism derives from the fact that the signifying economy of visual art cannot be understood in terms of algebraic formulae or simply as a formal system but has to be understood as a *dynamic* operating on a level which is fundamental to all representational activity. The dynamic identified by Rosolato is that of an oscillation between the two axes of metaphor and metonymy, or the two dynamics of condensation and displacement. (This formulation is in many ways assimilable to the 'formal system' of Peirce, the icon being the metaphoric process, whilst the index, the other signifying relation at work in imagistic representation, works metonymically, taking the part for the whole; the smoke for the fire.)

Rosolato's third point concerns the *pleasure* of art, its conditions and causes, and he proposes that this pleasure be thought of as a fascination or jubilation, that is, as the pleasure of identification, a process of stabilising the relations of subject to the unconscious. The identification process in art is a repetition of the mirror phase, during which the subject starts to form an ego, a stable and unified sense of self, precisely through a misrecognition, a subjectivity which is an alienation and a splitting of the self through representation. The doubling and repetition in paintings such as *The Chess Players* is an externalisation of the fantasy of a double, a wish which is the corollary of the alienation of the subject in the mirror phase (the spaltung), the basis of which is a denial of the loss of the dyadic unity of pre-oedipal subjectivity. Rosolato remarks that this fantasy is to be found in the many paintings with doubled perspectival systems and cites Holbein's *The Ambassadors* as example.

The fourth point that psychoanalysis raises for the understanding of art is the question of authorship, which is the question of paternity. Rosolato locates this especially in the tradition of the signature, which he understands as a direct act of placing a name within a history of names, within the paternal law of the Symbolic order. Every time a name is signed or assigned to a work the 'author' is created and the law is reinvented. (He claims also that even collective work, usually unsigned, is a reinstatement of the law insofar as the decision to have no signature, no author or artist, is made with reference to the superego, as a moral imperative.)

Cultural production is the transformation of rules and representations in a field of laws which, up until that point have been taken as

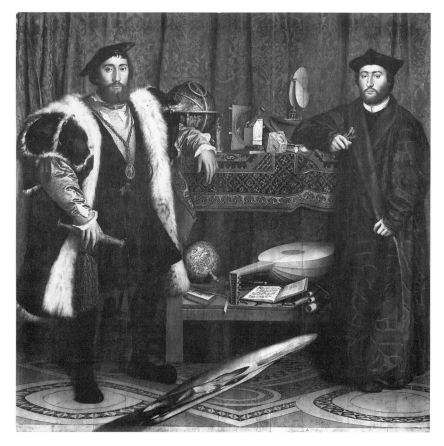

Figure 3.2 Hans Holbein, *The Ambassadors*, 1533
Source: Reproduced by coutesy of the Trustees, the National Gallery, London

authoritative or true, i.e. they have hegemonic status or the approval
of specialists.

(Guy Rosolato)[1]

But the transgression of rules *is* the law of the father; the more the father
is killed by the transgressive sons, the more dead and Symbolic he becomes;
and thus the modernist law of the transgression of rules as progress is a
fallacy, it is simply reinventing a genealogy within which to be new. This
supports Pleynet's view of the American formalists, and also serves to prob-
lematise the equation of modernism with a progressive subjectivity as a kind
of feminism (as has been derived from some readings of Kristeva), because
the repeated transgression serves only to reaffirm the Symbolic law.

Rosolato suggests that the pleasure derived from identifying is the result of a stabilisation of an oscillation between the metonymic and metaphoric axes of representation as this movement is carried for the non-sense of bodily and unconscious processes towards language or systematised meaning (a code). This is diagrammatically represented as:

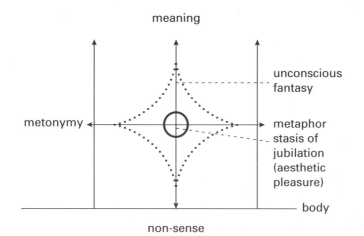

Rosolato also uses the metaphor/metonymy structure to analyse pictorial signification in a synchronic and in a diachronic way. As part of a synchronic analysis of meaning within any given picture the two axes work thus:

<table>
<tr><td rowspan="7">metonymy</td><td>1)</td><td>Traces of marks (T)</td></tr>
<tr><td>2)</td><td>Formal organisation of Rhythm (R)</td></tr>
<tr><td>3)</td><td>Signifiers of Language (L)</td></tr>
<tr><td>4)</td><td>Representational Signs: pictograms (RS)</td></tr>
<tr><td>5)</td><td>Objects Represented: picturalisation (OR)</td></tr>
<tr><td>6)</td><td>Decorative (R + S or OR) = (D)</td></tr>
<tr><td>7)</td><td>'Cinétique' (T + RS or OR) = (Ci)</td></tr>
<tr><td rowspan="2">metaphor</td><td>1)</td><td>Non Representational Signs (NRS)</td></tr>
<tr><td>2)</td><td>Symbolisation (Sy)</td></tr>
</table>

He claims that this classification has the advantage of surpassing the figure/ground, form/content, figurative/abstract dichotomies which usually serve art history. The classification shows that most elements of painting can be ascribed meaning in terms of contiguity or displacement, that is through metonymy; whereas only those elements whose non-sense cannot be reduced to any evident contiguity are metaphoric.

The second use to which this classification is put is the diachronic description of the relations between schools of painting, which Rosolato represents in diagrammatic form as an oscillation between the two axes and their different signifying relations.

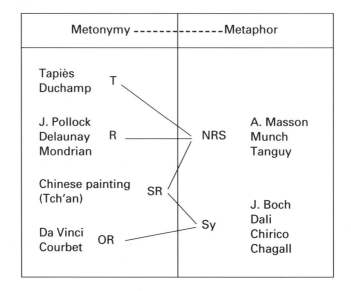

This application is interesting, and is one of the influences on Kristeva's work on rhythm and light in the essays on Bellini and Giotto. The main elucidation provided by an analysis such as Rosolato's, a Lacanian psychoanalysis, is that of identification, showing that the system of doubling and repetition such as that described by Schefer in *The Chess Players*, can be understood as an economy or dynamic within which a spectator and/or painter is returned to a transformed mirror in which the act of mirroring is represented and the ego finds itself, jubilant and pleasured, in an identity which serves to stabilise it.

In the Bordone painting the aggressivity which characterises the specular relationship, an aggressivity born of the anxiety of difference and loss of imaginary unity, is mediated by the triangular structure of the gazes. As spectators we are placed by the double gaze of the two portraits as each man looks at us and not at each other. The dyad has been triangulated, codified meaning has become possible, stability and positionality has been effected.

One of the effects of fetishism is that it serves to make women, for men, adequate sexual objects. It mediates sexual difference with similarity, and in so doing protects men, protects masculine subjectivity from the possibility or threat of homosexuality, or rather it defends men against the unconscious fantasy of enjoying a passive relation to other men (or the father). Similarly

if we follow Freud's suggestion that the structure of art has a psychic equivalent in hysteria, and understand hysteria in its relation to bisexuality,[4] we can see an ensemble of psychic relations that underlie the structures of meaning at work in the painting.

If authorship means paternity, being an 'artist' is a compromise identity forged by the adult ego as a way of mediating his fantasy of being a woman and of creating, and 'art' is male hysteria institutionalised and contained within social structures of representation. Look again at *The Chess Players*: surely the most remarkable thing about this picture is not that it depicts a system of binary oppositions, although it does do this, but that it depicts *a relation between two men*. This relation is not direct; it is doubly mediated, firstly by the chess game, the game of convention and rules and the battle of winner and loser. Also, as I remarked above, the relation is structurally mediated by an 'outside', by the two gazes that project a third term, the painter and/or the spectator, who is placed as the triangulation point from which the 'men' can measure their relation to one another.

What Schefer, as a man, completely effaces from an analysis of the painting is that it describes masculinity; not the 'world' nor 'conventions', but the relations between men. Two men at war and at play are fixed by a third man, the 'artist', who has made a mother–father of himself by displacing his subjectivity and sexuality on to the screen of his canvas and calling that displacement 'a description of the world'. Next, Schefer describes this as a signifying system, which it certainly is, but it is not simply a mythologisation of nature and culture in a structural articulation of subsystems; *it is masculinity*, a homosociality displaced and metaphorised, admittedly through a complex and fascinating system of codes and tropes, of signifying substitutions.

The problem for us as women is that it is within this 'world' of male fantasy, which has gained 'hegemonic status and the approval of specialists', and within this paternal law that the meaning of what it is to be male and what it is to be female, is produced. The identities of masculine and feminine are organised within a system which hallucinates sameness where there is none, and denies similarity where it exists.

In the analysis of the cultural products of this social order, psychoanalytic theory helps to account for the necessity of structural systems as these operate as the reglementation required by the symbolic function. It also serves to show how the order of the Symbolic is partial, how it requires its Other in order to be order. And structural analysis shows how the subject is the product of the conflict between the Symbolic and its Others, as a fragmented, heterogeneous, and sexed subject in constant contradiction between unconscious drives and their partial containment/fulfilment in figurational forms and in codified meaning systems, such as the security of perspective and the pleasure of colour and rhythm.

Julia Kristeva's essays 'Motherhood according to Giovanni Bellini' and 'Giotto's Joy' take up these issues. In the first essay she looks at the differences

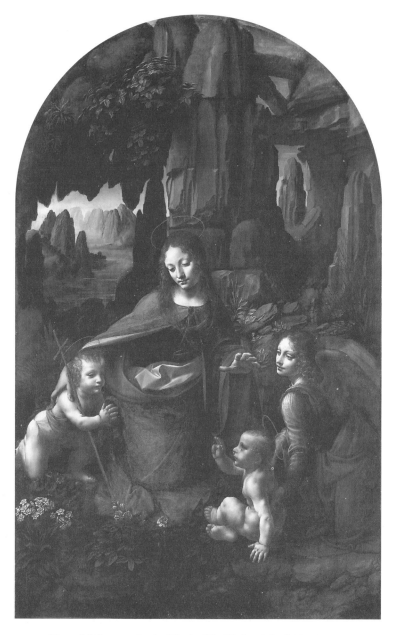

Figure 3.3 Leonardo da Vinci, *The Virgin of the Rocks* (c. 1508)
Source: Reproduced by coutesy of the Trustees, the National Gallery, London

between the pictorial style or signifying economy of Leonardo da Vinci and Giovanni Bellini. Each is situated both as a man, the mother's and the father's son, and in relation to the historical context of the Florentine and Venetian schools of painting with their different relations to the historical, social and economic changes that characterised Renaissance Italy. In addition to setting out the politics of the epoch Kristeva cites what biographical information 'is not insignificant' and proposes that a basic structure of the codes of pictorial style in each man's work is that of a process of identification, which consists of the paintings themselves, or the act of painting itself, which is a representation of a psychic relation to the maternal body. Each man has a different relation to his separation from the maternal body which is evident in the pictorial styles, their uses of light, line, spatial relationships, and colour. Da Vinci's style is graphic, using lines to delineate the edges of bodies when representing the human forms; like Michelangelo's his drawings of the female form are often from male bodies, with the addition of rather incongruous looking breasts; Kristeva characterises this psychic relation to the maternal body as fetishistic. This style is contrasted to Bellini's paintings which have a very different representational system, using light and especially colour to shape spatial relations. In Bellini's work there is the separation of edges, boundaries, bodies and background without delineation, as the illusion of the third dimension is 'carved out' with light and the tone and intensity of colour.

The discussion of the representation of the mother's body is carried across several discourses: art, science and religion; and Kristeva suggests that the fundamental paradoxes of pregnancy and childbirth have not yet found an adequate form of description. She discusses the way in which institutions of religion have mythologised the maternal body and how medical science also has misrecognised the process of procreation. Above all, humanist ideologies fail to understand the meaning of pregnancy and childbirth, mistaking the foetus for a person, and making the mother into a Mother, the author or 'artist' who is personally responsible for this activity which is occurring in her body. After discussing these ideological systems in abstract terms, Kristeva turns to look at a series of Bellini's paintings of Madonnas and child, and looks with greater historical specificity at the problematic of the Renaissance – how to represent three-dimensional space – and the growing humanism of the quattrocento in increasing conflict with the ideologies of religion, and shows how, within this ensemble, Bellini negotiates a range of positions in relation to the unconscious fantasies of the maternal body.

In the essay on Giotto, Kristeva suggests that the analogy between painting and language falls apart when we try to understand colour, either as a formal system or as part of the practice of painting. What is needed, she proposes, is a method which is not structural but economic, and like Rosolato she uses psychoanalysis as a theory to implement semiotics. She suggests that we adopt Freud's version of the sign, the one developed in his work on

45

aphasia. This sign has a triple register, linking the body to language and to the outside world (referent). In this version the primary processes are cathected to word-presentations and thing-presentations through a complex interrelation of images, sounds, acoustic images and tactile associations, as well as words as signifiers within systems of language. This is Freud's diagram from 1891:[5]

Words are mixed in with images in the unconscious, and it is only through the ego process of identification that the two are rendered separate and distinguishable, just as tactile sensations are separated from aural and visual perception. In the Freudian economy of the sign we have the pleasure of the drives, coming from a biological organ, which is directed externally at an object, through a cathexis to a sign, which is always a sign within a system of signification.

Turning back to painting, colour is something whose meaning, despite being partially ideologically constructed by symbolic systems that are specific to any given history and culture, is nevertheless more bodily than other imagistic forms and their meanings. Kristeva suggests that through the use of colour in painting a subject can escape its alienation (the splitting) within a code. This, she suggests, is characteristic of Giotto's painting, in which he 'escapes' the constraints of the new perspectival and narrativised forms of Christian imagery through the use of colour. The terms of the 'escape' are best understood with reference to Kristeva's theory of the symbolic and semiotic modalities of language or signifying practice. The 'semiotic'

refers to the manifestation within a symbolic order of the feelings, ideas and prelinguistic processes which characterise the pre-oedipal stages of onto-genesis, and which are partially transformed into the 'symbolic' order of monological or monocular, syntactic or perspectival forms. The textual structures that characterise the symbolic are those of transparency of signi-fication, narrative closure, thetic coherence; and these are held in place, and often disrupted by, the semiotic processes which indicate the arbitrariness of the symbolic, through forms such as punning or polysemic play, prosody in writing for instance, and rhythm and colour in visual representation.

Perhaps colour acquisition could be mapped in the way that language acquisition has been studied; it seems from studies on infant development that colour perception precedes object identification, partly through psycho-logical development and partly through physiological development of the eye, which is not fully formed as an organ of visual perception for some 16 months after birth. We might find an equivalent of the pre-oedipal semiotic forms of the pre-specular subject; Kristeva suggests that colour has such pre-specular properties. The colour blue it seems has a wavelength which makes it one of the most primary of colours to be perceived, both ontogenetically (it is perceived before other colours) and also as the most readily perceived (blue rays reach the retina before others). Blue is the predominant colour of Giotto's paintings and is seen as a semiotic escape from the entirely symbolic structuration of meaning. An equivalent might be suggested in the way in which, for infants, sound can be without symbolic value, and through the dynamic which renegotiates the semiotic and symbolic modalities of sound within a cultural form such as music, which has both syntactic and narrative structures as well as less symbolic and more semiotic qualities.

In such a short space and within such a specific argument I cannot do justice to the complexity of the above theorists, and can only recommend that readers go to the original texts and read for themselves; but by way of conclusion I want to suggest some ideas about further work that arise from the consideration of these theories.

First it seems that the opposition of image to language is an untenable formulation, as is the proposition of the equivalence of image and language. The textual method of analysis sought either to incorporate the structure of images into a general semiotics or else to form a separate, annexed branch of its analysis to 'deal with' images. The question raised by the signification of visual forms – particularly of processes such as colour – is that of the validity or adequacy of a purely structural method of analysis. A psycho-analytic method provides us with an understanding of signifying practice as a dynamic within an economy. It allows us to consider the 'organisation' of the body, as drives coming from the 'organs' of the body,[6] within represen-tational structures. Freud suggests that imagistic representation, aural repre-sentation, tactile sensation and word-presentations are inextricably linked, and remain so on the level of unconscious meaning. What seems interesting,

then, is to discover the way in which the eye and the ear, the visual and verbal/aural registers, come to be differentiated and separated in such a way that we experience these as different; this must be part of a symbolic activity the task of which is to organise the body into organs, to produce the eye as eye, the ear as ear; the mouth, the anus, the genitals and erogenous zones. (Different socio-symbolic orders will do this differently, as is perhaps evidenced by the national differences in French and English languages: in English 'to see' is colloquially synonymous with 'to understand', whereas in French it is *entendre* – 'to hear'.)

So what does the interrelation of psychoanalytic and semiotic theories understand of the signifying practice of painting and art? It seems that the necessity of the work of art, like all other signifying systems, is its double function as mirror and as screen for the fictitious unity of the subject's sense of self to parade before and hide behind. We produce these mirrors to show us who we would like to be, and screens on to which we project everything we reject, and we endlessly repeat the game of stepping inside and outside the rules of what is and what ought to be.

Or in other words, the function of the work of art is to represent the dialectic of the subject, split and triangulated through the exigencies of the incest taboo, to represent and contain this splitting; to represent it as a doubling which is the process of negotiating an imaginary identity, the ego. This process of identification requires the negotiation of sexual difference, it is perhaps its most important function; and pleasure and meaning (the two tenets of bourgeois concepts of art) are simply by-products of this socially prescribed and biologically inscribed process of the organisation of energy.

If the revolution of Marx consisted of understanding the product of capitalist economy not as commodity or object (which is what it appears to be) but as the surplus value produced by the production of the object, then we too should fully recognise the value of the structural method and understand the product of signifying process to be the production of identity rather than the art object or text.

The analysis of this process of production of identity, if it is to be of any use, has to include at a fundamental level an understanding of sexual difference, and feminist practice must begin to incorporate into its questioning of the representation of women an understanding of masculinity.

NOTES

1 J.L. Schefer, *Scénographie d'un Tableau*, Editions du Seuil, Paris, 1969. J. Paris, *Painting and Linguistics*, Carnegie-Mellon University, 1975. M. Pleynet, *L'Enseignement de la Peinture*, Editions du Seuil, Paris, 1971. G. Rosolato, *Essais sur le Symbolique*, Gallimard, Paris, 1969. J. Kristeva, *Polylogue*, Editions du Seuil, Paris, 1977. Translations in *Desire in Language* (ed. Leon Roudiez), Blackwell, Oxford, 1981.
2 'Not so long ago, art history and in particular the history of literature was not yet a science, but rather gossip. It obeyed all the laws of gossip; it moved cheerily

from one theme to another and the lyrical flood of words on the elegance of the form gave place to anecdotes drawn from the artist's life. Psychological truisms alternated with problems related to the philosophical basis of the work and to problems about the social milieu in question. . . . Gossip does not have a precise terminology. On the contrary, its variety of terms and equivocal words function as a pretext for word-play; they are qualities which bring charm to the conversation. Thus the history of art knew no scientific terminology since it used words from the common everyday parlance without first critically screening them or defining them with precision or taking their polysemy into account.' R. Jakobson, 'On Artistic Realism, Theory of Literature', quoted by J.C. Lebensztejn, *Ground part 2*, translated in *Oxford Literary Review*, vol. 4, no. 2.

3 'One of us would leave the group and decide secretly to identify with a specific object (eg. a staircase). The rest of the group would then decide in his absence that he pretend to be a different object (eg. a bottle of champagne). He must then describe himself as a bottle of champagne whose characteristics are such that gradually the image of the staircase is superimposed upon and eventually substituted for the image of the champagne bottle. In case his monologue, lasting two to five minutes should not lead to the proper guess, the audience is allowed to ask questions. In the course of an evening Mme Sabatier was described as an elephant's tusk, a terrier was described as a flowerpot, a lock of hair as an evening gown, a sorcerer's wand as a butterfly, a leer as a partridge, a shooting gallery as a church porter, a child being born as an hourglass, an amazon as a coffee container, a gloworm as the assassination of the Duc de Guise, and a rainbow as the Rue de la Paix, as follows: I am a very long Rue de la Paix who has taken the form of the nearby Pont de la Concorde in order to light up the world. I display only seven windows of different colours; even they are visible only when the sun comes to dry the water which has wet them.' The game 'One in the Other' (L'Un dans L'Autre) is detailed by André Breton in *Médium No. 2* and quoted by Roger Caillois in *Riddles and Images*, translated by *Yale French Studies*, no. 41.

4 S. Freud, 'Hysterical Phantasies and their Relation to Bisexuality', in *The Standard Edition of the Complete Psychological Works of Sigmund Freud*, vol. IX (eds James and Alix Strachey), Hogarth Press, London, 1955.

5 S. Freud, 'The Unconscious', in *The Standard Edition of the Complete Psychological Works of Sigmund Freud*, vol. XIV (eds James and Alix Strachey), Hogarth Press, London, 1955, Appendix C: On Aphasia.

6 Michèle Montrelay, *L'Ombre et le Nom*, Editions Minuit, Paris, pp. 38–96 ('A propos du plaisir d'organe').

ART, ART SCHOOL, CULTURE
Individualism after the death of the artist[1]

Griselda Pollock

(*From*: Issue 11, 1985/6)

The terms of the debate – art, art school and culture – seem at first sight to link easily into a consecutive movement. Art is taught at art schools and both institution and practice are part of culture. On further reflection about the contemporary state of any one of these terms, let alone that to which they might refer, a profound disjuncture begins to fissure the neat simplicity of apparent interdependence.

Let me start with a mundane example from everyday experience. I regularly visit art schools either to give a lecture or as an external examiner and in recent years there has been a recurrent crisis over the assessment of a certain kind of art practice. It is usually photo-text, scripto-visual or some such form; it is often sustained by reference to a body of cultural theories; it generally handles questions of gender, representation, sexuality. The students offering such work are often well thought of intellectually and produce theoretically developed work in complementary studies and art history. Most of the resident staff do not like this work and cannot assess it. (They still try to do so nonetheless.) To an art historian involved with a decade and a half of conceptual art as well as the diverse and sub-stantial feminist practices of that period, such work if often not brilliant is recognisable in terms of what it is addressing, what frames of reference are suggested, what work it is trying to do. It is by any criteria certainly assess-able.

This conflict can be explained sociologically. There is in art schools a generation or two of teachers and artists whose sense of art and culture[2] was formed at a different moment from that of their current students. Confrontation with deconstructive practices is found hard to accommodate to their paradigm of art and its appropriate terms of assessment (such as does it move me?). Added to this cultural generation gap there is the fact that the majority of teaching staff in art schools are men and the majority of the students engaged in this tradition of work are women. Thus is produced a quite vicious antagonism. It is one thing to say that many art

school teachers hold outdated notions of art, having themselves been socialised within one form of modernism or another, and that these folk find it hard to adjust to radical post- or anti-modernist art. Such an account falls within the legendary narratives of bourgeois histories of art with their radicals against academics. What makes the current crisis so acute and significant is that art schools have become a particular terrain of feminist struggle and masculinist resistance at a period of intense social conflict.

I am considering this issue from a feminist perspective. That much must by now be obvious. Such a viewpoint does not entail that I only address women and their (often ignored and repressed) participation in cultural production. It is a necessary part of feminist cultural intervention to analyse the nature of the discursive exclusion of women from the records which we call art history, the effect of which is to celebrate the great and creative as exclusively masculine attributes.[3] Man is an artist *tout court*. Thus a feminist is of necessity an analyst of mainstream ideologies of art and art education. These are not, however, mere historical relics. For instance in a recent collaborative review with Deborah Cherry of 'The Pre-Raphaelites', an exhibition held at the Tate Gallery in March to May 1984, we identified the implication of high cultural practice and writing in the reproduction of patriarchal constructions of sexual difference. This ideological strategy to secure masculine dominance in the mirror of an apparently asocial world of creative art was also to be located within other aspects of contemporary political culture in Britain in the 1980s. The exhibition was sponsored by a major multi-national corporation, S. Pearson and Son Ltd, which owns Doulton and Co. (plastics, ceramics and engineering), Doulton Glass Industries, Royal Doulton Tableware (Holdings) Ltd, Fairey Holdings Ltd (aluminium, engineering, filtration and hydraulics), Fairey Nuclear Ltd, S. Pearson Industries (land and mineral companies in USA, Cayman Islands, Singapore, Mexico, Venezuela, Nigeria, Canada), Lazard Brothers and Co. (merchant bankers, former employers of Mr McGregor of the NCB). Pearson also, however, owns Madame Tussaud's, Chessington Zoo, London Planetarium, Warwick Castle and Wookey Hole Caves, as well as the publication group Pearson Longman which in turn controls *The Economist*, *The Financial Times*, *Apollo*, Goldcrest Films and Longman Penguin whose subsidiary is Ladybird books. Sponsoring exhibitions at the Tate, Pearson is not only exemplifying the practice of legitimating corporate capital by cultural patronage. Financing cultural ventures is part and parcel of its daily business practices in the leisure industries which not only sell commodities such as exhibitions, catalogues, books, posters, postcards, plates, calendars and so forth, and even plates by Royal Doulton commemorating the exhibition. They also sell meanings.

This is not to suggest that they sell their own pre-packaged meanings. But that the consumption of cultural experiences is also a consumption of a discourse produced by the specific practices of the curators, art historians,

experts, connoisseurs and dealers who collectively produced and authored the exhibition about Victorian artists. This raises a question about the relationship between sponsorship of such an event and the meanings such an event could generate within its specific sphere of ideological effect. What are the resonances of Victorian romantic painting celebrated in terms of creative geniuses painting beautiful passive women within contemporary British culture in the mid-1980s?

In the notes accompanying the exhibition called 'Purity and Danger in Victorian Painting' (Leeds University Gallery 1978) T.J. Clark probed at the socio-historical conditions for the revived taste for Victorian art currently celebrated by the grand opening of the Arts Council's show 'Great Victorian Pictures' at the Leeds City Art Gallery on 28 January 1978.

> Nothing could be more insignificant than the present fashion for things Victorian. Like other current symptoms of cultural reactions in Britain, it will blow away in the 80s with the first puff of North Sea gas. But we shall be left with the task of understanding our vicious forefathers, the task of reconstructing the culture of the British Ruling Class when what it controlled was the world and its workshop.

Clark was wrong. The fashion has not passed but gathered momentum to be legitimated in the Tate Gallery in 1984. Cultural reaction has become entrenched in the mainstream of British politics and Thatcherite Tories openly espouse 'Victorian values'.[4]

We thus concluded:

> In the *Pre-Raphaelites* and *The Pre-Raphaelite Papers* the images and the artists have been removed from their historical conditions of production and are reconstituted in a present day field of knowledge, power and pleasure to produce and reproduce patriarchal relations. The failure to confront the historical and social meanings of cultural practices can no longer be politely discussed as a 'difference' of methodology, approach or even paradigm. Women have been and are today subordinated to men within a wide range of social practices and institutions. High Culture plays a specifiable part in the reproduction of women's oppression and in the circulation of relative values and meanings for the ideological constructs of masculinity and femininity. Representing creativity as masculine and circulating Woman as the beautiful image for the desiring masculine gaze, High Culture systematically denies knowledge of women as producers of culture and meaning. Indeed High Culture as constituted by prestigious and expensive exhibitions and their well-distributed literatures is decisively positioned against feminism. It not only excludes those knowledges of women artists and their works produced within feminism, but it works within a phallocentric signifying system in which woman is a sign

within discourses on masculinity. The knowledges and significations produced by such events as *The Pre-Raphaelites* are intimately connected with the workings of patriarchal power within our society. In the specific discourses on Pre-Raphaelitism feminine sexuality is construed around the categories of bourgeois definitions of sexuality and gender, that is within masculinist parameters of pleasure, a phallocentric economy of desire. Furthermore, those discourses are racially specific; the domain of high culture extends current racist practices and policies. *The Pre-Raphaelites*, as so many exhibitions, presents us with the spectacle of white masculine history, a glorious parade of the cultural activities and imperialism of white bourgeois men.[5]

In this review and elsewhere we argued that the central structuring strategy of art historical discourse on the Pre-Raphaelites is biographical and it is sustained by unquestioned notions of Individualism.[6] Typically this kind of art history, not exclusive to but paradigmatic of writing on nineteenth-century British culture, offers narratives composed of anecdotes and speculations organised so as to construct for the reader the illusion of a knowable, accessible but fascinatingly other individual, a charismatic Rossetti, an evangelically earnest Hunt, a brilliant but destroyed Millais and so forth. The effect of these strategies of writing and of curation (*re* the exhibition and its literature) is to provide, by means of that named individual, coherence for the consumption of specific ideologies. Rossetti thus produced stands as a sign for the creative, masculine individual, the private producer of self-generated ideals and dreams. But, at the risk of crude deduction, what appears a bit quaint in its Victorian guise, is in fact intimately related to dominant conservative ideologies of our day when the very notion of the social is daily eroded in the name of individual self-help and free enterprise. High culture is therefore permeated by and constitutive of social ideologies compatible with, though never directly reflective of, the interests of dominant economic and social fractions.

Art is a potent field for these practices, especially in that reified form, 'Art'. Bourgeois concepts of art celebrate individualism by means of the idea of the self-motivating and self-creating artist who makes things which embody that peculiarly heightened and highly valued subjectivity. It is funda-mentally a romantic idea of the artist as the feeling being whose works express both a personal sensibility and a universal condition.[7] What art schools today actively propose or promote any other concept of the artist, for instance, as producer, worker, practitioner?[8]

Consider the organising principles of many schools. The basic pedagogical plan is that the privileged independent spirits selected for the course at interview are given the opportunity to sink or swim. Space is provided, materials, a few technical resources. The student is expected to develop a programme of work, 'my work', that precious phrase, a project about which,

from time to time, a conversation is held in unequal, ill-defined and educationally lamentable conditions. Assessments, when recorded, tend towards personal comment and register from the staff point of view the kind of contact (was the student aggressive, resistant to advice, willing to take up suggestions, etc.?). Undoubtedly many students thrive in this hostile and unsupportive environment, especially where their own sense of identity is implicitly reinforced by the hidden agenda of macho self-reliance and aggression, the son's battle with the father. (Maybe Norman Bryson's book *Tradition and Desire* (1984) does have a place somewhere after all?) The hidden agenda is institutional sexism. Let there be no flippant underestimation of what this intimidating and bizarre parody of an education means to women. Some have literally died of the experience.

One response to such a critique would come from educationalists. Many professional teachers not involved with fine art traditions find the typical art school scenario quite horrifying in the licence it potentially gives to those in full-time paid employment at an educational institution. Better teaching methods, more pastoral care cannot however be the answer, though they might be an improvement in the worst cases. What is overlooked in such a response is the structural contradiction which is at the root – the collision of two professions – artist and teacher; the collision of two ideologies – individualism and socialisation.

Education has been named as one of the major ideological state apparatuses – that is, not just a place of learning, but an institution where, as in the family, we are taught our places within a hierarchical system of class, gender and race relations.[9] The recent conflicts in the education sector between teachers, colleges and universities and the State have brought to the surface what is usually hidden, that education is a vital site of social management. Professionals of course deny their implication in state strategies by proclaiming the high ideals of critical education. Art schools are a particularly contradictory site. They are a location for the perpetual production of key ideologies. But in practice art schools deliver very little education. Indeed art students are put at a scandalous disadvantage (and ironically glory in it) *vis-à-vis* other students in higher and further education. The absence, however, of systematic induction into an (ortho)doxy leaves open unexpected possibilities for counter courses, women's workshops, etc. The rationale of the art schools is to train rather than educate artists to become professionals who must compete with each other and other professionals in a difficult market for jobs and sales. Yet their training leaves them totally unequipped to grasp their place in the competitive world of business, professionalism or, no longer so inevitable, education. The school sustains a powerful sense of the being of an artist in total mystification of what working as one entails.

Art schools, and especially the one in which this debate is taking place (see note 1), are not immune from the social strategies of the present

government and the political culture which supports it. All sectors of education are being asked to be more *productive*, i.e. to produce something quantifiable, both in terms of marketable goods and saleable personnel. Against this radicalism, traditional ideologies of art schools offer the weakest of defences, the ideals of High Culture:

> We certainly need to remain open to public needs and opportunities in the field of public art, but we must remain firmly established in the traditional role that art has held in society in the past. Art schools should be there to preserve and keep alive the higher values of art. As educationalists teaching in art schools we have a role to play in society. We need to remain firmly entrenched in values that society in its quest for economic survival tends to ignore. The values that artists hold inevitably have their source in a spiritual, rather than a mental or material one.[10]

Art is thus the realm apart from the utilitarian demands of economic survival, which as in the early nineteenth century must be protected for fear the higher values it alone secures will wither. Few ever dare to question what these values are, whom they serve or how justified is this division of the spiritual versus the utilitarian. History does not bear out the defence of higher values or the spirit in art.

There would seem, however, a contradiction between what has been suggested above about the compatibility between Thatcherite conservatism's cult of the self-made individual and its ideologies of art, and what is now being said about the incompatibility between the Thatcherite demand for productivity and the defence of pure art. It is possible that these two propositions are endemic contradictions. In histories of the early formation of modern bourgeoisies historians have already pointed out the paradoxes of the way in which defiant public exponents of political economy or utilitarianism returned to their domestic hearths to muse upon the natural wonders evoked in the romantic poetry of Wordsworth.[11] I have argued in an earlier article that the notion of the artist formed by the culture of the British bourgeoisie articulated contradictions within the norms constructed around masculinity, satisfying fantasies of freedom from social constraint within a world of strict regulation of sexualities, behaviours, gestures and common senses, while art itself was elevated to a repository of values which were desirable in terms of social prestige but were expendable in the logic of capitalism.[12] Historically, therefore, the middle-class ideologies of art and artist demonstrate a series of fissures which have permitted the accommodation and appropriation of notions of the role and purposes of culture and its sacred individualism which are, if not necessary to, sometimes even in conflict with, economic ideologies.

Crucially historians and art historians investigating the relations between class formation and cultural practices have underlined the work cultural

practices and ideology perform within the construction of the class hegemony of the bourgeoisie and its allies.[13] Hegemony here refers to the establishment of some form of consent to the exercise of power by newly emergent classes, established with the constant threat of the use of more coercive means of subordination.

It is however possible that the relation between the support of High Culture and the apparently antagonistic demand for a more economistic view of its use and productivity may in fact relate within the ideological formation characteristic of multinational capitalism, which can crudely be said to have dispensed with the forms of social hegemony required in the nineteenth and early twentieth centuries with still localised and highly visible power struggles between fractions of the ruling bloc. Such an argument leads towards the position advanced in Fredric Jameson's article 'The Cultural Logic of Late Capitalism' (1984) in which the following propositions are made.[14] We are currently witnessing a major cultural rupture ushering in a new era, the post-modern, a moment which is in turn explicable in relation to the latest, multinational phase of capitalism. This world of multinational capitalism has become for its inhabitants 'illegible' and incomprehensible. We have been shifted from a world experienced in terms of historical time to one experienced in terms of space, a kind of post-modern hyperspace which transcends the capacities of the individual human body and consciousness to locate itself and to organise its immediate surroundings perceptually and cognitively. The disjunction between the body and the environment, both social and economic, points to the inability of our minds to map the global, multinational and decentred communicational networks in which we are caught. In a world so bewilderingly vast – or sublime – forms of social control such as the nineteenth-century bourgeoisie desired, which still depended on visible displays of authority and 'cultivation', leadership and personalised mastery become redundant.

What may be possible to develop from the Jameson thesis is that this Culture is no longer protected and cultivated as part and parcel of the social practices of the grand bourgeoisie. In work undertaken with Fred Orton, I analysed the relation between certain key factions of the American ruling class, symptomised by the Rockefeller family, and the institutional promotion of modern art. Critical of theories previously advanced which reduced the Museum of Modern Art, owned and run by Rockefeller and fellow capitalists, and its promotion of American Abstract Expressionist painting to devious political exploitation of culture for conspiratorial ends, we argued that analysis of the social composition of class and its constitutive practices revealed an overlay between business activities, education, politics, philanthropy and the founding and running of private museums.[15]

The MOMA as both producer of exhibitions and publishing house was a field of intense activity for members of the Rockefeller family and their associates at crucial periods in the securing of a world open to and eventually

dominated by the interests of American internationalising capital. Business remains a key factor in the support of the arts today but sponsorship is currently taking a distinctly different form. Sponsorship, as Pearson's example showed, is just another part of the corporate enterprise, the entertainment industry as well as the selling of plates, posters, postcards, books. Instead of the personal publicity which the listing of MOMA trustees and officers regularly provided in the publications and exhibition catalogues produced by the MOMA, the naming of sponsors such as IBM, Xerox, American Express, refers us to impersonal, multinational business entities.[16] What is being suggested here is that Culture capital C, as it was inherited by the bourgeoisie from aristocratic uses and defended and redefined in the nineteenth century, has become largely expendable to those socio-political and economic conglomerations which currently dominate our world. Nonetheless it remains a growing arena of investment, and certain meanings associated with that now archaic defence of Art still have a currency. The job such a reified notion of Art can do is to occlude the social, to picture the world in terms of the individual private producer, a kind of creative Robinson Crusoe making the world all by himself (with a little help from the Third World).

In the opening passages of the Introduction to the *Grundrisse*,[17] Marx considers where he should start a study of production. Bourgeois economists would begin with the individual, but Marx cogently argues that the point of departure must be the individual producing in society, hence socially determined production. He points out the historical conditions for the creation of the figure of Robinson Crusoe in bourgeois philosophy which treats the individual not as the result of a long and complex historical process but as its beginning. The individual is a historically created persona coming into existence according to Marx only when social relations have reached a very high stage of development and complexity. The individual is only possible when the forms of social connectedness appear to confront one member of that society as the mere means towards his private purposes in the form of something external to him. Associated with the 'individual effect' as it may be called is not only a high level of social and economic development, named civil society, but the divisions associated with that epoch of the public and private. The separation of the spheres of human social activity produces illusions of separatedness, privacy, home, family, from which one 'individual' emerges to confront the outside world, to make *his* way. What Marx does not perceive is the gender specificity of the individual thus produced in bourgeois thought and social practice.[18]

Following on from Marx though not necessarily Marxist there have been many critiques of the idea of the individual which derive from those discourses which stress the social character of all production of human life and activity. Thus not only is it possible to argue that the idea of the individual is a historical product of a highly developed form of social

organisation, but also to propose that the division of labour which produces the distinct category of skills we name art is equally historical.[19] All modern art making is a highly socialised activity. But within a capitalist system of production the fact is mystified for both producer and consumer. Like all consumers in a capitalist marketplace we misrecognise the social character of the goods we buy, seeing them only as commodities and privileging art as apart from such impersonal goods by virtue of its evident individual authorship. We fail to recognise that the authorship is precisely what in many cases is being traded and bought. The sequences of labour, trade and retail which are required to make pigments, weave canvas, manufacture videos, quarry stones, etc. is fetishised and the student perceives the process of art making, in its practical dimensions, as a matter of simple encounter between subject and tool, discovered 2001-like on the studio floor.

There is a further dimension to the understanding of artistic practice as social. Although, in the modern era, artists no longer have a public, or a public arena, such as for instance even Courbet could still effectively address in 1850–1,[20] and although art making like all production has become a matter of private competitive producers, it is nonetheless the product of a socially determined discursive formation. Put another way, it is produced within a conversational community, a form of social exchange which sustains the terms of reference, the appropriateness of strategies, and ensures that what is produced will be legible – at least to someone. The classic form of this discursive formation in the era of privatised artistic culture is the avant-garde. The avant-garde was a grouping of artists, intellectuals and buyers, membership of which defined an identity in difference from other social and cultural groupings, providing a collective definition of a project within which particular ventures could be explored in an environment of stimulating competitiveness.[21] The avant-garde peculiarly secures the possibility of an intensified individualism – the creation of particular styles, habits, clichés, within a social environment necessary for any production and validation of art. It does so by offering a cohesive commonality of terms, ambitions and criteria of assessment. The history of this phenomenon is not consecutive, despite the way art historians write of it as virtually synonymous with modern art. The avant-garde was the product of specific historical moments, Paris in the later nineteenth century, New York 1938–45. Perhaps one should add Paris 1905–14 although by then it is more appropriate to talk of a period of transition with the multiplication of conversational communities and to see how small they could get – Picasso, Braque, Daniel Henry Kahnweiler and a few others for instance in the period of Analytical Cubism. The important fact is always the society, however small, for as Marx and others have insisted, there can be no such thing as a language created in isolation, no private language.

Beyond these two propositions on the social character of art making lies an even more complex field of argument about the ideological aspects of art. The insistence on artistic practices as products of a socially produced

discursive category sustained by a community of specialist users – makers, consumers, managers and related professionals – is often coupled with more elaborated theories about the social production of the individual. Indeed, in several influential trends in twentieth-century theories, the individual is completely dissolved as an ideological category into the notion of a split, fragmented and mobile subject, held only in the place of illusory unity by the structures of language and society of which being a subject is but an effect. The most extreme statement of this position derives from the structuralist Marxist theories of ideology and the interpellated subject associated with Althusserian writings.[22] Related but distinct is the psychoanalytical intervention, also based on a structuralist premise about the split subject – conscious/unconscious – produced as an effect of entering into the social/symbolic system of language.[23] Feminist theory has explored the implications of both these resources and articulated specific theories about the production of the gendered subject, that is our sexuality is not natural, pre-given, innate, but the product of multiple determinations at the psychic and social levels.[24] Many of these have been deployed in the specific area of cultural analysis to argue for the so-called 'death of the author'.[25]

A great deal of traditional literary and artistic criticism concerns itself with discovering in the works analysed the presence of the originating subject, the author. The meaning thus found is often no more than what is claimed as the artist's intention. In art history in particular, supporting evidence is often directly biographical (see back to points about about the Pre-Raphaelites). In contrast it can be argued that the reader is in fact the author of the meanings of the work read or viewed. Yet to be able to make a reading of a work the reader/viewer must possess a modicum of social knowledge about the practice (what is a novel, a painting, a photograph?), what kinds of behaviour are appropriate, what kinds of readings will be recognised as art consumption and so forth. The reader/viewer therefore herself becomes a site for social exchanges which displace meanings from being a something put there or taken out to being a process of productive activity predicated again upon a social community. The death of the author, or the artist, as privileged individual speaking herself through the medium of work to a sensitised receiver is displaced by an awareness of the calculations and ventures of producers working within, for, or against the community of knowledges and expectations which constitute the social practice of which she is but one active participant. Where this knowledge is mobilised by feminist producers, the challenge to the orthodoxies of art, art school and culture begins to appear in its true proportions.

Feminist practices in art schools therefore do more than irritate the established staff at the level of personal affronts to their masculine privilege as the Fathers and Sons of Culture. They threaten the dominant modernist paradigms of art and artist. Modernism is traditionally posed as radical, anti-establishment. This is of course a myth, for by the third decade of this century

modernism became the official art of the capitalist West and has been insti-
tutionalised as such since the 1929 foundation of the Museum of Modern
Art in New York. Feminism and its cultural politics are inevitably posed
against that modernism. Indeed Lucy Lippard has defined feminist art as
anti-modernist in her statement that the major contribution of feminism to
the future vitality of art is its *lack of contribution to modernism*.[26] This is far too
simplistic for it tends to equate modernism with only one recent phenomenal
form, formalism, identify that with men and oppose to it women's art with
its political or autobiographical purposes. Since the late 1960s Western
culture has been rapidly diversifying but it has been re-assimilated to the
modernist concept of post-modernism (cf. Impressionism and Post
Impressionism, coined by Fry and McCarthy in 1910 and sealed in modernist
orthodoxy by John Rewald in 1956).[27] Feminist concerns with figurative work,
overt subject matter and personalised testimony can be accommodated in
this renewed trend towards figuration and expressionism but subsumed as a
second category of women's expressionism within the major trope of extreme
claims to individualistic creativity in the Grand (Men's) Tradition.

More convincing is Mary Kelly's dialectical analysis of modernism's
contradictory field in the late 1950s and 1960s, torn between objective
purposes and transcendental subjects (Clement Greenberg's pure opticality
in painting and Rosenberg's action pioneers), which led to a serious threat
to the economy of desire in modernism's market.[28] The market she argues
literally could not afford to sustain the loss of the author, the loss of that
commodification of the name splattered across the canvas or sculpture or
whatever. In the move towards abstraction what had been lost at the level
of content – what the artist expressed through recognisable narratives or
obsessional concerns – had been retrieved by fetishising the trace of the
artist at work, the gesture which comes to stand for the creative subject.
The market has relished the revival of gestural expressionism, an added
bonus for the associated producers of art literature who once again have
biographical subjects to interrogate. This form of practice moreover satisfies
the constant pressure for novelty within the diversified field of contemporary
art. The predominant strategies of art school education – develop yourself,
find your own project, define your own speciality – all these collate within
that economic and ideological structure.

Faced with the conservatism of much that is heralded as post-modernist
art, some critics have attempted to distinguish between a conservative and
a radical trend. The progressive practices according, for instance, to Hal
Foster, produce a culture of exposé, shock, discoordination and disidentifi-
cation.[29] One leading feature is to disown the notions of creative authorship
by means of appropriation of publicly authored media imagery in order to
force us to recognise the collective identities which seduce us from the bill-
boards, cinema and video screens, magazines and TV programmes as well
as the places of High Culture.

Feminist activity in this field addresses the deconstruction of the collective noun 'WOMAN' in order to expose the social construction of femininity. Characteristic of this kind of feminist work is a rejection of the auto-biographical personalised 'I' as a point of identification for the audience with the artist as somehow embodied in the work. The loss of the author and the associated individualism upon which it rests cannot be seriously mourned by women because they have never truly enjoyed the privilege. As artists they have always been condemned to a collectivity of otherness, the category 'women artists'. As has been suggested, the very notion of the indi-vidual as it emerged and was socially experienced rendered it a facet of the masculine. The Individual is a man in the public field of self-determination and it hardly needs to be rehearsed here how since the foundation of bourgeois civil society the feminine has been sedulously constructed as self-less, ever losing itself in the man it loves, the children it bears and nurtures, the parents it cares for, the tremulous emotionality with which it melts.

In cultural activity the expression of a point of view by a woman has traditionally been consumed as an expression not of an individual but of some facet of WOMAN. The struggle of women now is complexly caught between a resistance to the ideological collectivity of WOMAN and the construction of a politically conscious collectivity, the women's movement, which tries to defend the specificity of women's experiences while refuting the meanings given them as features of woman's natural and inevitable condition. The struggle is therefore a collective one composed of distinct persons with particular and heterogeneous personal ends and means but neither of these is oriented towards the celebration of individualism.

The form which this exigency takes in feminist practices involves on the one hand creating for women the conversational communities of which they have been deprived. After 15 years there is a feminist tradition with various strands, offering points of recognition, identification and indeed competition through which women can both locate themselves and develop related practices. There have also been, on the other hand, the production of what Rozsika Parker and I have called strategic practices to complement these practical strategies.[30] This work focused particularly around the issues of representation and sexuality, the title in fact of a recent exhibition 'Difference: On Sexuality and Representation' which was first shown at the New Museum in New York December 1984 and then at the Institute of Contemporary Arts in London in September 1985.[31] The exhibited work demonstrated several of the tactics outlined above, the critique of author-ship in the work of Sherrie Levine, the analysis of popular images by Silvia Kolbowski, the use of advertising methods to confront and discomfort a viewer who can no longer escape the sense of being got at in the work of Barbara Kruger. In the work of Marie Yates, Mary Kelly and Yve Lomax as it was shown in New York Paul Smith noted the strenuous refusal to locate the she or person speaking in the pieces with a specifically

documentable woman. The effect is to make the viewer conscious of how much she desires to find within a work of art a secure locus of meaning either in a woman about whom a story is being told or in one telling the story. We scan the work for that identity around which our fantasies can be permitted to develop. Marie Yates exhibited a work called *The Missing Woman* (1983–4) which utilised all the rhetorics with which we are familiar from novels, magazines, serials and films. Narrative, biographical excerpts from diaries, photographs, mementoes, scenarios of intimate spaces, recorded conversations, all these typically promise us the plenitude of woman but their deployment and recalcitrance in this piece forces the viewer to recognise the fact of representational strategies, a fact which is overlooked in our normal consumption of their constructs as truths revealed.

Equally it is possible to use a first person noun within a text to allow for the fact that the producer of the work is to some extent referring to and drawing on particular and personal experience. But that experience is not displayed for a voyeuristic consumption of someone else's life, suffering or anxiety. It is subject to the rigorous revisions of being remade within a practice; it is thus changed to perform a job for the viewer, to provide active places for the viewer so that what is referred to in the work can be mobilised for the viewer to produce knowledge, not of the private circumstances of the work's producer, but of the social conditions within which that aspect of a woman's life intersects with aspects and concerns of other women's lives. This is particularly apparent in two works, one by Marie Yates called *The Only Woman* (1985) which handles a daughter's mourning of a mother, a search for a relationship through a social history which hints at a network of personal and familial histories and public collective histories which can conjoin private grief and the struggle of the miners.

Mary Kelly's new project *Interim* addresses the public and private faces of women as they confront getting older. The project (four parts with several sections each) activates public discourse about women, using as its sign the framework of J.M. Charcot's publication of photographs of women patients at his clinic in what he defined as five passionate attitudes of hysteria (Threatened, Supplication, Eroticism, Appeal and Ecstasy). But whereas in the three volumes of images *Iconographie Photographique de Salpetrière* (1877–80) a woman's body is exposed to the scrutinising gaze, Mary Kelly has displaced that woman as object by a trace, i.e. an object belonging to a woman which thus functions as both a sign of a person and at the same time a reminder of the public discourse of fetishism in which parts of women's bodies and their attributes are reworked in fantasy to stand for the object whose lack in woman threatens the masculine viewer.

In the first section of the first part (there are four major parts of the project – The Body, History, Money and Power) a black leather jacket is used as the object of clothing and it is presented in a number of different poses, each of which is suggestive of one of the ways in which a woman's

sexual identity is constructed: fashion and beauty, medicine, romantic fiction. Thus there are several layers of reference available to be activated, some general knowledge, others more specialist, and focusing their resonances is a piece of written narrative, in part a scene, in part conversations, in part analysis, giving access to the procedures – of consciousness raising, personal testimony, historical and theoretical analysis – by which women have been learning to make sense of and produce knowledge of the social world which endlessly plays over their minds and bodies, producing them but never entirely captivating them within its contradictory and discontinuous patterns.

What gives such work specificity is not any simplistic opposition to modernism but the complex strategies evolved by such practitioners to produce a certain kind of image and discourse which is both recognisable as art – it means to be nothing else – but which constantly erodes the ideological limitations to which historically the dominant definitions and procedures have constrained the making of art. This artistic practice intends to reinsert art in the social and in history – and that means it addresses and works upon the ideologies and social relations of class, gender and race.

What this article has been concerned to articulate are the complex relations between feminism and modernism in current art, art school and culture. Women have trouble in art schools because they are the bastion of reactionary ideas about art, teaching, self-expression and above all individualism. The positions sustained by these ideas are difficult if not impossible for women to adopt without some severe distortion or negation of aspects of their particularity as persons – they can become one of the boys, or accept being graceful and decorative. The problem exceeds the simple but harrowing daily experiences of sexist behaviour – from ribald jokes to intimidating or patronising encounters with teachers. These could and do happen anywhere. What makes the institutional sexism of the art school more violent is the interface between a sexist hierarchy of staff (usually all male (full-time)) and students (many of whom are women) with the structural ideologies of the practice, the production of saleable individualism masked as the pursuit of personal truth, the truth of an artist. A feminist consciousness in art schools is often an existential response to daily tribulations. Feminist artistic practices, however, develop a sustained critique of both the economic exchange and the ideological formation of which current art and art schools form the discursive and institutional base.

The women who produce work which belongs to this tradition of feminist strategic practices are experienced as threatening; their novelty is barely accommodated even within the most pluralist establishment for their particularity as members of a conversational community is simply not recognised. They defile the category existing for self-conscious women artists, namely women's art, while defying the authority of Art and Artist in their masculine privilege. Over and over again I have heard and been told of the ways in which women thus involved are dismissively categorised as 'that bunch',

that lot, the feminists. In one instance several students were actually assessed as a group because of the commonness of purpose and despite the difference of strategies. Would anyone ever imagine assessing all the gestural painters as a group as that lot of modernists, or neo-expressionists, or whatever? As I have argued elsewhere femininity was once the blanket term through which women's art was marginalised, now feminism performs the function of disqualifying the work from being seen as art.[32] There are numerous sub-stitute definitions – it's all theory, it's all politics, it's all too personal – they vary but at heart they say the same thing. What is different however is that the feminist critique exposes the skeleton in the cupboard by insisting upon the relations that art and art schools sustain to the social world, to the culture of class, of a sexist and racist society. And furthermore the argument is that art and art schools are actively involved in its reproduction – and not a protected realm apart for the cultivation of higher, spiritual values. It is therefore urgent not to confront the Higher Education policies of the present administration with retrenchment behind the lines of Individualism, Creativity and High Culture, or with a born-again messianic avant-garde. In April 1984 Martha Rosler and John Tagg debated this issue on Channel 4's *Voices*. John Tagg pointed to the survival of the idea of the special mission of the special person, the artist, in Martha Rosler's otherwise exemplary statement about the necessity for resistance to incorporation and the mounting of critical interventions from what she called the margins.

> Only those artists who raised their voices on the outer bounds of the high art world were able to speak with the urgent impetus of a challenge which goes beyond style. . . . The art world, like the mass media, has learned to fill the void at its centre by sucking into it these figures at the margins. Black, Third World, gay and lesbian, political and street culture artists supply the necessary transfusion of energy and style, and social conflict magically appears solved by this symbolic acceptance of the socially dispossessed. The art system has recently entered a period of strongly renewed control by dealers who mean to regulate production and reputation. . . . It is only marginal figures who still represent the oppositional trend yet in a hungry market they too are candidates for celebration virtually as soon as they emerge. It is only through guerrilla strategy which resists deadly universalisation of meaning by retaining a position of marginality that the production of critical meanings still remains possible. It is only on the margins that one can still call attention to what the universal system leaves out.[33]

In contrast, John Tagg argued for a more centrally focused and calculated programme of interventions based on a full understanding of the numerous participants in the production of culture and thus abandoning the residual avant-gardism which still privileges the artist as the voice outside the city

64

gates, able to make these critical meanings alone in the studio garret on the margins.

> The specialness of the artist, point of honour of the avant-garde and held fast even by practitioners like Martha Rosler, can no longer serve as a mobilising myth. Cultural institutions require a whole range of functionaries and technicians who contribute their skills or service cultural production in a whole range of ways. A painting is as much a collective work as a film and only takes on the currency of social meaning through the application of multiple levels of expertise. It follows, then, that any adequate cultural intervention must be collective – as collective as advertising, television or architecture – as collective as the accumulated skills, the layers of habit, practices and codes, production values, rituals of procedure, technical rules of thumb, professionalised knowledges, distinctions of rank and so on, which makes up the institutional base.[34]

It is evident from this kind of statement that a great deal of theory is being mobilised, theory about production, society, history, the subject, and so forth. Very little of it is so-called art theory. I teach, as John Tagg[35] used to, the course at Leeds University on the Social History of Art. It attracts a lot of applicants from Fine Art courses who are aware of a serious absence in their education, a lack not just of art history but of the means of under-standing art and its history past and current. The course spends a great deal of time reading texts on historiography, theories of society as a complex totality, theories about language, subjectivity, ideology. What is being offered is some means to map a place as cultural producer in the social synthesis of which cultural production is a part. This should be one of the jobs of art education, to produce for its students a usable knowledge of the social and of culture's complex relations to the structures of economic, social and political power and to the production of meaning. These tasks become more urgent precisely because the world we now confront threatens to lose us in the gloss and glitter of its spectacle while demanding the art students to become its ever more explicit functionaries.

I have posed the struggle throughout this article in terms of a conflict of gender power. I cannot leave the subject without further reference to the question of race. There is a massive absence in British art schools of students from the growing sections of the multicultural communities. This absence speaks of an even vaster gap between the Eurocentric Western ideal of competitive Individualism and the cultural and social experiences of Afro-Caribbean and Asian peoples. The changes needed now can only come about with both the recognition of the specificity of peoples' struggles against racism both inside and outside other politically progressive moments and by some form of alliance between the displaced and marginalised, the dominated. Art schools may never be high on the general political agenda,

but culture in its broadest sense is now the scene of massive investment and attempted regulation. Art schools will remain the privileged site for the reproduction of white male supremacy, and as such an easy target for and all too willing ally in the doomed Thatcherite reconstruction of imperial Britain, unless the double challenge of feminist and anti-racist struggles is confronted now.

NOTES

1 This article is a corrected version of a lecture given at the Royal College of Art on 14 June 1985, in a series of seminars organised by Guillem Ramos-Poqui and the Students' Union. The other speaker in this debate was Professor Philip King.
2 The reference to the title of the collected essays by Clement Greenberg published in 1961 is intended.
3 Rozsika Parker and Griselda Pollock, *Old Mistresses: Women, Art and Ideology*, Routledge & Kegan Paul, London, 1981.
4 Deborah Cherry and Griselda Pollock, 'The Pre-Raphaelites and Patriarchal Power', *Art History*, vol. 7, no. 4, 1984, pp. 481–2.
5 Ibid., p. 494.
6 Deborah Cherry and Griselda Pollock, 'Woman as Sign: The Representation of Elizabeth Siddall in Pre-Raphaelite Literature', *Art History*, vol. 7, no. 2, 1984.
7 M.H. Abrams, *The Mirror and The Lamp: Romantic Theory and the Critical Condition*, Oxford University Press, London, 1953; M. Shroder, *Icarus: The Image of the Artist in French Romanticism*, Harvard University Press, Cambridge, Mass., 1961.
8 W. Benjamin, 'The Author as Producer', in *Understanding Brecht*, New Left Books, London, 1973.
9 L. Althusser, 'Ideology and Ideological State Apparatuses: Notes Towards an Investigation', in *Lenin and Philosophy and Other Essays* (trans. B. Brewster), New Left Books, London, 1971; K. Jones and K. Williamson, 'The Birth of the Schoolroom', *Ideology and Consciousness*, no. 6, 1979.
10 Philip King – statement made for the debate, 14 June 1985.
11 J. Seed, 'Unitarianism, Political Economy and the Antinomies of Liberal Culture in Manchester 1830–50', *Social History*, vol. 7, no. 1, 1982, pp. 1–26.
12 Griselda Pollock, 'The History and Position of the Contemporary Woman Artist', *Aspects*, no. 28, 1984.
13 Robert Gray, 'Bourgeois Hegemony in Victorian Britain', in *Class Hegemony and Party* (ed. Jon Bloomfield), Lawrence & Wishart, London, 1977. See also T. Bennett *et al.*, *Culture, Ideology and Social Process, A Reader*, The Open University, Milton Keynes, 1981, Section IV (Gray's essay is also printed in this reader).
14 F. Jameson, 'Post-Modernism, or the Cultural Logic of Late Capitalism', *New Left Review*, no. 146, 1984.
15 Material published in Open University programmes for *Modern Art and Modernism*, 1983: MOMA 1929–39; The New American Painting 1958–59.
16 This point needs to be underlined. While culture may not appear as a major factor in people's daily lives, it has none the less become a growth area for both economic and intellectual investment. It is now part of the tourist and leisure industries, attracting significant funding not just as in the 1950s from government bodies and private agencies such as MOMA but now from major conglomerates in the communications industry. IBM Corporation for instance sponsored the Renoir exhibition at the Hayward Gallery in 1985; IBM UK Ltd sponsored

the Post Impressionism exhibition at the Royal Academy in 1979–80; 'The Genius of Venice' exhibition in 1983–4 was sponsored by Sea Containers Ltd and Simplon-Venice-Orient Express – which is in fact one of the former's (US company) British subsidiaries; American Express sponsored 'Dutch Painting in the Age of Vermeer and de Hooch' at the Royal Academy in 1984; 'The Hague School' at the Royal Academy in 1983 was sponsored by Unilever; and their exhibition of German Painting in the early twentieth century was sponsored by Lufthansa, the Deutsche Bank, Mercedes-Benz, Beck's Bier, Bosch, Melitta and Siemens.

17 K. Marx, 'Introduction', *Grundrisse* (trans. M. Nicolaus), Allen Lane, London, 1973, p. 83.

18 Catherine Hall and Leonore Davidoff, 'The Architecture of Public and Private Life in English Middle Class Society ... 1780–1850', in *The Pursuit of Urban History* (eds D. Fraser and A. Sutcliffe), Edward Arnold, London, 1983.

19 R. Williams, *Culture and Society 1750–1950*, Chatto & Windus, London, 1958.

20 For an excellent discussion of the privatising of art making and consumption see Christine Schoefer, 'The Power of Creation: Lukacs and Clark on Politics and Art in France after 1848', *Berkeley Journal of Sociology*, vol. XXV, 1980.

21 F. Orton and Griselda Pollock, '*Avant-gardes* and Partisans Reviewed', *Art History*, vol. 4, no. 3, 1981.

22 See note 9.

23 For a useful discussion of Lacan's notion of the subject see Rosalind Coward and J. Ellis, 'On the Subject of Lacan', *Language and Materialism*, Routledge & Kegan Paul, London, 1977.

24 Rosalind Coward, Sue Lipshitz and Elizabeth Cowie, 'Psychoanalysis and Patriarchal Structures', and Cora Kaplan, 'Language and Gender', in *Papers on Patriarchy*, Women's Publishing Collective, London, 1976. See also J. Mitchell and J. Rose, *Feminine Sexuality*, Macmillan, London, 1982.

25 R. Barthes, 'The Death of the Author', in *Image-Music-Text* (trans. and ed. S. Heath), Fontana, London, 1977.

26 Lucy Lippard, 'Sweeping Exchanges: The Contribution of Feminism to the Art of the Seventies', *Art Journal*, vol. 41, no. 1/2, 1980.

27 F. Orton and Griselda Pollock, 'Les Données Bretonnantes ...' (review of 1979–80 exhibition on Post Impressionism), *Art History*, vol. 3, no. 3, 1980.

28 Mary Kelly, 'Reviewing Modernist Criticism', *Screen*, vol. 22, 1981; reprinted in B. Wallis (ed.), *Art after Modernism: Rethinking Representation*, New York New Museum of Contemporary Art, 1984.

29 H. Foster, *Postmodern Culture*, Pluto, London, 1985.

30 Rozsika Parker and Griselda Pollock, *Framing Feminism: Art and the Women's Movement 1970–85*, Pandora Press, London, 1987.

31 This is not a full discussion of the exhibition for it omits reference to the three men who also participated whose work also addresses the issues of sexuality and representation, Ray Barrie, Victor Burgin and to a lesser extent Hans Haacke.

32 Griselda Pollock, 'Feminism, Femininity and the Hayward Annual 1978', *Feminist Review*, no. 2, 1979, reprinted in Parker and Pollock, op. cit.

33 Martha Rosler, statement made to Brook Productions 1984.

34 J. Tagg, 'Post-Modernism and the Born Again Avant-garde', paper given at Newcastle Polytechnic 1984: see *BLOCK*, no. 11, 1985/6.

35 See J. Tagg, 'Art History and Difference', *BLOCK*, no. 10, 1985.

5

ART HISTORY AND HEGEMONY

Jon Bird

(*From*: Issue 12, 1986/7)

PART 1

Why does it matter politically for feminists to intervene in so marginal an area as art history, 'an outpost of reactionary thought' as it has been called? Admittedly art history is not an influential discipline, locked up in universities, art colleges and musty basements of museums, peddling its 'civilising' knowledge to the select and cultured. We should not, however, underestimate the effective significance of its definitions of art and artist to bourgeois ideology. The central figure of art historical discourse is the artist, who is presented as an ineffable ideal which complements the bourgeois myths of a universal, classless Man [*sic*].

Our general culture is furthermore permeated with ideas about the individual nature of creativity, how genius will always overcome social obstacles, that art is an inexplicable, almost magical sphere to be venerated but not analysed. These myths are produced in ideologies of art history and are then dispersed through the channels of TV documentaries, popular art books, biographic romances about artists' lives like *Lust for Life* about Van Gogh or *The Agony and the Ecstasy* about Michelangelo. 'To deprive the bourgeoisie not of its art but of its concept of art, this is the precondition of a revolutionary argument.'

(Griselda Pollock, 'Vision, Voice and Power:
Feminist Art History and Marxism', *BLOCK*, no. 6, 1982)

At the Association of Art Historians Conference of 1981, held at the Institute of Education, the opening address was given by the Rt. Hon. Paul Channon, the then Minister for the Arts in the 2-year-old Conservative Government, and now Secretary of State for Trade and Industry. The AH Bulletin, which reported the Minister's speech in full, referred to his presence as: 'an honour, and one which perhaps signifies the growing recognition of the Association's influence in the field of the visual arts'. What I would suggest is that his presence was, in fact, simply a restating of the role of the traditional intellectual (in the Gramscian sense) – a service rendered, and sold, to the authority of the State.

Mostly, Paul Channon's talk was about the benefits and achievements of the recently established National Heritage Memorial Fund. Primarily concerned with the retention and maintenance of official high culture, the Fund flows from the National Heritage Act of 1980. The relation between the conservative rhetoric of traditionalism, patriotism and high moral worth, and the exigencies of monetarism are most clearly encapsulated in debates and policies over the national identity. The National Heritage Act both preserves property and objects defined as 'our heritage', and seeks to encourage its widespread cultural assimilation – a process exemplifying the material effects of ideology. Let me quote from the Minister's address:

> Our policy is that, wherever possible, private owners should be helped
> through tax concessions to retain works of art provided that in return
> they preserve them and make them reasonably accessible to the public.

Not only, then, does the Government reimburse the owners of the approved constituents of the 'national heritage', the essentially private aspect of possession is reaffirmed as a fundamental right! Channon continued:

> Moreover, it is not widely appreciated that someone offering an item
> in lieu of tax may attach to the offer a condition as to the allocation.
> In this way, a condition could be attached, for example, that an item
> should be allocated back to remain 'in situ' in the house or building
> with which it had long been associated.

Channon mentioned the 'in situ' debate as of particular interest to art historians and conservationists – a pretty fair estimate of the depoliticising tendencies of academic scholarship which has traditionally tended to obscure the real affiliations that exist between the production of knowledge, on the one hand, and corporate, State and military power, on the other. In the 'post-modern' period, the widespread fetishisation of information and its political potential, serves to reinforce the essential interconnectedness of all discourse and the relativity of all values, in a system which is always being threatened and always being restored. Paul Channon concluded his talk with an explicit recognition of the tacit understanding that ought to exist (*sic*) between art history and conservative politics:

> I am delighted to have had the opportunity to talk to you and am
> pleased that you do not see yourself as a pressure group. I think this is
> a most responsible way of handling matters and I deeply appreciate it.

An exchange is being enacted here, a recognition of shared symbolic power – of mutual value systems that gain their power to confirm or transform the social world only to the extent that they are implicitly acknowledged – which is to say, only to the extent that their ideological operations are misrecognised. The French social and cultural analyst Pierre Bourdieu puts this very well:

JON BIRD

symbolic power ... is defined in and by a determinate relationship between those who exercise power and those who undergo it, ie in the very structure of the field in which belief is produced and reproduced.[1]

The 'national heritage' is a part of this field: left undefined by the Government-appointed trustees, it is the domain of like-minded individuals of taste and discretion, and, of course, the right social connections – the Memorial Fund is currently administered by an ex-headmaster of Eton, Michael McCrum. As always, the questions to be asked in relation to the preservation or conservation of a national heritage are: 'who from, and for whom?'

A far more explicit expression of the conservative discourse of the owner-ship and control of high culture can be found by examining those texts pro-duced by the current ideologues of Right-intellectualism, particularly the group originating from Peterhouse College, Cambridge and the *Salisbury Review*. Since the late 1970s with the publication of *Conservative Essays*, edited by Maurice Cowling, this group has consistently argued for a redefinition of traditional high Toryism derived from the principles of non-interference with the right of unlimited appropriation and the mechanisms of the free market economy, towards a fundamental rejection of liberalism – that is, the defence of individual rights and freedoms – and have called for a politics of authori-tarianism – the right of government to govern.

The attack upon, particularly, democratic liberalism, has been on-going since the post-war development of the interventionary State combating the worst forms of social inequality. From Hayek's *The Road to Serfdom*, published in 1944, through the monetarist philosophy of Milton Friedman to the *Salisbury Review*, there has been an uninterrupted offensive against all defi-nitions of liberty that allow some degree of choice over social and political alternatives, with the State monitoring and facilitating those possibilities for all of its citizens. For Hayek and Friedman, then, the 'true' nature of liber-alism is to seek to reduce to a minimum State interference in the essentially private matter of individual liberty, thereby opening the space for the New Right to restrict the State's social role in order to align it with the function of the market as an instrument of discipline and order. The social effects of this doctrine are, on the one hand, the limitation of any form of public participation and decision-making to narrowly defined, and market deter-mined, groups of experts and specialists, and, on the other, to encourage non-threatening forms of autonomous self-expression. It is not difficult to see how this scenario has certain attractions and correspondences with those traditional (high) cultural practices, including of course the visual arts, which privilege self-expression and individual subjectivity.

In an article in *Art News* (September 1983) rejecting the case for the return of the Elgin Marbles, Roger Scruton, editor of the *Salisbury Review*, *Times* columnist, Birkbeck College philosopher and member of Margaret

Thatcher's 'Think Tank', attacked the 'guilty liberal conscience' that allowed serious consideration to such questions. After reflecting upon the rightness of individual ownership and the desirability of contemplating art in its rightful setting of private property: 'I have often stood before some minor masterpiece in a crowded museum and reflected how much deeper and more-lasting the pleasure it would bring were it to be hanging above the mantelpiece in a private house, receiving from its domestic circumstances some of the warmth and sympathy that are art's due' – he concludes the case against restitution on the grounds of actual possession regardless of the means by which that possession has been effected:

> Either these people have retained sufficient hold on their culture to safeguard its monuments, in which case we need no longer feel guilty that some of them have been scattered abroad; or else they have not, in which case they ceased to exist as a cultural entity and have no greater right to the works of some previous epoch than anyone else ... the greatest entitlement rests with the private purchaser, with the person who has sufficiently loved an object to make a sacrifice to acquire it.

Put this attitude together with the recent statement by Richard Luce, current Minister for the Arts, of his belief in the negative aspects of funding upon creativity, and it becomes clearer who is being asked to make sacrifices, and what is at stake in this re-enactment of imperial ambitions masquerading as cultural conservation. In all of this, we have to ask what role is being played by those institutions and discourses which mediate and articulate the authority and operations of hegemonic culture.

If, in the private sphere, the art auction is the paradigmatic expression of the operation of market forces upon cultural ownership, then, as Baudrillard has observed, in the public realm it is the museum that acts as the guarantor for cultural exchange and legitimises the acquisition of cultural capital:

> just as a gold bank is necessary in order that the circulation of capital and private speculation be organized, so the fixed reserve of the museum is necessary for the functioning of the sign exchange of paintings. Museums play the role of banks in the political economy of paintings.[2]

And, to stretch the analogy further to include the functionaries necessary for the smooth operation of the whole structure, art historians frequently act as the system's clerks, cashiers and accountants.

We do not have to look far for evidence of art history's complicity in the dominant culture's redefinition of the signifiers of tradition and the national past. The recent Stubbs exhibition at the Tate Gallery, funded by the (besides other activities) armaments manufacturers United Technologies, raises questions about the production and consumption of cultural meanings. In 1984,

the major Pre-Raphaelite exhibition, also at the Tate, was sponsored by the multinational corporation S. Pearson, who have interests in plastics, ceramics and glass in the UK, mining and nuclear industries in the US, the Far East and Africa, and, in the guise of the merchant bankers Lazard Bros, are former employers of the NCB's Ian McGregor. S. Pearson have something of a history of cultural resourcing which includes Madame Tussaud's and Warwick Castle and publication, in the form of Pearson Longman, of *The Economist, Financial Times, Apollo* magazine and the *Salisbury Review*. Reviewing this exhibition for *Art History*, Griselda Pollock and Deborah Cherry questioned the 'resonances of Victorian romantic painting celebrated in terms of creative geniuses painting beautiful passive women within contemporary British culture in the 1980s'.[3]

Similarly, the major exhibition 'German Art in the Twentieth Century' at the Royal Academy has been sponsored by a consortium of national and multinational corporations comprising Lufthansa Airlines, Deutsche Bank, Bosch, Hoechst, Siemens, Mercedes-Benz, Melitta and Beck's Bier, and had Helmut Kohl and Margaret Thatcher as patrons. Further financial assistance came from the West German federal Ministry of Foreign Affairs and from an award from the Business Sponsorship Incentive Scheme. Finally, the whole exhibition was indemnified under the National Heritage Act. In the press pack publicising the exhibition, these respective sponsors laid out their corporate and aesthetic credentials ranging from the faintly ridiculous – Melitta claiming a connection through the shared origins of filter coffee systems and Die Brucke artists (Dresden, between 1905 and 1908) – to the blatantly opportunistic – Beck's Bier heralding an advertising campaign targeted at 'the more discerning, style conscious section of the under 30 age group' for whom 'authentic German heritage is seen to be very important'.

Three of these corporations (at least) have been the targets of political photomontage works produced by German artists. In this respect another significant absence from the exhibition, besides the work of women artists, the critical work of the Dadaists, post-war Realism, the work of East German artists, and recent performance and scripto-visual work, was any reference to another relatively recent exhibition of German art in London – that of German political posters at the ICA in 1977. In this, Mercedes-Benz, Siemens and Hoechst were all subjects of critical representations – the latter in a reference to that company's polluting of the Rhine through the illegal discharge of chemical effluents.

The German exhibition clearly raised questions of nationalism and national identity as a referent of cultural practice. This is also a factor in the exporting of cultural treasures for exhibitions which either seek to maintain a cultural continuity, or to celebrate a particular (hegemonic) history of taste. The exhibition 'The Treasure Houses of Britain: 500 Years of Private Patronage and Art Collecting', opened by Prince Charles and Princess Diana at the National Gallery of Art in Washington, and guest-curated by the

National Trust's Gervase Jackson-Stops, contributed to the discourse of nation as unbroken continuity and congenial exchange. Supposedly chronicling the development of British taste since the fifteenth century, the exhibition succeeded in satisfying the demands of nostalgic conservatism and market economics. This exhibition (and others like it, e.g. Joshua Reynolds at the Royal Academy, sponsored by National Westminster Bank) successfully mobilises an acceptable past while simultaneously stimulating investment through a narrowing of the gap in saleroom prices between the fine and decorative arts.[4]

The centrality of 'tradition' in conservative discourse has long provided a bulwark against 'progress' seen as the potential rupture of socially emancipated subjects, while providing the possibility for constantly representing a (mythologised) history as the continuum of institutional authority and the obedient self. Thus John Casey, in his essay 'Tradition and Authority', praises T.S. Eliot's account of tradition, as still the best this century, as:

> something that is both impersonal and at the same time open to personal appropriation; as both something existing in its own right and yet as needing recreation in every age. This recreation, which is also the acquiring of an 'historical sense', involves the finding of a language that is the language of the present, and which at the same time re-establishes real relations with the past. Such a picture of tradition . . . will allow for the understanding of a self that endures through time, that has a past and a future.[5]

Casey also emphasised the tendency of conservative utopias to stress the past as a utopian immanence contained within the present; something that sets them apart from both liberal and socialist visions. The crucial articulating concepts for neo-conservative authoritarian utopias, from Hayek through to Scruton, are authority, allegiance, tradition, nationalism, defence and 'nature', although their precise relations and boundaries are variable.

The ease with which a supposedly 'neutral' art historical/critical discourse becomes reliant upon 'tradition' as an articulating concept to avoid the discontinuities and contradictions of a properly reflexive historical analysis, is provided by a number of the essays for the catalogue accompanying the German art exhibition already cited, in particular those of two of the organisers, Christos Joachimides and Norman Rosenthal. Joachimides, for example, argues that 'it is our experience of works of art and the background of our own time acting as a sounding board for our decisions, that enable us to develop critical tools and establish criteria'; while Rosenthal suggests that a primary motive behind the exhibition was 'to demonstrate the existence of a deep-rooted and complex painterly and sculptural tradition in Germany in this century'.[6]

The present Government's abolition measures for the Metropolitan Boroughs carries draconian implications for arts funding of all varieties. On

the one hand, State patronage, via the Arts Council and the Regional Arts Associations, is halved, while simultaneously the private sector is urged to make good the deficit. The initial major Government statement on this, written in 1982 by Norman St. John Stevas, clearly recognised the task as the familiar complicitous one of selling audiences (markets) to advertisers:

> Individual artists and arts companies can tell you about the audiences they attract. Obviously they vary. One could be particularly appropriate to your business. If you value prestige, remember that the typical arts audience includes opinion formers, leaders and executives as well as impecunious students.[7]

As museums and art galleries are forced to seek matching funding from the private sector it becomes increasingly likely that they will separate out the functions of economic support, seeing the public sector as providing the base for the day-to-day operations of the institution, and the private sector as the primary means of support for the actual exhibition programmes. And, given the extent and penetration of this Government's attack upon critical and oppositional practices across the social, political and cultural fields, the pressure upon curators and museum and gallery directors, arts administrators, RAAs, artists, art critics and historians, is to mute the critical edge of their discourse and to apply those same processes of self-censorship and control.

Museums and art galleries in the public sector are part of those 'institutional state apparatuses' that exemplify the material effects of dominant ideologies; a process clearly identified by Carol Duncan and Alan Wallach in their influential article 'The Universal Survey Museum':

> In the Museum, the visitor is not called upon to identify with the state per se, but with its highest values. The visitor inherits this spiritual wealth but only on the condition that he (or she) lay claim to it in the museum. Thus the museum is the site of a symbolic transaction between the visitor and the state. . . . Hence the museum's hegemonic function, the crucial role it can play in the experience of citizenship.[8]

In all of these examples, and, presumably, in many more forthcoming, the consumption of the cultural experience is mediated through the discourse of experts and specialists – art historians, critics, curators, dealers – and is unavoidably linked with both the production of the obedient subject, and the beneficial (*sic*) effects of corporate capital.

PART 2

There are political implications inherent in the act of interpretation itself, whatever meaning that interpretation bestows. What is the meaning, interest and benefit of the interpretive position itself, a position from which I wish to give meaning to an enigma? To give

a political meaning to something is perhaps only the ultimate conse-
quence of the epistemological attitude which consists, simply, of the
desire to give meaning. This attitude is not innocent but, rather, is
rooted in the speaking subject's need to reassure himself of his image
and his identity faced with an object. Political interpretation is thus
the apogee of the obsessive quest for A Meaning.

(Julia Kristeva, 'Psychoanalysis and the Polis',
Critical Inquiry, September 1982)

The role of the humanistic disciplines in this country in cementing, as
opposed to subverting, English cultural traditionalism, has been well docu-
mented, especially in the late 1960s/early 1970s, by Perry Anderson and
Tom Nairn.[9] In fact, Anderson actually excluded discourses of art from his
argument on the grounds that their disproportionate emphasis upon subjec-
tivity produced too complexly mediated relations to the social structure to
clearly determine their role and effectivity.[10] He therefore concentrated upon
the philosophy of Wittgenstein and the literary criticism of Leavis. Nairn was
also primarily concerned with literary ideology, and the absence in British
society of an alienated (Marxist) Left-intelligentsia, a historical trajectory that
has produced an extremely homogenised sense of cultural nationalism. The
distinguishing characteristic of the discourses they analyse is the absence
of any notion of a problematic – that is, the self-reflective and critical
mechanisms whereby discursive formations can be made to reveal their
meaning-producing and ideological structures.

The class-belongingness and relative underproduction of a broad strata
of intellectuals in this country has been partly responsible for the dominant
sense of academic community and shared sensibility enjoyed by the owners
of cultural capital. (And it should be noted that the gradual disruption of
those class allegiances, which began in the inter-war period, produced, with
only a few notable exceptions, on the one hand the Leavisite tradition of
literary theory as the defence of the 'organic community', and, on the other,
the anarchistic and existential revolutionary subjects of literature's 'angry
young men': and we know where most of them fetched up politically!) This,
along with Anderson's emphasis upon the 'absent centre' – that is, the lack
of any totalising social theory of the kind found in either Marxism or radical
sociology – helps to explain the hegemonic role of literary theory. However,
it is also the case that within the discursive formation of hegemonic practices
which constitutes the totality of dominant and subordinate social relations,
discourses of art in their traditional, aesthetic, historical and evaluative
modes have played, and continue to play, an important function in articu-
lating individual and social identities.[11]

This is evidently so if we consider the crucial role played by visual repre-
sentations in the culture as a whole, in maintaining the regime of sexual
differentiation and the oppressive ordering of institutional racism. Despite

the critical analyses of patriarchy and imperialism, the general anti-theoretical tendencies of the majority of art historical texts has been one aspect of the discipline's easy assimilation into the discourse of taste central to neo-conservative theories of art and the picturesque. However, it is equally important to recognise how theory has frequently been employed to either 'polish-up' the tarnished institutions of art or to re-instate the (masculine) voice of authority, rather than towards a fundamental transformation of its meaning-producing categories and conceptualisations.

In relation to this, one aspect of feminist theory has been the deconstruction of the opposition between the political and the aesthetic towards analyses of aesthetic effectivity in terms of audience and context – the recognition that there is no privileged space external to some institutional framework determining the circulation of cultural signs. Against this, the dominant belief that such spaces do exist has characterised theories of art and art historical methodologies committed to an autonomous realm for aesthetic value, and the free creative play of, primarily, masculine individualism. Thus the studio and the museum are seen as hallowed institutions enabling the enactment of uniquely valued forms of action and response: the production and reception of art. In this way, the hegemonic discourse of possessive individualism mythologises the historical gendered subject and evades the issue of institutional power. Each element in the art historical field is accorded a unity and coherence independent of its relation to all other elements, thereby allowing a history of styles, or themes to be produced out of (preferred) formal characteristics; or a body of work to be examined and evaluated free from, or reflective of, all of the conditions of its production.

Two major theoretical developments have contributed to fundamentally altering this form of essentialism: the Althusserian notion of the social as a complexly structured totality, and Foucault's concept of 'discursive formations'.

A key concept of Althusser's theory was the role given to the process, first elaborated by Freud, of 'over-determination'. There has been a tendency for this concept to be applied far too literally, particularly in relation to textual analysis where it has been taken to imply a plurality of meanings coalescing to destabilise any fixed interpretation which attempts to uncover a single source, or cause, of meaning (signification). In *The Language of Psychoanalysis* Laplanche and Pontalis stress the fundamental role of over-determination in all unconscious formations, and its intimate connection to the work of 'condensation' in dreams.[12] It is, therefore, evidence of the multi-layered nature of unconscious processes whereby a symptom (or dream-image) represents the intersection of various signifying chains where each element (or 'nodal point') is over-determined: that is, is symbolic of both presence (signifier – the dream) and absence (signified – wish-fulfilment).

Over-determination thus implies both a symbolic dimension and a plurality of meanings. Althusser's use of this concept is in order to think the

social as a symbolic order, thereby attempting to avoid the determinism of predicating a world of reality – the economic base; and a world of appearances – the 'superstructures', while still holding on to determination 'in the last instance'.[13]

If the concept of over-determination emphasises the symbolic nature of the social and the inadequacy of seeing subject identities as complete and fixed, then Foucault's 'discursive formation' helps us to analyse the articulating principles of a system that allow it to become hegemonic. In general terms, Foucault is concerned with the ways in which fields of knowledge (specifically in the Humanities) produce and reproduce themselves and their objects; what are the conditions under which discourses can operate, and how do those conditions change historically? His overriding concern with statements ('serious speech acts')[14] leads him to make a distinction between the discursive and the non-discursive (institutions, technologies, etc.), while arguing that it is the discourse specific to a practice (i.e. medical discourse, art historical discourse, etc.) that establishes the system of relations that give the unity and coherence to the discursive formation, while simultaneously raising the question of the power that pertains in discourse: whom does the discourse serve?

(However, Ernesto Laclau and Chantal Mouffe in *Hegemony and Socialist Strategy* make a convincing case against any distinction being made between the discursive and the non-discursive, arguing that all objects and practices are constituted within a discursive field.)[15]

In the sense that I am intending it then the art institution is *fundamentally discursive* – that is, it is the relation between all of those elements that are in play in a society at any specific historical conjuncture, defining and determining the meanings and parameters of a given field of knowledge. In this respect, the art institution contributes to what Foucault has called the 'epistemic systems' of Western thought.[16] It is thus possible to speak of dominant discourses, or 'discourses in power', which achieve and maintain their authority by the suppression of those discourses critical of or opposed to them; consequently the field of discourse analysis is directly concerned with questions of power. Power in this sense (Foucauldian) is essentially relational and active and is not a function of consent or control; rather it is premised upon a relation between elements where the subject of power – the 'other' – is constituted throughout as SUBJECT, as a person who 'acts'. Power is thus directional and governmental – structuring and determining a field of action, a play of forces ('desires').

If one of the most persistent discourses of art is that of Romantic Individualism – the integrity and autonomy of the individual creative subject as origin and meaning of the work of art – then it is also evidence of the discursive exclusion or marginalisation of women in any capacity other than as the site of difference. The subject position 'artist' in the discourse of Romantic Individualism becomes, therefore, a subject produced both as a

direct response to the demands of bourgeois culture, and as a model for political economy and sexual differentiation: a field for transgression of the social order but only within the confines of patriarchal law.[17] In its most pervasive sense then, the Romantic discursive formation is the embedded-ness of that discourse within the institutions of art – the selection, training and practice of artists, art teachers, historians and critics (with the attendant operation of processes of exclusion from those activities), the architectural structure of the art college or university including the design of lecture theatres and studios; the use of double-projection, the arrangement of seating, etc.; the design and layout of art galleries and museums; the economic relations of the art market at all levels; the relation between these discourses and the marketing of commodities through the attribution or connotation of artistic/aesthetic values and, ultimately, the articulation of all or any of these discourses in (neo-conservative) political discourses of posses-sive individualism, free enterprise, and sexual identity – a trajectory which flows from the visible and discrete to the invisible and fragmentary.

The re-emergence of Romantic Individualism as the central legitimating concept of visual arts practice, after the lean and critical years of minim-alism, conceptualism, performance, film and video, a period which also marked attempts at a 'feminisation of the visual' through work which prob-lematised the dominant modes of voyeuristic objectification through empha-sising the tactile, the spatial, the contamination of boundaries and the body as an ideological site, is clearly evidenced in the historical pastiche of 'Pittura Culta', the neo-expressionist 'neuen Wilden' painting, the post-modern eclec-ticism of much contemporary art practice heralded in the private galleries and international exhibitions, the celebration, once again, of rampant masculinity. Thus Rudi Fuchs, curator for Documenta 7, confessed the desire to 'disentangle art from the diverse pressures and social perversions it has to bear', while hailing the artist as 'one of the last practitioners of distinct individuality'.[18]

PART 3

We could argue at length about whether interpretation is a circle or a spiral: in other words, whether the interpretable object it assigns itself is simply constituted by the interpretation's own logic or whether it is recreated, enriched, and thus raised to a higher level of knowl-edge through the unfolding of interpretive discourse.

(Julia Kristeva, 'Psychoanalysis and the Polis',
Critical Inquiry, September 1982)

The founding subject produced by the romantic discursive formation constantly threatens, despite the rigorous anti-humanism of post-structuralist discourse, to return to centre-stage, particularly through certain tendencies

within that most-contested ideological terrain – post-modernism. If, as Fredric Jameson has argued, 'We are *within* the culture of postmodernism', then we are still left with the fundamental question of its politics – that is, a radical or a reactionary form of post-modernism.[19]

I think that there can be little doubt that the dominant art historical and critical discourse, with its insistent emphasis upon the autonomy of the creative individual and the transcendent power of the artwork, participates in what Jean François Lyotard terms the post-Enlightenment narratives of legitimation. That is, until the relatively recent turning-away from the canon of high art to the consideration of mass or popular cultural forms (mostly, it must be added, validated through the discourse of modernism), the objects of study have been thoroughly institutionalised and the historical narratives linear and evolutionary.

Of course there have been some changes, but if we take the whole field of the production of art historical texts, then it is predominantly not only pre-postmodern, but pre-modern in both object of study and method of analysis. It is easy to forget, outside of Left-intellectual art historical circles, just how fixed, particularly in relation to questions of gender and race, are the terms 'art', 'artist', 'history', 'society', etc. . . . in the broader context of the dissemination of high culture. On the other hand, in street-wise, post-structuralist, post-modernist deconstructive circles, questions of truth, political morality, cognition, etc. are dumped as outmoded referents in the celebration of image, spectacle and surface. As Terry Eagleton has recently pointed out, in some post-modern scenarios 'the CBI are spontaneous post-structuralists to a man, utterly disenchanted with epistemological realism and the correspondence theory of truth'.[20]

One major aspect of arguments for thinking the present as post-modern is the reference to the fragmentation and de-centring of the contemporary individual subject. For Jameson it is the nature of multinational capitalism itself, with its total penetration, by commodity production, of all levels of public and private life, its incorporation of all aesthetic innovation into the packaging and marketing of commodities – from military hardware and political leaders to household goods and art exhibitions; its shifting relations of power and control which are part of ever-expanding, ever-more complex and concealed computerised communicational networks, of which an analogue is to be found in the disorienting spaces of post-modern architecture; that has 'finally succeeded in transcending the capacities of the human individual body to locate itself, to organise its immediate surroundings perceptually, and cognitively to map its position in a mappable, external world'.[21]

What has been lost in this vertiginous post-modern scenario is that crucial factor of modernist discourse, at least for theories of dynamic and challenging cultural practices, of a fixed position for the bourgeois subject against which can be opened the space of 'critical distance'.[22] But if all the spaces

of post-modernism are suffused with the Being of global capital, there is no critical distance – no place to go to from which an assault can be launched upon either subjectivities or institutions; there is only co-operation or co-option.

Jameson uses the example of architecture to illustrate the dramatic modifications in aesthetic production characteristic of post-modernism. It is the case that the articulations of post-modernist critique are most consistently evidenced in relation to architecture, almost to the extent that architectural discourse presents the paradigm for mapping the field of the post-modern. Significantly, it is also with architecture that the separation of cultural artefact from economic mode has been most resisted; the critique of modernism has thus been sustained at the level of formal analysis – the reductionism of high modernist aesthetics – correlated with the effects of social estrangement produced by intensive urbanisation.

Jameson emphasises the celebration of difference as central to the 'post-modern experience of form', and then proceeds to seek out those proto-typical cultural 'texts' that manifest a dialectical tension in their separate parts produced through fragmentation and discontinuity. Inevitably this tends to particularise the cultural object/commodity as a function of (late capitalist) economism, rather than as articulated across the spheres of economic and cultural production.

Thus the examples Jameson selects – the video art of Nam June Paik[23] and John Portman's Bonaventura Hotel in Los Angeles – are unconvincing partly through their representation as objects mediated by Jameson's narrative, which coheres and unifies them in the moment of their disarray, and partly through his emphasis upon a reading of surfaces as images of late capitalism. That is, if the play of differences is to be taken as a significant aspect of the post-modern deconstruction of authority, we have to ask whether this extends to a potentially fundamental displacement of hegemonic power, or is merely a manifestation at the surface of representation – 'signs taken for wonders'. Clearly the unconstrained ability of multinational corporations to encompass many orders and levels of difference (sexual, racial, cultural, historical, etc.) is not to be read as a full recognition of 'otherness', but as a strategic manoeuvre in the interests of the accumulation and concentration of capital.

In a recent review of the Saatchi phenomenon, I took the company annual report for 1984 as a post-modernist text. One section was devoted to:

> a series of glossy colour reproductions laid out to resemble an endlessly extendable series of television screens, the image on each taken from campaigns for 'pan-national' clients and 'assignments coming on stream'. Country follows country – Brazil, France, Peru, Germany, USA, Australia, Puerto Rico, the UK, Taiwan, etc; product follows upon product – Wrangler jeans, Shredded Wheat, Nissan cars, Kodak,

Paracetamol, chocolates, cigarettes, alcohol, hotels, services, etc . . .
Identical faces smile out of identical frames, making identical gestures
in identical settings: all signifiers of difference are concentrated on the
brand products – the 'family of man' consumes the world of commodi-
ties. This unification and homogenisation which seeks to eliminate
difference and contradiction in the interest of the abstract space of the
global market, allows separation only as a characteristic of spectacu-
larisation: the coherence of myth and the myth of coherence.[24]

Against this, let me propose two alternative examples/articulations of the
post-modern scenario:

(1) In a number of recent cases use has been made of Lyotard's key
category of the 'sublime',[25] although with a tendency to anchor the concept
to the return of historical or romantic references in architecture or painting
– thus an article by Lyotard in *Artforum* (April 1984), 'The Sublime and the
Avant-Garde', was illustrated by two of April Gornik's landscapes. However,
I think that a more convincing case can be made for contemporary repre-
sentations of the sublime as being present in the construction of the post-
war period as the 'nuclear age'.[26] Thus the mushroom cloud can be seen
as that elusive signifier of absolute power and absolute terror – the referent
to end all reference. Apocalyptic visions have often served the function, at
least in the history of Western art, of the inadequate presentation of an
imaginary and ultimate reality. Paul Virilio has spoken of the nuclear age
as re-introducing a sense of the sacred through the global realisation of the
imminence of the death, not of the individual, but of the species: 'We're
already in the apocalypse, which is annihilation. The apocalypse is no longer
the revelation of the soul's immortality, but the extermination of all bodies,
all species, all of Nature, everything.'[27]

In this apocalyptic vision of a negation to end all negation, the missile
replaces the Messiah as the Star Wars fantasy comes to signify the collapse
of all discourse beyond all boundaries, limits or frontiers.

(2) My second example is drawn from the use made by the international
financial markets of the communication media – specifically, the simulta-
neous exchange of information on a global scale made possible by comput-
erisation and the databank. It is currently estimated that the turnover in
foreign exchange markets (that is, the trading in currencies) is approaching
$200 billion a day – process of international speculation in money that is
facilitated by a fundamental instability in the market, contributes nothing
to any nation's Gross National Product, and is thoroughly Baudrillardian in
its simulated spectacle, lack of a referent and implosion of meaning. Nothing,
literally, is exchanged except information in its pure state, telexed between
the computer screens of the world's Stock Exchanges, only to be consumed
by the major banks and multinationals free from all political constraint. For
those excluded from this circle of exchange (i.e. most of the inhabitants of

81

the globe), the process is experienced as a zero-sum game where whole economies become subject to violent fluctuations or collapse, totally independent of the actions of government or the State: a scenario where the effects of this financial terrorism upon the least stable economies can be devastating – the 'real' experienced as imaginary referent or as a catastrophe of meaning.

Jameson's arguments are forceful and convincing in many respects, particularly his emphasis upon the historical and social specificity of the emergence of the Utopian aspects of modernist movements, and his insistence that any attitude towards post-modernism implies both an aesthetics *and* a politics.[28] However, there is the suggestion that underlying the theoretical structure of his polemic is that familiar conceptualisation of culture as the expression of pre-existent and determining economic relations. Thus it is the fragmentation and duplicity of late capitalism that produces the de-centred and displaced subject, and the inauthentic and heterogeneous works of culture. In this formulation, it is not surprising that the element of critical distance is eliminated, as there is no way in which criticism can be anything other than just one more effect of the totalising processes of cultural commodification. Given this, his call for an 'aesthetic of cognitive mapping', capable of representing the complexities of post-modern culture, is already answered – we possess it in the infinitely imaginative simulations of promo-videos, the post-apocalyptic 'Mad Max' visions of George Miller, or the simulated replicants in *Blade Runner*, the knowingly ironic sexism of a David Salle painting, the spatial games and contradictions of a Charles Moore house, the evolution of an abandoned washing tub into the full war head-dress of an American Indian chief.

CONCLUSION

What, then, is to be the fate of the humanistic disciplines in the post-modern period? What might be either a post-modern art history, or the response of art historians to the full complexities of post-modern culture, or pre-modern culture in the post-modern age? Lyotard has suggested that contemporary, post-industrial society has fundamentally altered the status of knowledge so that the relationship between its production and consumption increasingly reproduces the commodity relations of global capitalism – exchange-value totally excludes use-value. As scientific knowledge is packaged as information and marketed as commodity, so cultural knowledge is either marginalised or becomes just another item in the list of profitable assets. The de-legitimisation of the master-narratives of art history – the artist: white, male; the artwork: autonomous, transcendental; art history: linear, evolutionary – opens up the discourse to the flow of difference, thus recognising the attempt to arrest meaning as a process within the social thought as a symbolic field traversed by antagonistic forces accessible to hegemonic articulation. There

has been a tendency for discourses in opposition to celebrate marginality – to colonise those spaces on the edge of the social from where it is thought possible to mount an offensive against the voice of authority. But even without the disposition of this model to reproduce the ideal of critical distance – the marginal as the historically ordained place of the 'other', the avant-garde – or the public/private distinction of, on the one hand the eradication and, on the other, the validation of difference, this strategy misrecognises the fundamental ambiguity of the social and the concomitant redefinition of political space.

In an article in *diacritics*, Alice Jardine discusses the crisis in the dominant narratives of Western thought as originating from the original dualism of Classical philosophy between 'techne' and 'physis' – time and space. Historically, the former has always connoted the male, the latter the female. She suggests that in recent French critical theory, feminist writers have recon-ceptualised the 'other' of those master-narratives, and that: 'This other than themselves is almost always a "space" of some kind, over which the narrative has lost control, *a space coded as feminine*'.[29] In the area of praxis, in Britain, the most significant and *outrageous* redefinitions of political space have come not from the post-modern visions of the architectural profession, nor from the cultural front of Left-intellectualism, but from the actions of women in colonising the perimeters of American nuclear bases – at Greenham Common and Molesworth – and of organisation, politicisation and resistance throughout the year-long miners' strike. No margins these – but sites within a 'war of position' that are transgressive, collective, active and critical.

If, then, we are looking for a post-modernism of resistance, it is perhaps to be found in the proliferation of political spaces located between the division of the public and the private, and with the fragmenting of the unified subject of bourgeois ideology allowing the emergence of a plurality of subjects and subject positions. For a white, male academic 'lost in a maze of delegitimised narratives', it has been the theory and practice of women and Black peoples demystifying the discursive formations of patriarchal culture and imperialism that offer the prospect of a way forward.

Jameson ends his article calling for 'an aesthetic of cognitive mapping'. I'm not sure about 'aesthetic' – perhaps more appropriate would be an *ethics*,[30] but if art history is to offer anything to such a project then we have to recognise that it is no longer possible to maintain the position of disin-terested scholarship: whatever we do we are implicated in a politics of inter-pretation, and for our critical discourse to have any broader social effectivity it must also engage with, and become part of, a politics of action.

NOTES

1 *Two Bourdieu Texts* (trans. Richard Nice), Centre for Contemporary Cultural Studies, University of Birmingham. Stencilled Occasional Paper (no. 46).

2 Jean Baudrillard, *For a Critique of the Political Economy of the Sign*, Telos Press, St Louis, 1981, p. 121.
3 Griselda Pollock and Deborah Cherry, 'The Pre-Raphaelites and Patriarchal Power', *Art History*, vol. 7, no. 4, 1984.
4 An editorial in *The Burlington Magazine* pointed to the contradictions in the catalogue's polemic in arguing for preservation 'in situ' of the country house and all its contents through 'removing objects from their context and sending them across the Atlantic', vol. CXXVII, no. 991, October 1985, p. 663.
5 John Casey, 'Tradition and Authority', in *Conservative Essays* (ed. Maurice Cowling), Cassell, London, 1978.
6 Christos M. Joachimides, 'A Gash of Fire Across the World' (p. 11) and Norman Rosenthal, 'A Will to Art in 20th Century Germany' (p. 16), both in *German Art in the 20th Century: Painting and Sculpture 1905–85* (eds C.M. Joachimides, N. Rosenthal and W. Schmied), Royal Academy, London, 1985.
7 This attitude was reaffirmed by a number of speakers at the 'Art at Work' Conference held at the Royal Institute of British Architects, Autumn 1985. For example, Gilbert de Botton of Global Asset management and a Tate Gallery trustee and sponsor of the recent Francis Bacon exhibition, had this to say: 'There should be no doubt about the self-extolling motives of sponsors. They are out to do good for themselves by doing good to others. To the extent that in an irreligious age such as ours, art still occupies its privileged position between the sacred and the profane, it is a widely registered act of approved philanthropy.'
8 Carol Duncan and Alan Wallach, 'The Universal Survey Museum', *Art History*, vol. 3, no. 4, December 1980.
9 Perry Anderson, 'Components of the National Culture', in *Student Power* (eds R. Blackburn and C. Cockburn), Penguin, London, 1969, and Tom Nairn, 'The English Literary Intelligentsia', in *Bananas* (ed. E. Tennant), Quartet, London, 1977.
10 It is interesting to note that one of the most important voices from the European Left intelligentsia – Jurgen Habermas, writing from within a somewhat different Marxist tradition, develops an alternative analysis, and one which has had a fundamental effect upon discourses of post-modernism. Thus, in *Legitimation Crisis* (Beacon Press, Boston, Mass., 1975), Habermas argues that the contradictions of late capitalism, and their related crisis tendencies, can be most clearly located not in the economic sphere, but in the reproduction of those 'structures of intersubjectivity' found in the socio-cultural spheres.
11 In a discussion of the discursive character of neo-conservatism, Ernesto Laclau and Chantal Mouffe emphasise the role of key concepts in constructing social subjects: 'The form in which liberty, equality, democracy and justice are defined at the level of political philosophy may have important consequences at a variety of other levels of discourse, and contribute decisively to shaping the common sense of the masses.' E. Laclau and C. Mouffe, *Hegemony and Socialist Strategy: Towards a Radical Democratic Politics* (trans. W. Moore and P. Cammack), Verso, London, 1985, p. 174.
12 J. Laplanche and J.-B. Pontalis, *The Language of Psychoanalysis*, Hogarth, London, 1973.
13 Barry Hindess and Paul Hirst have provided a convincing critique of Althusser's reliance upon economic determination 'in the last instance' as providing the organising principle of the social formation. See B. Hindess and P. Hirst, *Mode of Production and Social Formation*, Macmillan, London, 1977. Paul Hirst has also offered a critique of Althusser's theory of ideology specifically around the question of representation (as a representation of the 'imaginary relation') in P. Hirst, *On Law and Ideology*, Macmillan, London, 1979.

14 '[What] is in question is that which governs statements and the manner in which they govern one another in order to constitute a set of scientifically acceptable propositions which may, in consequence, be verified or falsified by scientific procedures'. Quoted in Meaghan Morris and Paul Patton (eds), *Michel Foucault: Power, Truth, Strategy*, Feral Publications, Sydney, 1978, p. 32.

15 See particularly the chapter 'Beyond the Positivity of the Social: Antagonism and Hegemony': 'Our analysis rejects the distinction between discursive and non-discursive practices. It affirms: (a) that every object is constituted as an object of discourse, insofar as no object is given outside every discursive condition of emergence; and (b) that every distinction between what are usually called the linguistic and behavioural aspects of a social practice, is either an incorrect distinction or ought to find its place as a differentiation within the social production of meaning, which is structured under the form of discursive totalities.' Laclau and Mouffe, op. cit., p. 107. In this context it is appropriate to emphasise that the visual also falls within the 'social production of meaning'.

16 'By "episteme" we mean ... the total set of relations that unite, at a given period, the discursive practices that give rise to epistemological figures, sciences, and possibly formalized systems. ... The episteme is not a form of knowledge ... or type of rationality which, crossing the boundaries of the most varied sciences, manifests the sovereign unity of a subject, a spirit, or a period; it is the totality of relations that can be discovered, for a given period, between the sciences when one analyses them at the level of discursive regularities.' From *The Archaeology of Knowledge*, quoted in Hubert L. Dreyfus and Paul Rabinow, *Michel Foucault: Beyond Structuralism and Hermeneutics*, University of Chicago Press, 1982, p. 18.

17 It is appropriate to emphasise that, prior to its operation in modern liberal-democratic states, 'legitimacy' referred to sovereign right – the law or rule of succession – a line of descent that takes its authority from the sovereign and extends downwards throughout the social body as the paternal fiction of patriarchal culture: the judicial embodiment of the Law of the Father.

18 Rudi Fuchs, Catalogue for *Documenta 7*, Kassel, Germany, 1982.

19 Hal Foster, in his introductory essay to *Postmodern Culture*, outlines the project for an 'oppositional postmodernism' as an engagement with, amongst other concerns, 'a critical deconstruction of tradition'. An ironic comment upon a British readership's possible sensitivity to such a project might be read into the altering of the title of the original American publication from *The Anti-Aesthetic*. Hal Foster (ed.), *Postmodern Culture*, Pluto, London, 1985.

20 Terry Eagleton, 'Capitalism and Postmodernism', *New Left Review*, no. 152, July/August 1985.

21 Fredric Jameson, 'The Cultural Logic of Capital', *New Left Review*, no. 146, July/August 1984.

22 A similar point has been made by Habermas, who has argued that the norms of bourgeois society that once provided the basis for a critique have shifted to such an extent that 'bourgeois ideals have gone into retirement'. Jurgen Habermas, *Toward a Rational Society*, Heinemann Educational, London, 1971.

23 For a critical account of the video art of Nam June Paik, see Martha Rosler, 'Video: Shedding the Utopian Moment', *BLOCK*, no. 11, Winter 1985/86.

24 Jon Bird, 'The Star Commodity', *Artscribe*, no. 54, September/October 1985.

25 Jean François Lyotard, *The Postmodern Condition: A Report on Knowledge* (trans. G. Bennington and B. Massumi), Manchester University Press, 1984.

26 Significantly, Edmund Burke, in his 'Essay on the Sublime and the Beautiful', makes the strongest possible connection between power and terror as the concomitant aspects of the sublime, writing that 'the sublime is an idea belonging

to self-preservation; that it is therefore one of the most affecting we have; that its strongest emotion is an emotion of distress, and that no pleasure from a positive cause belongs to it'. From *Essays by Edmund Burke*, Ward Lock, London, 1876, p. 98.

27 Paul Virilio and Sylvere Lotringer, *Pure War* (trans. Mark Polizotti), Semiotext(e) Inc., New York, 1983, p. 50.

28 Fredric Jameson, 'The Politics of Theory: Ideological Positions in the Postmodern Debate', *New German Critique*, no. 33, Fall 1984.

29 Alice Jardine, 'Gynesis', in *diacritics*, Summer 1982.

30 This is, of course, a philosophical minefield and will have to be expanded upon at another time. For the present, I would only indicate that any such 'mapping' would have to avoid the normalising tendency of a moral science derived from the history of metaphysics, but should also recognise that in the post-modern period, questions of ethics are *fictions*, but *fictions* that are not opposed to the *True*, but, rather, obliquely, reticently, disturbingly, indicative of the fictional status of truth.

6

PRESENT, THE SCENE OF . . . SELVES, THE OCCASION OF . . . RUSES

Fred Orton

(*From*: Issue 13, 1987/8)

Such things run through my work, relationships of parts and wholes. Maybe that's a concern of everybody's. Probably it is, but I'm not sure it is in the same way. It seems so stressed in my work that I imagine it has a psychological basis. It must have to do with something that is necessary for me. But of course it *is* a grand idea. It relates to so much of one's life. And spatially it's an interesting problem. In painting, the concern with space can be primary . . . the division of space and the charges that space can have . . . the shifting nature of anything . . . how it varies when it's taken to be a whole and when it's taken to be a part.

(Jasper Johns to Christian Geelhaar, 1978)

Jasper Johns' *Untitled*, 1972 is a painting of surfaces, four of them bolted together to make one (1.8 × 4.9m/72 × 192in). It begins with marks: a painted surface insisting on the fact of its flatness. Then, a series of abrupt transitions from panel to panel, facture to facture, image to image, to something quite unlike that which began it, a surface below but in front of it, objects: emphatic, palpable, and human.

The surface of the first panel, oil on canvas, is a network of hatched green, orange and violet lines on a mostly white ground. Parallel to each other and in bundles of three to nine, these lines mark the surface in changing directions. There is something mechanical in the precision of their placing. Maybe there is some underlying scheme governing colour and number, some mirroring and symmetry. Maybe there isn't. Maybe we are merely supposed to think that there is. It looks like changing-your-mind painting, but it isn't. Here and there some overpainting, white usually, redefines an interval or area, or just *is*. Whatever else this hatched pattern is doing, it is being used to make the surface. Each bundle attracts attention to its own identity as a pictorial technique for crossing the canvas from edge

87

Figure 6.1 Jasper Johns, *Untitled*, 1972 (oil, encaustic and collage on canvas with objects, 183 × 488cm/72 × 192in)

Source: Rheinisches Bildarchiv, Museen der Stadt, Cologne (Jasper Johns/DACS, London/ VAGA, New York 1996)

to edge, pressing out everything flat and even. Johns has said that he derived the motif from a car which once passed him by on the Long Island Expressway. 'I was riding in a car, going out to the Hamptons for the weekend, when a car came in the opposite direction. It was covered with these marks, but I only saw it for a moment – then it was gone – just a brief glimpse. But I immediately thought that I would use it for my next painting.'[1] This panel is that painting.

Next to the hatchings, 'flagstones'. By 1972 this pattern had been in Johns' repertoire of surfaces for 5 years. Johns' story about finding it occurs in several versions; this is Michael Crichton's:

Johns was taking a taxi to the airport, travelling through Harlem, when he passed a small store which had a wall painted to resemble flagstones. He decided it would appear in his next painting. Some weeks later when he began the painting, he asked David Whitney to find the flagstone wall, and photograph it. Whitney returned to say he could not find the wall anywhere. Johns himself then looked for the wall, driving back and forth across Harlem, searching for what he had briefly seen. He never found it, and finally had to conclude that it had been painted over or demolished. Thus he was obliged to re-create the flagstone wall from memory. This distressed him. 'What I had hoped to do was an exact copy of the wall. It was red, black and gray, but I'm sure that it didn't look like what I did. But I did my best. . . . If I could have traced it I would have felt secure that I had it right. Because what's interesting to me is the fact that it isn't designed, but taken. It's not mine.'[2]

The 'flagstones' were first used in *Harlem Light* of 1967. But on the surface of *Untitled*, 1972 they most resemble the variation devised for *Wall Piece* of

1968. Some of the 'flagstones' have been cut to shape out of silk and 'painted' on to the surface – creamy white paint accumulates in ridges at their edges. Some 'flagstones' are relatively flatly painted, others more thickly – brush-strokes track the pointing between them.

Next to the 'flagstones', more 'flagstones', this time in encaustic. What little transition there is from one to the other is in the manner of a mismatch of two halves which do not quite fit together to make a whole. Crichton pointed out that 'if, in your mind, you move the right-hand flagstone panel midway over the left-hand panel, you get a congruity – a matching – that actually implies a secret square in the middle of it all'.[3] As with its neigh-bour, some of the 'flagstones' have been cut out of silk to give them a slight relief effect; again, travelling brushstrokes track the pointing between them. Two lavender-pink brushstrokes, one on top of the other, mark the surface and dribble down it.

Lastly, another encaustic surface, and the wax casts: a female face in profile (no eyes); a foot on a black sock, a hand next to it, both on floor-boards; a buttock; a knee, a female torso, breast and navel; the back of a leg, calf and heel; and feet in green sling-back shoes, ankles crossed. Casts of body parts have appeared in Johns' work since the mid-1950s, in plaster and individually boxed in *Untitled* of 1954 and *Target with Plaster Casts* and *Target with Four Faces* of 1955; in wax and attached to the canvas by way of a fragment of a chair for *Watchman* and *According to What* (1964), and bolted into place on *Eddingsville* (1969) and *Passage II* (1966). Evidently, Johns had first tried cutting holes in the canvas and pasting the casts into them, but they fell forward, and made the panel awkward to transport and store.[4] So he decided on wooden battens attached to the stretcher with blocks, bolts and wingnuts; and for fixing the casts to the battens, wire netting, bandages and dollops of wax. The battens were then numbered, stencilled 'l' and 'r', and colour coded – red, yellow, blue, grey, violet, orange, green – to guide assembly and disassembly. Of course, you do not have to give instructions in this way. It is Johns' way. His instructions become part of the way he makes the surface. The changes made as Johns worked on this panel have been recorded.

(1) blank canvas ripped in two places revealing stretcher bar and wall behind canvas (March 10, 1972); (2) some casts made (May 13, 1972); (3) Johns replaced the torn canvas with another blank, brown canvas and silkscreened two white targets on it, one whole and one cut off at the lower edge (June 7, 1972); (4) boards with anatomical fragments attached to canvas over targets, bits of colored paper marking each board (June 8, 1972); (5) targets covered over with layer of encaustic in bright colours . . . ; (6) canvas now painted in gray encaustic; numbers and letters stencilled on boards (July 2, 1972); (7) canvas painted beige (August 1972).[5]

Two objects have imprinted this surface, the rim of a can and the sole of an iron – part of which also marks the encaustic flagstone surface and makes a transition from one to the other in such a way that they are seen together at this point. Both imprints have a history of use in Johns' work. The can imprint goes back to *Field Painting* (1963–4), and the iron imprint goes back to *Passage* (1962). Something rectangular has been collaged to the surface above the place where the red batten is screwed to the stretcher at the left side. That will do as a description.

Untitled, 1972 met its first audiences at the Whitney Annual in the spring of 1973. One cannot generalise what they made of it. According to Richard Field, Thomas B. Hess was the only person prepared to engage with it publicly at the time, in print. Initially he did little more than I have just done. He described its surfaces, their media and imagery; he noted its reflex-iveness to Johns' studio practices and drew on explanations provided by him. But he also pointed out how Johns 'seemed concerned with preserving memories and re-evoking lost experience' by painting these 'glimpses of Harlem and of Long Island that have haunted him, bits and pieces of four or five friends'.[6] I must say I find the idea that Johns paints about his studio practices a relatively uninteresting one, and also a relatively uninteresting practice *per se*. Modern artists cannot exclude art history from their project, and must choose consciously to carry their own art history with them, continu-ally making reflexive paintings: paintings of their studios. Johns' oeuvre is full of studios, but what is more interesting about his practice as a studio painter is that it periodically becomes necessary for him to make a studio painting as an index of his practice in order to sort it out, to find out what he is doing and why and whether he should go on doing it. This I take it was the point of *Field Painting* (1963–4), which is probably the first painting to do this by design, and *Untitled*, 1972. Moreover, these paintings are not just practical or technical critical histories. I would want to argue that they are also moral histories in that they refer to Johns' character and conduct, to the character and conduct of others, to actions, events, and feelings.[7] I would like to think that Hess had something of this in mind when he referred to the surface of *Untitled*, 1972 as a 'metaphorical scaffolding' into which Johns had 'slotted autobiographical elements'.[8] However, I think he got the trope wrong. Generally explainers of modern art write meanings for paint-ings and bits and pieces of paintings as metaphors without giving much thought to what or how metaphors mean. Most of the time all that is meant when it is asserted that something is a metaphor or a visual metaphor or is to be read metaphorically is that it has in addition to its literal sense or meaning another sense or meaning. Metaphors offer the line of least resis-tance to explainers who are thoughtless about the subtleties of figuration. It seems to me that Johns' trope is very much not metaphor, and I would prefer to see *Untitled*, 1972 in terms of metonymy, its surface as metonymic, and its elements as metonyms and synecdoches.

Metonymy seems to have had its day. Metaphor is the fashionable trope among those who study rhetorical and figurative aspects of language. Metonymy, however, needs to be recovered if *Untitled*, 1972 is to be questioned about its order, the arrangement of its hatchings, flagstones, and body fragments, and how that order and those surfaces might articulate and enable the production of meanings. Metaphor and metonymy put twists in the tail of meaning. Depending on the author's purpose or upon his or her typical if unpurposed and unconscious mode of figuration, metaphor or metonymy can bring a new meaning into view or obscure it.

According to Roman Jakobson, who discussed metaphor and metonymy in a purely linguistic analysis of aphasia, language functions because of the association between the participants in the speech event.[9] The separation between the addresser and the addressee is bridged by an internal relation which is one of equivalence between the symbols used by the addresser and those known to the addressee. Without this equivalence, the message will be more or less meaningless. In order for the meaning of an utterance to be understood there must be a common code permitting encoding and decoding by the addresser and the addressee. In terms of the 'language of art', we might say that the artist and the gallery goer have the same set of prefabricated representations with the same – or almost the same – relations holding between those relations, a syntax and grammar which structures the relation and production of meaning. The artist selects one or more of these preconceived possibilities, uses them in his or her work, and the spectator of the work is expected to make an identical or nearly identical choice from the same range of possibilities already foreseen and provided for. This is, in a sense, the common code of the artist and spectator. However, it is not enough to know the code in order to understand the message. One needs to know the context which provides the necessary area of associative reference upon which intelligibility depends, and which comprises two relations. The components of any message will be linked either with the code by an internal relation of equivalence, or with context by an external relation of association. The two tropes, metaphor and metonymy, present, for Jakobson, the most condensed expression of these two basic modes of relation. Underlying metaphor is the internal relation of similarity and difference, and determining metonymy is the external relation of contiguity and remoteness.

Metaphor is based on a proposed similarity or analogy between the literal object and an object substituted for it. It invites the perception of a similarity between two otherwise quite distinct fields of meaning such that the sense of distance between them is preserved in the act of imaginatively leaping across it. If it is successful, a metaphor makes us attend to some likeness, often novel or surprising, between two or more things. The idea is that in metaphor certain words take on new or what are often referred to as 'extended' meanings; this is to say that the class of entities to which a word

in a metaphor refers is extended. A metaphor is usually easily understood because the metaphoric associations, the links between the literal object and its metaphoric substitute, are alive in culture. This is the conventional and familiar wisdom which has been much discussed and debated recently.[10]

Metonymy is based on a proposed contiguous or sequential link between the literal object and its replacement by association or reference. It is the record of a lacuna, of a move or displacement from cause to effect, container to contained, thing seen to where it was seen. The metonymic processes are reduction, expansion and association and these represent historical relations of experience in particular exempla. Closely related to and taken as a kind of species of metonymy is synecdoche, where the part is referred to by the whole, or the whole is referred to by the part, or something omitted is referred to by what is included.[11] With metonymy the move is escape. It represents not the object or thing or event or feeling which is its reference but that which is tied to it by contingent or associative transfers of meaning, and in this way it permits the utterer the power to bypass obstacles of social censure including those which are consciously or unconsciously self-imposed.[12] Metonymy accords a kind of privacy to language. 'A kind of privacy' because there can be no such thing as a wholly private language, possessing totally individualised and isolated meanings. Even the most private metonymy is public insofar as it is a language, a communication, has a history. It can therefore be pursued along its associative chain to the moment of its constitutive production, which will, in principle at least, reveal its meaning and reference.

Untitled, 1972 is structured metonymically. It is a series of fragments, bits of surfaces, parts of the human body, traces of objects. Each pattern, object, imprint is tied by the association of ideas and values to something else, reflexively to Johns' own work, to events and objects in New York, and, as we will see, to the work of other artists and other ideas and associations, and so on.

Any individual use of language, verbal or iconic, will contain both metaphors and metonyms, but it will also evidence a preference for one or the other. Evidently the aphasics studied by Jakobson were, like Johns, disposed towards metonymy. But they were brain damaged and Johns is not. Amongst those who use language knowingly producing culture, the disposition towards metaphor or metonymy as the preferred trope will have to be seen as determined, consciously or unconsciously, by the pre-given availability of certain cultural resources, by social relations which include such resources and their users, and by the constraints and contradictions present in any particular historical situation.

I would argue that Johns has, since the mid-1950s, largely denied himself the metaphoric mode, refused the idea of representing or painting signs or gestures which are to be interpreted as metaphorically expressive. This is not to say that he has denied himself the 'use' of the 'look' of metaphorically

expressive painting or that he has not invoked ideas of, for example, cancellation or erasure metaphorically in ways which might be quite important for his meanings. He has not. However, whatever it was – and maybe still is – that Johns wanted to represent or express, it seems that he could find no metaphors for it in the tropes of then public art. Either that, or he did not want to represent or express it metaphorically.

Johns' disposition towards metonymy has to be seen as *of* Johns, who attempts, consciously or unconsciously, to escape censure by making paintings which resist, evade or control the interpretations and meanings which can be produced for them. Johns' paintings have subject matter, but it is elusive. With the mechanism of metonymy in mind, one can understand how and why it is that the surfaces which are his paintings are often, like *Untitled*, 1972, felt, by those whose job it is to explain them, to hide or conceal expressive content or subject matter. Over the years Johns has developed many mechanisms of surface – ways of waxing, oiling, watering, metalling, collaging, dotting, dribbling, dripping, scraping, scratching, scumbling, sweeping, attaching, hanging, hinging, interposing, stencilling, screening, imprinting, camouflaging, veiling, permuting, reversing, rhyming – which give the spectator some more or less interesting busy-ness to look at wherever the focus. These attract the attention, and distract the enquiring mind. They seem to hide the subject, give the explainer something to find, and keep explanation cutaneous. Johns' surfaces play hide and seek, impose and simultaneously resist interpretation in terms of subject.

Such a formulation may be reconstructed in terms of what conventional artistic wisdom has taken to be the feasible area of ambition in recent painting – say painting of the last 120 years or so; i.e. in terms of the supposedly antinomic, though actually contrasted, nature of two interests: the practical and/or conceptual concern with subject, and the practical and/or conceptual concern with surface. Crudely, the putative evolution of Modernist painting has been characterised as the gradual victory of the latter over the former. For a painter in whose practice this contrast seems to be raised as a real issue – is experienced as if it were an antinomy – it may seem as if all decisions that have to be taken in making a given painting can at some point or other be indexed to one or other of these two concerns: vivid surface or vivid subject. The problem may then seem to be how to decide between the requirements of subject and surface as priorities in actual practice.

Clearly these two concerns have not always been seen as antinomic, and it is possible to question whether they are now. But most artists continue to work with the antinomic structure as an unquestioned determinant. And because the dynamic, historical tendency of Modernism in its own self-image is to set decorativeness, holistic expressive surfaceness, and facticity against and over semantic detail – so that decorativeness is supposed to come out on top – ambitious Modernist painting has tended towards decorativeness.

Johns offers no exception. But what is interesting about his strategy as a Modernist painter is that while he seems, by the efficacy and elegance of his various mechanisms of surface, to assert the decorative potential of surface and to establish that surface in terms of reflexive relations which go back either to his own art or the art of others, he has been able to admit and develop within his practice the representation or expression of vivid subject matter which has been generally overlooked or if noticed misunderstood or played down in description. The decorum of Modernist criticism and history functions to restrict discussion to, or permits explanation to be restricted to, such matters as how the surface is made out of what it is technically made out of, how the hatching works, how the 'flagstones' make a hidden square, how the physical construction and arrangements iterate other works in Johns' oeuvre, etc. Constrained by the Modernist paradigm it is almost impossible to pursue into real criticism or history the possibility glimpsed by Hess *et al.* that there might be more to *Untitled*, 1972 than surface.

I have already suggested that the surface of *Untitled*, 1972 might be made of metonymic relationships. So in discussing what it might mean I must be discussing some transfer of properties not originally or naturally possessed by what is depicted. In other words, I must be considering not what is depicted but how, and by reference to what, that depicting is done. I must be considering the mechanism of meaning, the metonymic chain of contiguity. And this will entail causal as well as hermeneutic enquiry, not simply into the conditions of production and consumption, but into the complex genetic history of imagery (which in Johns' case is a category which includes style as a property open to quotation and translation) which itself will be a history of transformations. This is to say that such an inquiry will not merely be a matter of connecting some image (the hatchings, 'flagstones', figure fragments, brushstrokes or imprints) back to that which it iconically (descriptively) corresponds to in the world (a paint job on a car, a wall in Harlem, a previous painting by Johns, a painting by another artist), in order to see how it has been reworked according to the interests of artistic style. I will have to recognise that within some complex and heterogeneous constellation of conditions, the genetic history of a surface, or a bit of a surface, a figure fragment, a brushstroke or an imprint goes back into a world of events and feelings. And I will also have to acknowledge that no one such history will close off inquiry into any other. That I might also trace a brushstroke back to other brushstrokes in other paintings or an imprint back to an object made by another artist in no way disqualifies the claim that it is somehow expressive of or referring to some specific event or feeling. Rather the reverse, given that metonymy entails just this kind of displacement or transfer.

What I have attempted to do so far is justify the possibility glimpsed by Hess that Johns' *Untitled*, 1972 is not simply an empirical or phenomenal

experience of a vivid surface and its formal organisation. A field of context must exist sufficient for the possibility of meaning to be glimpsed. We can reconstruct the metonymic chain, and also attempt to explain why what-ever it is that *Untitled*, 1972 refers to needed to be referred to metonymically.

Not everything that makes a 'Johns' surface what it is need be seen as metonym or synecdoche. Metaphor is also present. Also the existence of a brushstroke here or an imprint there might well be contingent on making the surface, on the need to assert surfaceness tastefully with some colour or other, or with a certain shape or line. But it seems safe to assume that the lavender-pink brushstrokes and the imprint made with an iron or a particular can in *Untitled*, 1972 which have recurred over two decades in Johns' work have not recurred merely as useful formal devices.

My speculation, here, is that these repeated formal devices including the hatchings, 'flagstones' and figure fragments of *Untitled*, 1972 are discrete metonyms or synecdoches in a private language, at least as 'private language' is colloquially understood as an exclusive, socially closed linguistic mode rather than an inclusive, socially open one. They contribute to the compo-sition of more or less socially open surfaces, but at another level they signify concepts privy only to Johns and a few close friends who know the contextual field and are in a relation of association to adopt the appropriate cognitive style.

There is, then, in Johns' work a conventional tension between private and public, between meaning available only to those who have access to the socially closed code and the larger community which understands and admires Johns' vivid surfaces. What happens to the socially closed meaning when the painting moves from 'private' to 'public', when it is exhibited, sold, reshown, reproduced and discussed in the literature of art? What happens to the private meaning when a painting enters into the public exchange of money and meanings? It enters a community unable to describe or explain it adequately because that community's mode of enquiry and explanation – Modernism – is also socially closed. Modernist criticism and history, which is relatively socially open in its linguistic mode, is never-theless comprised of all kinds of interpretive closures like those which work to restrict enquiry and explanation to surface rather than subject, compo-sition rather than signification, 'style' and 'influence' rather than conditions of production and consumption.[13]

So my enquiry starts out from and operates within these two closed spaces of private and public meaning, and in effect I have to admit that these two spaces cannot be plausibly fitted together to produce an adequate or coherent account of *Untitled*, 1972. However, I can undertake an enquiry which goes towards opening up the private code by trying to reconstruct the contextual field; to enquire into the significance of hatchings, 'flagstones', fragments, imprints, etc., to establish contiguities which match contexts of use to what can be learned of the world in which they are used. I might

then be able to re-pose private and public in a different register. My account will probably be in a kind of oscillation between individual and culture, private and public, but if so, these categories will be in a more viable form because interposed between them will be the relevant, necessary but not sufficient, coherence of an interpretation located in mechanisms of reference and association, in the trope of metonymy mediating private and public. To justify the relevance of this project I have to go back to two earlier moments of Johns' work – back to 1954–5 and 1961–2. It has become commonplace to say something along the lines that Johns emerged as an artist in 1954–5 with *Flag*, or that his mature work begins with it. He didn't, and his art doesn't; but *Flag* will do as a first painting so long as we bear in mind that this idea, produced by and for Johns and then taken up in criticism and history, of a finished artist sprung from nowhere is dubious, to say the least. *Flag*, a flag and, tediously, a visual metaphor, has subject matter. The stars refer to the number of states in the Union, the stripes to the original colonies, and so on. With obvious calculation Johns reintroduced the cultural element which the typical Abstract Expressionists had excluded from painting and almost produced an 'American-type' painting *par excellence*: holistic, two-dimensional, with no hierarchy of forms or focus.

The painting which Johns made directly after *Flag* was *Target with Plaster Casts*. The main area, concentric bands of blue and yellow set into a square field of red, making a kind of neutral target devoid of values and associated with no aim, is, like its predecessor, made of encaustic collage; but above it, attached to it, is a row of boxes which contain – all but two of them – plaster casts of fragments of the human figure. Each cast is painted with the same colour as its box: a purple foot, white nose and lips, a red hand with the little finger missing, pink breast, orange ear, green penis, and yellow heel. A greenish-black object which suggests the female genitals is, in fact, a bone. One box, the blue one, is empty. Seven or eight synecdoches and a gestalt.

Flag and *Target with Plaster Casts* are usually discussed in terms of their 'similarities' as surfaces – the figure fragments being regarded as taking a secondary role in the arrangement – and 'ready-made' images, 'things the mind already knows', 'flat objects and signs'. I see the two paintings as more significantly distinct. In what Johns wants to be taken as, and what Modernism takes them to be, his first two mature works – one could say his 'master-pieces' – he posited alternative directions to follow. Established critical practice circumvents the connotations of violence. To put it crudely, the *Target with Plaster Casts* has a kind of subject matter which inescapably evokes the artist himself; it is also, with its *corps morcelé*, a very loaded image interpellating the psychologist in most Modernist critics and historians. This, I take it, is part of the painting's job: to provoke psychologising and to deny it. Leo Steinberg wrote about this painting in an article first published in 1962.

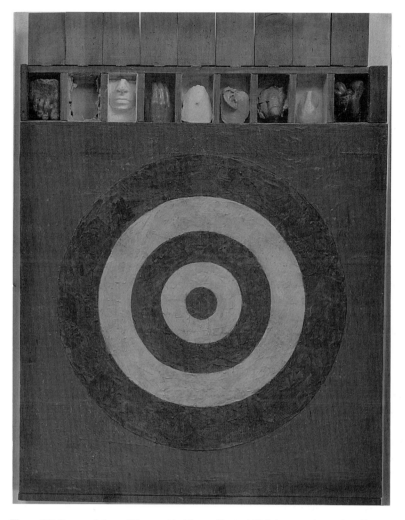

Figure 6.2 Jasper Johns, *Target with Plaster Casts*, 1955 (encaustic and collage on canvas with objects, 129 × 112cm/51 × 44in)

Source: Leo Castelli Gallery, New York (Jasper Johns/DACS, London/VAGA, New York 1996)

Apparently the artist wanted to know (or so he says) whether he could use life-cast fragments of body and remain as indifferent to reading their message as he was to the lineage in the newspaper fragments pasted on the canvas below. Could our habit of sentimentalizing the human, even when obviously duplicated in painted plaster – could this pathetic instinct in us be deadened at sight so as to free alternative

attitudes? He was tracking a dangerous possibility to its limits, and I think he miscalculated. Not that he failed to make a picture that works; but the attitude of detachment required to make it work on his stated terms is too special, too rare, and too pitilessly matter-of-fact to acquit the work of morbidity. When affective human elements are conspicuously used, and yet not used as subjects, their subjugation becomes a subject that's got out of control. At any rate, no similar fracturing of known wholes has occurred since in Johns' work.[14]

That last sentence was perhaps still defensible when it was written in December 1961, but, as Steinberg acknowledged later, only just. What is of interest here is both the disposition such an enterprise as *Target with Plaster Casts* represented, and the reasons for its apparent rejection in the character of Johns' work over the rest of the decade.

The artistic culture of the mid-1950s in New York has by now been well enough characterised in terms of its distinctiveness from, even reaction against, the culture of the Abstract Expressionist generation.[15] The difference may not have been that great, but it seems to have been there and represented, for example, in the general apolitical – though not depoliticized – demeanour of social and artistic practices and changes of image and sexuality. If the art historians and gossips have got it right the self-professed male avant-gardist of the 1950s was likely to be cerebral, philosophical, iconoclastic, and physically and intellectually very different from the Abstract Expressionist. He had a dandy-like elegance of body and manner, delighted in cool and elegant plays of the mind, and was probably homosexual, bisexual, or experimenting with his sexuality. That description, for the most part taken from Moira Roth,[16] can be and is applied to Johns, and to John Cage, Merce Cunningham, and Robert Rauschenberg as members of one socially closed group among several others in the comparatively socially open sub-culture which was the New York artistic culture in the 1950s.

It is not my intention here to attempt a sociological account of the New York culture of Johns' generation. It is important, however, to establish some plausible characteristics and tendencies of that culture which will at least serve to relate it to its comparatives. I would expect a tendency to the private (socially limited or closed) exchange of meanings and a matching cultivation of public euphemism (which entails metonymy) and irony; a withdrawal from prevailing forms of self-identification in social behaviour (including those which structure sexual relationships); a stance of public indifference towards those issues which invite the parading of commitment and belief; and a protective solidarity between intimates. We need not forget the historical conditions in which this apparent withdrawal was made: the burgeoning of an artistic culture which was geographically and stylistically more diffuse and diverse than any previous artistic culture in New York, accompanied by an enormous increase in public awareness of it; and beyond and affecting

it, as it had been affecting all sections of American society since 1946, the general institution of a pervasive climate of repression: the burning and banning of books in US libraries around the world; the jailing of CP members for 'conspiring to teach'; the legal establishment of 'detention' camps for 'subversives' in times of 'national security'; the censorship of art works in the US; the denial of US travel visas to left-wing artists and intellectuals; the congressional intimidation of film-makers as well as writers; the framing and execution of Ethel and Julius Rosenberg[17] Here it is important to avoid that form of idealisation of the artist which identifies a constant type against a changing background. Different historical and cultural conditions offer and impose the identification 'artist' on very different kinds of persons. The 'artist' as well as 'art' is a socially produced category. In the 1950s in New York the idea of 'art' – the kind of object a painting was, or a piece of music was, or a dance was, or a poem was, or a play was – and how it should be made, and the idea of what kind of identity 'artist' was, and what his or her responsibilities might be, were subjects of debate, serious ambition, recategorisation, difficulties and obligations.

One difficulty which seems to have been more of an issue for Cage and Cunningham, Rauschenberg and Johns than for others was how in the pursuit of an expressive but not expressionistic character for their art they could arbitrate between the conditions of individual (private) life and the social (public) conditions of art. Hence their concern with and conversation about self-expression and expression, intention and non-intention, subject and object, determinancy and indeterminancy,[18] life and the gap between it and art,[19] seeing 'it' and painting 'it' and painting 'it' and seeing 'it'.[20]

In effect Johns opted for *Flag* and the direction it suggested and withdrew for the rest of the 1950s from the dangers – real or imagined – of self-exposure which could be identified in the *Target with Plaster Casts*. *Flag* seems to have been understood as nothing more or less than a well known visual metaphor, not *of* Johns at all, except in so much as he fabricated it in art. Wherever it came from, the residue of the day or the lower depths of child-hood, the flag was dreamt at the right time and place to function as an appropriate image in art. It resolved or circumvented the antinomies of Modernism by posing the question 'Is it a flag, or is it a painting?'[21] and in so doing managed almost completely to distract attention from considering whether it should or could be read as an endorsement or criticism of a certain kind of patriotic sensibility.[22] Is it all vivid subject, or, in art, all vivid surface? *Flag* sign-posted a direction to follow which seemed almost Wittgensteinian, philo-sophically and personally neutral. He pursued the idea for about 6 years, 'illustrating' critical murmurs, painting more flags and targets (without plaster casts), numbers and letters, colours and the names of colours.

In 1961 Johns' subject matter and mode of representation changed. After the frequent high colouration of the previous years, the works from this

99

FRED ORTON

moment are subdued in colour; they are predominantly grey, and titled to connote emotional conditions like dishonesty, anger; denial, negation or rejection; feelings lost or recalled. I shall consider two of these paintings, *No* and *In Memory of My Feelings – Frank O'Hara*.

In *No* the letters, cut from soft metal, are suspended from a straightened wire coathanger attached to the surface by a screw. It has been pushed into the sculp-metal and encaustic surface and also shadows that surface. In the top left corner the base of one of a bronze edition of Marcel Duchamp's *Female Fig Leaf* has been placed on to the surface and drawn around.

There is a story to the effect that Johns was amused with the idea that 'no' in Japanese translates the preposition 'of', and that in *No* the suspended NO, its imprint and shadows are of the canvas and each other. With this information we could approach the painting by attending to its surface and the relations between levels of representation. *No* has been taken 'to write a new role for the picture plane: not a window, nor an uprighted tray, nor yet an object with active projections in actual space; but a surface observed during impregnation, as it receives a message from real space'. 'In many ways the word NO seems to caution the observer from jumping to conclusions about the nature of what he is seeing.' '"No" is a pun on "know", referring to the importance of the conceptual aspect of Johns' work.' For Cage, 'Someone must have said YES (NO), but since we are not now informed we answer the painting affirmatively.'[23] One might even carry on: 'no' is 'on' spelt backwards, etc. The point is not that such speculation is necessarily informative. It is rather more important to observe that the almost irresistible invitation to engage in it is distracting, and that such distraction – induced by the mechanisms of surface – may at one level be what Johns intended.

However, if we focus on mechanisms of surface as subject and ask what it means to quote Duchamp's *Female Fig Leaf*, because that is effectively what Johns is doing, and to do so in a relation of association to the negative 'no', we are obliged to consider a work concerned not so much with the production of a vivid diverting surface as with the signification of a vivid perplexing subject. The imprint does not only mark the surface. There is an existential bond between it and its object (a cast which seems to have been taken from the female genitals), and between its object and that from which it was taken (a female body or a representation of a female body). The imprint is made a sign which might function metonymically with reference to what the cast reproduces, and even to how in its making it closed the female, negated an area of sexual desire. This is one, and only one, chain of contiguity which may be produced for the delineated imprint in *No*. It might also refer to – and probably does – the time and place, circumstances and events associated with Johns' acquisition of his *Female Fig Leaf*. In this sense it's a souvenir of a trip to Paris in 1961, of events and feelings, of what caused the visit, and what its effects were – among which we may include the

100

imprinting of *No.*[24] I know the sign is arbitrary, but I also know that there is a cultural route from the non-arbitrary trace to the culturally produced sign.

The other painting I want to consider is *In Memory of My Feelings – Frank O'Hara.* The title, which is stencilled along the bottom of the painting, refers to a poem by Frank O'Hara written in 1956, published in 1958, and anthologised in 1960.[25] O'Hara was a figure of frenetic centrality in the artistic culture of New York in the 1950s and 1960s.[26] The literature of that culture constructs with fondness and affection a poet (primarily) and playwright, a chronicler of art and collaborator with artists. Though his friendship with Larry Rivers was and probably still is most public, recorded as it was in the published reminiscences of both as well as in the poetry of the one and the painting of the other, his closest friendships were with Joe Le Seur, with whom he lived between 1955 and 1965, and Vincent Warren, the object of the love poems written between 1959 and 1961. O'Hara also loved and was loved by two women, one of whom, the painter Grace Hartigan, is the dedicatee of the poem *In Memory of My Feelings.* O'Hara and Johns were friends from the late 1950s until the poet's death in 1966. In 1959 O'Hara was writing to Johns about Jack Kerouac's *Doctor Sax,*[27] recommending that he read the work of Gary Snyder, Philip Whalen and Mike McLure, and

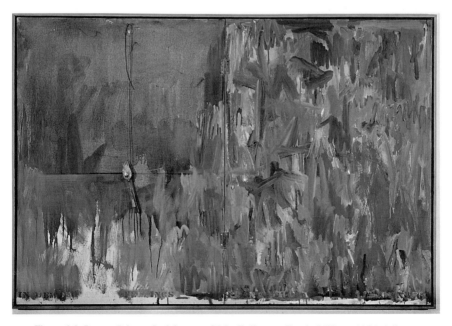

Figure 6.3 Jasper Johns, *In Memory of My Feelings – Frank O'Hara,* 1961 (oil on canvas with objects, 102 × 152cm/40 × 60in)

Source: Collection of Mr Stefan T. Edlis (Jasper Johns/DACS, London/VAGA, New York 1996)

101

comparing Robert Duncan and Charles Olson as West Coast and East Coast poets.[28] Johns turns up in O'Hara's poetry: both of them with Vincent Warren entraining to a weekend party at Janice and Kenneth Koch's (where O'Hara will fall in love with Warren);[29] O'Hara 'zooming downtown' to Johns,[30] or Johns in South Carolina, recalled by O'Hara in New York.[31] Between 1961 and 1965 Johns made, or planned, several works which can be seen as associated with or referring to his friendship with O'Hara, including one lithograph with poem which was something of a collaboration.[32]

In Memory of My Feelings – Frank O'Hara, which was painted some 5 years before the poet's death, cannot be interpreted as an In Memoriam for O'Hara. But using the title of the poem and acknowledging its author, quoting them like Duchamp's *Female Fig Leaf* was quoted on *No*, may well have enabled Johns to make another painting which represented or expressed his own feelings, something he had not been able to do, apparently, since *Target with Plaster Casts*. Reading *In Memory of My Feelings – Frank O'Hara* as a surface of metonymic relationships can produce a painting which represents or expresses Johns' feelings by way of reference to the poem and its author.

A synthesis of two lit. crit. readings of O'Hara's *In Memory of My Feelings* gives a poem which is an inventory of feelings.[33] It is not a poem recalling events, nor is it about what has happened; what is being remembered by the poet is how he felt, or how he feels about what he felt when something happened. The central theme is the fragmentation and reintegration of the inner self. New feelings generate new selves. And from the poet's many selves a vision of an essential self emerges which is determined to escape fixed limits. Images of death recur throughout the poem which concludes with what the poet regards as a necessary death in order that the poet's true self can survive.

> And yet
> I have forgotten my loves, and chiefly that one, the cancerous
> statue which my body could no longer contain,
> against my will
> against my love
> become art,
> I could not change it into history
> and so remember it,
> and I have lost what is always and everywhere
> present, the scene of my selves, the occasion of these ruses
> which I myself and singly must now kill
> and save the serpent in their midst

Johns' *In Memory of My Feelings – Frank O'Hara* does not illustrate O'Hara's poem: none of its imagery is represented in the painting; it refers to it, and by referring to it alludes contiguously to its main themes of feelings

remembered and metaphorical deaths of selves or the self. I take it that the 'feelings' are on the surface and that death is more or less under it. A 'DEAD MAN' is stencilled in the lower right. Though relatively large the words are difficult to see because they have been almost obliterated by busy grey brush-strokes – brushstrokes which by the 1960s had come to represent, and would continue to represent, the constant, repeated 'Johns'.

With this DEAD MAN Johns returns, albeit referentially, to figuration after years of painting flags and targets, numbers and letters, colours and the names of colours. Cage concluded his essay on Johns, 'Jasper Johns: Stories and Ideas', with a quotation, a note from one of Johns' sketchbooks: '*A Dead Man. Take a scull. Cover it with paint. Rub it against canvas. Skull against canvas.*'[34] This note relates the DEAD MAN in *In Memory of My Feelings – Frank O'Hara* to *Arrive/Depart* of 1963–4 (with its skull print, can print, *Female Fig Leaf* print, hand print, scallop shell print, brush print, etc.), and *Evian* of 1964, to the screenprint *Untitled (Skull)* of 1973 (with its signature cancelled, negated or put under *sous rature* by the crossed lines which now and then occur in his work), to the *Tantric Details* of the early 1980s, all by way of some drawings Johns made in 1962 by covering bits of himself with oil and pressing against sheets of drafting paper which were then dusted and rubbed lightly with powdered graphite. One of these, *Study for Skin I*, eventually provided the prototype ground for the poem chosen by Johns from amongst those offered by O'Hara as possibly suitable for illustration. *The Clouds Go Soft*, the poem in the lithograph *Skin with O'Hara Poem* (1963–5), can be read as a meditation on the inexorability of fate, its 'holes' to be understood metaphorically not as 'armholes' but as 'graves'.[35]

But why the fork and spoon, bound together, used, suspended on the wire screwed to the top of *In Memory of My Feelings – Frank O'Hara*? Are they connected by some family resemblance to the other household objects – the beer can, the coffee can, the coathanger, torch and light bulb, etc. – which find themselves in Johns' studio and thence in his art? Or do they signify in some more distinctive sense? I should make it clear that to ask such questions is not to invite a reply which organises Johns' practice into a rational iconography. The point is rather that coherence might be found in the underlying mechanisms of reference, association and displacement.

In 1967 Johns illustrated O'Hara's *In Memory of My Feelings* for a posthumous edition of a selection of his poetry published by the Museum of Modern Art.[36] The principal illustration is of a place setting – a knife, fork and spoon. At the end of the poem there is a single spoon. One of O'Hara's poems, a poem associated by him with *In Memory of My Feelings*, was titled *Dig my Grave with a Silver Spoon*.[37] It seems likely that there is some private set of associative meanings or references at work in *In Memory of My Feelings – Frank O'Hara* between Johns and O'Hara, Johns and O'Hara's poem, the poem and feelings felt when something happened, the poem and metaphoric death, death (metaphoric or real) and a spoon, fork and knife; a set of moves

103

in a language which signify to those who know the language and know how to read it.[38] To say that the spoon signifies death (of some sort) is not to say that it signifies death (of some sort) wherever it appears. The meaning of the cutlery, which is a leitmotif in Johns' work after 1961, depends on the context of use in each specific work. However, the genesis of a metonymic exemplum goes to some kind of consistency, just as the genesis of a word may be what serves to determine appropriate contexts of use.

We can now begin to reconstruct the contiguities and relations of human experience which Johns may associate with the cutlery and imprints in these paintings of 1961, and if we can do so in terms of subject rather than surface, then perhaps we can envisage doing the same for the cast fragments, imprints, brushstrokes and surfaces of *Untitled*, 1972.

I have suggested that Johns' work underwent some distinct and discernible change in 1961, and that that change entailed a shift of emphasis from the kind of work in which his initial, and considerable, success was based – the flags, targets, numbers, letters and so forth of 1954–60 – to a form of emotionally expressive painting adumbrated in and with *Target with Plaster Casts* but apparently rejected immediately thereafter. In speculating on the causal conditions of this shift – and speculation is all it can be – I resort to the reproduction of biographical gossip. The years of 1954–61 were the years in which Johns and Rauschenberg were together. The following excerpt is taken from Calvin Tomkin's biography of Rauschenberg, *Off the Wall*, published in 1980.

> Sometime in 1961, Johns began spending a large part of his time in a house he had bought on Edisto Island, off the coast of South Carolina. Rauschenberg had moved, meanwhile, from Front Street to a huge, fifth-floor loft in a commercial building on Broadway near Twelfth Street, in Greenwich Village. They continued to live together when they were in New York, but their friends felt a growing strain between them. Before, as Ileana Sonnabend once said, they had been 'so attuned to one another that sometimes it was hard to tell who was who', but now Johns was guarded and withdrawn, and sometimes bitingly sarcastic.
> ... They both went up to Connecticut College in the summer of 1962, to work with Merce Cunningham, who was there under the college's dance residency program. By the time the summer ended they were no longer together. The break was bitter and excruciatingly painful, not only for them but for their closest associates – Cage and Cunningham and a few others – who felt that they, too, had lost something of great value.[39]

There is one more bit of gossip. Johns would have known that in 1960, the year prior to the painting, O'Hara's relationship with Grace Hartigan had ended. Perloff notes that between 1951 and 1960 Hartigan and O'Hara

saw each other or spoke on the phone almost every day. They frequently spent weeks – even months – together in the country. ... In 1960, after a major quarrel with Frank, Grace left New York, married, and settled in Baltimore. She sent him a strongly worded letter breaking off all relations. They did not see each other again for five years, and then only briefly.[40]

O'Hara's *In Memory of My Feelings* written in 1956 may have been read somewhat differently in 1961. The intimacy between the poet and the poem's dedicatee by then terminated, the poem gained a new context for reading and a context of use which maybe Johns utilises. Maybe it is also significant to the analysis of the possible references mobilised in *In Memory of My Feelings – Frank O'Hara* that Johns, who was there on the first weekend which O'Hara spent with Warren in July 1959, would have known in the summer of 1961 that their love affair was ending.[41]

I assume that those who knew of the break between Johns and Rauschenberg, and were involved in some way during 1961–2, were potentially able to respond to paintings like *No* and *In Memory of My Feelings – Frank O'Hara* on at least two levels: they would be able to admire the mechanisms of surface, and to read the details as meaningful by reference and association – metonymy snatching the socially closed subject from the spectator's grasp while never subverting the socially open and highly valued surface. What is of interest here is not that such readings are exclusive but that they are publicly kept at a distance by metonymy.

As I noted earlier, the hatched surface appears for the first time in Johns' work on the left panel of *Untitled*, 1972. It has been argued that its use there and the change of style it inaugurated evidences Johns' late interest in Jackson Pollock and his work and that this led to, or was accompanied by, an interest in Picasso.[42]

Philip Leider wrote of Pollock in 1970, 'It was as if his work was the last achievement of whose status every serious artist is convinced.'[43] This was particularly true for the New York artists in the later 1950s and 1960s. Pollock had established American painting as something in relation to which they could establish their practice. Thanks to his legacy they were liberated from the need to go back to Cubism. They had to transcend it, and transcend it by way of Pollock. That is part of the conventional wisdom of Modernism in the late 1950s and 1960s.

Johns seems to have been the exception to that generalisation. There is little sign before the early 1970s – that is to say before he started producing the hatched surfaces – that he was interested in Pollock. Yet in 1973 he gave the first of his independent all-over hatched paintings – an extended development in oil and encaustic of the surface in *Untitled*, 1972 – the same title as what is generally taken to be Pollock's last or penultimate painting, *Scent* of 1955. To see the allusion as accidental would be to attribute to Johns

an insouciance inconsistent with his persistent and identifiable use of this kind of reference. The title takes a knowledge of Pollock and his art practice back into Johns' *Scent* and the hatched surface of *Untitled*, 1972. It picks up on Pollock's concern with subject. According to O'Hara it was with *Scent* that Pollock 'turned again toward his beginning and the manner of *Eyes in the Heat*' of 1946.[44] I take this to mean that O'Hara thought it was with *Scent* that Pollock resumed his practice of concealing subject matter in between and under the painted activity which made the surface. The idea of concealment and various procedures of concealing or veiling the imagery were important to Pollock's practice.[45] They were also important to Johns and had been for many years prior to *Scent* and *Untitled*, 1972. Both artists seem to have had in common the need to represent or express something in their paintings, then to conceal it; to depict and then erase. With this in mind we may be alerted to the idea that what is veiled in Johns' work, as it is in Pollock's, is nevertheless alive, signifying, referring.

Taking *Scent* as a key one may produce a reading of the hatched surface and its use in *Untitled*, 1972 as a kind of homage to Pollock, or as a reference to Johns' concerns with or problems of surface and subject, or even a way of creating a lineage and history whereby he paints himself into a tradition while differentiating his work from it. Maybe Johns, whose currency and value in the 1970s was fast becoming established as the multinational world's 'super-artist', as the pre-eminent artist of his generation,[46] was painting on the assumption of coeval status or value or that he was consciously or unconsciously producing the kind of surface which would stake his claim to that status or value. If this reading is correct, if Johns was concerned to acknowledge, refer to, and equate himself with Pollock and to assert the distinctiveness of his own work, he might well have felt the need to adopt a form of 'holistic', 'flat', factitious surface as an appropriate reference. However, he would have found this difficult to achieve by means of his normal mechanisms of surface, his usual mention of Abstract Expressionist derived protocols and procedures. He had to 'adopt' a novel means of producing such a surface, a new mechanism which would establish some distance. Johns could not produce his all-over surface by means compatible with Pollock's, but the effect had to be more or less the same. The story of the decorated car on the Long Island Expressway is apt in this sense at least. Johns' mechanisms of surface – as he said with reference to the 'flagstones' – tend to be appropriated rather than invented. But the story of the decorated car is dubious in another sense, because the hatched motif seems to have been appropriated not from it but, via it, from Picasso. If we can defensibly say that the use of the hatched surface and the change of style it occasioned is significant of a late interest in Pollock then there is a sense in which that very lateness renders the reference to Picasso more plausible. In the metonymic chain the mention and use of Pollock refers to Picasso, as does the mention and use of the decorated car.

Johns' triptych *Weeping Women* of 1975 provides a clue to the network of interests within which aspects of Pollock's and Picasso's work were capable of being synthesised on the same picture plane. The title refers to Picasso's *Weeping Woman* of 1937 and takes a knowledge of it and its producer back into Johns' painting. There is just enough striation or hatching in Picasso's painting – I have in mind the version in the Tate Gallery, London, Zervos IX, 73 – to cast further doubt on the role of the decorated car as a determining factor. However it is relatively unimportant whether the hatchings are derived from Picasso's *Weeping Woman* or from his paintings of 1907–9, or from the hatchings in *Femmes d'Alger* of 1955 which was probably closest to hand and mind in 1972. It is more important to realise why Johns should have been interested in Picasso's use of such a device particularly if I am justified in calling attention to the practical determining power of the surface–subject contrast in Modernist painting and to his disposition towards producing surfaces which represent or express their subject by reference and association. For Picasso, striations or hatchings were a form of autonomous decoration organising and controlling a surface of a painting with vivid imagery, nudes, *demoiselles*, *femmes*. In the literature of art around the time that Johns was working on *Untitled*, 1972, this vivid imagery was being scrutinised with reference to *Femmes d'Alger* and questioned as to why Picasso would scar and mangle, dismember and fragment the female body in the process of representing it.[47]

There are no *femmes* in the hatched surface of *Untitled*, 1972, and if they are there in Pollock's *Scent* they are veiled, concealed. But they are referred to. Here Johns uses Picasso's hatching to refer to the subject it, for example in *Femmes d'Alger*, surrounds or edges. The perimeter is used to signify the centre. What is presented refers to what is absented. In the end the fragmented figures are there plain enough for all to see as casts over the right surface. The move from left to right is one of revelation: Johns revealing what is metonymically referred to by the hatchings taken from Picasso, and maybe veiled in the work of Pollock.

Johns' story about the decorated car now has to be seen as a feinting – though not a disingenuous – retrodiction rather than as an adequate explanation of what the hatched surface is *of*. We may accept that the sight of the eccentrically painted car provided a stimulus or impulse or link in a causal or metonymic chain, but this is far from according that glimpse a privileged status in any explanation of Johns' use of and variations on the hatched surface. It is important, however, to realise the story's importance to Johns as a way of talking about the hatching motif in a manner which satisfies and diverts his attention and the attention of would-be explainers from what and how the hatched surface means. The surface of *Untitled*, 1972 may perhaps best be seen as signifying some point of intersection and dispersion in Johns' thinking about Pollock and Picasso and the means and meanings of certain paintings by them. If so, that intersection and

FRED ORTON

dispersion is a surface and subject – and an explanation of that surface and subject – rendered feasible or possible for Johns by connection with and reference to a decorated car. After *Untitled*, 1972, Johns could not only *mention* Picasso; he could also *use* him.

As far as I know Johns has not chosen to comment on the right panel of *Untitled*, 1972 with its veiled targets, collage, brushstrokes, imprints, battens and wax casts – not in terms of what it might mean. Here the association of body fragments and now veiled targets suggests that at some point in its genesis this panel reprised the moment in 1955 when Johns made *Target with Plaster Casts*.[48] However, as we have seen, that moment was not so much periodically reprised but carried forward as an ever present, at least after 1960. The actual wax-cast body-fragments used in the mid-1950s persist, not just as imagery but as metonymy; the mutilated body, at first an image, has a life in the 1960s and 1970s as a textual articulation, a figure of speech.

The challenge or puzzle presented by *Untitled*, 1972 – 'what are these surfaces doing together . . . ?' or 'what does it mean, represent or express?' – is a textual one. The ease with which the problem can be circumvented or disposed of by attending to the mechanisms of surface – identifying its 'secrets' as located in the juxtaposition of its four surfaces and in particular in the hidden square formed by the oil and encaustic 'flagstones' or else by reflexivity – evidences the efficacy of the way the dominant narrative closes down on investigation and the production of meaning for Johns' work by burying them in the surface.

The traces of meaning on the right panel of *Untitled*, 1972 are several, and I ought to consider, once again, whether the wax casts and imprints are there merely to make the surface or – and this would be much the same strategy – to produce the illusion of meaning. All classical theories of the sign allow for the relative independence of the signifier and for its freedom in relation to its signifying function. If, for instance, there is an imprint of a can or the sole of an iron in a surface one has to question whether that mark was generated by its property as a signifier, by possessing a certain shape which could be used to imprint an encaustic surface, or whether that mark was generated by its meaning as a mark made by a can or an iron, or by extended metaphorical or metonymical meanings. It is possible that the imprints have no semantic depth. I acknowledge that possibility but think, as I said earlier, that it is unlikely to be the case. The iron imprint, for example, was first used in 1962, where it seems to function as a kind of *memento mori* in the context of *Passage* – one of several paintings Johns made in 1962–3 which can be read as referring to his life circumstances and art practice and to death (real or metaphorical) by way of association with the poetry and life of Hart Crane. It is certainly much more difficult to make the case that something as vivid, emphatic and alive in culture as the body fragmented has no semantic depth. However, to say what that semantic depth is in the context of *Untitled*, 1972 (specifically) and Johns' work (generally) is problematic.

108

No one is in a position to provide a secure reading of *Untitled*, 1972. How could it be proven? And how could the proof be proven? The production of meaning is social and institutional, differential and dispersed, contestable and continually renewed. All I have been doing is producing possible meanings for some surfaces on the reasoned assumption that we should read them metonymically as meanings evoked by associations with or references to other surfaces, poems, authors, events and feelings and as associations defined by – even momentary – contiguities in time and space. Johns' little stories are academic exercises in metonymy. Synecdoche is also important. This is the trope that a beholder can pick up on most easily. Johns uses it in a peculiarly cool way, sometimes making the edge or the margin refer to the absented bit on which he is fixated. It is in the spirit of this kind of critical enquiry that I refer to some paintings by René Magritte as a means of linking the right panel of *Untitled*, 1972 to the other three panels and the 'flagstones' to the wall in Harlem.

Johns' interest in Magritte is attested to by his ownership of *The Key of Dreams* of 1936. In Magritte's painting *The Elusive Woman* of 1927 or 1928, the naked figure of a woman is embedded, together with four large hands, in a wall of eccentrically shaped and placed stones not unlike – but not that 'similar' to – the 'flagstones' of *Harlem Light* and *Untitled*, 1972. Magritte's 'flagstones' can be seen in other paintings he made in the late 1920s and early 1930s. As the façade of a building, drapes drawn, it turns up in *The Empty Mask* of 1928 or 1929, *The Six Elements* of 1928, *On the Threshold of Liberty* of 1930, and *Act of Violence* of 1932. These are all paintings of accumulated surfaces; fragments which are seemingly unrelated except as they appear together in Magritte's paintings. Some of them, like that of the façade, appear more often than others – a fragment of blue sky with clouds is another constant element – usually in relation to a body fragment, a female torso, breasts and navel.

As with *Untitled*, 1972's hatched surface, what we are considering here is not some mechanical action by contact, a painted storefront seen whilst driving through Harlem, or a simple case of 'influence', but a more or less fortuitous and exploitable sighting of a wall in Harlem by means of which some of Magritte's work and the meanings and references Johns could produce from it and for it could be made to serve his representational or expressive aims and his need to represent or express them obliquely by means of the Modernistic plausibility of his surface and his account of its genesis. The wall in Harlem was adapted, not invented, to refer to those paintings of Magritte in which a wall similar to that one in Harlem – 'similarity' is all right on the streets[49] – surrounds or is associated with the female and with the female fragmented.

I have to acknowledge that I have no explanation to offer of the meaning of *Untitled*, 1972. However, it is perhaps not entirely fanciful to suggest that *cherchez la femme* or even *cherchez l'homme* is a relevant pursuit in front of many

of Johns' paintings (quite apart from those such as *Viola, Weeping Women, Dutch Wives, Watchman, Periscope (Hart Crane), Diver, Good Time Charley*, or *In Memory of My Feelings – Frank O'Hara* where she or he is clearly flagged) and also that the end of such a search is likely to be a fragment, *corps morcelé*, negation, or a surface. This is not simply what may be seen as represented or expressed by individual paintings, it is also the mechanism by which they represent or express the culture they speak from and for.

What can be explained and understood ought to be explained and understood, albeit no explanation is ever sufficient and no understanding ever secure. Closures protect mystiques. If mysteries can be explained they are no longer mysteries, and that is that. But they remain mysteries, if they do, by virtue of their capacity to evade open enquiry. Johns' work has eluded explanation because those who undertake to explain it are constrained by the closed explanatory system with which they approach the job in hand, and because Johns' use of metonymy as a mode of signification is a kind of closure in so far as it allows meaning to escape from all but a few readers who know what procedures to carry out, competences to execute, or techniques to apply to produce meaning from his work.[50] Modernist consequentialism restricts enquiry and explanation to 'artistic' and 'technical' matters, to surface rather than subject or mechanisms of meaning. Those persons who know why Johns' metonymic function is required, and who know what predictive or other technical functions his work is required to perform and who can approach it with the correct competences and techniques, have remained silent. These are the socially-open-but-still-closed and the socially closed worlds that metonymy mediates in Johns' work: the world of Modernist criticism and history and that distinctive other world in Modernism where Johns' interests were first formed.

> What you say about my tendency to add things is correct. But, how does one make a painting? How does one deal with the space? Does one have something and then proceed to add another thing or does one have something; move into it; occupy it; divide it; make the best one can of it? I think I do different things at different times and perhaps at the same time. It interests me that a part can function as a whole or that a whole can be thrown into a situation in which it is only a part. It interests me that what one takes to be a whole subject can suddenly be miniaturized, or something, and then be inserted into another world, as it were.[51]

NOTES

1 Michael Crichton, *Jasper Johns*, Harry N. Abrams Inc. and the Whitney Museum of American Art, New York, 1977, p. 59.
2 Ibid., pp. 54–5.
3 Ibid., p. 60.

4 Ibid., pp. 59–60.

5 Roberta Bernstein, *Jasper Johns' Paintings and Sculptures 1954–1974*, UMI Research Press, Ann Arbor, 1985, p. 237, n. 30.

6 Thomas B. Hess, 'Polypolyptychality', *New York Magazine*, vol. 6, no. 8, 19 February 1973, p. 73. Here quoted from Richard Field, *Jasper Johns: Prints 1970–1977*, Petersburg Press, London, and Wesleyan University, Middletown, CT, 1978, p. 23.

7 On studio paintings and paintings as moral and technical or practical studios see 'A Cultural Drama: The Artist's Studio', in *Art & Language*, Los Angeles Institute of Contemporary Art, 1983, pp. 17–19.

8 Field, op. cit., p. 23.

9 Roman Jakobson, 'The Two Aspects of Language and Two Types of Aphasic Disturbances', written in Eastham, Cape Cod, 1954 and published as Part II of *The Fundamentals of Language*, Mouton, The Hague, 1956, and in a somewhat different version in *Language: An Enquiry into its Meaning and Function*, Harper, New York, 1957 and *Selected Writings II*, Mouton, The Hague, 1971, pp. 239–259. The metaphor–metonymy distinction has not recently been a standard pre-occupation of language theorists and Jakobson's formulation of the 1950s is still the focus of what little discussion there is on the subject. Jakobson's works were published when Johns must have been thinking about his mechanisms of signi-fication. He may have read them, but probably – almost certainly – did not.

10 See, for example, the special issue of *Critical Inquiry*, Autumn 1978, which comprises contributions delivered in earlier versions at a conference on metaphor sponsored by the University of Chicago Extension in February 1978.

11 The distinction between metaphor, metonymy and synecdoche varies quite alarmingly amongst those who study poetic or figurative language. Hayden White directs the reader to some interesting literature on the subject in *Metahistory: The Historical Imagination in Nineteenth-Century Europe*, Johns Hopkins University Press, Baltimore and London, 1973; see the Introduction, pp. 31–33. It may be worth pointing out that White's conceptualisation of the difference between (reductive) Mechanistic–Metonymic and (synthetic) Organicist–Synecdochic linguistic modes as one of extrinsic and intrinsic relationships between entities in substitution might be relevant for extending my discussion of Johns' mechanisms of meaning.

12 Those of a psychoanalytic bent will know that Jacques Lacan used Jakobson's work on the two major forms of aphasia, metaphor and metonymy, in 'The Insistence of the Letter in the Unconscious' (1957), reprinted in Richard and Fernande DeGeorge (eds), *The Structuralists from Marx to Lévi-Strauss*, Doubleday, Anchor Books, New York, 1972, pp. 287–323. For Lacan metaphor and metonymy are the two 'slopes' of 'the effective field of the signifier in the consti-tution of meaning'. Metaphor is based on the substitution of one word for another, metonymy on a word-to-word connection. *Verdichtung*, or condensation, belongs to the field of metaphor – *verschiebung*, or displacement, which Freud described as the main method by which the unconscious gets around censor-ship, belongs to the field of metonymy. Lacan suggests that the symptom is a metaphor and that desire is a metonymy, that metaphor is linked to the question of being and metonymy to its lack.

13 For a discussion of some of the restrictions which Modernist art history and criticism imposes on explanation and knowledge see Charles Harrison and Fred Orton, 'Introduction: Modernism, Explanation and Knowledge', *Modernism, Criticism, Realism*, Harper & Row, London, 1984, pp. xi–xviii, xxiii–xxvi *passim*.

14 Leo Steinberg, 'Jasper Johns: The First Seven Years of His Art', first published

in *Metro*, nos 4/5, 1962; revised version Wittenborn, New York, 1963. Reprinted in *Other Criteria*, Oxford University Press, 1972, pp. 17–54, cf. p. 37.

15 Moira Roth, 'The Aesthetic of Indifference', *Artforum*, November 1977, pp. 45–53. There are numerous accounts of the artistic culture of New York in the 1950s. I've drawn on the following: John Gruen, *The Party's Over Now: reminiscences of the fifties – New York artists, writers, musicians and their friends*, Viking, New York, 1972; John Bernard Myers, *Tracking the Marvellous. A Life in the New York Art World*, Thames & Hudson, London, 1984; Marjorie Perloff, *Frank O'Hara: Poet Among Painters*, George Braziller, New York, 1977; Irving Sandler, *The New York School: The Painters and Sculptors of the Fifties*, Harper & Row, New York, London, 1978; Calvin Tomkins, *Off the Wall: Robert Rauschenberg and the Art World of Our Time*, Doubleday & Co., New York, 1980.

16 Roth, op. cit., p. 49.

17 This list is taken from David Craven, 'The Disappropriation of Abstract Expressionism', *Art History*, vol. 8, no. 4, December 1985, p. 502.

18 John Cage, 'Experimental Music: Doctrine' (1955), in *Silence*, Wesleyan University Press, Middletown, CT, 1961, pp. 13–17.

19 Robert Rauschenberg (Statement), *Sixteen Americans*, Museum of Modern Art, New York, 1959, p. 58.

20 Jasper Johns (Statement), *Sixteen Americans*, p. 22.

21 Alan R. Solomon, *Jasper Johns' Paintings, Drawings and Sculpture 1954–1964*, Jewish Museum, New York, 1963, and Whitechapel Gallery, London, 1964, p. 9.

22 In 1958 the Trustees of the Museum of Modern Art, New York, 'disapproved its purchase for fears that it would offend patriotic sensibilities'. MOMA archives, Johns' file; see letter from George Heard Hamilton to Philip Johnson, 23 February 1973, on receiving the gift of the *Flag* in honour of Alfred H. Barr Jr.: 'It is hard to imagine that such a mood could have existed only fifteen years ago, but that is what the minutes of the time reveal. I must say we owe you a great debt of gratitude, and I send you my thanks, on behalf of the other Trustees (even those who once voted against Johns) for this marvellous gift.'

23 These fragments from writings – by Leo Steinberg, Richard Field, Roberta Bernstein, and John Cage – are taken from Bernstein, op. cit., p. 77.

24 Johns went to Paris for an exhibition of his work at the Galerie Rive-Droite, June–July – the gallery which, in the same year, produced the edition of Duchamp's *Female Fig Leaf*. Johns stayed on for a performance by David Tudor of John Cage's *Variations II* at the American Embassy Theatre, an event which also involved Rauschenberg, Jean Tinguely and Niki de Saint-Phalle.

25 O'Hara's *In Memory of My Feelings* is dated 27 June – 1 July 1956. First published in *Evergreen Review* 11: 6, 1958; reprinted in *The New American Poetry: 1945–1960* (ed. Donald Allen), Grove Press, New York, 1960.

26 Marjorie Perloff, *Frank O'Hara: Poet Among Painters* and Alan Feldman, *Frank O'Hara*, Twayne Publishers, Boston, 1979 provided me with basic texts on O'Hara and his poetry.

27 Perloff, op. cit., p. 203, n. 42.

28 Ibid., p. 203, n. 41 and n. 44.

29 'Joe's Jacket', 10 August 1959, in *The Collected Poems of Frank O'Hara* (ed. Donald Allen), Alfred A. Knopf, New York, 1972, pp. 329–30.

30 '. . . What Appears To Be Yours', 13 December 1960, *The Collected Poems of Frank O'Hara*, pp. 380–1.

31 'Dear Jap', 10 April 1963, *The Collected Poems of Frank O'Hara*, pp. 470–1.

32 In 1961 Johns made a cast of one of O'Hara's feet and a drawing for a sculpture, *Memory Piece*, made in 1970, in which a footprint could be impressed in

sand in the drawers of a specially constructed box. Note the line in O'Hara's 'Dear Jap': 'when I think of you in South Carolina I think of my foot in the sand'. The print-poem collaboration *Skin with O'Hara Poem* begun in 1963 was published as a lithograph by Universal Limited Art Editions in 1965.

33 Perloff, op. cit., pp. 141–6; Feldman, op. cit., pp. 91–97.
34 John Cage, 'Jasper Johns: Stories and Ideas', in *Jasper Johns' Paintings, Drawings and Sculpture 1954–1964*, p. 35.
35 Perloff, op. cit., p. 167. O'Hara also offered Johns' 'Poem (The Cambodian grass is crushed)', 17 June 1963, 'Bathroom', 20 June 1963; see *The Collected Poems of Frank O'Hara*, p. 555, p. 556.
36 *'In Memory of My Feelings': A Selection of Poems by Frank O'Hara*, (ed. Bill Berkson), Museum of Modern Art, New York, 1967, a commemorative volume of O'Hara's poetry illustrated by thirty American artists.
37 Perloff, op. cit., p. 215, n. 23.
38 Riva Castleman has suggested that Johns concluded making *Voice* (1964–7) by suspending a fork and spoon at its right side in memory of Frank O'Hara. See Riva Castleman, *Jasper Johns: A Print Retrospective*, Museum of Modern Art, New York, 1986, p. 24.
39 Calvin Tomkins, *Off the Wall: Robert Rauschenberg and the Art World of Our Time*, pp. 197–8.
40 Perloff, op. cit., p. 210, n. 5.
41 Ibid., p. 162, Feldman, op. cit., p. 82.
42 See, for example, Charles Harrison and Fred Orton, 'Jasper Johns: Meaning What You See', *Art History*, vol. 7, no. 1, March 1984, pp. 78–101 and Rosalind Krauss, 'Jasper Johns: The Functions of Irony', *October 2*, Summer 1976, pp. 91–9.
43 Philip Leider, 'Abstraction and Literalism: Reflections on Stella at the Modern', *Artforum*, April 1970, pp. 44–51.
44 Frank O'Hara, *Jackson Pollock*, George Braziller, New York, 1959, p. 116.
45 'Once I asked Jackson why he didn't stop the painting when a given image was exposed. He said, "I choose to veil the imagery".' Lee Krasner in 'An Interview with Lee Krasner by B.H. Friedman', in *Jackson Pollock: Black and White*, Marlborough-Gerson Gallery, New York (Exhibition Catalogue), 1969.
46 See the cover of *Newsweek*, 24 October 1977 and pp. 38–44, the essay by Mark Stevens and Cathleen McGuigan, 'Super Artist Jasper Johns, Today's Master'.
47 This painting was the subject of a long essay by Leo Steinberg, 'The Algerian Women and Picasso At Large', first published in *Other Criteria*, 1972, pp. 125–234. Another essay in this collection was Steinberg's essay on Jasper Johns (see n. 14).
48 Those of a psychoanalytical persuasion should note the exchange between Johns and Peter Fuller, in 'Jasper Johns Interviewed Part II', *Art Monthly 19*, September 1978, p. 7.

> *Crichton wrote that, like Rauschenberg, you shared a belief that art sprang from life experiences. Would you agree with that?* Yes. *What life experiences do images like the shattered body spring from? It haunts so much of your work.* I don't think that I would want to propose an answer on the level of subjective experience. I can come up with a substitute. *But the body in several parts, which occurs in 'Target with plaster casts', and later works, can* only *be derived from your earliest fantasies, if art springs from life experience, surely. You have presumably only experienced such things at the level of fantasy?* I don't know that it can only be that. I would not take that point of view. (Laughs.) I think any concept of wholeness, regardless of where you place it, is . . . Well, take the 'Target with Plaster Casts', the first one. Some

of the casts were in my studio. They were things among other things. Then, of course, they were chosen again for use in that way. But I don't feel qualified to discuss it on that level, I must say. I've not been in analysis, and I wouldn't want to give it that meaning in such a specific way as you have done. I believe that the question of what is a part and what is a whole is a very interesting problem, on the infantile level, yes, on the psychological level, but also in ordinary, objective space.

49 Nelson Goodman, 'Seven Strictures on Similarity', in *Problems and Projects*, Hackett Publishing, Massachusetts, 1972, pp. 437–46, reprinted in Harrison and Orton, *Modernism, Criticism, Realism*.
50 Metonymy persists in the cross hatched paintings of the 1970s and early 1980s and in the works made after them, including *The Seasons* (1986). However, Johns' recent paintings seem much less euphemistic than his other works.
51 Jasper Johns in conversation with Christian Geelhaar in 1978; see Christian Geelhaar, *Jasper Johns' Working Proofs*, London, pp. 55–6.

7

'UNPICKING THE SEAMS OF HER DISGUISE'

Self-representation in the case of Marie Bashkirtseff[1]

Tamar Garb

(*From*: Issue 13, 1987/8)

In describing the position of woman within patriarchy, Luce Irigaray uses a sartorial metaphor. She writes: 'Stifled beneath all those eulogistic or denigratory metaphors, she (woman) is unable to unpick the seams of her disguise and indeed takes a certain pleasure in them, even gilding the lily further at times.'[2]

To which mechanisms of coping or defensive strategies does Irigaray allude? How do the operations of disguise, display and collaboration function in the creation of feminine subjectivities? Moreover, how do these seem to manifest themselves within a specific historical moment, or should I say temporally bound textual moment? A moment in the 1880s, in Paris, France, when an aristocratic Russian émigré woman, Marie Bashkirtseff lived, wrote and made art; a time in which living, writing and making art were circumscribed within terms which were sexually coded in highly specific ways. These are the questions I shall address in this paper.

In the spring of 1884, the artist Marie Bashkirtseff initiated an anonymous correspondence with the naturalist writer Guy de Maupassant. The anonymity of her position facilitated an elaborate game of shifting identities, one into which both parties entered willingly but with unfair odds, for while Bashkirtseff knew both who she was, or thought she did, and who her correspondent was, de Maupassant was in a state of semi-darkness, left to surmise the identity of his correspondent, with only her textual manipulations to help him. And because these exist in the form of responses to his assumptions, they function more as a mirror to reflect and deflect his prejudices than to counter them. Woman is in this configuration in a not unfamiliar position. Forced to live within patriarchy although marginalised through its discourses, she knows both her own position in it and the public discourse which defines her. She lives in a space constructed as the Other but knows,

although she may not choose to recognise, the cracks within the edifice. Man, blissfully or wilfully ignorant of a subject position outside of his own and his fantasised Other, can live unscathed, in the logical clarity of his own semi-darkness.

Already in the first and unsolicited letter Bashkirtseff feeds expectations based on notions of appropriate masculine and feminine behaviour so that even before the correspondence is begun, the terms of the interaction are of course settled. (Much like the foetus who while still in the womb has already had conferred upon it a subject position.) Bashkirtseff flatters de Maupassant as an artist and teases him as a man. In projecting herself initially, she constructs a caricature of jealous and flighty sentimentality offset by the taunting and obviously false assertion that she is a 'slovenly old English-woman', called 'Miss Hastings'.[3] Later on she playfully asks him, 'And what if I were a man?', appending to her letter a sketch of a stout man sleeping on a bench under a tree at the seaside.[4] What characterises the correspondence throughout is the game played over gender. Not only does Bashkirtseff undergo a temporary sex change, becoming for a period the schoolmaster Savantin Joseph; her textual identity as woman is teasingly ambiguous, sometimes adopting the tone of a young precocious admirer, at others of an irate mature woman. Within each guise certain verbal inter-actions become permissible, the most noticeable change being that of the adoption of the mask of masculinity, prompted by de Maupassant's mistrust of her erudite literary allusions which he half-teasingly insists must establish her identity as male. Under the guise of a correspondence between two males, the underlying discussion of the status of woman, already present in the correspondence, can be made explicit.

From the start de Maupassant had been keen to establish his anonymous correspondent's physical appearance, chastising her for assuming that he would consider corresponding with someone whose 'physical form, the colour of whose hair, whose smile and look . . .' he did not know. He asks rhetori-cally: 'Does not all the sweetness of affection between man and woman . . . come especially from the pleasure of seeing each other, of talking face to face, and of catching again in thought, as one writes to one's friend, the lines of her face floating between one's eye and the paper?'[5] In a subsequent letter he speculates hopefully that she is a 'young and charming woman whose hands he would be happy one day to kiss', but fears that she may be an 'old housekeeper, nurtured on the novels of Eugene Sue', or worst of all 'a young woman of literary society' and, as he put it, 'dry as a mattress'.[6]

What is clear throughout is that if his correspondent is female, de Maupassant is far more interested in a flirtatious encounter than an exchange of ideas. Once he gives himself the liberty of addressing her as a male though, whether he truly believes her to be one or not, he is able to dispense with any chivalric pretences. In a tone of bravura and defiance he declares, 'In truth, I prefer a pretty woman to all the arts. I put a dinner, a real dinner, the rare

dinner, almost in the same rank with a pretty woman. There is my profession of faith, my dear old professor!'[7] Under this guise too, he is able to recommend to her his favourite brothels and give her detailed information of addresses and streetcorners worth visiting.[8] That the allusions to prostitution and overt sexual innuendoes are cut from the original publication of the correspondence of 1901, from de Maupassant's collected correspondence of 1938 and the English translation of the letters to and from Bashkirtseff of 1954, indicates just how transgressive these continued to be seen to be. By playing the game of the masculine subject, Bashkirtseff could allow herself to enter into the world of the sexually forbidden, and is able even to taunt her male recipient, calling him mockingly a 'great devourer of women'.[9]

But this is only one, and in fact the more obvious, of the maskings that the texts reveal. What they also show is the skill with which Bashkirtseff plays the coquette, mimics the mores of 'femininity', inscribes herself as truly womanly, and these guises are shown to be no more naturally her own than the voice of the schoolmaster Joseph.

We become aware of the distance between the writing subject and the masks of identity which she wears and mobilises so deftly. Are we to consider 'Marie Bashkirtseff' as none of these masks but rather as an amalgam of them all, living in a state of Lacanian alienation, an inevitable decentred-ness, and leave it at that, or can the gap between the writing woman and the masks of identity be seen to be a productive one? If we follow Irigaray's theory of 'mimicry' it can. This is a theory which seeks to make sense of the position of woman writing within a closed linguistic system in which the masculine and the feminine are already determined. Given the coherence of the system, asks Irigaray, how are women to speak out at all? One answer is through what she calls 'mimetism', 'an acting out or role playing within the text which allows the woman writer better to know and hence expose what it is she mimics'.[10] It is a form of subversion, or a place of writing of the 'feminine' whether consciously adopted or not, in which the inadequacy and limitations of the binary oppositions of phallogocentric discourse are exposed, not through standing outside of them, which is impossible, but through imitation, almost pastiche, which thereby reveals a gap between the writing subject and the clothing of sexed identity.

As Irigaray puts it:

> To play with mimesis is ... for a woman, to attempt to recover the place of her exploitation by discourse, without letting herself be simply reduced to it. It is to resubmit herself ... to ideas, notably about her elaborated in/by a masculine logic, but in order to make 'visible' by an effect of playful repetition, what should have remained hidden; the recovery of a possible operation of the feminine in language.[11]

How can we account in a more historically specific way for the operations of mimicry in Marie Bashkirtseff's writing? Perhaps such a strategy was one

of the few ways for a woman of her class, inclinations and aspirations to engage with so renowned a misogynist as the naturalist writer. Not that de Maupassant was alone in his views on women. His writings provide a very useful indication of the construction of femininity current in late nineteenth-century France, and one explicitly developed in naturalist literature, with its rhetoric of truthful reportage, but its underlying essentialist assumptions.[12]

Bashkirtseff's access to the aesthetic ideologies of naturalism was gained both through her own extensive reading of contemporary literature, in itself a form of transgression (the *Journal des Demoiselles* of this time forbidding to young women the reading of any novels by men), and her involvement with art, the serious nature of which was equally transgressive.[13] By the time she entered into her correspondence with de Maupassant, whom she saw as someone who, as she wrote to him, 'adores the truth of nature', she wanted to see herself as part of the modern school of naturalists. She identified with the increasingly successful group of landscape and genre painters associated with Jules Bastien-Lepage (1848–84) who chose the Paris Salon as their exhibiting forum.[14] She herself had gained some success at the 1884 Salon for her painting *Le Meeting*, depicting a group of working-class children in a Paris street, whom she purports, in characteristic naturalist fashion, to represent truthfully.

In fact the rhetoric of truth and sincerity so tied up with debates around realism and naturalism, is echoed throughout her writing, most specifically in the journal which she kept from 1873 to just before her death in 1884.[15] In the preface to the journal written 6 months before her death, she declares to the reader that in it she 'reveals herself completely, entirely', invoking Zola, de Goncourt and de Maupassant as sureties of the journal's interest as 'a document of human nature'.[16] Throughout her journal she seeks to reassure her reader of its veracity, of its dependability as 'truth'. 'You will be able to trace my life from the cradle to the grave. For a person's life, her whole life, without any concealment or untruth, must always prove a great and interesting thing', she assures us.[17]

How then was Bashkirtseff to make sense of the construction of 'femininity', paraded as truthful observation, which she witnessed through the writings of contemporary naturalists? For de Maupassant, woman's prime function was to please; his female characters (with the unique exception of Mme Forrestier in *Bel Ami*, who in any case is not a principal character but a foil for her successive husbands) never show any intellectual interest or ability, such concern being outside of their legitimate and natural sphere. His ideas on femininity, strongly based on those of Schopenhauer, and characteristic of the misogynist response to debates around the 'new woman' of the 1880s, were expressed in an article, 'La Lysistrata Moderne', published in *La Gaulois* on 30 December 1880.[18] This article is a vicious indictment of women's intellectual abilities and political aspirations and intervenes into an ever intensifying debate on women's rights stimulated by the feminists of

the late 1870s. In defending his case for women's intellectual weakness, de Maupassant points to their alleged intrinsic incapacity to produce any artistic masterpieces, resulting from their lack of an ostensible objectivity of mind. To require women to engage in intellectual labours is for de Maupassant akin to demanding that a man breastfeed a baby. It is not within the scheme of Nature. Women's true power lies in being Man's inspiration, the hope of his heart, the ideal always present in his dreams. Women's only legitimate right is the right to please, her true domain and arena of power is that of love, and any granting of political rights to women would serve only to demean their legitimate sovereignty in affairs of the heart.

Bashkirtseff is then defining herself as an artist in a society which is openly hostile to such aspirations, and more specifically within an aesthetic ideology which circumscribes women's behaviour through recourse to the authority of the natural. Such constructions of 'femininity' were not, of course, peculiar to de Maupassant. When *Le Meeting* was shown in 1884, critics expressed surprise that it was painted by a woman. The critic of *La Gaulois* is reported to have said on seeing the work: 'Oh, Yes! M. Bashkirtseff is indeed a very strong man', to which Emile Bastien Lepage, brother of the famous naturalist painter, responded that its author was a young woman, and a pretty one at that.[19]

In the mobilisation of Bashkirtseff's 'prettiness' as part of her defence lies the nub of the issue. It functions in a number of ways: one, to confront the expectation that any woman whose work was strong or whose talents were intellectual must be 'unattractive', or 'unwomanly', and thereby to double her achievement; another, to dissuade hostility against her, and to assure her place within appropriate and desirable constructions of the 'feminine', as if to say, 'she may be talented, but she is, all the same, a true woman, a desirable woman'.

Bashkirtseff herself expressed the tension between 'feminine prettiness', on the one hand, and the strength, tenacity and intelligence constructed as masculine, which was required to produce a painting, on the other. Legitimate expression of female talent was, as is by now well known, confined to the sphere of gentle accomplishment of the type promoted by the illustrations in the *Gazette des Femmes*, where the paintbrush and easel are used as so many fashion accessories rather than as signifiers of professional engagement with the act of painting.

But Bashkirtseff also derived a certain pleasure from the unlikely image that she presented as an artist. When *Le Meeting* was exhibited she situated herself in front of the picture to observe the viewers and commented later in her journal: 'No one would suspect the artist in the elegant young lady who was sitting there with her little feet in such trim boots.'[20] In one of her fantasies of future fame she muses about being both a great artist and a desirable woman gloating at her rival Louise Breslau's ostensible unattractiveness. 'Breslau is lean, crooked and worn out; she has an interesting head,

but no charm; she is masculine and solitary. She will never be anything of a woman unless she has genius; but if I had her talent, I should be like no-one else in Paris.'[21]

Bashkirtseff knew too the cost of her striking image at which she laboured so conscientiously, stating after attending a reception at the Russian embassy, 'I was so pretty and so well dressed that they will be convinced that I don't paint my pictures alone.'[22] On another occasion she laments the restrictions placed on her life as an aristocratic woman, seeing her 'attractiveness' as part of that which confines her, and declares: 'I'll get myself a *bourgeois* dress and a wig, and make myself so ugly that I shall be free as a man.'[23]

It is the splittings, conflicts and contradictions within Marie Bashkirtseff which are most instructive. While she was quite capable of using the category of the 'feminine' in a collaborative and denigratory way (she compliments her rival Breslau by asserting that 'she does not draw like a woman') she also railed against the injustices which she experienced as a woman.[24] The journal is filled with her remonstrations against women's lot. A typical example taken from 1882 is:

> Ah! how women are to be pitied; men are at least free. Absolute inde-
> pendence in everyday life, liberty to come and go, to go out, to dine
> at an inn or at home, to walk to the Bois or the café; this liberty is half
> the battle in acquiring talent, and three parts of every-day happiness.[25]

But to express her feelings and grievances in any constructively political way Bashkirtseff found it necessary to adopt a disguise. When visiting the suffragist Hubertine Auclert whose organisation she supported both intel-lectually and financially, she blackened her eyebrows, donned a dark wig and assumed a false name, that of Pauline Orell.[26] Interestingly, she finds herself comforted at the meeting with this powerful woman to observe that she was not as unattractive as reports led her to believe.[27]

It was under the assumed name of Pauline Orell that Bashkirtseff wrote art criticism for the suffrage newspaper *La Citoyenne*, on one occasion arguing forcibly for the admission of women to the Ecole des Beaux Arts, on another taking advantage of the possession of an anonymous voice to criticise her own painting of the women's salon at the Académie Julian which she had exhibited at the Salon of 1881 under the pseudonym Mlle Andrey.[28] Multiple splittings are apparent.

So even on the most superficial level, we can observe intriguing forms of self-consciously adopted disguise which make certain forms of behaviour, otherwise prohibited, permissible to a woman of Bashkirtseff's class. But there seems to be, in addition, the operation of a much more fundamental and unconscious form of masking which is brought into play. It can be exemplified not only in images of self but in images of other women too.

In *The Question of Divorce*, a 5-foot-high painting exhibited at the Salon of 1880, a young woman is shown reading the contentious book recently

published by Alexandre Dumas fils which had contributed to the still highly controversial debate over divorce, widely associated with feminist agitation.[29] But the way in which Bashkirtseff has staged the painting belies the controversial nature of the subject. The woman is shown in a state of semi-undress, clad only in lace undergarments, her hair informally hanging over her back. On the table is the book in question but it is juxtaposed with a bunch of violets which softens and contains its potentially threatening nature. The one hand supports the head, the other rests in the customary docile position clutching a rolled piece of paper, so that the body is opened up towards the spectator. The threatening and transgressive act, that of reading a potentially inflammatory book, one deemed both politically radical and occupying the sphere of intellectual debate and public controversy outside of the realm of legitimate feminine interest, is assuaged by the costume of feminine frailty and vulnerability which reinscribes a sense of order into the pictorial world.

What is happening here is that the mask of 'femininity' is used to reassure both a hostile world and a guilt-ridden subject. The threat is veiled by the reinscription of woman as castrated object. The use of femininity as disguise, or what has come to be called 'masquerade', has been well theorised. In 1929 Joan Rivière published the influential article 'Womanliness as Masquerade' from which Lacan was to develop his important assertion that 'masquerade is the very definition of "femininity"' . . . because it is constructed with reference to a male sign'.[30] But the terms of the problematic were already stated, if not satisfactorily resolved by Rivière. She analysed the case of a highly articulate woman whose work consisted in delivering public lectures which she managed with aplomb. The act of lecturing, though, was usually followed by a period of excessive flirtation and coquettish display aimed at certain older men. Rivière explains this unconscious adoption of the 'mask of womanliness' as a defence to avert anxiety and the retribution feared from men; 'it was an unconscious attempt to ward off the anxiety which would ensue on account of the reprisals she anticipated from the father-figures after her intellectual performance'.[31] The professional woman takes on the position of the castrated woman in order to reassure men who function as father substitutes, and whose reprisals she fears, that they are still in possession of the penis. That is, to assuage castration anxiety in men and simultaneously to reassure herself that she is guiltless and innocent. It was, says Rivière, 'a compulsive reversal of her intellectual performance', conceived as masculine and transgressive.[32]

The difficulty with Rivière's article is the still unproblematic way in which she utilises the categories of 'masculinity' and 'femininity', juxtaposing the concept of 'womanliness as mask' with a notion of 'fully developed heterosexual womanhood'.[33] It is from such traps that Lacan retrieves the debate on the masquerade, seeing it as the condition of femininity rather than a repressed homosexual pathology or failed femininity. For Lacan the adornment of 'womanliness' serves to reassure that 'woman' does not have the

penis, thereby displaying her 'lack', so that the 'woman behind the veil, bears witness to the absence of the penis and as such is inscribed as phallus, or object of desire'.[34] In order to be the fantasised Other of the masculine order, woman must represent 'lack'. 'Adornment *is* the woman, she exists veiled; only thus can she represent lack, be what is wanted.'[35] The masquerade serves to reinscribe the phallic order with the phallus as the privileged signifier and womanliness as the 'veil' used to cover the threat of castration. The masquerade is the representation of 'femininity' within patriarchal culture. For Luce Irigaray 'the masquerade . . . is what women do . . . in order to participate in man's desire, but at the cost of giving up theirs.' 'Femininity' becomes the representation of this subjection to the phallic order.[36]

One may feel that the Lacanian fatalistic inscription of the sexual economy under patriarchy leaves one stranded and helpless in its grip. But it is worth seeing whether any of this helps us to understand the mechanisms of self-representation adopted by Marie Bashkirtseff.

That Bashkirtseff was caught between conflicting desires should by now be clear. That she lived in a time in which 'womanliness' and 'artistic genius' were regarded as mutually exclusive is also apparent. Bashkirtseff's writings are filled with articulations which give voice to this gap, and a despair that it could ever be resolved. What is equally apparent is her own fear of what would in Joan Rivière's terms be constructed as her 'masculinity', her expressed knowledge that 'celebrated women' frighten people and her anxiety to reassure herself and others of her innocence.[37] We see her pleasure in reading about herself described as child-like, or resembling a woman in a painting by Greuze.[38] We witness her adoption of obviously child-like behaviour, the infantilisation of self, the constant vigilance and anxiety about the effect her behaviour produces.[39] This is accompanied by an intense wish for fame and independence, and a horror at the realisation of marriage as a commercial interaction with woman as the object of exchange.[40]

Nowhere is Bashkirtseff's obsession with her own physical appearance more apparent than in the many photographs that she had taken of herself. From an early age Bashkirtseff's appearance is 'recorded' in photographs. In many of these she adopts obvious costumes, sometimes wearing the robe of a Capuchin nun, sometimes of a Russian peasant. Most often she is elaborately dressed, suitably veiled, adorned in a costume constructed to inscribe her within accepted notions of 'femininity'. Her body too adopts the disguise, eyes downcast, unseeing, gestures contained and carefully arranged, the whole signifying modesty, refinement, restraint.

That Bashkirtseff railed simultaneously against this 'mask', the mask of femininity, is, as we have seen, apparent from her writing. On one occasion after she laments the present conditions of woman at the same time regarding demands for equality as utopian and stupid, she writes: 'I do not demand anything, for woman already possesses all that she ought to have, but I

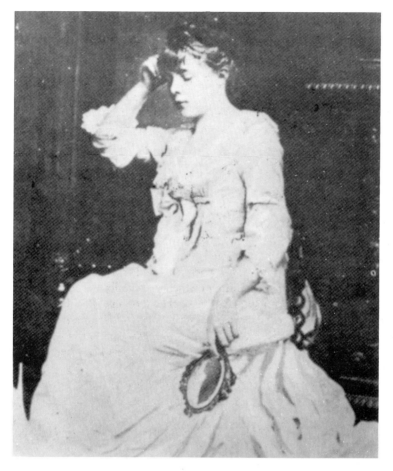

Figure 7.1 Photograph of Marie Bashkirtseff, date unknown

grumble at being a woman because there is nothing of the woman about me but the envelope.'[41]

Juxtaposed with the 'envelope' is the threatening spectre of the woman artist, double usurper of the penis, in the shape of the brush (phallic in form and phallic in function), and in her appropriation of the gaze, her refusal to be spectacle, object of man's desire, or in de Maupassant's words 'the ideal always present in his dreams'.

In *L'Autoportrait à la palette* the gaze is direct, the professional identity clearly proclaimed. But even this assertion of power is tempered, softened by the presence of the harp which serves to inscribe the identity of the woman within the sphere of activity deemed appropriate for a refined lady. The presence of the harp disclaims the seriousness of the involvement with the

123

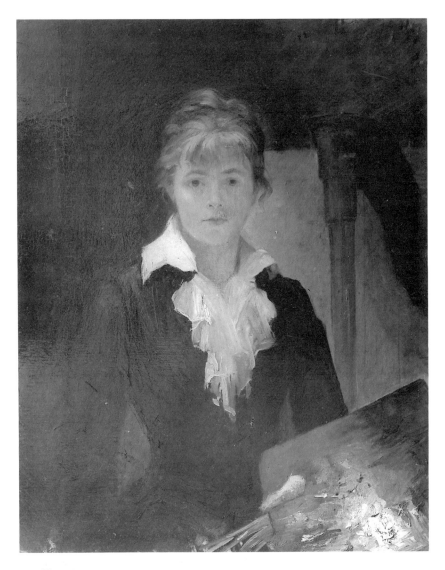

Figure 7.2 Marie Bashkirtseff, *L'Autoportrait à la palette*, Salon 1855 (exhibited posthumously)

Source: Musée Chevet, Nice

brush. Perhaps there was no way out for Bashkirtseff. Frightened by her power to seize that which was forbidden to her, she veiled her ambition, 'even gilding the lily further', by living the masquerade.

Would it be wildly utopian, if not wilfully naive, to hope that the mimicry which the masquerade demands presupposes a gap, and that 'if women mime so well, they do not simply reabsorb themselves in this function. They also remain elsewhere'?[42] For surely it is in the gap that hope resides?

NOTES

1 This is a transcript of a paper delivered at the Conference of the Association of Art Historians, April 1987, in the session 'The Artists I, Autobiography and Ideology'.
2 L. Irigaray, 'Any Theory of the "Subject" Has always been Appropriated by the Masculine', in *Speculum of the Other Woman*, France, 1974, translated into English, Cornell University Press, New York, 1985, pp. 142–3.
3 An expurgated version of the correspondence is included in René Dumesnil's *Chroniques, Etudes, Correspondance de Guy de Maupassant*, Paris, 1938. It is translated into English and collected into a small book *I Kiss Your Hands: The Letters of Guy de Maupassant and Marie Bashkirtseff*, Rodale Press, London, 1954. The censored letters are published in Colette Cosnier, *Marie Bashkirtseff: Un portrait sans retouches*, Pierre Horay, Paris, 1985.
4 *I Kiss Your Hands*, p. 25.
5 Ibid., p. 14.
6 Ibid., p. 20.
7 Ibid., p. 28.
8 Cosnier quotes his advice in full: 'Alors, tu veux que je t'indique les bons coins. Il y a en ce moment 4 rue Joubert, un phénomène, un monstre charmant que j'ai decouvert l'été dernier à Clermont-Ferrand. Tu peux aller aussi rue Colbert, simple et bon. Rue des Moulins, cher et médiocre. Rue Taibout: ne mérite pas son nom. Rue Feydeau: honnête moyenne' and so on (p. 331).
9 *I Kiss Your Hands*, p. 32.
10 Quoted in Mary Jacobus, 'The Question of Language', *Critical Inquiry*, vol. 8, no. 2, Winter 1981, p. 210. Jacobus gives a very lucid account of Irigaray's theory of mimetism. She explains Irigaray's position which is premised on the assertion that women only have access to existing linguistic structures which are masculine. How women speak at all within these closed systems of representation becomes the problem. 'Mimetism' is offered as a solution and one which mirrors the role historically assigned to women, that of reproduction, but here deliberately assumed.
11 L. Irigaray, from 'Pouvoir du discours', p. 74, in *Une politique des femmes y est-elle possible?*, transl. and reprinted in Jacobus, p. 210.
12 Perhaps one of the most startling exemplifications of this occurs in the preface of Zola's *Nana* which purports to be a 'true-to-life portrait of the modern courtesan'. In keeping with the pseudo-scientificism of his approach, Zola kept a 'descriptive card' of each of his characters. The card on Nana included the following ostensibly neutral and detached description but one which reveals to the modern reader deeply held masculine assumptions about women's nature and fear of female sexuality:

> Superstitious, frightened of God. Loves animals and her parents. At first very slovenly, vulgar; then plays the lady and watches herself closely. – With that,

ends up regarding man as a material to exploit, becoming a force of Nature, a ferment of destruction, but without meaning to, simply by means of her sex and her strong female odour, destroying everything she approaches, and turning society sour just as women having a period turn milk sour. The cunt in all its power; the cunt on an altar, with all the men offering up sacrifices to it. The book has to be the poem of the cunt, and the moral will lie in the cunt turning everything sour.

Emile Zola, *Nana* (first publ. 1880), Penguin, London, 1982, pp. 12–13.

13 See Cosnier, p. 280, for an assertion that at this period *Le Journal des Demoiselles* forbade to young women '*tout roman tracé par une plume masculine*', while Bashkirtseff read the complete works of Zola, de Renan, Tourguéniev, les Goncourts, and works by Flaubert and Balzac. Her awareness of the transgressive nature of the act of reading naturalist literature is indicated in one of the identity games she plays in the correspondence with de Maupassant. Feeding his curiosity as to her 'true' identity, she asks 'If I were not married, could I read your abominable books?' *I Kiss Your Hands*, p. 25.

14 For a brief summary of Bashkirtseff's involvement with 'naturalism' see the introduction by Griselda Pollock and Roszika Parker to *The Journal of Marie Bashkirtseff*, Virago, London, 1985, pp. xxvi–xxvii.

15 An expurgated version of the journal was first published in France in 1887 and in England in 1890. It was the Bashkirtseff family, in particular Marie's mother, who made the original selection for publication from the eighty-four handwritten manuscripts that she left. Subsequently other fragments and selected extracts were published but much was omitted, altered and suppressed so that the 'Marie Bashkirtseff' who was widely known and admired was a fabrication, a construction of various editors complying with certain notions of appropriate femininity. The rectifying of these distortions and the construction of an alternative Bashkirtseff, in this case a feminist one, is the subject of Colette Cosnier's 1985 book. The new edition of the letters published in 1985 contains an illuminating introduction by Parker and Pollock, analysing the journal in its various forms, as a site for the negotiation of the ideology of femininity.

16 *The Journal of Marie Bashkirtseff*, p. xxxi.

17 Ibid., p. 30.

18 This article is republished in R. Dumesnil (ed.), *Chroniques, Etudes, Correspondance de Guy de Maupassant*, Paris, 1938, pp. 56–60. De Maupassant's hostility to women's political rights is one of the themes of his novel *Séance publique* which contains a description of a meeting at the 'Association générale internationale pour le revendication des droits de la femme'. The voice of reason is represented by a young man who claims: 'la femme est moins douée que l'homme, physiquement et intellectuellement, mais elle a la grâce, le charme, qui font d'elle une souveraine'. See H. Alvado, *Maupassant ou l'amour réaliste*, La Pensée Universelle, Paris, 1980, p. 12. For a discussion of the representation of women in the work of Guy de Maupassant, see L. Gaudefroy-Demombyres, *La Femme dans l'oeuvre de Maupassant*, Paris, 1943.

19 Cited in Cosnier, p. 289.

20 *Journal*, p. 659.

21 Ibid., p. 526.

22 Ibid., p. 674.

23 Ibid., p. 347.

24 Ibid., p. 319.

25 Ibid., p. 536.

26 See Cosnier, p. 218. As Cosnier mentions, Bashkirtseff's involvement with Auclert and her organisation is minimised in the published journals.

27 For the conservative press, Auclert was a figure of public ridicule, articles on her simultaneously belittling her political aspirations and insulting her physical appearance. According to one commentator in the right-wing *Le Figaro*, who describes her 'salon' decorated with a bust of the republic, a portrait of George Sand, a mean library and brochures untidily scattered about, only a poor, weak fire burned without flame in the foyer. Auclert herself is constructed as 'sérieuse, dans son austère costume de quakeresse, lisant sans se presser, avec l'intonation prédicante; toute sa personne, du reste, exhale un parfum de séminaire et de couvent; voix onctueuse, petits rires étouffés, gestes discrè te. Elle n'est pas belle, pointe laide.' Vidi, 'Un Soirée chez La Citoyenne Auclert', *Le Figaro*, 5 January 1881, p. 4.

28 See Cosnier for the reprinting of both articles, pp. 220–1 and pp. 226–7. Of her own painting, Pauline Orell wrote: '*L'atelier de femmes dirigé par M. Julian* par mademoiselle Andrey. L'artiste nous montre toutes ces jeunes femmes au travail, il y en a de jolies, c'est assez amusant, vivant et bien composé, mais que de duretés, que de choses lâchées! Le modèle qui pose sur la table n'est pas bon du tout. On dit que c'est une jeune débutante, elle est alors presque excusable.'

29 For example, one of the resolutions passed at the First International Congress on Women's Rights, held in Paris in 1878, was: 'Convinced as we are that the legislation presently in force is inadequate; that the system of legal separation is immoral and should be eradicated; that the indissolubility of marriage is contrary both to the principle of individual liberty and to morality and has the most unfortunate and terrible consequences; that divorce is necessary from the perspective of humanity, of morals, and, in a word, of the future of society . . . the Congress demands: . . . The establishment or re-establishment of divorce, according to the principle of equality between the spouses.' S. Groag Bell and K. M. Offen (eds), *Women, the Family and Freedom: The Debate in Documents*, Stanford University Press, California, 1983, vol. 1, p. 454. The question of divorce remained a contentious one throughout the nineteenth century. Civil marriage and divorce legislation was first introduced in France in 1792, but civil divorce was abolished in 1816. From 1830 onwards there were sporadic attempts to re-establish divorce but the campaign only became effective during the Third Republic resulting in 1884 in the passing of a cautious law which still failed to satisfy those campaigners who had argued for the granting of divorce by mutual consent. See S. Groag Bell and K. M. Offen, *Women, the Family and Freedom: The Debate in Documents*, vol. 2, pp. 181–90 for a brief discussion of the debate.

30 J. Rose, 'Introduction II', in *Feminine Sexuality: Jacques Lacan and the école freudienne* (eds J. Rose and J. Mitchell), Macmillan, London, 1982, p. 43. It was in 1958 that Lacan entered into the debate on the 'phallic phase', when women's relationship to the phallic term was described in terms of 'masquerade'. See J. Lacan, 'The Meaning of the Phallus', repr. in Rose and Mitchell, pp. 74–85. J. Rivière, 'Womanliness as Masquerade', *International Journal of Psychoanalysis*, 10, 1929, reprinted in *Formations of Fantasy*, Methuen, London, 1986. All references in the text are from this edition.

31 Rivière, p. 37.

32 Ibid., p. 38.

33 In a very useful article, Stephen Heath places the discussion on 'masquerade' into historical context, situating it within psychoanalytical debates on female sexuality and unpacking some of its ideological constituents. He provides a critique of the assumptions underlying Rivière's theory, pointing out the ways in which she collapses the integrity of the former with the artifice of the latter. S. Heath, 'Rivière and the Masquerade', in *Formations of Fantasy*, p. 50.

34 Heath, p. 52.

35 Ibid., p. 52.
36 Ibid., p. 54. Irigaray exposes the fabrication of the Other in patriarchal culture as a fragile mirror, reflecting back to the 'subject' *his* own self-image. In this economy, woman has access to men's 'reasonable worlds' only through 'mimicry', but remains 'powerless to translate all that pulses, clamors, and hangs hazily in the cryptic passages of hysterical suffering-latency'. Words themselves become the 'wrapping with which the "subject" modestly clothes the "female"' and it is from language itself, 'the belt of discourse', that woman must learn the need to break out. Irigaray, 'Any Theory of the Subject', op. cit., pp. 142–3. Irigaray was expelled from the *Ecole freudienne* for her iconoclastic *Speculum de l'autre femme*, published in 1974.
37 *Journal*, p. 617.
38 This comparison was made by the society columnist Etincelle in *Le Figaro*, January 1882. See *Journal*, p. 520.
39 An 1882 entry in the journal reads as follows: 'I truly believe that R.F. (the successful painter Tony Robert-Fleury) has a very correct opinion about me; he takes me to be what I should like to appear, that is to say, perfectly amiable, or, to speak more seriously, a very young girl, a child even, meaning that while talking like a woman, I am at my heart's core, and in my own sight, of angelic purity.' *Journal*, p. 544. On another occasion she attempts to charm the painter Bastien-Lepage 'by artificial childishness', p. 573.
40 See *Journal*, p. 645 for one of the many expressions of a wish for fame. Of marriage she writes: 'Commerce, traffic, speculation are honourable words when properly applied, but they are infamous when applied to marriage; and yet there are no words more appropriate to describe French marriages.'
41 *Journal*, p. 335.
42 Irigaray, 'Pouvoir du discours', op. cit., p. 210.

Part II

DESIGN HISTORY

INTRODUCTION

BLOCK evolved in an art school where the majority of students were engaged in design practices. From the early 1960s there was an institutional assumption that students should be taught the history of their own studio specialism, and from the early 1970s the phrase 'history of art and design' began to be used in official documents. The National Advisory Council on Art Education saw the function of these studies as essentially evaluative – 'elevating taste and discrimination', but for art historians whose interests in the social dimensions of artistic practice had drawn their attention to the Arts and Crafts Movement and the Bauhaus, this raised the possibility of approaching design as a more material and politicised practice of production and use than 'art'. Design history was given institutional space and a sympathetic reception from students who had puzzled over the relevance of black and white slides of Cézannes.

Official reports produced at the end of the 1960s noted that there was a shortage of staff with expertise in teaching design history, and in the aftermath of the student unrest of 1968 art colleges saw an investment in 'relevance' as a priority. Clearly there were other influences from social history, technology and a growing interest in 'recent antiques', but for the editors of *BLOCK* there was a particular virtue in seeking to redefine art history with reference to the more pragmatic and democratic procedures of design history.

Middlesex hosted the second annual Design History Conference in 1976 and by that point we had drafted a version of the submission that was to become the first postgraduate course in the subject. Critical perspectives which were to become components of the 'New Art History' acquired an early relevance in the drive to provide a social context for various components of everyday life.

BLOCK set out to treat design, like art, as an ideologically encoded commodity, the value and significance of which were dependent on dominant modes of consumption. This approach was in opposition to prevailing versions of design writing which adopted untransformed art historical notions of univocal authorship, inherent meaning and received hierarchies of value. The first priority was to disengage from notions of authorship and the

131

pathetic fallacies of intentionalism, unself-reflexive paradigms which left little room for the complex processes of investment and desire which imbued objects with social and existential meanings.

Re-reading the articles reprinted here, the single most important precept that seems to underwrite them all is the dialectical insight offered by Marx that the design and production of objects is also the design and production of their users. As Philippa Goodall says: 'design for use is design of use'. Alongside this, from an early stage, is an interest in the cultural agency of the consumer.

The subversive pleasure of laying out images and publishing analyses of radically ordinary objects is hard to recapture in the design serious image culture of the 1990s. There was a thrill in refocusing the 'art historical' eye to take in that undergrowth of visual culture. Design history was an opportunity to explore the productive *frisson* of botanising the apparently mundane object – to investigate the minutiae which, from the lofty vantages of art history, appeared as an unauthored blur.

Hannah and Putnam's 'Taking Stock' is, as it says, a timely summation of the achievements and discontents of thinking these issues at the end of the first decade of 'design history'. The article brought a positive response from Necdet Teymur and Tony Fry ('Unpacking the Typewriter', issue 7); their interest in the intersection of processes of production, mediation and consumption was reflected in the influential historiographic overview carried into the US design community by Clive Dilnot, through the pages of *Design Issues*. Teymur systematically deconstructs the term 'design', demonstrating as he does so the complexities of the divisions of labour involved and criticising the predominance of political and economic analyses in favour of an approach which focuses the metaphoric and poetic relations design objects enter into. His interest in the micro-politics and discursivity of design indicates an indebtedness to Foucauldian thinking which underlies a new archaeological mood apparent in most of these articles.

In her article, Kathy Myers suggests the need to supplement traditional Marxist understandings to account for the productivity of consumption and to incorporate the home as a site of production. Goodall identifies the home as the site of the restructuring of capital, particularly in the new economy of Thatcherism. Together with the new analyses of advertising stimulated by Judith Williamson's work, such institutional analyses offered an anatomy of meaning and value in goods brought to the market.

BLOCK's approach to design was subliminal as well as material; it involved going beyond the frames and the simplistic antinomies to render design no longer a docile object of study definable according to notions of creativity, quality or 'style'. The strategies of the articles involved a double movement, both gesturing towards the conditions of a more socially responsible practice of design and, perhaps more significantly, rendering design as a physical shaping of social forces, aspirations and modes of power.

132

The study of consumption as a creative process was pioneered by Dick Hebdige in his work on the postgraduate programme at Middlesex. He developed the analysis of ritual and bricolage that first appeared in *Working Papers in Cultural Studies and Subcultures* (published in 1979) with a concern for the social positioning of objects and their potential for negotiating difference and defiance. The ways in which he integrated a sense of the materiality of design and its conjunctural and ethnographical dimensions provided something of a breakthrough in design studies – a confluence of the innovations of contemporary cultural studies, and the revisionist energies released by a reconceptualisation of visual culture. Design as a condensor of social relations and roles was central to Philippa Goodall's discussion of the gendering of the home environment which linked with the work of the feminist design collective MATRIX and informed the V&A/Middlesex 'Household Choices' project.

The editors were conscious (and admiring) of the energies of the members of the Birmingham Centre for Contemporary Cultural Studies and their joint initiatives with *Screen* and *Screen Education*. Their radical anthropology of everyday life was a particular inspiration for the design conscious. At one time, in Birmingham, the work of Foucault and Klaus Theweleit were influential for the Visual Pleasure Group – which included Owen Gavin, Angela Partington and Andy Lowe – an extensive project on the Festival of Britain is represented here by Barry Curtis's 'One Continuous Interwoven Story' which attempts to locate a 'style' in a complex of ideological, subjecting interpellations.

In 1987 the Design History Society began to produce its own journal, and the critical perspectives established on the subject in *BLOCK* have increasingly set its terms of reference. During the faux boom of the Lawson years 'design' was deified as a mysterious value-creating activity in the popular press, but for *BLOCK*'s writers and readers its relations were more transparent and contingent. The processes of demystifying and 'unpacking' went hand in hand with a degree of wonder at the wilder significations and investments involved in the day-to-day engagement with objects and environments. On re-reading these characteristically 'difficult' articles it is a pleasure to find them far from doctrinaire – rather they seem positively charged with the imaginative pleasures of iconoclasm and discovery.

8

TAKING STOCK
IN DESIGN HISTORY

Fran Hannah and Tim Putnam

(*From*: Issue 3, 1980)

What is 'design'? How, and for whom, has it existed? What is a history of design a history of? What are its distinctive problems and methods? To whom is this knowledge of any use or interest?

In the mid-1970s, when design history was emerging as a distinct area of study in Britain, these questions were much discussed. Lecturers in poly-technics and colleges of art, who had experimented for a number of years in adapting the history of art to the needs of design students and had come to think of themselves as 'design historians', felt a need to define the area of their study. To a large extent this was a definition *against* ruling conventions of art history; the designer was not to be considered an artist-hero; design was *not* to be treated as an art object. As Bridget Wilkins wrote in 1976:

> There can be no one person who can be called a designer, as there can be no one function of an artefact; for a 'designer' acts within his historical environment, his social situation. Many of the criteria for an artefact have already been decided for him, for example the availability and nature of materials, the social and economic circumstances. Even the decision to produce that category of artefact may have already been formulated. Such limitations do indeed form an important part of the design. Design satisfies requirements of society, but in order to satisfy them, the need must have existed in the first place, before the actual production of the artefact, and before the arrival of the designer.
>
> Most of the above considerations are not visual but they go a long way towards explaining the artefact. This is the scope of Design History. However, much Design History is being written and taught on very different lines. Often the choice of the artefact is limited to those accepted as 'beautiful' or 'decorative': and the main function of these artefacts is frequently just that; to be 'decorative'. When these artefacts are discussed the main point for consideration seems to be the form and decoration and how they relate to other objects, especially Fine Art objects. Admittedly most of these stylistic features will have

134

originated in Fine Art; but in Fine Art there are usually intellectual or philosophical connections which on the whole are lacking when the forms are transferred to artefacts. This means that the question of style is treated on a comparative basis, as in Art History, and discussion will centre, for example, on the development from Art Nouveau, through the Deutscher Werkbund, Futurism, Constructivism, De Stijl and so forth, to Art Deco. (This approach has led to considerable confusion already: What is Art Deco?) These visually oriented categories have been accentuated and popularised by colour supplement spreads and publishing houses producing picture books on the 30's and 40's (used by nostalgic revival students as pattern books). This is not Design History. It is applied art connoisseurship. It does not involve or relate to people. Style is important to the Design Historian for its psychological significance rather than for its comparative or developmental aspects.[1]

Although this statement was considered controversial, related points were made at the time by a number of others. Noel Lundgren, for example, argued for viewing design as a commissioned process in which failure in fulfilling complex functional requirements was historically more important than aesthetic or other judgements of excellence.[2] Jon Bird argued for the demystification of the processes by which design becomes the repository of idealised aesthetic categories and the development of means by which we can understand design as a process of communication.[3] These critical comments pointed in two directions: (1) a *departure* from art history into a new field with its own objects and methods and (2) the annexation of design to art history as a catalyst of theoretical development in that discipline.

Today, half a decade later, design history seems on the surface to have achieved the status of a distinct subject specialism: it has its own degrees, conferences and publications.[4] Yet neither of these critical routes has been followed very far by very many. The empirical 'consolidation' of the subject has largely taken place around the formula *the history of design in social-economic context*. All too often this means that art-conventional notions of design still pass as the substance of the subject while context amounts to an eclectic dipping into new fields. Bits of business history, history of technology or social history find their way into an account without consideration of the problems proper to those histories or even the processes by which they have become established as knowledge. 'Context' is not really established because we are still in thrall to certain categories which present themselves as the self-evident substance of any history of design. Such notions as 'designer', 'school', 'artefact', 'medium', 'style', continue to be taken as starting points even when they have been the subject of critical discourse in art history. Far from being a greener pasture free from the contradictions of art history, design history is in fair danger of becoming an academic backwater.

This would be a great shame, as the subject has many pretensions and not a small list of responsibilities. Its development in Britain, due to the nature and scope of art and design education in this country, is unique and is attracting an increasing interest overseas. It is the very way in which design history teaching has grown out of the design courses however which has created many of the difficulties in defining the area of study. In this paper we first show how this pattern of education has encouraged an eclectic approach to the subject, and then go on to discuss some consequences of this eclecticism. The aim of our critique is to root out the idea that there is a 'thing' identifiable through art-derived categories, which design history is about, and which only needs to be described and put in order to be understood. We want to open up the way to thinking historically about design as a complex social relation interconnected with other relations. This knowledge should involve and relate to people, and it should relate to the practical knowledge involved in making and using design. A first stage in developing this knowledge is distinguishing the different 'histories of design' extant in design history, or which need to be developed in order to meet the demands placed upon it. A critical comparison of these histories may then lead to the establishment of the History of Design which would be the appropriate object of study for design historians.

THE FORMATION OF DESIGN HISTORY ECLECTICISM

When the new Dip A.D. courses began in 1963 they contained a compulsory art historical element. This was intended as a background to the 'fine art' element of visual analysis which was considered the appropriate general theoretical study for 'designing'. The students were to study 'the major Arts in several significant periods'.[5] From the beginning the actual place of art historical work in design courses was problematical. While visual research might pretend to a general theoretical position in relation to design, art history could only escape from the deep background by becoming involved with the history of aspects of design studied on diploma courses. These are the forces which induced the development of design history, apart from those areas, chiefly related to the history of architecture, which formed part of the art history survey courses.

This increasing integration with design education was reflected in the substitution of an extended essay project or thesis for the final examination in art history. The drawing up of the guidelines for these pieces of research, the definition of their subject matter, and the criteria used to assess them embodied the embryo of a new theoretical and empirical study more directly related to the main study areas. The subjects undertaken in the theses, chosen by the students, came to include a progressively wider range of cultural artefacts, including works of popular culture hitherto disregarded by art history.

In practice the closer involvement with design students meant accommodating the media-based grouping of the design courses themselves. This pattern is quite historically specific. It derives in part from the nature of subject differentiation in British academic tradition, in part from a regard for the structure of British industry. The desire to produce designers suitable for industry has been a major factor in post-war design education and prompted numerous debates which affected course structure. Certain of these concerned the relative merits of British models of designing (which are generally organised around in-house designers) as opposed to the American system of freelance industrial design. The 'generalists' argued for inter-media courses based on study of design methods and problem analysis, while the 'specialists' claimed that a knowledge of processes for specific media was necessary until the pattern of employment itself changed.[6] The result was the retention of the linear structure of the courses. Design history may well have developed differently had there been more of a move towards the American 'generalist' method.

As it was, in the construction of design history courses two alternative approaches were adopted. These were determined by the range of students taught. In situations where design students from several areas came together, a more comprehensive coverage of design types could be undertaken. The courses depended fairly heavily on the available literature concerning architecture with a strong emphasis on the 'Modern Movement' and the Bauhaus. Pressure to include material outside that of the dominant avant-garde (partly a result of the nostalgia boom of the early 1970s) led to the inclusion of stylistic categories such as Art Deco and 1930s streamlining. What this did was simply widen the range (adding-in on a stylistic basis) which led to the kind of confusion referred to in B. Wilkins' note. Art Deco has been seen to have significance as a style since the dominance of 'Modern Movement' functionalism has been questioned, but it is generally still defined in terms of its origins in Cubism, primitivism, etc.

Where, as was often the case, design history teaching followed the media basis of a design course, a different pattern of eclecticism emerged. The starting point was existing discussions of the 'minor' 'decorative' or 'applied' arts, together with literature written for collectors. The limitations of such accounts were all too apparent: concentration on visual or stylistic features became a sterile exercise in classification once categories of objects were treated in isolation. In addition, connoisseurship encouraged a closed system of relation between monetary and aesthetic value, divorced from the conditions in which the objects in question were made and used.

Design historians frequently sought to break this circle by drawing on other disciplines, with mixed results. Aspects of relevant production processes were often documented in the history of technology. Unfortunately, these accounts often mirrored the defects of histories of the minor arts: chronologies of fixed visual or physical properties, anachronistic assumptions of

137

contemporaneity as progress, and idealisation of inventor-heroes, rather than discussion of actual production processes. Design historians were pushed in the direction of business history and of social and economic history generally for a discussion of modes as well as means of production, which allowed them to locate the design activity within an overall organisation of production. A discussion of Josiah Wedgwood, for example, as an entrepreneur and salesman in the context of late eighteenth-century business, could contribute more to a history of design than discussing Wedgwood merely as a promoter of the neo-classic taste.[7]

Understanding a firm or an industry, however, involves placing it in its conditions of existence. While design historians specialising in particular industries could draw, for example, on studies of comparative industrial structure, media orientation of staff and students encouraged fragmentation and the belief that areas of design can be studied and understood in isolation. Such fragmentation was an even greater barrier to studying how design is used, apart from 'the trade' itself. Isolated social phenomena, such as tea drinking or hygiene, were referred to when needed as external props to a product history, but the nature of such phenomena was seldom discussed or even established.[8] Chatty social history, or a narrow sociology which abstracts functions appropriate to particular product types, were integrated into media-based work while 'social and economic context' remained an aspiration.

Would-be design historians, therefore, found themselves following lines of least resistance which, while not exactly dead ends, were certainly not new departures. The new subject reproduced the reality of borrowings from art history and constraints from particular patterns of design teaching. This situation produced the critiques and programmes discussed at the beginning of this paper. As we pointed out, the chief common characteristic of these critiques was that they polemicised against certain art historical practices. If the ground were cleared of these obstacles, all would be well. Now, 5 years later, we have to consider why this estimate appears sanguine. Why, while individuals have developed new and distinctive styles, are the old patterns still reproduced?

Our first observation would be that the conditions in which design history was formed still apply to a large extent. Most design historians approach the subject from an art historical or design medium background. The possibilities of individuals or even small groups adopting new perspectives and new skills are daunting; this situation encourages eclecticism or a preoccupation with 'theoretical' work to the exclusion of research. The scope of design history requires extensive co-operation across, and within, colleges. We are only beginning to see this interaction and the openings it will make for purpose-built design historians. Similarly, most design history is still taught within the same constraints, which have, if anything, become narrower due to the cuts. (The lifting of the '10% rule' may, in this context, be a

blessing in disguise allowing a closer integration with complementary or related studies via, for example, a single thesis.)[9] These forces are not ultimate determinants if they are recognised and opposed: unfortunately critiques largely ignore these 'material forces', and criticise their effects instead.

From this point of view, even the institutional 'consolidation' of design history may have been deceptive, encouraging the illusion that the subject exists *because* people meet to discuss it, write papers, organise courses, irrespective of *what* is said, or written. The old enemies, however, have not really been overcome: they exist within design history. To a large extent covered over by the formula *history of design in social-economic context* they will continue to exist until they are transformed or exchanged for new means of organising work. This requires a continuing process of discussion, the results of which cannot be given in advance by some macro-theory. The balance of this paper is a small contribution to keeping this discussion alive. We focus on three unresolved historiographical problems in design history writing: the nature of aesthetic evaluation; innovation and influence; and 'design itself'. In each case we attempt to expose and transform categories 'given' to design history by the circumstances in which it has been created.

AESTHETIC EVALUATION

It is widely recognised that historians should make explicit their reasons for defining a subject as worthy of study. Anachronism is inevitable if what is presently considered significant cannot be contrasted and related to the orders of significance which have prevailed in other times and places. The crudest form which this problem takes in design history is the unrecognised intrusion of aesthetic evaluation. Historians have taste which cannot and need not be suppressed, but if this taste operates as an unknown and therefore arbitrary determinant of what is selected as good or significant design, then the result is indifferent design criticism rather than any kind of history.

The influences of important traditions of design writing which are antihistorical in this respect have been exorcised to a certain extent. Connoisseurship knows the periodisation of design criteria intimately in one sense, yet typically lacks a sense of the constantly shifting boundary around what is worthy of attention by the connoisseur. It is now well understood that this lack of self-consciousness derives from the fact that connoisseurship operates within boundaries of current social cachet and market valuation which it does not need or want to see. (This charmed circle is broken only by entrepreneurial fashion-launching literature.)[10] How historians of design are to understand their work in relation to these powerful forces is, however, a more difficult problem than seeing the difference between the two.

The 'Modern Movement's' peculiar combination of functionalism and aestheticism is now recognisable as a profoundly anti-historical influence.[11] The only history allowed is one of progressive realisation and the uncovering

of anticipations. Though many critiques and oppositions have now been mounted against this avant-garde-become-many-headed monster, we are still some way from being able to put into perspective its most pervasive assumptions concerning the nature of significant design. For example, Stephen Bailey's recent *In Good Shape*,[12] issued under the Design Council imprint, recognises the historically limited character of the 'Modern Movement', but bases its own selection of 'significant' modern design on whatever has 'style and wit'. A complex taste operates without being recognised or discussed as such. More consistent bases of selection, such as pioneering form or scale of production are surreptitiously introduced without being systematically employed. One only has to imagine the historical limitations of a museum which collected on such a basis to see the need for a more self-conscious approach. If what counts as historical data is arbitrarily determined, the results of any enquiry based on such data will be equally arbitrary (garbage in, garbage out). Even if the principles of the ruling taste could be specified, we would still be left with little more than a document in the history of taste, circa 1979. Covert aestheticism then provides us with our first example of misplaced substance in design history. In this case it is easy to recognise that what appears as the substance of the discourse is not comprehensible in itself.

INNOVATION AND INFLUENCE

Covert aestheticism is pervasive in design history writing, though often stigmatised, as it is far easier to recognise in the work of others than it is to avoid in one's own work. It is not, however, the chief organising, or disorganising, principle at work. Many monographs on great designers and schools of design are organised around a notion of fundamental innovation or extensive influence rather than an endorsement of visual values.[13] Even here, however, where an apparently more historical criterion of significance and ordering is being employed, the choice of designer or design school as an organising category often interferes with the exploration of the problems raised. There is great temptation to treat the designer or school as the *substance* of the discourse, whose existence is not taken as problematic, and to place the substance in context, following out selected lines of connection which are then given the name of influence or innovation. In our view, such a procedure assumes away most of what is worth examining about these processes.

In the first place, it is not possible to judge either innovation or influence without a mapping of the overall distribution of design variations. That such a mapping will remain incomplete for many years in no way undermines its logical importance in historical judgement. Accounts which take great designers or schools as self-evident starting points cannot think such a map; they suffer from historical tunnel-vision. This point was made forcefully by

Tim Benton in 1975, concerning the self-confirming nature of the status attributed to the Bauhaus.[14] Similar points have been made in the history of ideas and in art history.[15] A second problem with this sort of account is that the substance is a *subject*, an individual or collective personality, which exercises creative or free, unconditioned agency. As Bridget Wilkins points out in the passage quoted above, there are serious problems with identifying designers as personal agents because their work is embedded in a complex social process of historically varying form. One must be able, therefore, to demonstrate the nature and limits of the actual agency involved, rather than assuming a substantial but undefined latitude of thought and action.

At the most basic level, one must be able to differentiate agency from situation. The simple description of the situation in which 'a designer' works involves specifying the available world of design possibilities and attempting to make clear the nature of the principles which accounted for what was, and what was not, thought and done. These design-generating principles need not be explicit or systematic. They may be more akin to 'second nature' than to any kind of theory.[16] There are variations, oppositions and gaps in a designer's culture, or second nature, as well as differing means by which it is propagated: for example, model, plan, varying codes of information. To the extent, however, that a common culture exists at any one time or over time there will be a kind of overall coherence in which what is made and thought will have meaning defined in relation to its complements. Specifying the nature of a designer's second nature considerably delimits the scope of personal agency. This does not mean that designs are not produced by real individuals but that personal creative activity operates with and through a designer's culture. Designing draws on and refers forward to a stock of knowledge and external requirements. The analysis of this culture involves:

(a) Characterising the limits of variation of what designers do: to the extent, for example, that design is a theoretical as opposed to practical activity it will be capable of being described as a set of rules rather than as a set of improvisations made by drawing on a repertoire.

(b) How does one learn to be a designer? Learning by example is clearly different from formal pedagogy.

(c) What is the place of designing in the social division of knowledge and labour involved in making things? What are the means of specification and evaluation which connect designing with its external context?

(d) What are the available means for circulation of information to and for the designer in a general cultural context, apart from those specified directly in relation to (b) and (c)?

The historical problems of innovation and influence may then be approached in terms of a culture so specified as changes in rules of thumb which delineate design possibility and changes in the processes which relate conception to execution. The study of these themes would not then involve

a circular opposition between agency and situation, as is often the case when a pure, unconditioned subject is used to organise a context the purpose of which is to account for the nature of his/her work. Taking the notion of design as an activity seriously involves reformulating our ideas of who or what acts, and the nature of the what that is acted upon, because it is also the acted *with*. In other words, because the culture is drawn through the designers, innovation and influence take place within the culture. These should be studied as processes in their own right and not employed as unproblematic criteria by which 'important' designers are selected as worthy (but necessarily incoherent) units of study.[17]

THE NATURE OF 'DESIGN'

The notion of designing as an activity may be pursued further, into the realm of 'design' the noun, which is supposed to exist in artefacts and in representations. Designing is relational in character, and these relations fix on objects, but the objects are not then fixed with an immutable significance forever. The production of design increases its complexity as a social process; the designed object enters into new relations of valuation and of consumption. Therefore a given design passes through and is defined within a plurality of relations. Further, when these relations change, the significance of the object as design is altered insofar as it is still a term in those relations.

This may involve a changed use of the object, a different valuation, even a material alteration, but design also alters in its signification of social difference (as, for example, the changing signification of gender difference by trousers).[18] In this way, the meaning of design is continually being historically reconstituted; it is a persistent complex of activities rather than a once and for all creation. Therefore there must be multiple *histories* of design.

This broader sense of design as activity in which all members of society participate should be brought to bear on the categories which are used to organise the description of design. These categories imply abstract objects: what is the historical status of these abstractions? Do they recognise the relational nature of design? Here we will consider, as examples, the *media* in which designs are worked and the complexes of perceptual (chiefly visual) qualities defined as historical *styles*.

The notion of *medium* may be a useful descriptive index in the sense of materials worked or means of communication. It points in the direction of a relation in the history of design which may be singled out for examination, e.g. in the scope of uses for different materials at different times and the implications of available materials and methods for the realisation of design projects. The notion of medium in this analytical sense is not at all the same as that used loosely to designate the different studio areas in design education. These areas involve the practice and pedagogy of a

number of different relations constituting design. Each of these areas has its own history, characterised at a different point in time by a distinctive combination of, for example, the constitutive importance of materials, manufacturing and design processes, product definition and marketing. Of the present design degrees, some are more defined by the nature of materials worked, others by product range, others by production and design process. The notion of medium is therefore either a limited or doubtful organising category for design history work, depending on whether it is taken in its precise or loose sense. Yet because much design history teaching takes place in courses which see themselves as medium based (in *some* sense, often left implicit) powerful forces are at work to objectify categories which may rest on nothing more substantial than the industrial structure of a particular country at a particular point in time. Much of the place occupied by the notion of medium needs to be re-occupied by an analysis of production processes which include material transformation (i.e. the interaction of medium in the narrow sense and physical processes), the social division of labour and knowledge (systems of manufacture), and economic calculation as applied to design and production decisions.[19] However, a reformulated study of production processes which opened up for comparative analysis the problems often obscured under the givenness of design 'media' would not in itself be a history of design, although it would go some way towards meeting the points raised by Noel Lundgren in his 1976 paper. For we have to consider how design is used as well as produced. Unless one identifies design and production studies with product types and product types with categories of functional needs or types of activities, or understands social development as an expression of essential process, e.g. rationalisation, the question of design in use cannot be subsumed under the discussion of design in production. In our view, it is crucial that categories derived from the world of production, embedded in functional technical-economic discourses, are not allowed to usurp discussion of the significance of design in use. (This is not to say anything about the *actual extent* to which all social life is organised through the formal economy, except that this extent can never be ascertained if technical-economic discourses are allowed to define the field in advance).[20] We would look askance, therefore, at any attempt to discuss the history of design in terms of social activities or needs which did not take the existence of those categories as an historical problem, or which failed to recognise that a fundamental characteristic of design is that it exists in a *multiplicity* of relations, which cut across each other. A 'useful' object, for example, may also be a gift, 'giving' a different act in varying social milieux and the giving of a particular gift at a particular time something else again.[21]

Vocabularies exist for the description of perceptual, largely visual qualities of design which are not tied to functional analyses. These vocabularies have been used to group diverse objects comparatively, and these groupings used in turn to form the basis of a periodisation (or other segmentation)

of the produced environment. Historical problems are considered to arise concerning the specification, application and temporal alteration and succession of these categories. What is the status of these categories in the discourse of design history? In particular, what is the historical significance of stylistic analyses? Several writers have emphasised that the most important considerations in histories of design are not *visual*, but concern the conditions in which objects are made and used. This seems an odd opposition, for visual properties are essential to an understanding of both the production and the consumption of design. Surely what is being opposed is a notion that the history of design may be conceived as a chronology of stylistic characteristics abstracted from these, indeed from any, relations. It is useful for comparative purposes to employ general descriptive codes, but the very supra-historical quality of these codes invites confusion. The codes assume a substantial rather than nominal existence, their a-historicity becomes historical continuity and a means by which present values are retrojected into historical situations. Yet it is recognised that the perception of colour, proportion and perspective are historically and culturally variable, and that the ways in which stylistic characteristics have been recognised and significant discriminations made have varied enormously. How artefacts and their representation change significance as they pass out of the conditions of their conception and production ought to be a high priority problem in design history. The variability of significance rather than the persistence of qualities should be at the forefront of analysis. What does it mean to assert a stylistic identity between a 'Louis XV' chair in eighteenth-century Paris and a 'Louis XV' chair in a twentieth-century museum?

To recognise that histories of design in use are part of the history of cultural valuation means that no stylistic vocabulary may be regarded as transparent, however nominalistically treated. An important object of research should be to uncover and articulate means by which significance is attributed to objects, in order to open up more dimensions in the history of styles, and pose questions about the relationships between changes in valuation and changes in patterns of production and consumption. The means by which these investigations are carried out may vary, but it is possible to see lines along which work needs to be done. As the history of valuation must be read to a large extent through linguistic evidence, there is a vast amount of research to be done to establish continuities and discontinuities in descriptions and evaluations of design existing at any time or over time. The patterns then derived may be compared with changes in other patterns of usage, and, outside linguistic media, with visual evidence, in order to establish changes in significance attributed to the perceptual qualities of design.[22]

The historical recuperation of stylistic analysis is not, of course, simply a question of historicising stylistic categories, or, more generally, relativising the bases on which discriminations of significance have been made in the

historical perception of design. The ultimate aim of research in this area is to recover the meaning of design through understanding its use, in the broadest sense of the word. Therefore, the analysis of style becomes the analysis of *styles of life*, of modes of use of the produced environment, both directly and indirectly. It is important not to lose either of these senses of use, although they are often, *in fact*, intertwined. *Direct* usage is what is often called utilitarian or functional; it refers to the sense in which designed objects may be said externally to constitute part of the objective conditions of a mode of living irrespective of whether they are seen as such from within that mode of life. *Indirect* usage is mediated symbolically; it refers to the sense in which discrimination between design qualities is used to define boundaries between different social and cultural categories and also, within a way of life, between times, moods, activities and other dispositions. These two sorts of usage must be studied together in bounded circumstances in order to recover any convincing sense of design in historical actuality. The study of 'functions' in itself imposes a reality which has a one-dimensional rationality; the study of systems of meaning in themselves fails to recover the pattern of practical activities which make up characteristic styles of life – both types of analysis are prone to a-historical abstraction, because they do not place at the centre of the analysis the problem of how those people whose activities are being reconstructed actually ordered their lives. If, for example, the nature of discrimination between stylistic qualities is recognised, in general, to be related to the definition of social boundaries, the nature of particular interpretations of design differences will vary with the way the boundaries are drawn. Hence one might expect fine degrees of discrimination in taste to apply in situations where social exclusion is evident, and also to be able to discover connections between the nature of the exclusion and the nature of the discriminations being made.[23]

If the historically important discrimination involved in the construction of meaning in design *is motivated within* practical situations which typically arise, then research should concentrate on the relationship between visual evidence and the other sorts of evidence by which patterns of typical activities can be reconstructed. In many cases, oral history techniques will be found to fill a gap between written and 'visual' evidence, although there is a great deal of scope for reading illustration as model narrative and for culling habitual action from literary sources. Fixed systems of evidence better display the oppositions and part–whole relations which seem to determine a universe of meaning but reminiscence often reveals better the real-time structure which shows how different activities were experienced as connected or disconnected. When one comes to consider the nature of the significance of design as determined by an overlapping set of activities, it is important to gain a real-time sense of the nature of this overdetermination. Only then will it be possible to say that we are studying the history of design as a social activity and not as a misplaced object.

CONCLUSION

In this paper we have argued that the conceptualisation of the historical space in which design can exist for those making and using it is essential if the proto-discipline called 'design history' is to achieve maturity. It is important to recognise that this process of discussion and criticism is not an end in itself, but the means by which design history can meet its responsibilities in design education, evaluation and research, as well as make a contribution to the understanding of the produced environment, as the world we inhabit.

NOTES

1 Bridget Wilkins, 'Design History in Polytechnics and Art Colleges', *Association of Art Historians Bulletin*, 1976.
2 Noel Lundgren, 'Transportation and Personal Mobility', in *Leisure in the Twentieth Century* (ed. B. Wilkins), Design Council, London, 1977.
3 Jon Bird, 'Art and Design as a Sign System', ibid.
4 To date, five CNAA BA (Hons) degrees with Art History, one BA and two MAs in its own right. The Design History Society publishes a newsletter which may be obtained from: Alan Crawford, 85 Clarence Road, Kings Heath, Birmingham, B13 9UH.
5 National Council for Art Education Report, 1960 (extracts in C. Ashwin (ed.), *Art Education: Documents and Policies 1768–1975*, Society for Research into Higher Education, London, 1975).
6 D. Warren Piper (ed.), *Readings in Art and Design Education, 1: After Hornsey*, Davis-Poynter, London, 1973.
7 N. McKendrick, 'Josiah Wedgwood: An Eighteenth Century Entrepreneur in Salesmanship and Marketing Techniques', *Economic History Review*, XII, 1959. Many of the points raised in this part of the argument may be illustrated in literature on the history of ceramics. Several books deal primarily with the dating of works from different factories. Industrial structure is discussed in such works as J. Thomas, *Rise of the Staffordshire Potteries*, Adams & Dent, London, 1971.
8 Bevis Hillier refers to the importance of tea drinking in the eighteenth century in his *Pottery and Porcelain 1700–1914*, Weidenfeld, London, 1968. Mark Swenarton's 'Having a Bath', in *Leisure in the Twentieth Century*, op. cit., isolates attitudes to hygiene as central to the evolution of the domestic bathroom but does not examine these attitudes or their formation.
9 In the 1960 NCAE report, art history was to constitute 10 per cent of the overall final mark, and a pass mark in the subject was required for completion of the course as a whole.
10 B. Hillier, *The New Antiques*, Times Books, London, 1977.
11 Of many examples: R. Venturi, *Complexity and Contradiction in Architecture*, MOMA, New York, 1966; M. Tafuri, *Architecture and Utopia*, MIT, Boston, 1977 .
12 S. Bayley, *In Good Shape*, Design Council, London, 1979.
13 For example, S.I.A.D., *Designers in Britain*, III, Allan Wingate, London, 1951.
14 Tim Benton, 'Background to the Bauhaus', in *Design 1900–1960* (ed. T. Faulkner), Newcastle Polytechnic, 1976.
15 Fritz Ringer, *Decline of the German Mandarins*, Harvard University Press, London, 1971; Michel Foucault, *The Archaeology of Knowledge*, Tavistock, London, 1972. See Adrian Rifkin's article in *BLOCK*, no. 3, 1980.

16 Pierre Bourdieu, *Outline of a Theory of Practice*, Cambridge University Press, London, 1977.
17 For example, Hazel Clark's and David Greysmith's papers on printed textile design at the Design History Society Conference, 1979.
18 Lisa Tickner, 'Women and Trousers', in *Leisure in the Twentieth Century*, op. cit.
19 For examples in the history of technology, see Maxine Berg, *Technology and Toil in Nineteenth Century Britain*, C.S.E. Books, London, 1979. In design history work see S. Worden, 'Furniture Design and Changing Sizes and Use of the Living Room: The Fireside Chair'. Paper presented at the Association of Art Historians Conference, 1980.
20 M. Sahlins, *Culture and Practical Reason*, University of Chicago Press, 1977.
21 See, for example, Bourdieu, *Outline of a Theory of Practice*, op. cit., Section 1.
22 P. Bourdieu, *La Distinction, critique social du jugement*, Editions de Minuit, Paris, 1979, examines the relationship between categories of discrimination and 'objective' social indices; J. Walker, 'The Old Shoes', *BLOCK*, no. 2, and Jon Bird, in *BLOCK*, no. 3, examine means by which significance is constructed.
23 See M. Douglas and B. Isherwood, *The World of Goods*, Allen Lane, London, 1979, for a discussion of exclusion.

9

THE MATERIALITY OF DESIGN[1]

Necdet Teymur

(This chapter is a revised version of the
article which appeared in *BLOCK*,
Issue 5, 1981)

INTRODUCTION

The pattern of design research and design education in the 1970s and 1980s
has been largely characterised by an over-emphasis on two seemingly legit-
imate extremes. They tended to take as their objects of study either the
'subjective' aspects of the design process mainly concerned with a universal
'designer' or a ubiquitous 'user'; or the supposedly 'objective' ones of design
problem-solving and designed artefacts themselves. Both these extremes,
however, correlated a 'man' with an 'object' – an epistemological operation
which is far from being a sound basis for understanding. What they seldom,
if ever, took into consideration was the fact that between the design and use
of an object existed a vast area where the designed objects were actually
produced.

Whilst the systematic studies on design were attracting often violent reac-
tions from traditionalist and professionalist quarters which are known for
their anti-theoretical stances, those who neither agreed with the traditional
nor with the seemingly 'scientific' approaches but believed in the relevance
of the neglected area of production, reacted by attempting to develop
production-oriented approaches. This involved the political, economic
understanding of the production of buildings, artefacts, literary or visual
artistic works, consumer goods and cities – an undertaking for which the
design disciplines were hardly equipped. These tended to over-politicise or
over-economise the subject for a variety of reasons: partly it was an over-
reaction to pseudo-scientism and the neglect of certain aspects of the subject,
a neglect partly arising from ideological prejudice; partly it was due to the
absence of the tradition in genuine theoretical research on production of
designed artefacts. The consequence of this was that the cultural, symbolic,
discursive specificity of the objects in question was largely ignored in
research, education and discourse.

148

THE MULTIPLICITY AND THE MATERIALITY OF 'DESIGN'

Another permanent feature of design discourse has been its failure to articulate and to theorise the multiple content of the term 'design'. 'Design' in general is as unhelpful a concept as 'life' in general or, indeed, 'production' in general. The concept of total design only adheres to the traditional notions of 'artistic' creation (whilst there is a world of difference between design activity and artistic activity), but by dumping whole sets of distinct activities and actions under one 'act'[2] it obscures the immensely complex and varied division of labour at the basis of any productive activity. One thing, therefore, that this paper will try to do is to make explicit what many feel, touch upon, but hardly articulate: the different usages of the generic term 'design' which is a noun and a verb, and also one which denotes a form of representation, an activity, a practice, a product, etc. at one and the same time. Whilst it is not possible in this text to deal with this problem in detail we will at least draw attention to this multiplicity by noting the variations and tentatively designating them with (D1), (D2), (D3) etc. These variations will, however, be discussed in the context of different forms of materiality.

All these and other problems seem to indicate a theoretical underdevelopment, an absence of rigour, a failure to distinguish between different levels of reality and abstraction and between different forms of knowledge. At this particular juncture therefore there seems to be an urgent need for a complex theoretical understanding of the design practices with all their dimensions, agents, variables, products and processes which exist in a socio-physical whole and which are not free of contradictions. With this objective in mind, this paper intends to contribute to such an understanding by offering a new set of concepts and frameworks, but not attempting to give yet another definition of design or an oversimplified and overgeneralised review of previous definitions. Instead, it will present a critique of some dominant trends while outlining a research programme on the *materiality* of design.

The question of 'materiality' (though not so far posed in this sense) has often been discussed in a simplistic manner which ends up correlating designed forms with particular socio-political patterns. Yet, to interpret design as a material force, as an ingredient of socio-economic reality or as a product beyond designed and manufactured consumer goods can generate more insight than simplistic correlations may have suggested so far. The materiality of design can be examined in specific terms of physical, technical, political, economic, institutional, epistemological and discursive materiality with significant implications for future research and education.

POLITICAL ECONOMIC MATERIALITY OF DESIGN

Design activity (D1) is an integral part of the general network of economic and technological activities which produce objects intended for consumption. This basic fact originates from an almost natural (and ontological) precondition of life, namely that every man-made object has to be produced before it is consumed, perceived, used, analysed or studied. Design is assigned the task of making decisions on modes of using materials, the forms they will take, the type of functions they will perform and, to a certain extent, the methods of manufacturing/constructing/making them. In this sense design activity is objectively integrated in production but apparently marginal to it. This paradoxical relationship is possible partly due to the specific nature of design activity but partly to the institutional, ideological, epistemological and discursive mechanisms which will be considered below.[3] The degrees of integration and marginality are variable but, in general terms, the types of design activity which we are considering here are carried out in definite socio-technical set-ups, organisations and institutions.

Thus, like any such practice, designing is carried out in and by definite sets of socio-economic relations which are determined by the dominant mode of production in particular social formations. Yet this determination within the same network does not iron out, or bridge, the gap between the respective activities of designing and making objects. On the contrary the gaps may be the necessary characteristics of particular modes of production.[4]

An institutional and professional separation of design process and producers from appropriators[5] crosses with the age-old separation of mental from manual labour and research and education from design practices. This complex set of separations cannot however be explained by simple correspondence at all levels. Design practices employ as much 'manual' as they do 'mental' labour, and these tend to correspond to the internal hierarchies of practices (as units of production).

Design, therefore, is the immediate and primary object as well as the product (D2) of a productive activity carried out by design practices (e.g. architectural, industrial, urban, graphic design practices) (D3). The socio-economic nature of these practices as productive units is of significance not only for the social scientific studies, or for managerial research. The properties, the quality and even the form (something which traditional design activity and research take as their primary object) of the products are effectively controlled and determined by these practices. Whether they are small or large, public or private, these practices are inseparably bound up with the patterns and modes of ownership and control of the materials, means of production, finance and (as we will see below) information. Design practices divide, manipulate, demarcate and shape the reality in collaboration with the signatures on titles, fences on land, money in bank accounts and

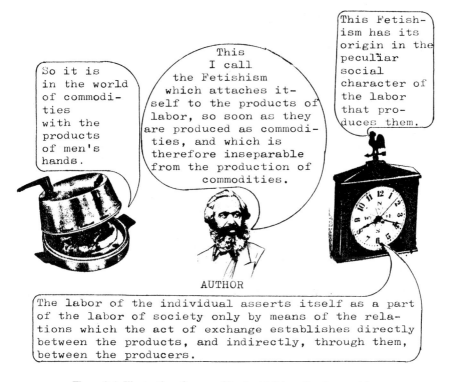

Figure 9.1 Illustration from a *Situationist International* pamphlet

keys in doors. In short, design activity takes place in the complex and contradictory space constituted by the system of production, consumption, exchange and management.

Research and education which take these absolutely fundamental facts of the world of design for granted are bound to suffer not only from inaccuracies, but also from irrelevance. Neglect of the production and the producers in their specific places in the social network amounts to the neglect of one significant part of reality. A society which under-educates and under-studies its producers (as producers on the scaffolding, assembly line, computer terminal or indeed on drafting machines, and not as passive 'users' with their shopping baskets) while dignifying and glamorising its decision makers and mystifying its consumers has to face the consequences of this imbalance in the uneven quality of its products, its life and its people.

Few designers are ever thought of as VIPs. In Stockholm, however, the creators of the Innovator range of furniture, Jan Dranger and Johan Huldt, behave like film stars. They are becoming well known for flying in and out of the capitals of the Western world, enlivening trade fairs

151

with stands emblazoned in the Swedish colours of blue and yellow, and being surrounded by beautiful girls (dressed in the same colours) and the music of Mozart. All this is rather strange because the furniture they produce is intended to be extremely simple and devoid of ostentation.[6]

Explaining the shaping of the designed world in which we live by reference mainly to some charismatic individual designers is like explaining social change by reference to the life-styles of some 'great' leaders or politicians – an all-too-common mistake which design research can do without. The fact is that the further design research has gone into the intricacies of the design process in isolation from the production process, the further it has got away from the realities of the world in which these activities take place. This trend, at least, has to be reversed.

The products of design activity, designs and plans are subject to the determinations of the prevailing mode of production just as much as the final products are. As specialized sets of instructions (D4) they are commissioned, paid for and used for definite financial, functional and, occasionally, ideological purposes. Therefore, in whatever immediate micro-climates the designs are made they are the outcomes of particular business or administrative sets of relations with their own frictions, exploitations, wage negotiations, hierarchies, divisions of labour, financial crises, etc.

To consider design process, design activity (and design research for that matter) as neutral, universal activities taking place in a vacuum is not consistent with the claims of scientificity and objectivity; nor is such an attitude helpful in understanding why there are so many anomalies, blind spots, unexpected difficulties and unexplained factors in the designed world. It is also important to see that conceptualising design activity as a productive activity in given socio-economic conjunctures and analysing design production itself as an integral part of the social production of goods and services adds up to a coherent perspective which, as we will see, can account for other, basically non-economic, instances too.

PHYSICAL/TECHNICAL MATERIALITY OF DESIGN

Obviously, any artefact which needs human skill, machines and techniques of production requires decisions to determine the multitude of choices involved in its making. Design and planning activities, whether institutionalised or not, are the activities of making these decisions at various stages of the process. Although the statement of a design problem often presupposes that the solution is say, a building,[7] i.e. a physical object, the conditions of existence of that physical object include various non-physical, non-brick-and-mortar factors which design activity is expected to manipulate. Design

activity covers a domain that largely falls outside even of its own scope.[8] The simple fact that design decisions have to co-ordinate and balance all the relevant physical, material, cultural, subjective, economic factors is universally recognised. The problem, therefore, is not to question this recognition but the terms in which it is preached, and the ways in which it is actually practised and made operational in design research and education. This is particularly important *vis-à-vis* the often ignored facts

(a) that there are not always physical/technical solutions to all given problems,
(b) that no solution can be the complete and universal answer to any problem – especially when the terms of the problem are far from being universal,
(c) that the researchers' definitions of problems may not necessarily be compatible with the practitioners' concept of solution,[9]
(d) that there is no single 'balance' between relevant factors of any given problem, and
(e) that even the definitions of problems may not match the intentions behind them.

It is therefore necessary to question the whole notion of 'design problem' and 'design solution' and, especially in the context of design research, distinguish between algorithmic and heuristic processes.

It is one thing to study buildings, typewriters, film posters or shopping centres as finished, well defined, largely self-contained unities that ubiquitous 'users' inhabit, use, look at, enjoy; it is another thing to see them as the physical outcomes of various technological, economic and ideological processes which leave their permanent marks on the ways in which they are consumed,[10] inhabited and perceived. Design as a form of condensed information (D4) and as a set of instructions is physically, technically and authoritatively present in any subsequent act of realising its contents. It is an ingredient in the technical production process. It gives shape to what is 'good' as well as what is 'bad'.[11] The answer to the question 'how is bad design possible?' is to be sought in the strategic intersections of technical processes, social relations of production, mechanisms of cultural and ideological reproduction and the exercise of the powers of access and control. A one-dimensional view of design as a 'form-giving activity' cannot account for the non-formal, non-visual, indirect and long-term effects of design decisions, nor can it explain questions such as why changes in forms do not necessarily correspond to changes in social life, ideology, politics, etc. or why forms are created on the basis of the most spurious reasonings.

Apart from the obvious physical order which he imposes, usually as a result of fashion or whim, upon our lives, there are the emotional pulls: ... It is the architects who decide what distance from the shops it is

suitable to put five-hundred mothers of children under five, architects who decide one year that old people like to be within sight and sound of children playing and the next day that linear terraces give better views and later that the same terraces produce a sense of isolation, and clusters are more socially desirable only to discover after a few months that clusters result in a lack of privacy, etc. etc. Yet each of these innovations which flit out of the architect's hand as drawings on paper, and can quickly be replaced by clean sheets on their boards, represent whole ways of life to thousands of people.[12]

As argued in this paper, a rigorous research programme (and a responsible education for that matter) cannot ignore these determinant facts in the course of studying objects, responses to them, their physical properties and formal configurations often referred to as 'designs' (D5). The reduction of the production to materials and technical operations, and consumption to objects and their use tends to deprive education and research of a real base from which to study real problems.

INSTITUTIONAL MATERIALITY OF DESIGN

Any concentration of units of production, decision, exchange or communication forms organisations ranging in scale from the family to states. No activity can today be said to exist in a vacuum. Whether it is writing poetry or building a railway network, one is inseparably connected to a series of visible or invisible mechanisms which regulate social, technical or economic

Figure 9.2 Advertisement for insurance brokers Marmot, Booth, Heylin & Co. Ltd, Manchester (c. 1980)

relations, which control or manage resources, behaviour, movements; which facilitate, inhibit, make possible, or manipulate the exercise of certain rights and, most significant of all, which in fact regulate the very connection that binds these various mechanisms together.

Design and planning activities are no exception. Whether they are done by individuals or by a team, by public offices or private firms, they are the activities all aspects of which are organised and institutionalised in various forms. These institutions employ people, run work-places, establish relations with other institutions, professions or individuals and lay guidelines for the operation of individual minds and hands that work in them. Even the proverbial 'gifted' individuals who are assumed to be 'creating' singular works of design have to have strong links with financial, ideological or professional apparatuses which would employ their services, and 'reward' and publicise their achievements.

> Olivetti is a company of 'firsts' or 'exclusives'. But it refuses to rest on the merit of having produced the best-selling printing calculator in the world, or of having made available to industry, technical and scientific laboratories and institutes of learning its famous 'Programma 101', the first micro-computer in the world with programs recorded on magnetic cards and the ancestor of a successful and ever-growing family of micro-computers. Olivetti is also the company whose name is associated with innumerable activities and achievements in the social, cultural and artistic fields. Others may have followed its example, but to Olivetti belongs the credit for having led the way in many directions.
>
> The evidence is everywhere: in the Olivetti plants and buildings, designed by the most eminent architects of the time; in the design of Olivetti machines, some of which are displayed as works of art in important museums; in the style of Olivetti advertising; in the numerous studies and publications initiated by Olivetti in the fields of urbanism, sociology, art criticism, linguistics, in which men as illustrious as Le Corbusier, Neutra, Jakobson have participated.[13]

With this fact in mind, it is neither realistic nor convincing to pretend that design is a mental process (and nothing else), or that it is a universal mode of problem-solving (without considering where the problems come from), or that the products of design are consumable objects, pure and simple, with a one-to-one relationship with their 'users' (as if both the object and its user drop from an outer planet into an uninhabited wilderness). Yet, in the meantime, professions are organised into institutions; interest groups and social classes form their associations and political parties; satisfactions are promised and advertised by powerful media while complaints are ignored or made harmless; resources are manipulated; harmful products are promoted and legalized;[14] whole social services (including their designers and planners!!) are dismantled and techniques and products of arts (from *Mona Lisa* to

155

promo-videos, from the 9th Symphony to CD-ROMs) are used to sell regres-sive, competitive, non-servicing and non-caring concepts of society.[15] The fact that 'quality' of one's life can be at the expense of those of many others, and that 'satisfying' a client may not always be compatible with the well-being of the society as a whole often escapes the otherwise perceptive and informed minds of 'successful' designers.[16]

Whether one explains these mental or physical facts in biological, ergonomic, psychological, systemic or semiotic terms it is still important to recognise the political, economic, legal and ideological contexts within which these facts and objects are made, consumed, perceived and researched. An institutional conceptualisation (integrated into other modes of con-ceptualisations examined here) would help explain these contexts, and overcome the dangers of fragmented and isolated research on problems whose terms of reference either loosely float in the air or, still worse, are unimaginatively grounded in the curtain walls or packages of equally unimaginative products!

Whilst many designers, researchers and educators pay continuous lip-service to 'context', it is possible to demonstrate that without a materialist conception of the institutions which not only determine or define, but also constitute these contexts, we cannot understand the fundamental paradoxes such as the relative or total autonomy and/or heteronomy of 'design'. Context is not what is external to a problem, nor is it synonymous with the negatively effective 'environment'.[17] Furthermore, context, seen as a stable and peaceful universe or as an organisation with an observable hierarchy,[18] cannot account for the constant changes, struggles, conflicts at every conceiv-able level. The comfort of ignoring conflictual complexity is often achieved by perpetuating glorified deaf-ears and institutionalised blind-alleys where new information and insights are stored away, domesticated, distorted and made ineffectual, and still worse, suppressed, as soon as they are produced.

An awareness and criticism of institutions is as important as the criticisms of products. Appraisal and analysis of products could be much more useful if they could show what made certain configurations impossible as much as how certain patterns or forms were made possible by designers and planners, but also by institutions which control both our reality and our knowledge of that reality.

EPISTEMOLOGICAL MATERIALITY OF DESIGN

'Building blocks' (to use a metaphor appropriate to the occasion) of designed and produced artefacts include in their constitutions not only 'bricks-and-mortar' (another literally meant metaphor) but many other ingredients without which these artefacts could not come into existence. These 'ingre-dients' (or constituents) include skills and techniques that evolved through

Foreword

The Prime Minister, The Rt Hon Mrs Margaret Thatcher

Throughout the world today, design ought to mean more than attractively finished products, important though these are in enhancing our homes and places of work. Design should be the starting point where the customers' needs for effective and reliable goods are brought together with the realities of manufacture.

The designer is thus the interpreter between the customer and the manufacturer. He must be aware of the market for which the products are destined, possibly involving extremes of environment or limited maintenance and repair facilities. Equally he must understand what can and cannot be done with the materials, machinery and skills available to the manufacturer. He must know about manufacturing costs and about giving the customer value for money.

Margaret Thatcher

Figure 9.3 Foreword to the Design Policy Conference report, London Royal College of Art, 1982

the ages; knowledge (K1) and information that guide the hands which put bricks on top of each other; the imagery, symbols, ideas and ideals which made products intelligible (or unintelligible) to people; and, finally, the procedures, concepts and tools of inquiry which enable the observers to study all these phenomena beyond the limits of visual perception.

The knowledge (K2) of this complex network of phenomena – which are of a different order, kind and level – is as important as the knowledge and information which enable designers to design, planners to plan and makers to make. This is the knowledge of knowledges. What it provides is an epistemological insight which neither detailed studies of use of space, nor of office organisation, housing choices, colour perception, ergonomic appropriateness or capital accumulation can in themselves yield. Thus, epistemological materiality of design is to do with the social existence of knowledge in practices which process and use knowledge for basically non-cognitive purposes. In other words, design knowledge is primarily concerned with the practical appropriation and transformation of material reality.

Design, seen as the result of design activity, incorporates, uses, processes and transforms knowledge at its various levels. The brief for the product, its production process, and choice of materials and techniques require not only knowledge and information appropriate to these tasks, but also a whole series of largely unspecifiable knowledge, information, insights, value judgements and assumptions which are part and parcel of the act of designing (D1a) (and planning).

Whilst there has been a considerable amount of research on the cognitive processes which are operative in the designers' minds, or the information retrieved in design practice, there has been only very limited interest in (a) the nature of design knowledge, and (b) the question of design as a form of knowledge.

The so-called design process (D1b) comprising analysis/synthesis/evaluation involves certain modes of dividing, classifying, ordering and transforming reality which is made intelligible through knowledge. Like any decision-making process, the design process makes use of, manipulates, selects, organises, suppresses, ignores, promotes, incorporates, distorts or simply requires, knowledge and information through the production, dissemination and control mechanisms to which the design activity is closely connected via the economic, physical, institutional and discursive materiality of design.

Knowledge is power, and power is exercised through knowledge.[19] Designers who draw lines on paper do so with the aid of know-how, experience, data, rules and regulations. They do also take part in the business of giving physical shape to the preferences, aspirations and demands of particular social forces. While specifying materials, or while including or excluding certain choices, designers (and planners) do not in fact physically handle the materials, land, resources or people, but deal with the data

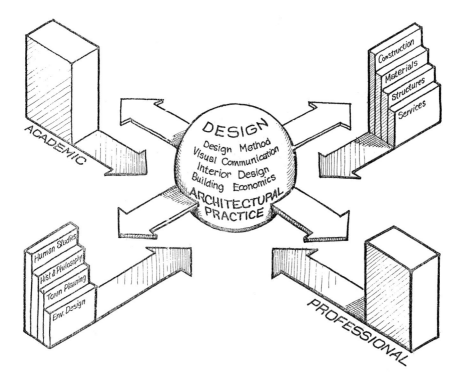

Figure 9.4 Diagram of a degree course structure for a British school of
architecture (c. 1977)

available about them; prior (political and economic) decisions already made,
boundaries, rights, privileges already drawn, priorities expressed in numbers,
charts, lists or standards, forms which are given shape and supported by
pre-selected 'findings', assumptions which are incorporated into bye-laws,
regulations or Acts of Parliament, and so on.[20]

By the very nature of design and planning practices the use of knowledge
and the exercise of power are not in fact the functions of isolated individual
'designers' or 'planners', but of collective and/or corporate bodies of various
sizes such as professions, offices, firms, departments, It does not there-
fore make sense to speak of the design process in terms of the cognitive
appropriations by individuals alone. The majority of design theory and history
teaching reproduce the myth of the individual by organising the course around
'great' designers, movements and styles whilst largely ignoring the collective
nature both of production and of the knowledge necessary for it.[21]

Research institutions and schools specialising in design and planning
generate and dispense knowledge in various forms. They also reproduce

given knowledge and information and reinforce (but seldom criticise) the received values, assumptions and preferences of the dominant socio-economic and institutional forces, which, incidentally, include professional institutions. Research and education and their various media outlets are thus themselves institutions through which (most) individual designers obtain their tools, methods, information and values in response to the demands of the dominant material interests. Whilst there is no one-to-one correspondence between what schools and research institutions are expected to do, and what they actually do (or can do), there are consistent patterns of collaboration and manipulation prevailing at several levels at once. The separation of design process from production process was said earlier to be related to the separation of education and research from both design and production practices. By distancing 'learning' from 'doing', the self-image of the supreme designer is conveniently reproduced in future professionals, avoiding unpleasant contact with the real reality of the 'outside world'. This, however, contributes neither to the training of practically minded, skilled, designers, nor to the emergence of intellectual, critical and informed individuals.[22]

One very significant kind of knowledge is the historical one. The way in which histories of art, design, architecture, city and technology are perceived, written and taught is not independent of the mechanisms of the exercise of power through (this time pseudo-) knowledge. Control of history is synonymous with the control of truth. As such, design historiography (which also parades under the respectable label of design theory) is built upon the mechanisms such as the predominance of visual aspects,[23] the emphasis on decoration, exclusion of certain objects and problems, mystification of 'beauty', the ideological opposition of 'Art' with artefacts, and 'Architecture' with 'buildings', and as such is largely responsible for the formation of tastes, norms, 'goods', 'usefuls', 'greats', 'rights' or 'wrongs' in discourses as well as in perceiving, analysing, evaluating, studying and teaching the reality. History is generally seen as the descriptive accounts of the (old) events and objects organised in a tidy and linear order devoid of multi-level contradictions. Design research, trapped in such a concept of design process, can neither understand the past nor usefully interpret the present. Similarly, a design activity which is purely concerned with the 'new' objects and is ignorant of the 'old' world into which the new are inevitably inserted, creates all sorts of discrepancies with manifold effects.

DISCURSIVE MATERIALITY OF DESIGN

The materiality of design involves not only the economic, technical and institutional conditions of design activity, and not only the power/knowledge relationship, but also the framework of their perception, cognition and communication. Designs and plans (D4a) are the representations of definite perceptions, points of view and decisions regarding appropriations of, and

interventions into, the material world. Whatever scale or medium is used, they express certain portions of reality as seen, envisaged, imagined or proposed for particular purposes by particular groups or individuals. There are two main problems here: first, that most planning or design 'theories', or discussions, elaborate some ideologically transformed objects rather than real objects, and, second, they do so in and through particular media. Yet, the media used in executing specific technical operations such as designing may not necessarily be the ones used in explaining, nor in fact understanding, them. Although the medium of representation is secondary to its contents and effects, the medium itself may impose upon the represented reality its own mode of perception.

Drawings emphasise the visual and cannot show many non-visual, e.g. temporal,[24] yet fundamental aspects, whilst words lack the spatiality and descriptive power of lines. When combined, they always transcend the roles which they are employed to play – though words can do that relatively better than lines.

Drawings, words and graphs – whether put on paper or stored in the memory of a computer, whether printed in journals, or uttered in lecture rooms, constitute a unity which we can call a 'discourse'. A design discourse (or discourses) is the domain where most of the institutional, economic, political and epistemological contents of design and planning practices are expressed. Design is inseparable from the discourse which helps form it, to which it gives form, and which justifies, presents and discusses its processes, products and problems.[25]

Each line one draws represents certain power relations, and certain modes of appropriating reality. It may occasionally be explicit – the design itself may declare the individual or corporate power of its owner/client – but, generally speaking, it is a much more implicit affair. Discourse both carries with it but also conceals, expresses, or keeps quiet about the social relations of production of which design is in fact a part. Discourse thus both provides the outlet for these power relations to be expressed in particular forms, and makes it possible for institutions, professions and individuals to speak about them. That they use additional means of representation, e.g. photography, is also important in manipulating not only the process of designing, but also the perception of the products, and not only 'creating' forms but also establishing norms. 'Quality', 'beauty', 'modernity', 'comfort', 'distinction' are concepts which are as much the products of language as they are the language of products.

Discourse enables designers to present not only their products, but also themselves, to the world. It also functions in presenting themselves to themselves by reproducing their self-images and self-definitions – in graphic, verbal, filmic and other media.[26]

There is also an amazing co-operation between the increasingly rational(ised) activity of producing commodities, and the somehow irrational,

often systematic and still crafts-like tendencies in the design process. Any sign of conflict seems to be resolved at the level of ideology which mediates between the aspirations inherent in form-giving activity and the requirements of profit-oriented production. This compromise or co-operation is articulated in a discourse which internally integrates the potentials of design activity into industry and externally presents it as the privileged and autonomous act of 'creation' which is carried out in spite of the repressive domination of industry! Here too lies the fundamental dilemma of design education which cannot make up its mind about its relationship to industry (or profession, practice, etc.).[27]

Representation in discourse may also be negative, i.e. the current socio-political and cultural reality may deny the 'creative' process to realise itself by not allowing it to re-invent and reconstruct modes of representation and perception.[28] Moreover, as in the case of knowledge, a discourse is never in a one-to-one correspondence with the truths it represents, nor is the discourse of a practice entirely uniform. The heterogeneity of the professions is partly concealed but also partly made explicit by the discourse(s) which they seem to share. It is thus the task of design research to understand the objects, mechanisms and effects of discourse in its various manifestations, forms and the material connections it has with society, its institutions and its artefacts.

Design research and education must therefore avoid reproducing the technicist, individualist, pragmatic and reductionist traits of design practices as they are manifested in discourses. The primary objective of design research is not to produce designs, or to lend uncritical support to the dominant design ideologies, but to understand the complex and contradictory reality of design activity largely by a critical study of how that activity is socially constituted and how it is made intelligible through its discourse. Discourse analysis can therefore be the natural companion of design research if the latter is to avoid uncritically reproducing the discourse which provides it with its 'problems' in the first place.[29]

CONCLUSIONS

Finally, introducing the elements of production, power, knowledge, discourse and institutions into design research and redefining design as a material force is not meant to overcomplicate the issue. On the contrary, by shifting away from false objectivity and overt subjectivity to theoretical complexity of contradictory reality, we create the preconditions for a clearer, if more complex and more rigorous, understanding.

One surprising fact is that while considerations of design activity and its products in such a material(ist) framework help relocate the bricks-and-mortar type of objectivity and you-and-me type of subjectivity, it opens up new possibilities for understanding the representational, metaphorical, poetic

and abstract properties of designed objects – possibilities which we cannot unfortunately examine here.

What this text amounts to is a comprehensive, if inevitably synoptic, critique of design discourses. Whether such an enterprise will, or can, lead to an 'alternative' design discourse largely depends on the impact it succeeds in creating in the minds, hands and 'tongues' of the practitioners of the activity itself.

The implications for various design practices, design research and design education are anything but negligible. As design practices are more interested in finding 'solutions', applying methods or securing returns for their invest-ments and labour than understanding the nature of their own practice, it would be far more realistic for design research to try to influence the education where some hope of positive change (at least at the level of under-standing) still lies.

Education and research are, potentially, the only levels where the iron-laws of politics, economy and technology can in fact be analysed at a distance from, though not totally independent of them. It is where the strategic collaboration of knowledge and power operates for greater efficiency and productivity, but can, also, contribute to greater understanding. The present composition of what is to be learnt and what is to be ignored[30] tends to result in unconvincingly confident but notoriously half-baked 'experts'. By trying to know and teach all parts of the process, fake self-images can probably be replaced by informed, inquisitive, socially responsible and critically creative minds.

If the design professions are not interested in the findings of a critical design research, or in the rare experimental efforts of education, or in the modest insights of this very analysis, it may either mean (a) that even at the straight, pragmatic, level neither the findings of research, the instructions of education or warnings of criticism are (or can be) useful for the day-to-day functioning of those professions; or (b) that the 'truths' analysed, exposed and reformulated through education and research are in profound conflict with the 'truths' of those professions. Yet, if we dare to commit the cardinal sin and even contemplate the possibility that the 'customer' may not always be right, or wants to stick to its rights, we may not only have to try to be right ourselves, but must seriously consider changing our customers!

NOTES

1 A shorter version of this paper was presented at the Design Research Society conference in Portsmouth on 14–16 December 1980 and at a Housing Workshop seminar in Sheffield; and published in *Design : Science : Method*, edited by Robin Jacques and James A. Powell, Westbury House, Guildford, 1981, pp. 106–11.
2 Cf., for example: 'Design as process and design as product, encompass practically every aspect of life. Design can be urban design or architectural design, or product design or dressmaking, but it can also be cooking or singing

or making war or making love' (Hans Hollein, *Building Design*, no. 329, 7 January 1977).

3 For a discussion on this paradoxical relationship of integration/marginality see L. Wolf, *Idéologie et Production: le Design*, Edition Anthropos, Paris, 1972, pp. 185–7.

4 On the absent (*and* undeniable) presence of economic dimension of all types of design activities and their products, see my 'Design without Economics', in Langdon, Richard (ed.), *Design Policy*, London, Design Council, 1984, v.3, pp. 75–80; and 'Economic Signification of Physical Surroundings', in Pol, Enric, Muntanola, Josef, Morales, M. (eds), *Man-Environment: Qualitative Aspects*, Barcelona, Ed. Universitat, 1984, pp. 230–36; 'Ekonomisiz Mimarlõktan Mimarlõõn Ekonomisine', in Özdeniz, Mesut (ed.): *Mimarlõk ve Ekonomi*, Trabizon, KTÜ, 1982, pp. 79–86; and 'Design Research and . . .', in Pamir, Haluk, Mamolu, Vacit, Teymur, Necdet (eds), *Culture Space History*, Ankara, METU / fi. Vanli Foundation Publ., v.2, pp. 67–78.

5 'Not to challenge this separation makes one seriously doubt the ability of our younger design radicals to make any serious impact. What is the point of total changes in decision processes if the means of executing them – the production processes – remain in the present ownership and control? The largest single item of productive resource in the environment is land – yet we have not one serious critique of land ownership and control' [that is, among over 100 papers presented to the Design Activity International Conference in 1973. (N.T.)] (Thomas A. Markus: Design Objectives: Introductory Comments).

6 The *Guardian*, 26 September 1974 (report by R. Carr).

7 Cf., for example, J. W. Wade, *Architecture, Problems and Purposes*, John Wiley, New York, 1976, p. 35.

8 Richard Foque, 'The Open-ended System: Some Investigations into the Nature of the Design Activity', paper presented at Design Activity International Conference, London, 1973, p. 1-3-1.

9 Especially considering the view that 'designers are traditionally identified not so much by the kinds of problems they tackle as by the kinds of solutions they produce', Brian Lawson, *How Designers Think*, Architectural Press, London, 1980, p. 38.

10 'Production thus produces not only the object of consumption but also the mode of consumption, not only objectively but also subjectively. Production therefore creates the consumer.' Karl Marx, 'Introduction', in *A Contribution to the Critique of Political Economy*, Lawrence & Wishart, London, 1971, p. 197.

11 'Good' and 'Bad' are not the type of notions we would rely on in a critique of this sort and this point should be seen as a polemical rather than a theoretical one.

12 *Time Out*, 3–9 November 1972, p. 49.

13 Olivetti, *Portrait of an Industry*, 1973, p. 25.

14 'He (Victor Pananek) is ashamed of his profession – industrial designer – and of ours, and he considers that we, and everyone else who engages in design, have been irresponsible in failing to put first things first. If 50,000 people are killed on American roads each year, then car designers are literally murderers, and architects aren't much better. Designers are seduced into acting as stylists, putting new cases around old products, encouraging obsolescence, and stimulating unnecessary consumption.' Geoffrey Broadbent, reviewing *Design for the Real World* in *RIBA Journal*, November 1972, p. 492.

15 At the time of writing and revising these lines in the early 1980s there was no need to remind the British people of the remarkable 'service' that Saatchi & Saatchi advertisement company rendered to *their* clients – this time by selling us the clients themselves!

16 Cf., for example: 'Their aim, in Forbes' words, is to "try to improve the quality of industrial life" ("and civic life" adds Crosby). Part of this is admitting the value of "the promotional aspects of design"'. '"Everything has to say something, has to work for the client", says Crosby.' *Building Design*, interview by John McKean, 30 January 1976, no. 283, p. 10.

17 On this negative conception of 'other-than-me' see my *Environmental Discourse – a critical analysis of 'environmentalism' in architecture, planning, design, ecology, social sciences and the media*, Question Press, London, 1982.

18 Cf., for example, the concept of organisational hierarchy in H.A. Simon, *The Sciences of the Artificial*, MIT Press, Cambridge, Mass., 1970; and a critique of his conception, Emel and Necdet Teymur, 'Understanding Society and Environment: as a "System"?', *Journal of the Faculty of Architecture* (METU), vol. 6, no. 1, 1980, pp. 55–66.

19 On the discursive materiality of knowledge in relation to power see the work of M. Foucault; for a brief statement see 'Prison Talk: An Interview with M. Foucault', in *Radical Philosophy*, no. 16, 1977, pp. 10–15.

20 Cf. my 'Design is Power is Design', in *Power by Design* (eds Roberta M. Feldman, Graeme Hardie and David G. Saile), EDRA, Oklahoma City, 1994, pp. 81–4.

21 Even a 'radical' theoretician of art, Herbert Read, is 'yet to be convinced that any project realized by an "architects' co-operative", for example, can have the aesthetic value of a work conceived by an individual architect. Sentimental mediaevalists used to suggest that the Gothic cathedral was a communal creation, but this is to confuse building and design: all that was significant and original in any particular Gothic cathedral was the "singular expression of a singular experience", and ... architecture ... is always the product of an individual vision and sensibility' (H. Read, 'Art and Society', in *The Arts and Man*, Routledge & Kegan Paul, London, 1956; the phrase quoted is from O. von Simson, *The Gothic Cathedral*, Paris).

22 On the fallacy of 'learning by doing' in the context of architectural education, see my *Learning by Learning*, South Bank Architectural Papers, no. 3, 1979.

23 On the domination of design discourse by 'appearances' see my '"Aesthetics" of Aesthetics' paper presented at the British Society of Aesthetics Colloquium, University of Sheffield, 1979, publ. in *Journal of the Faculty of Architecture* (METU, Ankara), vol. 7, no. 1, 1981, pp. 77–96. See also G. Bonsiepe, 'Outline of an Alternative for Design', paper presented at Design Activity International Conference, 1973, p. 3-4-2: 'The practice of industrial design which piously matches that principle is well known under the term "styling", and styling focuses passionately on shape, appearance and form which is used to stimulate the acquisitive appetite of the consumers. Hypertrophical concern with appearance marks conservative design theories, whereas an emancipatory design theory would centre around the concept of need.'

24 'Design however consists only of a symbolic representation of a small part of this process at a particular moment in time. This is confirmed by the fact that design is basically of a synchronic nature, as drawings cannot account for time.' Linda Clarke and Judith Ryser, 'The Myth of Design Objectives', paper presented at Design Activity International Conference, 1973, p. 3-3-4.

25 On this point see my 'Design Discourse: Doing vs. Saying – a Dubious Dichotomy', *9H*, no. 2, 1980, pp. 47–9.

26 For a comprehensive analysis of a multidisciplinary and multimedia discourse, see my *Environmental Discourse – a critical analysis of 'environmentalism' in architecture, planning, design, ecology, social sciences and the media*, Question Press, London, 1982.

27 For a critical analysis of the problems of professional education in architecture and design, see my *Architectural Education – issues in educational practice and policy*, Question Press, London, 1992.

28 Cf. *Afterimage*, no. 5, 1974, p. 2.
29 Cf. my 'From Theory to Discourse', in *Planning and Design in Architecture* (ed. J.-P. Protzen), ASME, New York, 1987, pp. 71–4.
30 'Ignorance, like knowledge, is purposefully directed' (G. Myrdal).

10

TOWARDS A THEORY OF CONSUMPTION
Tu – a cosmetic case study

Kathy Myers

(*From*: Issue 7, 1982)

The aim of this chapter is to use an empirical case study of an advertising campaign for Tu cosmetics, marketed by Woolworths, to try to point to some of the ways in which advertising texts work to construct specific versions of the consumer. Much of the material which follows is extracted from my research on a theory of consumption.

I think at this point it might be useful to clarify what I mean by consumption and what I mean by value.

CONSUMPTION

Within the economic context of political economy and positivist economics, consumption is referred to more specifically as 'social demand'. This signifies the combination of choices which consumers make in the marketplace. It is identified as a primarily 'rational' activity which in some sense dictates the play of market forces. In so doing, demand is invested with a power to exercise an authority over the organisation and supply of goods on to the market.

By comparison, Marxist analysis has tended to argue the opposite, positioning consumption as a process regulated and ultimately determined by the dominant relations of production. Production thus specifies not only what will be consumed, but also, by regulating income structure, the quantity and nature of consumption. Consumption is subordinated to the forces of production in the organisation and rationale of capitalism because it does not produce surplus value – the incentive behind capitalist economic relations.

Marxist economic analysis has therefore focused its attention on aspects of the social structure which are thought to contribute to the production of surplus value. As a result, kinds of social activity not thought to directly contribute to the production of surplus value have been marginalised.

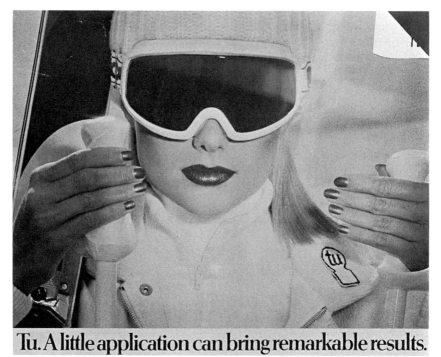

Tu. A little application can bring remarkable results.

Figure 10.1 Advertisement for Tu cosmetics
Source: Reproduced by courtesy of Woolworths Plc

For example, productive activity within the home – the private sphere – has been ignored by orthodox Marxist debate. Since housewives do not appear to sell their labour, and do not generate surplus value, their contribution to production has been marginalised. The home has been identified as the ideological and symbolic rationale which underpins labour relations. For example it becomes the justification for, and annealer of, exploitation in the workplace. Domestic labour is thus identified as a prop for, and rationalisation of, production under capitalism, as opposed to a structurally important part of that process.

This marginalisation of the home, and specifically women's production within that sphere, has been challenged from the political vantage point of feminism. Feminism has tended to organise its resistance to the marginalisation of women's role around the 'domestic labour debate'. In common with Marxism, the domestic labour debate privileges the role of production, and effectively ignores those aspects of women's labour which contribute to consumption. On the one hand it challenges Marxism's marginalisation of domestic labour, and on the other endorses the Marxist perspective of

consumption as a passive, determined process. This can be partly understood in terms of a fear that to elevate the role of consumption as economically important could have politically regressive effects, working to entrench women further into the ghetto of the home. The re-evaluation of consumption could, therefore, paradoxically collude with the ideologies which feminism sought to disrupt.

I want to suggest, then, that a theory of consumption cannot be effectively separated from theories which we develop around the notion of productive as opposed to non-productive labour, and that such a theory must inevitably take into account the role which women play in the organisation of consumption practices. The domestic market accounts for a large percentage of capital's industrial output. Marketing research suggests that women are thought to make over 80 per cent of domestic purchasing decisions in the UK. As a consequence, it is not surprising that advertising and marketing campaigns tend to address the consumer as 'she'.

I want to suggest that it is important for a theory of consumption to identify the act of consumption as a productive process. First, because the act of consumption necessarily entails a reorganisation of existing patterns of domestic labour. For example, the acquisition of a vacuum cleaner not only transforms the nature of cleaning, identifying it as an important feature of domestic labour; it also has implications for the other kinds of commodities which could be bought: for instance, the type of floor covering. Second, consumption needs to be identified as productive in so far as it generates meanings for the nature and substance of social life. The act of reading an advert, frequently a necessary step in the process of commodity consumption, demands that the reader bring meanings to bear on the text in the act of interpretation. I do not want to suggest that we can dispense with the notion of consumption as opposed to production. Rather, I want to suggest that they refer to different kinds of productive processes. The production of surplus value cannot rest as the sole determinant of that which constitutes a productive activity under capitalism.

Advertising, then, plays a crucial role in the rationalisation and positioning of consumption and production for the consumer. The main point which I wish to make in the analysis of the Tu campaign is that, under capitalism, advertising plays an instrumental role in transforming the products of industry into commodities. It does this by ascribing identities to products.

COMMODITIES AND VALUE

For Marx, every commodity produced under capitalist modes of organisation possesses a dual aspect: a 'use value' and an 'exchange value'. Use value is essentially functional: for example, the use value of a coat is its ability to keep its wearer warm. Use value, then, expresses a relation between objects and people. By comparison, exchange value refers to the value which a

product has when it is offered in exchange for other goods. On one level, this might be perceived as simply a relation between objects, but Marx emphasised that this level of appearances is simply the commodity's 'fetish form'. For Marx, relations between objects work to conceal the fundamental relationships between men who invested their labour to produce those commodities. Exchange value is, therefore, a measure of the labour invested in a commodity; it is fundamentally a social relationship between people, as opposed to use value, which is expressed as a relation between people and objects. Marx recognised that a certain amount of 'useful' labour must be expended in order to create use values for commodities, but fundamentally, use value is only realised in the act of consumption. To put it simply, exchange value expresses the relation between commodities and productive labour, and use value expresses the relation between commodities and consumers.

As I have already suggested, within orthodox Marxist theory, consumption is subordinated to production as a determining force. As a consequence, within the political economy of Marxism, use value is decentred from the analysis of capitalist rationale because it expresses 'consumer object relations' as opposed to productive social relations.

I want to suggest that a theory of consumption and advertising practice is contingent upon the re-evaluation of the concept of use value. Clearly, an understanding of use value has to shift away from an interpretation of needs and wants as purely physiological or biological in origin (for example food and warmth), and from a notion of use value as an inherent characteristic of an object or commodity. Commodities and needs are social in origin. To explain consumer choice (for example between a series of coats which perform an identical 'warmth keeping' function) in a highly sophisticated market economy, we have to be able to assess not only what a product does, but also what it means. I want to suggest that the construction of use values, and the transformation of these values into meanings identifiable by the consumer, constitutes the central role of advertising agency practice. The act of producing values and meanings simultaneously provides identities for commodities and consumers. What follows is a step by step analysis of a campaign for a cosmetic, tracing how forms of value and meaning are constructed for the consumer through the marketing strategy and advertising text.

TU – A TEST CASE:
THE CONSTRUCTION OF THE CONSUMER

In the mid-1970s, Woolworths, a large corporate system of retail department stores, decided to launch a range of own brand cosmetics. This cosmetic range would be produced by a company subcontracted to Woolworths, in much the same way as Marks & Spencer buys in products

from a variety of manufacturers and sells them under their own brand name of St Michael. Woolworths took the product idea to an advertising agency. It would be the job of the account director at the agency to work out the potential of the new brand, and to identify specific marketing problems associated with its launch. It became apparent that the primary marketing problems related to Woolworths own position in the retail market.

Woolworths' marketing problem

During the recession of 1975/76, Woolworths had suffered an economic setback, and were concerned that their future market stability might be jeopardised. They had long enjoyed a reputation as a cheap mini-department store priding themselves on their ability to consistently undercut competitors in the retail trade (sometimes achieved by monopolising sections of the retail market), and forcing smaller firms out of business. However, with the 1970s explosion in cut price supermarkets (a feature of advanced capitalism) on the one hand, and the mushrooming of small specialist stores, e.g. boutiques, on the other, Woolworths felt their market stability to be threatened.

Woolworths recognised that the majority of their consumers were women. In common with other retail companies, Woolworths recognised that their future economic stability and potential to expand was contingent upon securing the female market. However, research had suggested that the profile of the Woolworths consumer was unsatisfactory. Most of the consumers were identified as belonging to the 30–50 age group: people who had 'grown up' using Woolworths. Woolworths felt that it was important to attract younger women into the store since this was felt to be the most lucrative market. This was first because young women tended to have a higher disposable income than older women, and second because they wished to create a generation of women consumers who would be brand loyal to Woolworths. The primary marketing problem which confronted Woolworths therefore was to attract a young female market.

Woolworths had already noted the success of Boots the Chemists in this respect. Boots had promoted their own brand of cosmetics as a 'hook' to get the consumer in, in the hope that once in the store they would buy other personal and domestic products. To accompany this strategy Boots had diversified their retail trade, moving away from a concentration on pharmaceutical and toiletry products and introducing health foods, records, electrical products, home appliances, etc. Cosmetics were similarly being introduced into supermarkets and Marks & Spencer with a similar strategy in mind.

The decision to launch a cosmetic brand was taken in the face of these overall market developments, which specifically pertained to the economic problems of Woolworths, but more generally referred to a problem of an ageing consumer profile in other sectors of the retail industry.

From the agency's point of view, these general marketing considerations had to be translated into a specific formula: a 'problem' which strategic advertising could resolve. In terms of launching the cosmetic brand two primary marketing considerations had to be analysed: (a) the target market for the product, and (b) the position of the product on the market.

Target market

The target market of the cosmetic brand necessarily needed to reflect the wider marketing problems which Woolworths faced: namely the need to encourage young women into the store. The target markets identified were young women between the ages of 19 and 30. The 'ball point', or focus, of this would be women in their early twenties as the most desirable section of the young market. This 'young twenties' image would necessarily need to be reflected in the adverts produced. In economic terms, these women would be in the middle income bracket. The upper AB class were of less interest since they constituted only a small segment of the market which Woolworths wanted to solicit. Equally, the lower income groups, the DEs, were rejected as financially unviable.

Product position

Woolworths already sold other established brands, which appealed to the middle price range purchaser. Without exception all of these brands tended to have a youthful consumer profile: for example Rimmel, Outdoor Girl and Max Factor. The agency decided that Woolworths' own brand would be positioned against Max Factor, but, more crucially, against Boots' own range of cosmetics: No. 7 and 17. On one level this was to take trade away from the Boots cosmetic ranges, but, more crucially, to try to establish Woolworths as a competitor to Boots in the retail trade. Max Factor and Boots No. 7 and 17 already had established product identities. They were marketed as fashionable, colour coordinated, comprehensive ranges. They appealed primarily to the kind of young woman who thought of herself as 'sophisticated', 'sexy' and 'modern'. Neither of these ranges was over-glamorous; they sold on the strength of 'accessible', 'believable' good looks. Many of the socio-cultural indicators for the image of the Woolworths range (Tu) had already been established by virtue of the kinds of products which it would compete against. The account executives decided that Tu would have to fit into this genre of cosmetic representation, whilst at the same time establishing an identity and difference.

However, two further marketing considerations need to be borne in mind. First, the success of Boots' own ranges was reinforced by the tradition which Boots had already enjoyed as 'safe', 'trusty', 'scientifically approved'. Woolworths felt they could not compete against this tradition of pharma-

ceutical reliability. Second, they would not compete on the strength of simply providing a comprehensive fashionable range of cosmetics, since both Boots and Max Factor already traded on this.

Through an analysis of the young market, competitive advertising, and Woolworths' own consumer profile, the agency decided that Tu advertising should incorporate 'unobtrusive' information on how to use cosmetics – the practicalities of their application. This was based on the assumption that however 'sophisticated' young women thought themselves to be, there was a perceived lack of knowledge about how to use make-up to best effect.

We can now begin to see the emergence of an embryonic 'use value' for Tu cosmetics:

1 Tu as a comprehensive range which will coordinate with modern fashion wear.
2 Tu as a symbol of youth, sophistication and modernity.
3 Tu as a range which created dramatically effective transformations in appearance easily; a step by step construction.
4 Tu as financially accessible.

The emergent use value is selected out of a range of 'use' possibilities. Note for example the decision to reject the idea of promoting Tu on the strength of its 'healthy', scientifically tested qualities, which could not, it was thought, be endorsed by Woolworths' own image as a cut price retailer. Nor could such an image, even if it were to be created, compete against Boots' more established 'health' tradition.

The use values identified for Tu have specific genealogies on which it is worth commenting. First, any new cosmetic product, whatever its image, is already trading on an established set of cultural indicators about the purpose and function of cosmetics, which is already established as a necessary part of every woman's identity. These common-sense assumptions are already integrated not only into the philosophy of marketing but also the consumer mentality. In other words, many primary marketing assumptions trade upon identifiable social discourses already at work. For example, social discourses which privilege youth, the importance of a woman's appearance, the need to *work* at looking good, etc.

Second, cosmetics as a product system are already firmly integrated with other aspects of the fashion market. There is increasing coordination between colours in the fashion world and those in the cosmetic industry. The latter has tended to follow the former in this respect. Over the past 10 years the cosmetic market has been characterised by an increased seasonality which has had the net effect of linking it more securely to the discourses of clothes fashion, and guaranteed the need for increased total level of cosmetic sales. Last autumn's lipstick, for example, will clash with this spring's clothes. Cosmetic industries, therefore, tend to monitor developments in the fashion world very closely, so as to anticipate colour and style trends.

They have to consult, for example, dye manufacturers up to 2 years before anticipated retail dates to see what cloth dyes are likely to be available in the future.

Third, elements of 'personal' education are closely linked with developments in the fields of journalism. Agencies need to be aware of the latest developments in make-up techniques, health fads, beauty looks, etc., presented through the media. The media's ability to educate its audience into the importance of beauty and personal hygiene is often extremely beneficial to industry and representative agencies. This media documentation often provides a 'hidden' form of advertising, as well as acting as an effective promotional agent for the whole discourse of body economy. The media's privileging of certain health routines, beauty looks, etc., is itself allied not only to technological and aesthetic developments in commerce, but to other social discourses; for example, medicine, psychology, home economics, which all produce forms of knowledge about health and beauty.

I have outlined some of these discursive influences as a way of suggesting that 'use values' identified for a product such as Tu, in the initial stages of agency strategy, themselves trade on a host of social and ideological assumptions. Some of these influences are already ideological in nature. For example, the assumptions which circumscribe to the necessity of cosmetics, the economic links between the cosmetic and fashion industries, and the using of the media as informal commercial educators into product use. Other discourses are less clearly ideological in nature: for example, medical discoveries into aspects of health and personal care. What becomes an issue is the way that certain forms of social knowledge become ideological. For example, the deployment of medical information on aspects of health – the identification of health as not only a form of work, but also as a form of industry, the sprouting of the 'jogging' industry – cycle machines, etc. In the case of women, health as a form of work can be used as a justification for keeping them out of certain forms of employment. It can be used as a way of justifying the amount of time/personal labour expended on looking good and keeping fit. To oversimplify it, narcissism and health can become a form of work which may be used to justify their role in the home, and provide the basis for a 'health' product industry.

The point of these examples is to stress that identified use values for products are themselves the product of specific social and ideological discourses at work outside of the agency. They refer to general, social assumptions as well as to specific ones which are the product of cosmetic marketing as a system.

In terms of the agency's role in constructing use values for a product, the first process is one of selection from an existing number of social discourses. In the case of Tu, this initial selection can be reduced to five components:

1 Tu as fashionable and comprehensive: refers to the general clothes fashion system and to fashionable cosmetic competitors.

2 Tu as symbol of youth and attractiveness: refers to a variety of discourses: age, sex and class referenced through media, education, law, consumerism, romantic fiction, films, etc.

3 Tu as capable of producing dramatic make-up effects: refers to work/leisure relations; make-up and representation of femininity; boringness of peoples lives, etc.

4 Tu as easy to apply: identifies make-up as an area of necessary work. Simultaneously challenges notions of beauty as natural; hence all women need it. Differentiates Tu from upmarket 'complicated' cosmetic ranges, etc.

5 Tu as reasonably priced: allies Tu to a specific range of competitors and, to a certain extent through the price mechanism, identifies the kind of market that is likely to buy the product. This has the added function of promoting Woolworths as a 'colourful', 'fashionable', 'reasonable' store.

It is important to note that these identifiable use values for Tu, in so far as they are in association with Woolworths, are likely to transform consumers' perception of the usefulness/social value of Woolworths, promoting a more modern, trendy image whilst retaining its price credibility.

The marketing mix outlined above provides a rough guide to the ways in which use value may be constructed for a cosmetic product. The target market, young women between 19 and 30, was selected because it fulfilled certain identifiable marketing needs for Woolworths. The positioning of Tu as a competitor for Boots No. 7 and Max Factor refined the market further, i.e. the kind of young women likely to buy middle price range cosmetics. By positioning Tu as a competitor with Boots and Max Factor, Tu would 'inherit' many of the middle price range product characteristics already defined by the Boots and Max Factor market. For example, make-up as fashionable, glamorous, yet accessible, pitched to appeal to middle income groups: the C1s as opposed to the AB market. Further, it is precisely the C1 market which Woolworths wished to capitalise upon. It would have been unrealistic and tactically incorrect to pitch Tu against a more 'sophisticated' brand such as Charles of the Ritz, which has an AB consumer profile. It is therefore important to remain aware of the distinctions within the cosmetic market as a product system. The modern cosmetic market is characterised by stratification: i.e. there are different product systems and consumer profiles within the overall cosmetic market. For the moment this distinction can be referred to as the difference between the 'accessible' and the 'sophisticated' market (agency terms). As a point of reference, Tu, Max Factor (general range) and Boots No. 7 all fit into the accessible market. I shall try to point out later that 'accessibility' has specific implications for the formulation of adverts.

FROM MARKETING MIX TO CREATIVE GUIDELINES

The marketing mix outlined for Tu has identified the target audience, product position, and potential use value for Tu. It is important to note that the use value as yet is not a unified system. I have identified five potential use values for Tu:

- fashionable
- symbol of youth and attractiveness
- capable of producing fashionable dramatic effects
- easy to apply
- reasonably priced

These use 'functions' will be presented to the creative team who are responsible for actually executing the advert, in the form of a creative brief: a set of guidelines which marks agency strategy.

(So far I have concentrated on the Tu campaign as if I were describing its launch. In fact, whilst the marketing strategy remained unchanged, several attempts were made to launch it, i.e. several distinct 'creative interpretations' of the creative brief. The first of these was unsuccessful. Upon reflection the agency felt that this was due to 'misguided creativity'. The first campaign, which I do not have details of, used the copy line 'take off everything but leave on Tu'. The image designed showed a girl's clothes, casually strewn across a living room floor lit in 'noir' style, with an open door leading to a bedroom in the background. Whilst the agency felt that this had created the right 'tone' (modern girl, low key sophistication, etc.) the advert had failed because it had not given the new product an identity. The consumer could not see what the product looked like, nor what effect it had on the face. All that was signified was the effect of wearing it – social, sexual success. The agency felt that a re-launch based on the same marketing strategy needed to incorporate more 'product shots': made-up face as product, and 'pack shots'.

The marketing strategy outlined above pertains specifically to this re-launch; the need to 'educate' the market into product use and Tu as easy to apply, for example, was missing from the first launch. This 'use' was specifically part of the second launch.)

The following is a creative brief for the follow-up campaign to the second successful launch based on the use values outlined above.

Tu creative brief

The previous campaign for Tu has been highly successful and there is no argument for sudden change of direction this year – either visually or copywise. The 1980 proposals should therefore be a development of the 1979 campaign and based on the same proposition.

Target market

19–30 years ('ball point' early twenties)

Creative priorities

1 Tu makes you the woman you would like to be – confident, attractive, modern.
2 Tu is a wide and comprehensive range in high fashion colours.
3 Tu is available only at Woolworths.

Executional guideline

Copy should have same 'tone of voice' as 1979, i.e. intriguing, emotive and persuasive rather than simply flip or superficial.

Photography might well continue to feature black. 'Woolworths' mention to be retained in baseline.

Creative work

The fact that a marketing strategy can create a value for a product does not mean that the product, as yet, possesses an identity. The distinction between use value and identity can be recognised by reference to the initial 'failed' launch of Tu. The job of the creative team in an agency is to transform use values identified by the agency into meanings identifiable by the consumer. It is only when this transformation is effected that a product can be said to possess an identity. The creative brief is only an executive guideline to, but no guarantee of, the creation of meaning.

The advertising text

If the advertising text is a material manifestation of the transformation of use value into meaning, then the question which remains is, how is this done? The agency tends to euphemise this transformation as 'creative work', but it is possible to unpack what is meant by creativity. I want to suggest that meaning is in fact conditional upon the creation of a pleasure of the text. But the pleasure of the text is not an identifiable characteristic of the text/image. The pleasure of the text in fact refers to a relationship between the text and its reader/audience.

On this level the advertising text as a cultural product is indistinguishable from other cultural products, such as magazines or films. But the advertising text is a text with a purpose. It aims to identify a product and thus turn it into a commodity, and it aims to transform readers of the advert into consumers of the commodity. The pleasure of the advertising text, as

177

I hope to show, is then not simply a two-way relationship between advert and reader, but a more complex relation between advert, product, commodity, reader and consumer.

In terms of advertising at least, it would probably be incorrect to speak of the pleasure of the text. More accurately, the job of the creative team is to execute the necessary conditions for a pleasure of the text.

The production of the conditions of pleasure

Use values are presented to the reader in a codified form. It is not simply one code at work, but an articulation of codes. It would be useful at this point to refer to a specific example, the advert: 'Tu. How to hold a conversation without saying a word.' If we look at this advert, it is possible to identify the use values and marketing strategy behind the campaign. We are presented with a product shot: the face of a model wearing Tu, and with 'pack shots' of some of the Tu range: lipstick and nail varnish. Fashionability is signified through the choice of model, her clothing, etc., and through the copy – 'a complete range of highly coloured expression'. Youthfulness and attractiveness are signified through choice of model and through the copy. Similarly it is possible to find references to Tu as producer of dramatic effects: 'How to hold a conversation without saying a word'; and to Tu as easy to apply and cheap: 55p products. All the marketing priorities are there in the advert.

However, these use values have meaning for the reader not by virtue of the fact that they are listed, but rather, by the *way* in which they are listed. Creativity is the name given to this method.

The coding of use value

Narrative code

The 'story' of Tu is that make-up can create another you. This is not a transformation in the strictest sense of the word; rather the advert suggests a discovery of the 'real' you already there. The narrative suggests a voyage of discovery. The reader is led into the text by the copy line over the image (which links the image and text): 'How to hold a conversation without saying a word.' But the narrative code alone cannot resolve the problem of 'how' this is to be effected. It can only pose the problem and offer its resolution.

Hermeneutic code

The hermeneutic code responds to the question of how this transformation is to be effected. John Ellis said of the hermeneutic code in *Language and*

178

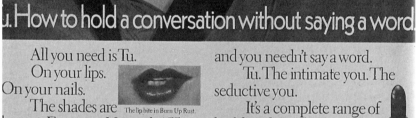

Figure 10.2 Advertisement for Tu cosmetics

Source: Reproduced by courtesy of Woolworths Plc

Materialism: 'So as not to answer its question too soon, the hermeneutic code delays in various ways; by constant reformulation, by the promise that there will be an answer.'[1] The hermeneutic code fragments the narrative with units of information: 'Just stroke on an exciting Tu lip colour', 'match it with a glossy Tu nail colour', 'All you need is Tu', 'On your lips. On your nails.' These fragments build up into a picture of how Tu will discover the essential you; they lead the reader through the narrative. But the narrative can never be fully resolved. The answer, the satisfaction, the pleasure, can never be found totally within the advert, for such fulfilment would preclude the need to buy the product. Narrative closure, the discovery of the real you, can only be effected by buying the product Tu. In this sense, the narrative text of an advert, as opposed to a novel, must always remain unclosed, unresolved. The whole advert must work as a hermeneutic system as well as its constituent parts. The hermeneutic poses an enigma which the narrative alone can never resolve. The promise is that advert narrative must be complemented by commodity purchase for complete resolution.

Adverts also work on a more general level of hermeneutic understanding which demands a complicity on behalf of the reader. Advertising is a closed, self-referential system; adverts refer to, and frequently trade off, each other; a trade-off which demands a certain level of communicative competence. But within advertising, a total system is a more specific level of hermeneutic understanding. Product markets are stratified. Tu competes against Boots No. 7 and Max Factor, not against Charles of the Ritz. It is important, then, that the Tu advert be seen in some sense as similar to Boots adverts and dissimilar to Ritz adverts. The Tu advert needs to be simultaneously similar to, and different from, its market competitors.

Semic code

The semic code presents units of information through the juxtaposition of images and words. It thus provides fragments of meaning which can only be fully understood in relation to the other codes. (NB This interdependence is a feature of all codes.) For example, the use of red in the Tu advert links the model's mouth with the fragmented mouth shots buried in the text, with the red of the lipstick and the nail varnish. These fragments work closely with the hermeneutic code in forwarding the narrative. In themselves they do not make sense. For example, the caption to one of the mouth shots – 'The Pout in Damned Pretty' – is teasing; what does it mean? It is only intelligible if we read the text and discover that 'Damned Pretty' is a lipstick. These semes of information demand that the reader actively engage with the text to find out what is going on; we want to solve the puzzle to find out what the apparently contradictory phrase 'How to hold a conversation without saying a word' really means.

Cultural code

In isolation, the narrative, hermeneutic and semic codes might suggest that meaning is a feature of the text. However, as the hermeneutic code also refers to advertising as a stratified system, we can see that the system is far from closed. The cultural code specifically refers to the deployment of values and meaning from the social world which are reconstituted or referred to by the text. This reference is usually far from explicit.

Many definitions of the cultural are available, but perhaps three definitions are particularly apposite to the analysis of advertising texts.

First, culture is often used in an anthropological sense to refer to the shared system of values, habits and traditions familiar within a particular society. This idea of a common way of life is informed by a kind of collective consciousness or shared belief system which works to unite a social group.

A second sense of the cultural has become familiar within sociological analysis of social formations. Rejecting the notion of culture as shared consciousness, culture has become aligned with the notion of ideology. Culture as ideology refers to the division of social values whereby some sets of social values are used to dominate social groups into roles of subordination. This notion of culture is frequently articulated in terms of the class divisions within society.

Third, culture is employed within the sociology of art to refer to certain forms of informed or educated cultural acquisition. For example, the appreciation of the cultural values invested in certain art forms, such as painting, opera, avant-garde film. This notion of cultural acquisition is juxtaposed against a notion of the mundane world of everyday experience, which may be euphemised as popular or mass culture. High culture is differentiated from mass culture along the axis of education, information and the acquisition of an informed aesthetic sensibility.

I want to suggest that in terms of advertising analysis it is useful to retain a distinction between these various deployments of the cultural.

The anthropological sense of culture

It is possible to do an analysis of advertising images in terms of the deployment of social symbols as archetypes. For example, the recurrent use of images of women as madonna, whore, *femme fatale*, mother, etc. However, the ways in which these social symbols are deployed will depend on their historical specificity. The *femme fatale* image of the Tu model relates to a history of *femmes fatales* from Lilith through to Circe, Salome and Cleopatra. This image reappears in many popular forms – for example the 1940s film noir heroine. These are symbols with which most people are familiar; nevertheless, the meaning which they convey will depend on the context and social time in which they appear. For example, the genealogical derivation

of a *femme fatale* image in a Tu advert may be qualitatively different to the derivation of the symbol in a more expensive 'upmarket cosmetic brand'. The former might be traceable back to a history of filmic representation in film noir, whilst the latter owes its form to modes of representation more familiar within the history of oil painting.

Advertising agencies themselves tend to use a form of social ethnography when analysing the cultural disposition of their intended consumer market, and in designing the kind of images which they believe will appeal to that market. These ethnographical data are usually organised around the agency concept of 'lifestyle' which refers to the supposed quality of life preferred by specific social groups. For example, this will lead to the collation of a cartography of social taste listing the kind of cars people buy, their eating habits and holiday preferences. It can also be suggested that this kind of social ecology of the market is readily amenable to sociological modes of analysis, which will interpret the ethnographic data of the agency in terms of the ideological and class implications. This difference in approach depends on the discourse which is chosen in order to analyse the social data. For example, sociologists 'reading in' ideological implications into ethnographic data.

The sociology of art and culture

In the binary model of high as opposed to mass culture, adverts tend to be assimilated into the latter because of their status as commercial art, which has to work to achieve popular appeal. This is a problematic division. For example, agency creative teams (responsible for advert execution) are usually comprised of people who have undertaken a formal literary or artistic training. Many of the photographic images of 'women as icon' used in adverts are referenced in notions of representation familiar within fine art oil painting, as well as more 'realist' forms of documentary style photography. There is, therefore, a continual overlap, and trade-off, between images referenced as 'high' art and those as 'popular'.

A second problem with this binary model is that it suggests that it is only 'high' forms of art that require the construction of an 'informed' or 'educated' audience. It ignores the fact that so-called popular forms are themselves heavily codified and complexly structured, demanding that the reader be socialised into ways of interpreting and making sense of familiar images.

Empirically, this model creates problems for analysis, since it is impossible to neatly categorise all forms of cultural production in terms of a binary division. The question becomes not so much how are cultural forms produced, as how are they used? For example, the commercialisation of Impressionist paintings by poster galleries such as Athena. It might be more useful to identify the cultural as the site of multiple forms of cultural production. How these forms are used and deployed can be best analysed in terms of principles of social organisation and ideological identification.

The ideological sense of culture

In relation to culture, the ideological refers to the organisation of codes, and signs and images, in order to create forms of meaning which work to reinforce the existing social system and, in so doing, conceal fundamental contradictions within it. Ideology, then, describes a specific form of work, or productive activity. However, whilst ideology may work to conceal tensions within the social system it is not in itself homogeneous. Social ideologies may operate on several levels at once. For example, the Tu advert conveys a lot of information about what is acceptable for (and expected of) women in our society. The copy line, 'How to hold a conversation without saying a word', refers uncritically to women's lack of a social voice. The copy reinforces the popular association of women as 'passive' and 'being' as opposed to men as 'active' and 'doing'. This simple polarisation of ideological concepts about the 'nature' of the feminine, works to reinforce existing hierarchical divisions of labour, excusing women's marginalisation in 'demanding' jobs or professional forms of labour. The message which is constructed in the Tu advert is that 'real' women get what they want by 'being' beautiful, as opposed to 'working' at an interesting job or whatever. Women's destiny is in their face: 'Others will get the message and you needn't say a word.' The make-up commodity can express the feminine personality better than self-expression. In fact, commodities have the power not only to discover, but also know, the 'real' you. 'Plain and pearl that say exactly what is on your mind. Even if you are too shy to say it out loud.' The notion of the silent feminine which speaks through the power of beauty is as old as Helen of Troy, but in the context of Tu it is deployed as an image which is thought to have appeal for the young, unsophisticated kind of lower middle class girl who constitutes the primary market for Tu. Here silence is reminiscent of class, as well as gender associations.

The Tu advert works to reinforce the silent beingness of 'women-as-image'. But this ideological message is contradicted by a second level of coding available within the advert. For, in order to discover the 'real' you, it is necessary to actively purchase the product Tu. The ideological construction of the notion of work is that it is identified with personal improvement, not the act of consumption/expenditure/purchase. Women's work is identified as an act of self-discovery, a personal experience, as opposed to the public work experience of shopping. This form of personalised labour is identified by the text as necessary and pleasurable.

The deployment of words and images in the advertising text creates new forms of ideological expression. This organisation of meanings and cultural codes works to fragment and stratify the market. For example, adverts adopt a qualitatively different mode of address depending on whether they are designed to appeal to a working class or middle class market.

Psychoanalytic code

This code refers specifically to the psychic pleasures experienced by the audience through the construction of his/her subjectivity in relation to the advertising text/image. The fundamental axis of this code refers to the symbolic organisation of pleasure derived from the sexual construction of the spectator through systems of representation. In response to the question: what kind of pleasure does the advertising text offer?, the psychoanalytic code refers to the organisation of systems of desire, needs, demand and fulfilment, offered by the advert.

The psychic-symbolic pleasure which advertising offers its audience has been substantially analysed by Judith Williamson in her book *Decoding Advertisements*.[2] She suggests that the function which the advertising text performs is to symbolically mediate relations between commodity and consumer by performing a series of transactions or exchanges. She says:

> The advertisement translates these 'thing' statements to us as human statements, they are given a humanly symbolic exchange value. . . . Advertisements . . . provide a structure which is capable of trans- forming the language of objects to that of people, and vice versa.

The advert offers a playing out of early psychic experiences facilitating the re-enactment, the remembering of early experiences which structured and organised the individual's identity. Nevertheless, the psychoanalytic code, like the other codes, can never work in isolation. The pleasure of identifi- cation and the promise of fulfilment and psychic satisfaction flirted before the reader by the advertisement are always negotiated in relation to other codes. The reader is positioned through class, race, income bracket and regional location by advertising. In this sense we cannot talk about the pleasure of looking at a beautiful woman in an advert in the abstract. Codes of beauty and attraction are themselves historically and socially specific. The aesthetic of the image must always refer to these determinations. On one level psychoanalytic codes are a feature of social consciousness in so far as they are a shared perception. But the way we perceive the Tu model, the pleasure derived from looking at her, would vary depending on whether the image appeared in a porn magazine, a family photo, or a fashion magazine. Her beauty would be fashioned differently depending on whether she was meant to appeal to a male or female audience.

CONCLUSION

In agency terms, the concept of use value is articulated as 'product benefit experienced'! In other words, cosmetic products such as Tu are usually marketed on the strength of what they do for you, as opposed to what they do in the abstract. The cosmetic market is very competitive; most of the

products are similarly constituted and are likely to fulfil the same material function – they can only be differentiated on the level of psychological function. This is epitomised by the top priority of the creative guideline: Tu makes you the woman you would like to be – confident, attractive, modern. The copy of the Tu advert conveys these levels of condensed meaning. For example: 'Tu. The intimate you. The seductive you. It's a complete range of highly coloured expression.'

In this one sentence it is possible to identify a number of creative priorities linking advert to commodity to reader to consumer. Tu, the name of the product, means 'you' in French. The name is accessibly exotic. Most people in the target market will know this. They will also know that 'Frenchness' in make-up and perfume has come to signify taste, expense, quality and exotica. Tu, an easy French word, is affordable exoticness, it is accessible French, in the same way as Tu is an accessible, easy-to-use product.

Tu, then, defines the quality and status of the product and simultaneously defines the reader: Tu/You. The meanings are interchangeable; a constant slipping between the order of commodity and anticipated consumer is invoked. The reader is addressed as already being a consumer, already being identified with the product; the product is given an identity by reference to the consumer.

However, Tu the commodity asks to represent not the already known you, but a latent undiscovered you – 'The intimate you. The seductive you.' It appeals to the reader on the level of the effect which consumer plus commodity can have on an audience – implicitly gendered as male – hence 'The seductive you.' The promise of Tu is that it offers women control over their appeal, accessible appeal. There is no mystery involved, application produces the desired results. One of the promises of Tu, then, is to apparently demystify the production of glamour. This fits with the marketing need to educate the audience into the use of the make-up; it is presented as something which everybody can do: looking good is no longer an enigma. This is a way of appealing to the market which Tu aimed to create – the Woolworths shopper who wants to look good but does not know how. The woman who is confused by make-up. Tu is fashionable and comprehensive – 'a complete range' – which positions it as an adequate competitor for the more established ranges from Boots and Max Factor. But more importantly, the complete range of cosmetics promises to express the complete range of the consumer's tastes and personality: 'a complete range of highly coloured expression'.

The advertising text then has several functions to perform:

1 To realise the overall marketing strategy and transform identified use values into identifiable meanings. This is done by the articulation of use values through a combination of codes as above.
2 To perform the job of cultural product. It must be instantly attractive and different, whilst establishing itself as an advert within a specific system

of product adverts: a specific stratum of the market. The advert needs to offer a form of visual pleasure which will entice the reader into paying attention. But the advert as cultural product must never overstep its margins. It must never offer complete satisfaction in its own right. In short the advert must not become a commodity. The exceptions to this, when cultural product becomes commodity, can be witnessed by the sale of posters, for example. The first creative priority of an advert is to establish a relation between reader and text.

3 To establish a relationship between reader, text and product. If this is successful two transformations will occur simultaneously: the product will achieve an identity and become a commodity and the reader, through identification with the commodity, will become a consumer. Adverts such as Tu encourage this metamorphosis by implicitly addressing the audience as reader, but explicitly addressing the reader as an 'already consumer'. Tu does not promise to express what will be on your mind, but what is already on your mind: 'Fifteen matching lip and nail colours in plain and pearl that say exactly what is on your mind.'

The reader is initially positioned out of a relationship between herself and the advertising text. The reader is then constructed as a potential consumer by the text in relation to the product advertised. But for the reader to become a consumer it is necessary that the marketing conditions for consumption are met. The consumer is located at the point of intersection of marketing, advertising text and commodity. As each commodity is marketed and advertised in a different way, the nature of this position is always subject to change.

NOTES

1 Rosalind Coward and John Ellis, *Language and Materialism*, Routledge & Kegan Paul, London, 1977, p. 55.
2 Judith Williamson, *Decoding Advertisements: Ideology and Meaning in Advertising*, Marion Boyars, London, 1978, p. 12.

11

DESIGN AND GENDER

Philippa Goodall

(*From*: Issue 9, 1983)

For sale: Mod Semi-det. dble bed. lux bath. well-dressed kitch.
sex div. domestic lab.

We live in a world designed by men. It is not for nothing that the expression
'man-made' refers to a vast range of objects that have been fashioned from
physical materials. Most of the jobs associated with designing and planning
work are done by men and the technical, scientific, managerial and aesthetic
expertise to do the work is largely their possession. This article will press
the view that design practice and theory operates with specific notions of
femininity that formulate and organise women's time, skills, work, inhabi-
tation of space and conceptions of self in relation to others.

In general terms, design is constituted as a field of action and theory in
various distinct ways. Within conflicting versions of the democratic society,
it is informed by conceptions of progress as a process of realisation of human
potential for the social good, overlaid with notions of progress as technical
advance, and it is perceived as primarily cultural in its orientation and effects.
Design is constituted by a range of discourses generated across fields
such as engineering, planning, art, psychology, social administration/policy
– from which accrue status and power to define and respond to problematics.
Woman, as a category for planning and design, is generated and regenerated
from sites of knowledge anterior to these fields and produced by and in
design.

THE HOME IS WHERE THE HEART ISN'T

The home will be the central object and vehicle through which we discuss
aspects of design and gender. In this context the home is understood as an
ensemble of material objects, as spatial organisation, as physical and social
envelope. We shall explore, for example, the boundaries of 'private' and
'public' (or commercial) through a range of domestic commodities. We shall

also assess agency in the production of the home. Though we should not forget that as classed, gendered subjects we are all producers *of* the home and, as consumers, we are producers *in* the home, whether we spend most of our time in it or are largely absent.

Feminists have identified the home and the social relations of domestic and personal life as a primary site of the subordination of women. It is a significant sphere of the construction of gender difference, of the division of domestic and paid labour, which, under capitalist patriarchal relations, coincides to a marked degree with the division of labour by gender.

This entity, ensemble and articulation is a site of interventions by state and capital mediated by a range of legislative and planning means, whose origins and trajectories have direct and indirect effects for domestic life and its material and social organisation. We can see the planned infrastructure of urban and rural Britain in terms of sexual divisions of space when considering the relations between the home and the work place, between private/commercial services, public services and 'high' and 'low' cultural sites. This spatial organisation locks women (and others) into particular relationships *vis-à-vis* producing, consuming and reproducing. In lived terms, space equals distance, time, energy and money. It also means access or limitation: spatial organisation can thus be understood as an instrument of control in the maintenance of a hierarchy of economic and social relations.[1]

The planned mix of commercial sites and housing represents the need of sections of capital to form spatial relations that encourage consumption and establish markets. Work sites are located according to a variety of planning priorities, where the social relations of domestic life and the needs of workers are low on the list. Women are thus placed in a relation of access to places of consumption and relative limitation with regard to production in the work place.

Extended capitalisation has made the home a focus for technical, functional and social reorganisation. Industrialisation, in the nineteenth century, was focused in commodity production. The mechanisation of domestic functions has been articulated by modernity as a complex regime, one strand of which effects a cycle of obsolescence and renewal through technical innovation and social change. Baking is an early example of a form of domestic production which, though having a longstanding small commercial aspect, was taken up for mechanisation. With this came commercial marketing on a new scale and production for need took on the character of any other profitable commodity. A range of skills associated with women's work was eroded and transposed into machinery in the masculine domain of paid labour. Much else of women's work has been extracted from the domestic sphere and organised as industrial paid labour, often male, and returned to women as commodities.

THE HOME AS ONE POLITICAL
HEARTLAND

Our view is that the home is a particularly pertinent object in the current phase of Thatcherite restructuring. The shedding of labour on a massive scale through investment in high technology, alongside the depletion and rundown of less productive sections of industry, means that large sections of the population are being re-positioned in class terms and forced out of productive activity into the home. In one sense, quite simply, no job means more time at home, and for women that time will be largely occupied working in it. In another it means that the home is becoming the repository for an underclass, detached from work structures, disciplines and forms of organisation.

Whilst unemployment affects all sections and varies by region and industry, the rate has been higher for women over the past decade, in some instances five times higher.[2] The extensive reductions of public services have placed the pressure to respond to the needs left unmet with the so-called community, a loose specification which often means women given their place in society. The home then is the site into which many of the effects of the crisis collapse and condense. Here some of the brutalisation of economic hardship and the worsened tensions between household members will be lived out in isolation. A limbo bereft of the forms of organisation available to workers, where the voluntarist nature of other social structures is inappropriate to the task of meeting need, enabling resistance and struggle. A limbo in which women are being appealed to, to hold it all together.

Secondly, the home as a site of commodity penetration will come under strain, for similar reasons. Under the present international crisis industries have limited scope for taking up the slack of domestic consumption through exporting the range of domestic goods. It seems likely that capital will, in part, try to forge new relations between production and consumption.

Further, the home is, in our view, an underdeveloped object of political examination as a designed ensemble. Within radical architecture and planning, the relations between production and reproduction have been concentrated in a Marxist class perspective and this has left examination in terms of sexual hierarchy weak. Feminist analysis has taken two main directions. One has concentrated on the domestic sphere as a site of the construction of femininity and studied patterns of socialisation. The other has been the study of the work–home divide in order to understand the articulation of patriarchy and capitalism and the material, social and economic effects.

There has been some historical work on the home as material ensemble, and of changing patterns of housework.[3] Dolores Hayden's history and rediscovery of the nineteenth-century American tradition of socialist-communitarian and feminist experiments is interesting because of the uncritical espousal of functionalist design and mechanisation that some of those

early feminists displayed.[4] Nevertheless, these social experiments more or less acknowledged sexual divisions and explored forms of collective working and co-operative housekeeping, though some were grandiose and middle class in their orientation.

A MATTER OF SOME URGENCY

The sketch outlined is one of the creation of groups of people being thrown into long-term withdrawal from economic activity, or being relocated in industries, of industrial reorganisation. In this context the function of the domestic environment is being thrown into focus as a significant site of the restructuring of capital. It seems unlikely that the major shifts being set in train can be managed without a political negotiation around the character of domestic and personal life. The gains made for women's rights and oppor-tunities have come under deepening attack and the screw is being tightened. It will be important to build an adequate understanding of the relation between material forms and the parameters in which they are constituted, in terms of social outcomes. Coupled to this is a need to find forms of resis-tance and counter organisation which can refuse that which is detrimental to women and at the same time propose viable persuasive alternatives. One significant element of that task should be focused round that most intimate skin which we call home, that common object as designed material form and social relations.

MECHANISATION: COMMODITIES: TECHNOLOGY

The history of work within capitalism has been one of shifting boundaries between the spheres of production and reproduction, between paid work carried on outside the home and unpaid work within it.

In the eighteenth and nineteenth centuries much of the household produc-tion, like the example of baking along with cloth, soap, etc., moved over into manufacturing industries, often to become men's paid work. Further encroachments in traditional areas of female labour took hold of work *in* the home. Domestic functions were taken up by nineteenth-century philanthropic and entrepreneurial inventions and remodelled through the engineering knowledge of the period as mechanised forms.[5] Some domestic functions had to await the introduction of the small electric motor together with piped gas and electricity supplies to become viable for mass production. Most were in any case only within the reach of the middle classes until after the Second World War, an astonishingly short span for the mass of working people to gain benefits from modernising capital.

The mechanisation of domestic functions entailed a reduction of the more back-breaking work for women. Feminists of the period, particularly in

America, actively intervened on design issues in so far as they were functional for social relations – they argued for the professionalisation of domestic work. Their aims were to increase opportunities for women to work outside the home for pay, and also to raise the status of women generally by validating and improving the body of skills entailed in the role of housewife.[6] Mechanisation of domestic appliances also fed into the service industries, catering, laundering, food production, fuelling the service economy. Over time each function was split in its commodity form into two scales, large for commercial sections, small for the domestic sector, using essentially the same technology.

The effects of mechanisation of women's work were complex. Areas like laundrywork had always provided paid employment for working class women; the introduction of improved laundry technology and the concentration of this on an organised commercial basis meant that women lost individual control of their work time and conditions by becoming employees. However, in becoming paid work, washing became a more collective activity and thus collective bargaining occurred.[7]

On a different note, the segregation of work in the home into male and female tasks, though rooted in traditions of craft training and production defined by gender, could be maintained and deepened. Although mechanisation of domestic work lagged behind industry, the contrast between conditions of work in the two spheres had to be closed. Without the appearance of parity, consent to the general thrust of modernisation and its full range of effects would have proved difficult to achieve.

Such a consent was sought for the reconstruction of post-war Britain. A complex reconciliation between the classes was attempted, the idea of 'one nation' was to be mobilised.[8] Reconciliation between the sexes had also to be forged; the wartime experience of men and women to be re-worked, bound into a perceived unity. Women's brief entry into production and access to socialised services confronted the influx of returning male labour which required to be accommodated. Britain was to be made fit for heroes (and heroines).

The woman question was a source of concern to government; their burdens had been acknowledged. Talk of domestic help and nurseries (for overstretched housewives to relax, rather than a facilitation of work for pay) fell silent in the face of economic crisis and the cold-war atmosphere. Many of the themes voiced in and out of government were framed as women's specific contribution to modern life as *women*. Beveridge voiced the view – 'Above all the housewife – the wife and mother – should be acknowledged as a full and responsible member of the community . . . her home is her factory, her husband and children a worthwhile job.'[9] But it was not to be a segregated women's ghetto; women and men would act together to build a family world, in *partnership*. An agenda, then, of unity and difference. The advantages of modern society were to be made available to women as

housewives. This agenda signalled the marshalling of forces to attend to the home as the focus through which to build this imaginary unity. It required reorganisation and the injection of goods and services to enable women to function adequately within the constructed role. While the agenda was unstable, and resisted, it opened a route to a measure of economic resurgence and the partial reorganisation of labour.

By 1947–8 the *Ideal Homes Book* was raiding national and international resources for technology, building, planning ideas and marshalling them into popular form as consumer tips for the modernisation of the home and its management, for childcare and the domestic arts.[10] 'A leaner Britain' was at this moment a necessary adjunct of modernity, capable of muscular and functional resolution of the problems of the continuing rationing system, shortage of raw materials, and the remaining need for fuel and other economies. Efficiency and domestic equipment was also a necessary alternative to servants, a post-war luxury for middle class families.

A rare reference to men helping in the kitchen took the form of planning it – with 'time and motion' and an extensive range of commodities in mind. The limits of support were plain enough:

> *you* will have to face that kitchen every day at least as a family man, I sincerely hope you do (among other things of course). That means your kitchen must be a human (generally *womanly*) place, light and *sympathetic*, on the one hand, and thoroughly well arranged on the other.[11]

It seems that the concept of partnership predicated on difference was to be formalised once again as the male breadwinner offering to provide the goods; the female in the partnership, the services. What form have these goods and services taken and what was the range of effects for women as the period progressed into enforced economic and social crisis?

A WOMAN'S WORK TODAY IS NEVER DONE

With twentieth-century capitalism there has been the shift from manufacturing to service industries, a substitution of goods for services and a concurrent post-war shift of a proportion of paid service labour over to unpaid service work.

The effects of new technologies across industries is well charted and recent work by Ursula Huws and others lays emphasis on the effects for women.[12] It is worth reviewing some of these briefly.

Services

Supermarkets, Launderettes, banks shed labour as technology is introduced, also a residue of work shifts on to the customer. The consumer's added work

is represented to her/him as convenient, attractively flexible, as increasing choice and control. Some of the 'new generation' of commodities returns work which was performed by paid labour into the home – laundries vs. washing machines, for example.

These shifts in the service sector often affect women doubly. It is they who are losing these jobs the fastest to automated service equipment; it is women who are chiefly responsible for 'consumption work' – they pay for automation in time and free work.[13]

Health and safety

A second set of effects on women's work are those associated with new products entering the home. Pharmaceuticals, cleaners and electric equipment all present heightened levels of risk, and thus additional work of constant surveillance of young children. Notwithstanding the disappearance of open fires, dangerous cooking facilities and poor sanitation, the home and its environs remain a severe health and safety risk.

Quality and quantity

Labour-saving equipment, when coupled to representation by manufacturers and the material effects of socialisation, belies its description. Flexibility and convenience become the watchwords by which women must service their families. Instructions for use come not only with the operating manual, they are inscribed in the advertisements. The microwave oven may indeed conform to specification in being able to cook a meal in 3 minutes; the advert can harness this facility to representations of the efficient housewife who is able to serve each member of the household as they return from school/work/pub rather than serve one meal for all. The notion of service is implicitly a dual one. A service performed by the machine for the housewife; who can thus be on call more readily to service the family.

In numerous such ways women's work is increased, the qualitative demands raised. The tyranny of the whiter-than-white wash is now for many a daily event, rather than a weekly one. 'Simplicity', 'convenience', 'serving the loved ones better' are slogans motivating and directing our work as consumers and producers.

Another feature that reveals a mismatch between the claimed performance of the appliance and its actual use in the domestic context, is the distortion of the scale of economy of time/effort. The use of mixers to provide omelettes for 200 saves time and effort. With the same operation for a family of four a proportionally large time is spent preparing the machine for use.

The sparse evidence available shows that, despite the spread of labour-saving equipment, time spent on housework has increased from an average of 70 hours in 1950 to 77 by 1971 in Britain.[14] This increase of the domestic

load coincides with the increase of married women going into paid work, either as homeworkers or in part-time jobs. The double shift is writ large.

Cultural and personal space

Finally, the influx of cultural commodities has produced significant effects on the social relations of private and public life. The successive introductions of sound and visual recording equipment into the domestic unit makes the family a significant resource for cultural consumption. Social interaction tends to be concentrated into the home more, which, while this reduces isolation for the woman, also condenses social relations as internal family relations and limits the scarce personal space and time available to women. This may add little further work, but, significantly, the possibilities for women to act as autonomous beings tend to be curtailed, both because of the cultural input and because of the condensed social interaction.

Class: public and private technology

Micro-electronic products in the field of services mobilise the *public* domain as their sphere of effectivity. Because relatively undifferentiated categories of consumers can be addressed in marketing presentation, in terms of public interests, i.e. values, within limits class categories may be overridden or crossed by the large scale introduction of, say, supermarkets and their associated service technology. Since supermarkets supply 'basic' needs, relatively non-class-specific needs appear to be in play in addressing consumers. However, class tastes are called up, jostle and compete in raising levels of consumption. Delicatessen counters provide the 'Harrods' end of high middle class eating values and display before the traditional tastes and smaller budgets of working class shoppers. At the same time the corner shop and ironmonger find their place in these emporia. Nevertheless supermarket chains do sustain a class orientation: Sainsbury's is a middle class store while Lo-Cost is not. With other service technologies, increasingly differentiated address is being made to class fractions. The extension of credit facilities in banking is more geared to the weekly wage packet and explicit address is made to skilled and semi-skilled workers and to women, in the latter case often by appropriating women's liberation.

Intervention into the market of the *private* domain confronts women as gendered and classed subjects differently. The forward planning of market construction seeks to articulate its objectives through strategies to address more highly differentiated consumer categories in the private domain, construed as specific and individual. This can be clearly seen with beauty products, with themes of the quintessential woman being combined with class identity, both to engage with real class positions and to construct class fantasies. As entry is made into the private domain to address, respond to

and create needs as personal needs, femininity is called up as that which is most intimately synonymous with female identity. Commodities for the home, while they may address the family, have very different significance for men and for women and it is women predominantly who make the decisions. The body of competences associated with the use of these commodities is assumed to be theirs and in this respect the objects themselves may be 'read off' through those competences and the gendered character they have acquired. These competences are social in the sense that they are widespread amongst women, if not universal, but they are exercised in private, at home and comparatively, in public, at work. Between the two spheres of work and home, women's work is differentially weighted between class and gender. It is a working class activity to work in a canteen, but woman's work (still with class determinations) to work at home.

It is possible to see how groups of objects signify their site of consumption in ways at least as differentiated as public/private and often in more specific sites such as house/hotel, bathroom/living room/study/garage and these sites carry class and gender meanings as do the commodities.

Skills, products: representation

Women face domestic appliances with formulated ideas, desires and wants about their relation to these machines as gendered users, mediated by social-isation, education, training and practical use. As workers in the home they may face the same machine with a different perspective than when working outside. The machine in office or factory represents labour in exchange for pay; at home it represents the complex pleasure and drudgery of caring, of performing tasks in exchange for material support in kind, or ascribed social status as female. Technical expertise and knowledge is clearly very different for women and men. For men, not only has access to these been far more extensive and their relation to machinery often been one of higher economic reward and social status, they are often also in a position to have a more detailed and critical understanding of the equipment they operate.

Our relations to machinery are also produced contemporaneously through representations of the objects and through the machine as it represents its function/facility. Accumulated experience means we read 'handle', 'knob' or 'lever' for the manipulative operation they require and the machine has a sediment of meaning accumulated. It represents its possibilities and is designed to do so. But here too gender determines use. Men may complain they cannot use a sewing machine – it is too fiddly or they cannot figure out how to thread the bobbin. Women may be put off using power tools, such as drills, because they are heavy, unwieldy. We tend to assume that if we cannot use them properly it is our fault, rather than a design feature that does not accommodate to our physical needs, or to approach the machine with a critical understanding of its potential and limits, and

195

the principles by which it has been produced. Far from being designed in the light of scientific investigation into differentiated use, much familiar machinery originated in an industrial context or by rule of thumb, most often a man's thumb, based on masculine experience. All too often men are content to let us go on thinking it is our incompetence rather than divulging their knowledge of tools in use which makes their capacities visible.

Technical and design changes in domestic appliances have affected women's relation to themselves as operators possessing skills; changed the character of tasks, differentiated their relation to machines and forged new social relations in private life. The washing machine has centralised several tasks into one unit, providing numerous washes, once individual jobs, rinsing, wringing and in some instances drying. This not only obliterates many tasks (for which many of us are truly grateful); it obliterates skills too, makes them redundant. The modern cooker on the other hand has, on the whole, shed facilities, decentralised tasks. Compared to the old kitchen range, it has lost one or more ovens, which reduces flexible cooking. The modern cooker has lost the warming drawer in many cases, and the towel drying and storage cabinets of cookers that appeared in the late 1930s. The advent of central heating and the electric immersion heater has further limited the cooker's functions. As a source of atmospheric heat it is redundant and the focal point of social interaction has shifted out of the kitchen into the living room. A concomitant effect for women is to be left to work alone. The separation of heating services and miniaturisation also paved the way for the compact efficient kitchen, often too small for more than one worker.

A further separation of cooking functions has appeared in recent years with the plug-in frying pan, stew pot, toaster, waffle iron, and an accompanying shift in visual presentation away from efficient, streamlined, hygienic connotations in favour of rustic, or modern chic. In principle these machines could be used anywhere in the house; the fact that they are not yet is an index of the highly developed connotations of gender associated with the object and the tasks and skills and sites of their use. The sexual divisions of designed machines then are partially the product of ideological effects in play as common-sense ideas of appropriate male and female roles. They are also the product of design as appearance and for use in its material forms, of design ideology.

Domestic appliances offer themselves to the consumer as easily operable, requiring a minimum of technical knowledge. The machine as facility determines that only prescribed tasks are performed according to the mechanical possibilities, within the time scale of operation. The operations themselves often require little intervention. The machine as technical process and envelope limits the intervention of the user to do maintenance or repair jobs. The casing reads as 'sealed' in so far as screws or bolts are countersunk and unassailable; the motor is in any case designed as an integrated unit, rendering repair techniques difficult for all but the expert, or requiring

a new unit. The user's relation to the machine in use is thus consigned to a manual automatism. A woman's intellectual/technical skills are not called upon – even a fool/child could use them – hers is a passive relation to the machine.

The machine not only obliterates skills and tasks in the user, it obliterates its own work. The designed form hides its work behind the surface appearance and finish of the object. Signs of task performance such as noise or shaking are reduced by insulation, weighted bases and so forth. Household plumbing has begun to disappear into the fabric of the building. The home as a site of the most concentrated labour processes seeks to present itself as pristine, calm, innocent of signs of toil – as the site of non-work – leisure.

The small size of appliances is related not only to desirable kitchen size, but also to assumptions about femininity – strength, dexterity are social constructs heavily inflected by gender, notwithstanding some real biological differences. Cynthia Cockburn has usefully exposed the process of exclusion of women from the printing trade, through notions of physical differences inscribed in practices and objects.[15] Ironically, women meet these same appliances in heavier, larger form in their paid work. A large pan with four handles gives notice of the heavy work of lifting it fully loaded: four handles enables two people to move it. Cooking in factory or school canteens is hot and heavy work on a par with many manual jobs carried out by men. Design for the sphere of reproduction is rendered differently than design for production!

In market development manufacturers attend to and create needs by splitting and differentiation of products and by linking them. The soap powder is indispensable to and contains almost identical information to the washing machine. Thus instructions read across and between commodities; often the visual presentation includes an image of the other product, representing the two in relation to each other and to the reader. This is a stitching up of consumption loops and at the same time a reinforcement of dependency on low level skills and presenting them back to the woman as discerning, caring, style-conscious or modern values in the consumer.

The forms taken up by micro-electronics products, on the other hand, do not signal particular uses or tasks in their presentation or design requirements. Computerised components can equally be used to instruct washing machines or tape recorders. In this way domestic appliances begin to take on appearances more similar to other computerised forms. The microwave oven looks very like a television, is no longer self-evidently a cooker. An element of parity is emerging, a greater uniformity of shape and size between items, which dissolves categories of objects into generalised meaning – 'hi-tech', 'space age' or whatever.

This dissolution of the specific qualities of objects has certain advantages for addressing female consumers, by suggesting parallel technical development for the home and the world at large. Our domestic world is being

catered for as well as industry, women too are reaping the benefits. However, manufacturers clearly do not want to leave room for doubt in the marketing of their products. Some sign of the context of use, or identity of user, is deposited in the advertisement. A rose on the new Belling ceramic hotplate, digitally controlled cooker, or an elegant tureen reflected in the bronze glazed microwave are recent examples sighted. So representations frame the use of objects, and present the user back to herself within a particular spectrum of skills and characteristics to be construed as appropriate to the user as the possessor of feminine qualities.

It may be useful to make a distinction between parity of appearance and parity of facility/provision. Much furniture and domestic equipment has been designed to look different according to context – office, hospital, restaurant. On the other hand there has been a converse claim to offer parity of facility/provision as between public and private technologies. What seems to be happening with the new wave of technical equipment is a loosening of the distinction, appearance becoming more similar; and provision/facility is too, in part because of the changing forms of skill or elimination of skills embodied in the object.

REDISTRIBUTION OF SKILLS AND LABOUR

Historically the changing pattern of work and skills at home has run approx-imately parallel to the broad tendencies of the reorganisation of intellectual and manual labour in the production sphere. Labour skills have been lost to automated processes, redistributed and up-and-down-graded between class fractions and between industries.

The arrival of domestic machinery for a mass market has undoubtedly eradicated some skills and enhanced others. Cooking has been upgraded at least as a theme that places value on women's prescribed role and engages women's desire to be adequate within it. The equipment, by eradicating the hard work, is presented as providing better resources to improve the quality of product. Cooking has become more socially desirable/acceptable for some men and in certain ways it may be the presence of modern technology that makes it so. Nevertheless it is not seen as their chief domestic activity by any means. It tends to be either the more socially visible cooking for guests, special occasions, a leisure activity and a spectacle which receives public or wifely acclaim – or the meals that require least competence, preparation or presentation, such as breakfast or snacks.

The range of knowledge and skills embodied in childcare has had most attention, while the manual skills have become relatively redundant in house-work. Childcare has been endowed with levels of intellectual and psycho-logical complexity through its appropriation by medicine, education and psychology, and returned to the mother as a special range of modernised skills peculiarly suited to women. Homemaking has been validated in a

number of ways as craft, art, the reduction of hard labour, allowing time to make or buy the refinements for homelife.

Increasingly the narrow range of quasi-technical skills associated with information processing are as applicable in the kitchen as in the office. The specificity of skills and tasks associated with machines is reducing, though the range may remain similar in preparing the materials for use on/in the machine.

In concluding this section we would argue that high technology in the home and raised standards of performance, though in some respects parallel to trends in industry, entail a crucial difference. These combined features together with social relations between the sexes in the form of divisions of labour, and perceived identities and roles, locks women into domestic *work* not into domestic redundancy, into productivity achieved by stealth.

In the context of the present restructuring, the screw is being tightened, with unemployment and the withdrawal of the State's responsibilities for public services as two immediate causes. Casting an eye to the future it seems likely that trends emerging now will further lock women into atomised private working lives.

The web of international capitalist power in the form of multinational companies, in selecting sites of cheap resources where political conditions are conducive and not openly opposed to the importation of labour processes, plant, personnel and cultural intervention, has concentrated on the so-called developing countries. Prior to the recession First World workers were too demanding and costly for multinationals to consider production on a large scale in the West. However, the political instability of the developing countries, coupled with the effects of chronic depression in Britain, could lead to changes in policy.

Homeworking has always been a source of work for women; underpaid, stressful and poorly organised though it is, for some it has been the only available means to a wage. A combination of the technical and social developments in the domestic lives of women, with the flexible facilities of mini-computers linked to a company mainframe, has already made possible a new form of homework. Instantaneous communications, reduced overheads and personnel make homework an attractive proposition for the larger and mid-size firm. The attractions to women with children can seem considerable. However, companies may require a special room set aside for work, thus some jobs are only available to those with sufficient space. Fitting in work with children is stressful, and working at home can feel isolated. Instructions can be received on the equipment; messages, time sheets, reports returned to head office – isolation could become intensified. Under these conditions purchasing from the range of company products could be integrated as a service flashed on the VDU for the worker and bought through a mail order service. In this way locking her/him into a closed circuit of production, service and consumption for the organisation, and securing for the company a captive market.

DESIGN AESTHETIC AS RELATION OF POWER

The previous sections outlined some specific instances of the articulation of design activity through and by material and ideological forces. As a constitutive field of practice, design is created from a range of discursive sources, conflicting and contradictory, non-unitary, but forming sufficient stability to present its forms to the world as coherent within particular frames of reference and presentation. As a theme of Modernism, design is understood variously as liberatory, innovative or universally viable. Some aspects of design claim overriding visual or tactile aesthetic qualities, others claim a functional aesthetic, and so forth.

In any event, as a field of active intervention on material objects, design marshals its forces, organises alliances, renders itself visible, constructs its audience and markets.

Functionalist principles and an accompanying technicist mode of resolution have constructed the terrain of modern design research and planning, though within a cacophony of competing discourses of modernity.

In its design practice and self-representation the thrust of functionalist aesthetics has been to integrate perceived requirements with perceived need as use-values. Aesthetic claims may be reviewed as commercial interests or as prescriptions of social relations. Examples have been given of commodities, claimed as liberating, which individually may indeed potentially be so, but which, within an ensemble of social economic shifts, aggregate into the deepened subordination of women, largely invisible and, though resisted, largely consented to. In order to organise consent and educate for consumption, design institutions seek to hegemonise the field of activity. They engage the desiring consuming subjects, remoulding them and articulating regimes of representation and social practice.

The socialisation and canalisation of desire organises pleasure, needs, which can be satisfied by specific means and objects. The social meanings inscribed in objects offer themselves as use-values in certain contexts for certain groups of subject, use-values in the form of pleasure. The lineaments of desire can be traced in the objects of pleasure, and can provide an index of use-value.[16] In taking the home as a means of articulation of desire/pleasure it is possible to posit the construction of private and public pleasure, gendered, classed, in the form of bricks and mortar. Internal spaces take on meaning defined by objects in use and social relations of use and users. The kitchen as a place is meaningless as 'pure space', being an organisation of functions and facilities in material form in relation to other spaces (as a minimal definition). Clearly the social meaning of spaces and the objects that define them changes according to cultural and economic conditions. For the Western European home it seems possible to construe an order of meanings. As spaces where signs of work are rendered invisible as far as

possible, kitchens signify 'easy' work, or work as technological intervention, or functional efficiency, or as returned to history, in the (modernised) 'country kitchen'.

The meaning of kitchen meets the consumer for whom the kitchen has already been formed in material practice, and in second order representations. These second order representations may also offer the kitchen similarly; the image, however, clothes and peoples its kitchen, and it is itself a selection from a range of possible skills, processes. Camera angle, lighting, focus, select and determine the signifying range and power of the kitchen, as warm, cosy, elegant, and the activity of the model as fun, expert, feminine, leisurely. These signifiers spread like a mantle permeating, mediating the imaged kitchen as function/worker or sets of social relations.

The knowing subject may be caught in a dichotomy. The representations of kitchen intersect with and may confront her image of herself at kitchen work, in the form of skills, pleasures, frustrations, failures. She yearns both for the pleasure of the represented kitchen and the pleasure to speak her own knowledge. In doing the latter she confronts a regime of truths about *kitchenness* which has the full force of architectural, technical, artistic resources behind it. The regime speaks delectably of work/leisure as truth; to gainsay that truth and resist it with her own atomised truth would be to appear mad, or ungrateful for the work of the specialists.

The kitchen has different meaning than the bathroom. Bathrooms are the most personal space, with a complex territorial threshold. Visitors never leave the door open, rarely bathe uninvited – though they may be at liberty to make themselves tea in the kitchen. As the site of bodily evacuations (filth) the bathroom also is the place of nakedness, restful cleansing. Bathrooms are presented quite differently in trade catalogues and in adverts for beauty products. Adverts use the eroticised female body as exchange value and in 'beauty/bathroom' images what is transferred to the space is the eroticised femininity as over-determination, as fantasy. With trade catalogues a woman may still appear, but the pictorial elements have to be disposed to give priority to product information appropriate to builders, plumbers or architects. In general, though, the meanings that accrue to domestic spaces are the feminisation and eroticisation of some rooms and the masculinisation of others – of study, workshop or garage. Household members are divided by spatial use, tasks and social identity.

The professional bodies and institutions associated with the public management of design values and products have created consumer organisations and take part in consumer education and advice. Suzette Worden, in looking at consumer advice and education in the 1930s, notes the different interpretations and evaluations placed on the meaning of design. She notes that institutions promulgating designed goods such as the Design and Industries Association (DIA) and Good Housekeeping Institute (GHI) treated appliances and domestic space with differential values.[17] She remarks:

one can see that the leisure area was considered very separately from the kitchen area by the associations. Looking at the kitchen of the Manchester Parlour showhouse it is evident that the DIA was giving an *impression* of efficiency – a visual representation of it and *not* an example of a tested solution. In contrast to this the living area has to show 'good taste'.

The Good Housekeeping Institute, on the other hand, limited its activities to the rigorous testing of products for performance in use. Findings were reported to readers and consumers in terms of the viability of these articles for use in particular domestic circumstances. The DIA was, then, presenting the designed environment as appearance – as look – while the GHI rarely made aesthetic judgements.

Both these organisations though, along with others, played their part in forming consumer values and choices. In these examples it is possible to see manufacturers and design institutions actively engaged in the education of taste, in the mediation of commodities and consumers. Design values, whether they are defined as utility, functional form or as aesthetic of appearance, are produced by cultural, social and economic priorities, policy and action. They themselves act to produce and prescribe the social relations of the sphere of reproduction, the material form of the home and the social relations of household members.

THE PERFORMING SUBJECT

Put simply, design *for* use is design *of* use. As such, design deposits preferred uses, defines them within the parameters of the material, technical possibilities of the object. Designing for use is also defined within the dominant frame of the social relations of use, reproduces those relations anew, as themselves productive.

We are talking of the deployment of skills, of the terrain upon which capital organises relations of production and consumption and of the discursive terrain through which agents (multinationals, R and D sections, or design teams) structure these relations as the production of the desiring gendered subject. We have noted how women's labour and skill has been re-deployed in the home as relations of dependency upon domestic commodities, and how women's domestic work, far from becoming redundant, has increased quantitatively by an upping of the qualitative stakes. Women have largely consented to this.

Consent, capitulation to feminisation, may take shape as merciless cleanliness, pleasure in efficiency or in the purchasing of the frilly four-poster as an index of consent to a body of sexual practice and representation. Resistance to feminisation of the home, in its atomised, disorganised forms – Valium popping, slovenly housework as refusals of quality performance –

is 'explained' by dominant medical or sociological discourse as the tensions of modern life. Placebos are offered in the form of goods and services. More positive forms of resistance are those which socialise and at the same time make alternatives. Small or not, coffee mornings in place of isolated house-work, activities in the locality or tenants' associations can be significant for women.

Divisions in education and training bring us to desire for technical or intellectual proficiency along routes defined by gender assumptions and practices. Commodities in the market place organise and harness desire/pleasure for consumption; they intersect with, intercede with, the perceived desire for intellectual and manual proficiencies, making them embodiments of social sexual identity and value.

In their deployment of the household budget women have to juggle the priorities of household needs with desire for imaginary identity. Incitements to buy products for the formation of their own status are presented in purchasing the item, as an index of discriminating taste, intelligent use of money, desirable intellectual skills. The wall-to-wall carpet or avocado bath-room suite offers status in material form and signals the desirable skill of discrimination.

Deployment of skill in the commodity must connect with the already desired skill, or fail as desirable object. The progressive evacuation of skills from the worker into the machine has limits, since sales have to be ensured. We can see in the blender and its instruction book the reintroduction and reorganisation of skill defined as feminine. The skill lies not in the operation of the machine but in the results its use make possible – economic or refined cookery divested of hard work. Sets of skills are connected together. Skills like discrimination (the window test) and the social perception of family needs (a clean wash) are framed as a desirable expenditure of self and a preferential deployment of skills as a form of service.

DESIRING DESIGNERS

The objectives, philosophy and practice of design framed by economic and political priorities demarcate its objects and activities and levels of inter-vention into the social body, and screens in or out the effects of its actions. It understands its effectivity through levels of legibility supplied by other disciplines as well as its own. At specific moments modernity and function-alism are linked as chiefly technicist solutions to material problems, or as social utility, or expressions of national identity. Such a link forms a tempo-rary and contradictory regime of sense.

Designers are no more free agents than women; their activity is constructed for them through the ideology dominating their field of practice. The solutions they achieve are predicated on its interdisciplinary philosophy and objectives. For example, public health issues jostle with the interests of

clients. The desire for spectacle, to engage the pleasure seeking eye, is brought together with a need for the presentation of a building which reads as part of a civic or state vocabulary. Themes are brought together, dismantled and reshuffled.

The social effects of these processes are understood through the theories available to the discipline. The status and rewards in this predominantly male field do not encourage designers/planners to seriously take note of alternative accounts of its activities. They can continue to accept common-sense notions of gender as different but equal, or as immaterial to the business of designing. Their agency as producers of the material world should not be underestimated.

Desiring designers seeking to mould the nation, town or teacup have often produced efficient solutions which do not integrate or recognise the social or political effects. For such reasons the bathroom has been piled up over the kitchen, work and leisure separated – which limits the possibility of organising space in ways that may provide some conditions for the removal of sexual divisions in personal life and the divisions of work and domestic life. Accountability may be an issue for design and technology in terms of technical malfunction or fiscal malpractice, and is primarily framed by the professional–client relationship. It is still much less an issue of public account-ability in terms of social effect, malfunction or malpractice, and in terms of political consequence – such as equal opportunities.

TOWARDS A POLITICS

There are implications to be drawn from these arguments which suggest a range of objectives informed by socialist feminism; some starting points for the building of a political field, the bones of a political strategy, some suggestions for discussion.

An understanding is needed of the historical character of masculine dominance under capital in its specific forms – in this case, design. A body of theorised historical work is needed which is predicated on an acknowl-edgement of gender divisions as a form of hegemony. This would of itself shift the terrain of study and could transform the use-values of such work. It is high time that those involved in forming the material environment took detailed stock of their activities, examined seriously their claims to be acting progressively for the social good, in the face of counter claims that reactionary effects can be shown. Effects which subordinate rather than liberate.

The rise of contemporary feminism was preceded by the post-war recon-struction of Britain and large-scale re-planning of towns, inner city areas, industrial and housing stock; it coincided with the contraction of state provision and the building industry. Attention to personal life and repro-duction has taken particular forms. There was a partial integration of the

communalism of the 1960s into feminist practice. This has tended to mean a split within feminism between those who prioritise living arrangements as a domain for exploratory personal politics and those who seek to attain feminist objectives through local and national politics. We may have been active in tenants' campaigns, damp campaigns, in reclaiming public space for women's use from sexual harassment and violence, but we have been less active in demanding of planning authorities physical and spatial conditions that would make it possible to break down divisions by gender in personal and public life. Housing types are predicated on a limited number of household forms – the family, single persons, the elderly for example – and do not readily allow for larger, looser groupings. In their spatial capacity and form, as well as in their relation to workplaces, homes make a reorganisation of paid work and personal life practically impossible. Choice may extend to the colour of a council house door, rarely to the arrangement of space. Thatcherism has traded on the monolithic bureaucracy of public services as an excuse for privatisation and it is through examples of lack of choice, delays in repair and maintenance that the government makes its appeal.

We believe this suggests an element of a feminist strategy (and a gap which needs to be closed) – to set out to constitute a debate and to develop an agenda around the built environment and domestic commodity production. This means encouraging participation from as wide a group as possible, from designers, historians, planners, technologists and, crucially, the consumers of their products.

DEMANDS

The model of socially useful production which has been developed in the labour movement will be a useful one for changing the priorities in the design and production of commodities and social space.[18] It is a democratic process whereby production is predicated on meeting social needs rather than the demands of capital. However in its present form social usefulness is understood within the limits of existing masculine industrial skills, processes and values, and needs to be changed to enable women to participate fully.

One strategy could be to intervene at the point of production and set out to argue the case that gender relations must be central to a programme for the transformation of the social relations of production and to assessing and prioritising social needs. This brings into focus the politics of work in the form of questions about women's access to opportunities for developing their contribution to ideas about social usefulness as well as conditions they currently face at work. Matters of childcare, wages, hours would be spelled out as issues which men must attend to and which are central in redesigning the labour process to meet demands for equality.

There is an opportunity to re-think home, work and homework as co-operative ways of organising life and new technologies could facilitate this. Of course built forms would be needed that allow the integration of productive work with personal life. Without making the mistake of returning uncritically to utopian forms of the past, some of which were heavily consumerist, it seems possible to learn from the experiments of the nineteenth century and to use that which is appropriate for us today. Granted the different conditions of a young entrepreneurial America, one important lesson is the *active* part women took in designing and building communal forms for working and living.

It will be important to resist technological determinism. In order to unlock the ways in which our daily lives are organised we must uncover the ways in which technological development is predicated on a common sense of industrial practice and process, of domestic practice and process. For in treading the ground of everyday life and linking its formation with the common sense of technology there is a risk that determinism can creep in and undermine the significance of struggle around social need. Conflicting and specific needs raise questions about existing forms of political representation and organisation – of the refusal by sections of the population, ethnic minorities and women, to participate. Race and feminism throw into focus the problem of democracy, need, and the forming of a politics of demands. The deployments of technology as forms of domination and instruments of restructuring, powerfully curtail the formation of demands and the democratic process. To allow ourselves to remain locked into determinism reduces our capacity to struggle actively over the use of technology.

SURVEILLANCE

Another strategy could take the form of surveillance to make demands on consumer research and change its emphasis, rendering consumer research a reflexive tool for consumers. This could be one arena where needs specific to women, men, black, white and class frictions are thrashed out publicly and where new organisations could be built and develop the muscle to recast production. Alongside this could be extended debate with the trade union movement to encourage a fuller recognition that working people are producers *and* consumers and that implications can be drawn from this.

Further, surveillance could take the form of policing representations and of exposing the oppressive uses of product presentations, information materials, instruction manuals and other associated materials. This would allow meanings ascribed to images to be debated as issues of gender and class. Demands could be brought forward for the defeminisation of adverts; for the detachment of the commodity form from association with gendered use and competences (e.g. Danish adverts now use male houseworkers to sell domestic items). In addition, on the basis of such principles as have been

established here and with substantially more work of development, demand could be made for the destabilisation of gendered space. In this way built forms are objects of struggle to ensure that they do not prescribe social relations along the present lines of gendered/classed use, or divisions of work/leisure/pleasure. It will be important to struggle over football grounds, bingo halls, factories, sex shops, supermarkets, schools, nurseries, subways, freeways, street lighting, parks and pram shelters.

And yes, all this does mean that men will have to cede power over the initiation, planning and construction of the material world if they really intend to take women's liberation seriously.[19] And yes, there is a serious question to be asked about whether we want socialism in our time, or whether Thatcherism is to be allowed to continue to call a tune of demoralisation and despair or *laissez-faire*. There is also the question of whether or not socialism and feminism can mobilise on the highly differential terrain of everyday life and inhabit its objects and places.

NOTES

1 'No Trespassing: The spatial dimension of history', *Radical History Review*, no. 21, Autumn 1979. The whole issue considered space. Manuel Castells, *The Urban Question*, Edward Arnold, London, 1976. Also *City, Class and Power* by the same author, Macmillan, London, 1978.

2 Birmingham Trade Union Resource Centre, *Male and Female Employment, Second City in Decline. A Draft Report*, 1982.

3 Caroline Davidson, *A Woman's Work is Never Done: A history of housework in the British Isles 1650–1950*, Chatto & Windus, London, 1982.

4 Dolores Hayden, *The Grand Domestic Revolution: A history of feminist designs for American homes, neighborhoods and cities*, MIT Press, Cambridge, Mass., 1981.

5 Siegfried Giedion, *Mechanisation Takes Command: A contribution to anonymous history*, The Norton Library, 1969; Oxford University Press, 1948.

6 Hayden, op. cit., chapters 2–3.

7 Ross Davies, *Women and Work*, Arrow Books, London, 1975. This book provides a brief historical survey of women's work from the pre-industrial era to the present day.

8 Elizabeth Wilson, *Only Half Way to Paradise: Women in postwar Britain 1945–1968*, Tavistock Publications, London, 1980. Wilson's work is paralleled by the Birmingham Feminist History Group.

9 Ibid., p. 22.

10 *Daily Mail Ideal Home Book 1947–8*.

11 A.L. Osbourne FRIBA, 'A Man in the Kitchen', in *Daily Mail Ideal Home Book 1947–8*, pp. 88–9 (my emphasis).

12 Ursula Huws, *Your Job in the Eighties: A women's guide to new technology*, Pluto Press, London, 1982.

13 Weinbaum and A. Bridges, 'The Other Side of the Paycheck', *Monthly Review*, July/August 1976. 'Consumption work' was first coined by these authors.

14 Ann Oakley, *Housewife*, Penguin, Harmondsworth, 1974.

15 Cynthia Cockburn, 'The Material of Male Power', *Feminist Review*, no. 9, 1982.

16 The Marxist and feminist engagement with post-Freudian psychoanalysis has been important and problematic for cultural studies. In the search for the

construction of subjectivity it has become plain that psychoanalysis cannot be 'tacked' on to feminism or Marxism. For some of the debates see Juliet Mitchell, *Psychoanalysis and Feminism*, Penguin, Harmondsworth, 1975; Michele Barrett, *Women's Oppression Today: Problems in marxist feminist analysis*, New Left Books, London, 1980; Steve Burniston, Frank Mort and Christine Weedon, *Psychoanalysis and the Cultural Acquisition of Sexuality and Subjectivity*, Women Take Issue, Women's Studies Group, CCCS University of Birmingham, 1978.

17 Suzette Worden, 'A Voice for Whose Choice: Advice for consumers in the late 1930s', in *Design History: Fad or function.* (ed. Penny Sparke), Design Council, London, 1978.

18 Dave Elliott and Hilary Wainwright, *The Lucas Plan: A new trade unionism in the making?*, Allison & Busby, London, 1982.

19 My thanks to Terry Smith, Michael Green, Andy Lowe, Derrick Price, Paul Willis and especially to Tony Fry who have all helped to provide an enabling structure for our recent work, and who *have* ceded power in a comradely fashion. In different and less direct ways I owe a lot to Teresa Davies, Rhonda Wilson, Brenda Burrell and Myra Connell.

12

ONE CONTINUOUS INTERWOVEN STORY (THE FESTIVAL OF BRITAIN)[1]

Barry Curtis

(*From*: Issue 11, 1985/6)

The Festival of Britain was marked out by its publicity as a contemplative space – a moment in British history for stock-taking and resolution-making. George VI's inaugurating speech[2] stressed the outward looking nature of the event: 'a visible sign of national achievement and confidence', an aspect of the 'hard experience' of the post-war years. But the Festival was primarily an address to a familial nation. Generically related to World Fairs and Great Exhibitions, the Festival refused their dominant concern with exchange values. In the Festival discourse 'trade' is commuted to 'production', 'exploration' and 'discovery' – the exhibits were primarily conceived in terms of utility and social significance, the address was to the socially responsible citizen. The 'continuous, interwoven story' seeks to produce a focal point for its perceptions of unities and diversities in the national totality. It is a circumlocutory narrative seeking to invest a new, classless citizen.

The 'self-evident' nature of the Festival's introduction to objects and spaces is the subject of the Visual Pleasure Group's work.[3] The essays which follow are investigations of the pedagogic 'style' of the Festival – its discursive emphasis on the productivities of planning and design as primary factors in the 'enrichment' of the 'British way of life'.[4]

The Festival's 'Guides' were resolutely narrative. Their 'story' was deliberately structured 'like chapters in a book'. The work of designers and the exhibits themselves were subordinated to an overall project. 'Captions' played a considered and prominent role, proffering meanings which were fundamentally 'visual', side-stepping the rhetorical and formal. The thematic exhibits were anthologised as in a book with Hungerford Bridge acting as an 'inner binding'. Democratic and idiosyncratic differences were allowable within this format. The aim was an induction of the citizen subject into a responsible relationship with the spectacle. The visitor was warned that a transgressive consumption of the narrative might lead to a 'mystifying' and 'inconsequent' experience.[5]

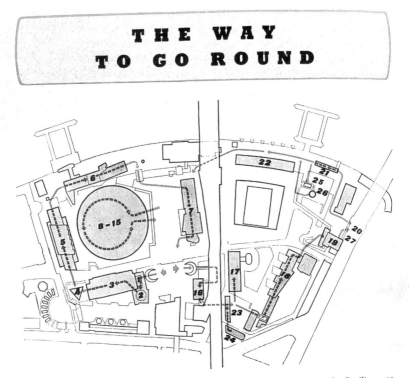

The Exhibition, which tells a continuous story, will make most sense if the Pavilions are visited in the order shown; but each Pavilion can be visited separately if so desired.

Figure 12.1 The Way to Go Round, 1951

Source: Ian Cox, South Bank Exhibition Guide, *A Guide to the Story it Tells*, HMSO, London, 1951

The Festival invited the British people to look at themselves, and, in looking, to participate more fully in their collective responsibilities and pleasures. Visual apprehension was at a premium; the 'social eye'[6] was calibrated with a compounded 'national–historical' and 'natural' vision to provide a particular point of vantage. The act of looking at 'things you can see and believe'[7] brought into focus not only the objects themselves but, with careful guidance, the processes of planning and design that had ordered them into symbolic, productive and disciplinary forms. Design, conceived as both expressive and problem-solving, was wedded to the task of producing a solution to the needs and pleasures of social-democratic citizenship.

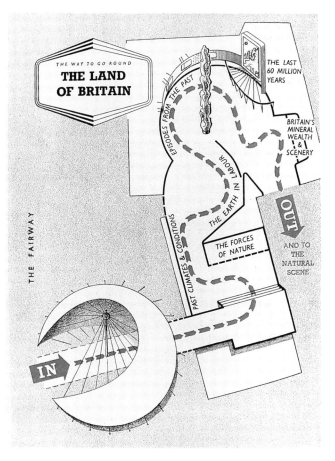

Figure 12.2 The Land of Britain, 1951

Source: Ian Cox, South Bank Exhibition Guide, *A Guide to the Story it Tells*, HMSO, London, 1951

DESIGN HISTORY AND THE 'FESTIVAL STYLE'

The 'jobbing' design historian may encounter and invest the Festival in a number of ways. It is most usually cited as a stylistic envelope, an origin, a terminal, a 'success' or 'failure'. The exigencies of the syllabus 'coverage' normally necessitate the organising of Festival 'material' into a consistent and paradigmatic object of study to be followed by 'The Independent Group' or 'Sixties Design'. The easy availability of useful commemorative texts makes for a richer 'background' – a point on the syllabus where political issues enter into discussions of design more easily. The Festival can be located

211

as an event where design is intimately, and with some consistency, related to proposals about how society should be ordered and how people should live in it. Since the beginning of 1984, the Birmingham Visual Pleasure Group have worked to 'make strange' these familiar accounts. They are interested in the descent of much longer historical continuities, of 'modernity', 'welfare', 'aestheticisation', the relations between 'pleasure' and 'efficiency'.

The Group's central concern is to analyse the technologies deployed for the inscription of the citizen/consumer into a new social space; the production of new normative values by an institutional centring of design. Our work refuses to totalise or empiricise the object of study – instead it proceeds by questioning the constructed unity of that object, by tracing genealogies of the forms and operations of power and the technologies deployed to produce the visible and iterable.

Teaching 'the Festival', particularly to students engaged in studio work, almost inevitably results in stressing the 'event' as presiding over a determinate collection of objects, not as an ensemble of histories and encounters. Using the easily available, 'typical' representations, it is difficult to expose the constituent components, the differences, diffusions – the play of appropriations and exclusions. Coherences have generated a 'Festival style' – a resource of motifs loaded with the inevitable ironies generated out of the discrepancies of historical knowledge between 'us' in the present and 'them' in the past.

In the constant recycling of the retrospectively constituted components of 1950s 'period style', the layers of interpretations, impacted to constitute timely and self-evident 'truths' about design, have warped apart. The component forms, motifs, signatures, have been re-deployed in different relations to construct new meanings. The 1950s 'style' – its images of unproblematic futurity, its biomorphic, macroscopic, out of register looks, its synthetic, experimental juxtaposition of forms, textures and colours, its *au-fait*-ness with the iconography of modernity have been used to different ends, most commonly to violate notions of 'taste' and 'harmony', but also to evoke an innocent optimism for design. It is possible to distinguish 'hard' and 'soft' appropriations, deviant or conformist pastiches which indicate, at very distant removes, the struggles over style – the regimes of the spiv and the architect with which the following essay is concerned.

EYE-OPENERS
AND THE NATIONAL PICTURESQUE

The hidden agenda of the Festival – to establish a normative regime of pleasures and satisfactions – inevitably predicated deviations. Exercises of power produce reprehensible, pathologised responses as well as dutiful and sanctioned ones. In the Festival literature, the stress was on the 'positive'

achievements of designing and the responsive act of looking. Its underlying principles were mobilised elsewhere to police the limits of responsible signification. In the issue of *Architectural Design* which reviewed the Festival Pleasure Gardens in terms of complete approbation, a caption – 'Crime in Piccadilly' – censured a large figurative hoarding advertising Hennessy brandy. Design in the Festival was a potent resource in the reconstruction of the nation. Designing and planning were conceived as ensembles of natural and technical operations dedicated to producing good citizenship. A coalition of the empirical, problem-solving, with authorial expressivity – a Lion *and* a Unicorn – embraced by considerations of the national and popular, were shown to be capable of producing efficiency and pleasure in dialectic relationship.

The persistent mobilisation of terms of vision is profoundly over-determined. Seeing and believing provided perspectives which opened up new kinds of relationships and knowledge, whilst reconstituting the viewer as occupier of the new position which made that knowledge available. 'Opening the eyes' of the people was regarded as a responsibility of the designer. It was a project which trailed a visionary romantic sense of spiritual renewal, of unlocking the 'doors of perception', as well as a more mundane renovation of the 'social eye', a politicised repositioning of those who had newly arrived at a position of democratic power. The 'unblinkering' is a remedial project recognisable within the discourse of architectural modernism as an education of those with 'Eyes Which Do Not See' – the enemies of technological rationalism.[8]

This re-visionary project offered new positions to the citizen/consumer; positions from which rifts and discontinuities in the social and national fabric could be seen, and compensatory resolutions recognised in the Festival's perspectives and closures. The problems were problems of unequal distribution – the solution lay through a knowledgeable integration. 'Space' was the dominant figure in the conception of a social terrain on which the problems could be resolved. National and domestic space could be reconceived through the terms of design, in ways which could remedy disadvantage. Class and unequal wealth were displaced as problems in favour of strategies for redistributing people and objects. An economy of space was a dominant consideration in planning the country, regions, 'new towns', the domestic interior, the kitchen. New configurations were produced by design out of the raw material of space – conceived as a valuable and rationed commodity. The Festival and its exhibits contrived a utility-picturesque: 'to give a feeling of space while economising in the use of space'.[9]

This new economics of space depended on a policy of management achieved through a: 'carefully contrived alternation of concealment and disclosure'.[10] The eye was to be re-educated, re-directed and pleasurably deceived by the traditional devices of the topographic – coulisse, repoussoir – wedded to the tectonics of modernist architecture with its capacity for

screening, hovering and rendering transparent. Good, scrupulous design provided the detailing which registered the participant point of view, motivated by a narrative apprehension of space:

> As one moves with the gently implied circulation, the views alter kaleidoscopically, the same grouping never occurring twice, such details as paving, water, chairs, litter bins, often beautifully designed, create interest and human scale.[11]

The picturesque, in its new application to the urban, served as a model of reconciliation – a healing of the severing of rural from the industrial culture by Victorian *laissez-faire* capitalism. The picturesque of the Festival is also picaresque, it is liberated from the prescriptive narratives of the previous century. Literary and visual metaphors, stories and vistas are 'interwoven', serially and thematically. The visual terms of this new 'mixed economy' of space are equally resistant to the modernist and the academic. The richly detailed vista of the *mise-en-scène* was made visible by a relaxation of the compulsions associated with more authoritarian systems of looking. The participant status of the viewing subject was a corollary to the informality of the view. This democratic nature of viewing was stressed in the cinema exhibit, where new technical effects, notably stereo sound and the new 'borderless screen', were dedicated to a more responsive and responsible experience of viewing. The potential of the image for relocating its audience at an enhanced level of participation, with its deep-focused and richly detailed 'choices', is proposed as an alternative to the constrained 'look' offered by the perspectival terms of monumentalism and the tendentious montage of avant-garde modernism. *Seeing* more closely and from more privileged positions, not previously afforded to the citizen-subject, is offered as a means of *participating*. Lionel Brett alludes to the upward (and forward) mobility which the South Bank offered, by referring to it as a 'dress circle seat'.[12]

The acuity and inclusivity of the citizens' perspectives are matched by those of the State. The need to know, to quantify and to discriminate as a basis for making the necessary re-adjustments in provision and distribution was conceived as crucial to the practice of design. Tim Benton's essay on the 'Pioneer Health Centre'[13] notes the relationship in pre-war welfarism between the biological enquiry into the body and life of the citizen and the visibilities produced by the new architecture of modernism. The architecture of the Festival was similarly designed to serve: its 'picture windows', floating walls and vestigial boundaries provided effective penetrations of air and light, and a 'healthy' visibility.

The nature of the picturesque was inflected by the national and popular. The gaze can be conceived as 'nationalised'. The acts of looking at the townscape of the Festival were invested with the genius of Wordsworth, Turner or Dickens. The stress on the choices of building materials for variety

and interest was not merely an exercise in Vorkurs aesthetics but an affir-
mation of the mingling of regional 'characters' in the composition of
'national' buildings, like the Royal Festival Hall – Portland stone, natural
English oak, Derbyshire fossil stone, and at Poplar – London stock brick
and Welsh slate. The de-personalised surfaces of the neo-classical and the
modern were revised in favour of an immanent labour process in ornament
and materials, manifest in the facture of textured and gestural surfaces.
Consumption of the new designed environment was to be an act of knowl-
edgeable patronage, engaged with processes of manufacture and materials,
and deriving pleasure from their sources and composition.

THE THREAT OF AFFLUENCE . . .
THE PERFECTIBILITY OF DESIGN

In the Festival, design was offered as a solution, and a social technology
compounded of aesthetic and rational operations. The 'technological' was
conceived as capable of restoring pre-industrial harmony and coherence by
liberating natural forces for social use. The 'discoveries' and 'advances' of
science were one of the themes of the Festival. Design, though responsive
to innovation, was frequently discussed in terms of a possible achievement
of stasis, capable of achieving a practice and style so rationally and emotion-
ally satisfying that change and reaction would wither away.

Paul Reilly's 'Letter from Sweden'[14] points to one of the reasons for the
paradigmatic nature of Scandinavian design in the literature of the Festival:
'Sweden is today achieving a stability of taste and an overall standard of
design such as has not been witnessed anywhere since the eighteenth century
in England.'

The primary obstacle to the attainment of this evolved ideal in England
was conceived as 'natural conservativism', but it could take a more sinister
form. Reilly, reporting from Holland in 1949,[15] in a letter titled 'Hitler's
Taste is Still Alive' warns of a return of *'heimatkunst'* coinciding with 'a return
to comfortable rations'. Fashionableness and irresponsible consumption are
equated with poor design and considered symptomatic of political and social
deviance. Untrained affluence was a threat to the attainment of standards
and stability in taste. For British design, a middle path was deemed appro-
priate – between the intellectualism of the Bauhaus and the indiscriminate
eclecticism of the 'Folkish'.

Addresses to the nation produced around the Festival drew on the generic
conventions of the British Documentary Movement and the wartime work
of the Ministry of Information. The temporal flow from past to present, the
spatial flow from country to town to city, the dialectic paradoxes of unity
and diversity were part of a complex construction of nationhood composed
over a relatively brief period. Opposition to the Festival was scornful of its
didacticism and its aesthetic of compromise. Robert Lutyens, writing in

Country Life, recorded his regrets at the loss of 'monumentality' and 'spirit', the bizarre results of an unresolved collision between what he termed the architectural and engineering, and the pervasive pedagogic tone: 'We are living in an age of educative presentation, that is to say, of pictorial and symbolic display, montage and graphology.'[16]

The pedagogy of the Festival sought to achieve a diffusion of middle class modernist taste, compromised with strains of a new national popular. The quest for a robust tradition of 'popular art' is already apparent in the empirical anthropologies of the Left in the 1930s and 1940s, and although some of the components were gathered into the 'picturesque', there is no sense in the Festival of what a post-war working class culture might look like. The pleas for a revolutionary synthesis of art and design, so common in the literature of the 1930s and best focused in Herbert Read's pre-war writings, was augmented by a new evaluation of the technological, the admission of the social sciences and a social 'organic' model, indebted to an arts and crafts/utility tradition and a pre-lapsarian 'Georgian' sensibility.

HISTORIOGRAPHY AND GEORGIAN VALUES

Mobilising the visual culture of an upper class élite of the eighteenth century in the interests of a social democracy in the 1950s presented some problems for the historiography of design. Georgian has a long history of deployment in the terms of a negotiated British modernism. The Georgian was a paradigm of stability, but it also trailed associations with the restricted access of an educated ruling taste. In an article on Raymond Loewy, in 1951,[17] David Pleydell-Bouverie attributed the superiority of British automobile design to its consumption by a relatively small and cultivated group of consumers, with the inevitable 'Georgian' comparison. The overthrow of Georgian space, scale and proportion was closely identified with the growth of an indiscriminate and ill-educated patronage ushered in by industrial capitalism.

Georgian had to be reconceived to accommodate popular tastes and to serve the middle path between modernism and vernacular. In 1947, Donald Pilcher introduced his book on Regency style with the homely metaphor of 'a double decker bus',[18] a tendentious presentation of the utility of Regency for the post-war era. On the lower deck there was a foundation of sculptural and spatial sensibility, on the upper a sentimental and irregular popular, the two brought into new found reconciliation by the technology of the time. This combination of the rational and the imaginative, cemented by neo-technicism, nationally validated and at one with nature, rendered Georgian a lexicon of solutions for post-war design. Soane and Nash, in particular, with their landscaping of urban architecture, were prominent models.

The proposed delivery of Georgian into the twentieth century by new technologies was presented in terms of an overthrowing of Victorian values.

Georgian was capable of holding, in productive tensions, the ubiquitous antinomies of the Festival. It was pragmatic *and* visionary; urban *and* rural; international *and* national; and most importantly refined *and* popular. Its organic poise had been brutalised by *laissez-faire* industrial capitalism. Victorian design's intrusive individualism – Steegman referred to it as: 'abandoning the signposts of authority'[19] – its 'devaluation of symbols',[20] tainted from the beginning with Imperial projects, its irresponsible use of machinery, and its preoccupations with visual strategies for marking out class boundaries, its squandering of resources and space, overwhelmed the proto-modern elements of Georgian design. The two paradigmatic solutions to the problem of creating participatory public spaces – the village green and the piazza/square – were overrun by speculative building. Victorian design was treated circumspectly in the Festival. There were obligatory nods to the Great Exhibition, repressed as an exhibit until, at the last moment, the centenary rationale was remembered. 'Victoriana' was already an enthusiasm and a period resource shortly to become an object of more serious study, but, in spite of some early re-evaluations, its clutter, scale and gloom was a villain in the 'story' of democratic design. In Marghanita Laski's 1953 horror story of a woman spirited from a neo-Regency present to a Victorian past, Victorian design is the monster.[21]

The Blitz and social democracy enabled planners to re-conceive Victorian London as a bulking landscape that could be re-cast for a new civic aware-ness. John Summerson in *Georgian London*[22] was concerned to retrieve the framework of a London rendered 'turgid, intricate, plethoric', by the later nineteenth century. For Summerson, post-war London was 'A city whose sky-line is the bed of an ocean where the nineteenth century has foundered.'[23]

For the picturesquely motivated gaze of the Festival-goer, the Houses of Parliament could serve as a 'rock strewn hill'.[24] The new national space of Georgian neo-technic was an antidote to Victorian values, constructed in terms of clarification and visibility – smoke abatement, glass envelopes, the circulation of light and space. Only where Victorianism was redeemed by close contact with the technological, with nature or popular entertainment – exhibition buildings, railways, canals, follies, seaside towns and pubs – could it be admitted to the new regime.

The *Architectural Review* had polemicised in favour of 'Sharawaggi'[25] since the late 1930s. Gordon Cullen's contributions, often in the form of picture essays, stressed the agency of the eye as a purveyor of moral as well as pleasurable discrimination. A disposition to the picturesque was regarded as a national 'capability', lingering on in DIY forms – the arrangement of ornaments on a mantelpiece, the planting of a front garden. In another, and functional sense, this empirical, modest picturesqueness was adaptable to the exigencies of utility, unit building in the post-war emergency. Picturesque provides variety and irregularity as aesthetic policy and, as Humphrey Repton proposed, these attributes are also the necessary consequence of

217

disposing a building to provide picturesque views from its windows. The adaptability to site and sympathetic tolerance to extension and addition were desirable attributes at a time of contingency building and economies of space.

The moral economy of the new planning was rooted in a major historiographic project – a teleological re-ordering of the architectural past. Modernism and the nineteenth century, with the exception of a tenuous strand that ran through both, marked a misrecognition of materials, spatial order and the vernacular genius for resolving the claims of technology and Nature. The remedy lay in a clearer vision and the adoption of enduring strands of a national design culture. History was adjusted – Medieval building was 'sound' but ill-planned and 'spoilt' by congestion; Elizabethan/Jacobean was a period of heroic self-sufficiency manifest in trade, printing and a new leisured class (and, as such, appropriable to the visual rhetoric of 'Coronation' and 'New Elizabethans' within a few years after the Festival); Baroque was an alien imposition, with the honourable exception of Wren's neglected plans for London – Georgian was the wholly beneficial nationalisation of the Renaissance.

'Planning' as a term acquired new meanings in the immediate post-war period. The victory of 1945 was represented as a triumph for a planned economy and an egalitarian national effort. 'War radicalism'[26] countered the State's insistence on 'duties' with an assertion of 'rights' and less confidently of 'pleasures'. 'Planning' meant both scheme of action *and* manipulation of space and provided a strategic point of entry for the theory of architecture and design in the wider arena of political solutions. The architects and designers of the Festival were engineers, social scientists and constructors of narratives.

The historic break afforded by the 'People's Victory' supposedly necessitated a repositioning of those people as subjects, and a Keynesian sense of the lapse between democratic participation and the development of democratic tastes conferred on planners a role of responsible guardianship. They took up the opportunity of re-composing the past and resolving its unproductive antagonisms. They fought on two fronts – against a myth of progress and against decorative historicism – from a position both empirical and eclectic.

Quests for 'expressive densities' of the 'neighbourhood', a new respect for the dictates of the site, aspirations to 'natural' light and air and a concern for the significant and tactile properties of materials dominated the architectural discourse of the years around the Festival. They are aspirations which have a close affinity with the terms used by Kenneth Frampton as a condition for 'critical regionalism' and are assumed to be defining characteristics of 'post-modern' practices. The *Architectural Review*'s interventionist editorial policy of the post-war years, aimed at the new civic élite of councillors and technical officers, was vitally concerned with a full range of 'post-modern'

issues – the place of ornament, scale and monumentality, the utility of the national vernacular and the claims of the pedestrian.

The implicit agenda of the Festival – to formulate a design practice and style adequate to social-democratic welfarism – its conceptions of Britishness and 'the land', bears in different ways and with different weights on the exhibits. Its collective, collaborative, integrative culture has been disintegrated in the 1980s and a large part of the impetus to investigate this event was an interest in analysing the conjunctural formation of forces and techniques, now in the process of ruthless revision and reversal.

NOTES

1 'What the visitor will see on the South Bank is an attempt at something new in exhibitions – a series of sequences of things to look at, arranged in a particular order so as to tell one continuous, interwoven story.' Ian Cox, *Festival of Britain Guide*, HMSO, London, 1951.
2 From the version transcribed in the *Journal of the Institute of Registered Architects*, 1951, Festival of Britain Souvenir Edition.
3 The Visual Pleasure Group: Owen Gavin, Andy Lowe, Angela Partington and Barry Curtis.
4 Terms taken from Ian Cox's introduction, op. cit.
5 Ibid.
6 See 'The Social Eye of Picture Post' by Stuart Hall, *Working Papers in Cultural Studies*, no. 2, Birmingham Centre for Contemporary Cultural Studies.
7 Cox, op. cit.
8 'Eyes Which Do Not See' – one of the central sections of Le Corbusier's *Towards a New Architecture*, first published in England in 1927 and an influential text for English modernists.
9 Quoted from *Architectural Review*, no. 656, August 1951.
10 Ibid.
11 Ibid.
12 Ibid.
13 Tim Benton, 'The Biologist's Lens: The Pioneer Health Centre', *Architectural Design Profiles*, no. 24: Britain in the Thirties, n.d.
14 Paul Reilly, 'Letter from Sweden', *Design*, November 1950.
15 Paul Reilly, 'Hitler's Taste is Still Alive', *Design*, June 1949.
16 Robert Lutyens, *Country Life*, 27 April 1951.
17 David Pleydell-Bouverie, 'Raymond Loewy', *Architectural Review*, no. 657, September 1951.
18 Donald Pilcher, *The Regency Style*, Batsford, London, 1947.
19 John Steegman, in the introduction to *Consort of Taste 1830–1870*, Sidgwick & Jackson, London, 1950.
20 In the sense defined by Siegfried Giedion in the 'Mechanization and Ruling Taste' section of *Mechanization Takes Command*, Oxford University Press, 1948.
21 Marghanita Laski, *The Victorian Chaise Longue*, Cresset Press, London, 1953.
22 John Summerson, *Georgian London* (first published in Pleides Books 1945, originating in a series of lectures given at the Courtauld Institute in 1939), Pelican, London, 1969.
23 Ibid.

24 *Architectural Review*, no. 656, August 1951.
25 'Sharawaggi' derives either from the Chinese 'sa-ro-(k)wai-chi', meaning 'graceful disorder', or the Japanese 'sorawaji', meaning 'not being regular' – first used in English landscape gardening terms in Sir William Temple's *The Gardens of Epicurus* (1685) where he defines it as the 'studied beauty of irregularity'. According to Hugh Honour (*Chinoiserie: The Vision of Cathay*, John Murray, London, 1961) the association of China and irregular gardens was chiefly motivated by images on lacquer screens and porcelain plates.
26 'War Radicalism' as defined in 'Out of the People: The Politics of Containment', *Working Papers in Cultural Studies*, no. 9, Spring 1976.

Part III

CULTURAL THEORY

INTRODUCTION

The project of compiling a reader makes us uncomfortably aware of the traps and slippery surfaces involved in the process of historical reconstruction. What can easily appear between the covers of an anthology as a developmental logic of topics, issues and methodologies was often experienced, in fact, as accidental associations, the search for copy, or, simply, what seemed like a good idea at the time. However, patterns do become clear with distance and reflection, and the three sections of this reader represent the major themes and interests that persisted throughout our 10 years of publication, although some articles deliberately cross boundaries and defy easy classification. This is particularly the case with the texts in this section which reflect an intention – to make a case for the interdisciplinary nature of intellectual inquiry and research in the Arts and Humanities departments which were the 'home' for many of our contributors, while also suggesting a sense of 'fishing in the dark'. As suspicions grew over the totalising claims of certain theoretical formulations there was, nevertheless, a shared belief that the impact of theory on the field of visual representation, from history and criticism to evaluation and interpretation, was positively destabilising the certainties and traditions that had underpinned these discourses. Perhaps the term, taken from semiotics, that best connected and described this venture was 'decoding' – the recognition that levels of meaning could be uncovered in any social practice or representation, not to reveal an essence or 'truth', but to display the incessant movement of ideologies and politics at work in and on the text. In this respect the work of Michel Foucault equating 'knowledge and power' proved, and continues to prove, of fundamental importance.

BLOCK tried to negotiate, not always successfully, the tricky path between an accessible voice and a commitment to theory – that is, to the necessity for self-reflexive forms of exposition – while at the same time recognising that there is a politics of theory and that theory has a history. Indeed the history of *BLOCK* is also a record of our theoretical legacies. The arguments about theory and its relation to practice, sometimes equable, frequently vitriolic, have accompanied us over the past 15 years and still await (avoid?)

resolution. (Stuart Hall has described the only worthwhile theory as 'that which you have to fight off'.) It seems that there is, once again, a new insistence to these debates and struggles. The long road travelled through the 1970s and 1980s – from the legacy of 'grand theory' (the attempted amalgamation of Marxism and post-Marxist theories of ideology, semiotics and psychoanalysis) to the reinscription of local histories and subjectivities ('identity' politics), the growing consciousness of the politics of environmentalism and the promise and the threat from the revolution in information technology – has returned us, uncannily, to familiar questions of meaning, value and our place in the world.

Another contested term for all this is 'post-modernism' and, throughout the 1980s, we seem to have been having an extended conversation over what Jameson calls 'postmodernism theory'. In the early days of *BLOCK* and of course-planning at Middlesex, we used to raid the bookshops, particularly Compendium in Camden Town, for new titles in this rapidly expanding field of critical and philosophical inquiry. Reading lists lengthened daily, talks and conferences mushroomed, undergraduate and postgraduate programmes were developed in response to these debates in an exhilarating and exhausting convergence of discourses and disciplines whose repeated refrain was the so-called 'critique of representation'. Discussions over what constituted knowledge in the arts and sciences, or meaningful action in politics (questions of realism, narrative, truth and identity), figured centrally in changes across all areas of culture. These ranged across the traditional fine arts and electronic media, the writing of fiction to the fictions of virtual reality; from manifestations of national identity and continuity to hybrid and nomadic forms of cross-cultural experience. However, to critique representation is not to escape it.

At times, the discourse of post-modernism has become so overloaded with definitions, claims and counter-claims, accusations and defensive protestations, that any sense of meaning or reference seems to be lost or deliberately abandoned. (See, for example Judith Williamson's interview with Jean Baudrillard from *BLOCK*, issue 15.) However, as Dick Hebdige argues: 'An ambivalent response to what Barthes might have called the "happy Babel" of the post seems on the whole more honest and in the long run more productive than a simple either/or.'

Whatever position is taken in relation to these debates and controversies, there is an overwhelming sense that the ground has shifted, and that even if many of the key political and cultural issues of the present bear the traces of earlier moments, their return is inflected through the critical analyses of post-modernism.

With *BLOCK*, we always tried to hold on to a sense of the political at work in the cultural sphere, and the articles we published, and now reprint, seem to us to connect theory with practice, construing the institution and the discourses of the academy, the media, the state apparatuses, as arenas

for relations of power and knowledge as they directly affect people's lives and everyday experience. This section of the reader explores theories and models within the context of forms of practice and the constraints and determinations of institutional structures. Frank Mort and Nicholas Green bring together questions of history writing, visual representations and sexuality to foreground 'pleasure' as a key concept in cultural politics. Olivier Richon's contribution to the critique of Orientalism and the structures of 'othering' in nineeenth-century painting and photography, and Martha Rosler's analysis of technological myths in the history and development of photography and video art, represent the application of theory to practice by two artists for whom the distinction makes little sense, and Dick Hebdige has always moved with apparent ease between disciplines and forms of writing and expression. Constantly and deliberately confusing 'high' and 'mass' forms of culture, Hebdige's adroit interweaving of theoretical exposition, striking visual case studies, poetic and playful uses of language, and consideration for a wide and varied readership, still provides a stimulating model of creative cultural analysis.

As we have written in the Introduction to this volume, the fifteen issues of *BLOCK* produced over a 10-year period, and our subsequent 'Futures' project of conferences and books, have emerged in the context of an educational institution undergoing considerable change and reorganisation, the day-to-day practice of teaching, research and course development, and the shared and often divergent interests of an evolving editorial group. What has, perhaps, held us together and made *BLOCK* more than a bricolage of occasional articles, has been an abiding interest in the specificity of the visual, and what might be the most appropriate concepts, models and theories for interpreting how the visual 'means'. To this end, the insights of critical and cultural theory over the past 15 years have been enormously productive. The corporeality of vision, the gendered and racial gaze of the viewer, the materiality of the image and the technologies and histories of representational apparatuses, the concept of the specular society and the optical unconscious, have all in their varied accounts contributed to the recognition of orders of visuality as forms of knowledge. Our hope is that the articles collected here have been a part of, and will continue to participate in, this process of the theorisation and practice of visual culture.

13

VISUAL REPRESENTATION AND CULTURAL POLITICS

Nicholas Green and Frank Mort

(*From*: Issue 7, 1982)

In this article we draw on and develop certain recent debates around language, ideology and discourse theory in relation to work on visual representation and to a number of key issues within cultural politics. The main force of our argument is directed at the current domain of art history. Art historical analysis works with a set of norms which have important implications not only for academic teaching, but for the ways in which visual material is ranked and evaluated within a range of institutions and within public debates over the arts. Despite recent efforts to develop new approaches to the analysis of visual representations from socialist/Marxist art historians, their work often reproduces the methods and concerns of mainstream art history.

We begin by outlining briefly the main problems with the current field of art and the discipline of art history. We suggest how a more adequate approach to visual material might be developed through two historical instances. First, the position occupied by representations of landscape within a debate over urbanism and class cultural relations in France from the 1820s. Second, the relation of visual representations to the construction and regulation of sexuality within official discourses and popular journalism. The conclusion draws out the implications of this work for current debates and struggles. We discuss the relevance of history for cultural politics, and we examine how issues of aesthetics and cultural enjoyment foregrounded in art history and high culture, raise important questions about pleasure. This issue – the politics of pleasure and the forms intervention might take – needs to be seen as important for current socialist and feminist strategies.

THE ARTISTIC FIELD

There have been a number of important critiques from the left of the current orthodoxies within art history, but the alternatives put forward preserve and reproduce many of the same procedures and definitions. The domain which constitutes art is still broadly accepted as a given. The overt application of aesthetic criteria and evaluative methods has been abandoned, but writers

such as T.J. Clark, Nicos Hadjinicolaou and John Barrell continue to cele-
brate the work of great artists and to be concerned with 'significant' art
objects.[1] What justification is there for the continued retention of a set of
artefacts designated by the term art as the focus of study? What guarantees
the art object its centrality, or indeed what gives the category art coherence,
as something ontologically constant from one historical period to the next?
The field of art history is not only discreetly organised around a set of
aesthetically defined objects, but it also operates with an internal, object-
based focus which serves to reproduce categories of aesthetic pleasure,
spiritual value and a particular notion of sensuous enjoyment. This primary
engagement or dialogue with *the object* still goes unquestioned. Again the
work of Clark and Hadjinicolaou demonstrates a continuing central commit-
ment to the art work as that which needs to be explained. Their arguments
work with an understanding of ideology whereby particular images are seen
to be significant carriers of ideological meanings. But the perceptual modes
of analysis – whether stylistic or iconographic – draw heavily upon the
conventions of mainstream art history. They serve to reinforce the unique-
ness and specialness of the object in itself. The question that needs to be
asked here takes us beyond the unchallenged notion of the object *as art*.
Why is cultural enquiry directed at and organised around individual objects
at all? The problem is not limited to art history; it is central to all of those
text-based analyses of film, literature and television, where single texts are
given special significance in the identification of ideologies.

In what ways can we transform those protocols? First, we need to
profoundly shift not just the analytical language, but the things we concen-
trate on and the questions we ask. As Griselda Pollock has recently argued,
this involves a renewed scrutiny of the couplet art/history and a rejection
of those polarities which distinguish between "'art *and* society" or "art *and*
its social context", "art *and* its historical background"'.[2] Visual representa-
tions need to be seen as part of an interlocking set of histories which involve
multiple relations and dependencies across a range of social fields and
practices. It is no longer a question of analysing an internal field of visual
imagery in its relation to a set of external determinations (science, the family,
sexuality, etc.), but of understanding the interdependence and interchange
of discourses and practices, with mutually reinforcing results. This is not a
question of a black on white, figure on ground, art and history relation. We
must hold on to this point at the moment of our analysis, which should not
be directed at any single object, image or sub-domain (art criticism,
patronage, etc.), but upon the play of interlocking social processes. Moreover,
the deconstruction of the field of art should entail the investigation of the
very processes by which its nature and status have been constructed and
secured through specific practices at different historical periods.

If we are to understand visual imagery in this way, then how we identify
the relation between particular visual meanings and their precise conditions

of existence remains a problem. Various forms of Marxism and marxist–feminism have tended to work with a notion of re-presentation; the idea that the particular discursive definitions and power relations represent and reinforce power relations whose origins lie elsewhere. For example, visual representations which define women in a subordinate relation are seen to be grounded in the general economic, political and ideological subordination of women. Social practices and discourses are ultimately seen to be coherently related and mutually reinforcing. The problem here is not only that the specificity of representations and power relations tends to be underplayed, both theoretically and politically, but that Marxist positions and marxist–feminist positions still require the levels of determination acting on the formation of a particular practice or discourse, to be conceptually ranked and hierarchised. They do not work with functionalist and reductionist concepts of determination, but they do still work with a necessary level of economic causation. What is at issue is precisely the notion of a general theory which defines one's mode of analysis in advance. Discourses and practices may at moments be dependent on particular economic and political transformations, but that provides absolutely no warrant for constructing a general theory about causality.

There is a further question here about the specific ways in which power functions in contemporary societies. As Michel Foucault has pointed out, it is not that power works to secure dominations *either* through forms of repression and physical violence *or* through the work of ideology. Rather, power is often simultaneously regulatory and productive. The production of pleasures and desires, and the creation of new knowledges and subjects, can be intimately bound up with the functioning of power.[3] This point is particularly important for work on those fields which are unified around notions of pleasure – art, literature, etc.

These points are not merely academic; they have significant political implications. Many of the forms of politics which have emerged in the 1970s and 1980s (crucially feminism and struggles around sexuality, but also black and anti-racist movements, youth subcultures, environmental campaigns, tenant, squatter and community action groups) have reassessed the ways in which power operates and the strategies for resistance. They have all been critical of social democracy and of orthodox Marxism for failing both to provide an adequate account of the multiple relations of power and domination, and to formulate a politics which is aware of the specificity of particular struggles, without operating with a tokenism or a strategy of incorporation. These political challenges to the classical perspectives of the left have stimulated fresh inquiries into socialist theory, and have involved a questioning of the way 'politics' and 'socialism' are to be defined. We want to explore this issue of power in relation to the historical formation of practices which are centred upon visual representations, and to go on to draw out the implications of that work for current cultural politics.

URBANISM, LANDSCAPE AND CLASS

The early nineteenth century in France saw the emergence of modern defin-
itions of urbanism, in the context of a debate around the nature of Paris which
was formed at the intersection of a number of discourses and institutional
strategies. Like many French cities, Paris underwent a partial transformation
in the first half of the nineteenth century. But this shift has been generally
overlooked in the twentieth-century histories of urbanism, in favour of the
more radical restructuring of the city undertaken by Haussmann after 1852.
In fact, a number of important features emerged in the course of the earlier
changes: the active alliance of State intervention (the prefect of the Seine) with
private financiers and speculators; the development of planned complexes of
streets, almost exclusively for the wealthy (in a series of quarters to the north
and west); the exploration and application of new technology (bitumen
pavements, gas lighting); the expansion of commercial initiatives (covered
arcades, glass shop windows, the first *grands magasins*); the renovation and
reorganisation of space around major edifices (the Hôtel de Ville); the focus
on communications (the establishment of the first railway stations) and an
extensive debate around health – social and individual. These elements
provided many of the dominant characteristics which underpinned the
massive planning and building exercises of the later Haussmann era.

Between the 1820s and 1840s, across a range of texts which were
concerned in some way with the city – government enquiries, novels and
popular journalism, texts on town planning and political pamphlets – a par-
ticular construction of Paris emerged. This identified the new or refurbished
quarters with 'modern' Paris, with the dynamism of finance capitalism and
with the glamour or the corruption of a thrusting *haute bourgeoisie*.[4] The
specificity of the image brought into focus, by contrast, that other Paris –
'old' Paris – perhaps visually picaresque but more centrally filthy, poverty-
stricken, rife with disease, criminality, immorality and potential insurrection.
These discursive representations had their conditions of existence in a
specific conjuncture of economic and institutional developments: the
economic boom of the 1820s, followed by the slump of 1826, which produced
the half-completed new quarters; the expanded role of government agencies
in stipulating urban regulations and in deploying new knowledges like
statistics for the accumulation of information; the expansion of the publish-
ing industry and of the press. But the juxtapositions and interaction between
these cultural meanings around the city did not reflect or express those
conditions in any simple way. Rather, they had their own logic and their
own effects.

In the many and varied forms of writing dealing with Paris at this period,
the two interdependent images of the city, 'old' and 'modern', were
frequently harnessed together in an unstable alliance, although they were
associated with different geographical areas and radically different social

229

groups. The result was that Paris represented, in one and the same breath, vital social activity *and* ill-health, dynamism *and* artificiality, modernity *and* immorality. These contradictory definitions were most explicit when the city was juxtaposed with an oppositional elsewhere: with the French provinces, with a vanished historical past, a potentially different political future, or with the certainties of nature. The naturalness of nature as signified by the burgeoning variety of landscape imagery available in the period, referenced, as against the representations of the city, a stable continuity between past and present, a natural and organic order of things, freshness, naivety and health – both physical and moral. These representations of nature, visual and verbal, were not autonomous, but were actively bound up with the debate around Paris; they were given meaning in and through that debate.

These meanings predominated in the whole spectrum of visual images of nature from the 1820s onwards, as well as in picturesque writing on the French provinces in poetic texts and tourist guides.[5] Daumier explored the contradiction of landscape as an urban phenomenon in his caricatures on the bourgeoisie in the countryside from the 1840s; they were shot through with meanings to be consumed by an urban audience. A decade later, the same attitudes to landscape permeated the planning of the new parks of Paris, which were laid out or transformed by Haussmann's team, with serpentine paths and successive pictorial vistas, with 'natural' events constructed out of artificial rock.

Representations of nature occurred across a range of texts, but we must be attentive to the specific organisation of the visual field. In the context of

Figure 13.1 W. Robinson, *The Parks, Promenades and Gardens of Paris*, London, 1869

Figure 13.2 H. Daumier, *Les Plaisirs de la Villegiature*, 1858. 'Here my love . . . it won't be said that we haven't any flowers on our estate this year . . . here's a rosebush that I've brought you from Paris.'

Source: Le Charivari, 16 June 1858

the early nineteenth century this means that we need to examine the contemporary practices and institutions of the art world. The hierarchy of genres which was integral to art criticism and institutional training systems allotted a particular space and status to landscape and, by the 1820s, promoted an increasingly differentiated form of training and 'creative' lifestyle.[6] This resulted in an increase in the numbers of practitioners and the rise in aesthetic importance of the genre within art. At the same time, the visual codes identified with the landscape genre were employed in a wide and expanding range of practices, which crossed or lay beyond the parameters of art: the illustrations and vignettes adorning novels and artistic magazines, such as *L'Artiste*; the extensive picturesque literature on regional customs and places; tourist guides and news and information images in periodicals and popular journals, including *L'Illustration* and *Le Magasin Pittoresque*.[7]

231

Urban meanings were significant here because they involved a set of power relations which played an active part in the cultural construction of sections of the bourgeoisie. Visual images of nature and the new parks of Paris were only comprehensible, of interest and of value to a certain public; an audience so positioned as to be able to relate to both sides of the urban/rural equation. Landscape had little to say to the peasants whose lands were painted. Writing on town planning and urban renewal was irrelevant to the problems and self-definitions of the urban unemployed, or the landed gentry. But both forms made active constructive sense to a range of urban social groups (not necessarily Parisian) who were also addressed by new housing and shops, by the products of art and the Salon exhibitions, by the new illustrated journalism and cheaper literature, the availability of leisure, of faster and more extensive travel. This network of cultural meanings constituted a set of 'ideal' subject positions which stood in relation to a wider mesh of already present or emergent values and beliefs and worked actively to exclude or marginalise others. The combination of values – health, morality, leisure, progress and civilisation – did not emanate from pre-existing class formations. Rather, at this historical conjuncture, they became redefined and reorganised *as bourgeois* – as central to the cultural life and identity of the middle classes.

Visual images of nature cannot be understood in isolation, through a scrutiny of their internal make-up, nor as expressive bearers of external social meanings. In fact the images as images cannot form the focal object of our attention. An analysis of cultural meanings and their significance depends upon a grasp of the positioning of landscape imagery as a relational term, in the complex cultural debate around the city and urbanism.

VISUAL REPRESENTATIONS AND SEXUALITY

Visual representations played a significant part in the construction and regulation of sexuality from the mid-nineteenth century. A number of visual codes or genres within official and journalistic photography and many of the rules and norms governing painting were bound up with the power/knowledge relations addressing sexuality. Debates around the physiology of sexual difference and sexual deviance, definitions of female sexuality and of the pornographic and the obscene, were developed not only in written texts but through a range of visual codes, which worked to consolidate particular hegemonies of power.

Official debates around sexuality formed part of the various moral strategies of English nineteenth-century environmentalism and philanthropy which were primarily organised around a programme of class disciplining and regulation. The various Royal Commissions and the statistical enquiries on poor relief, educational reform, health, housing and sanitation and the reform of industrial conditions, constructed the sexuality of the labouring

232

classes, and of women, around a series of oppositions – vice/virtue, cleanliness/ filth, animality/civilisation, etc.[8] These polarisations worked to define and regulate the subjects they addressed; for example, the respectable woman or the potential prostitute. But they also structured the organisation and experience of sexuality and sexual pleasure, for many middle-class and aristocratic men, around the transgression of moral, respectable and marital norms. If we turn to private letters, diaries, personal confessions and pornography, sexual pleasure for many such men seems to have been organised in terms of private debauchery, lust and licentiousness, which was experienced as pleasurable precisely because it stood in opposition to the sanctioned norms of middle-class domesticity and marital relations.[9] In nineteenth-century pornographic discourse, male sexual pleasure was frequently centred on the depraved and sexualised female prostitute – socially inferior, and seen to be suffused, shot through with male sexual desire.

Visual pornographic imagery in the Victorian period and beyond consistently defined a set of representations of women for the male gaze which worked across the virtue/vice, innocence/depravity oppositions. Perhaps the clearest examples were in the early pornographic studies of child prostitutes, where the innocence of childhood was framed against the visible signs of immorality (the exposed genitalia or the depraved stare), to produce a particular set of sexual meanings. Much current pornography operates with similar oppositions. Representations of women, positioned for the male gaze, are shot through with a 'liberated' sexuality for men. In these representations women are seen to be enjoying what men desire, and are implicitly defined against the norm of respectable femininity. Pornography reinforces the definitions of female sexuality in terms of the respectable woman and the woman who is defined for male sexual pleasure. These representations have a wide circulation and are central to the contemporary regulation of women's behaviour. Paul Willis' study of male working-class youth revealed how definitions of women in terms of the 'slag', or the 'easy lay', on the one hand, and the girlfriend, wife and mother, on the other, continue to reproduce these male definitions of female sexuality.[10]

Visual representations, whether working through the codes of high art or in advertising and pornography, have an intimate relation to the circulation of ideas and beliefs about the nature of female sexuality. Male sexual arousal and response is constructed and reinforced through specific visual codes, with their deeply embedded notions of immediacy, actuality and truth. The framing and presentation of visual material, as unique and textually authentic, promotes an active and immediate consumption by the viewer. We need to stop thinking of representations of female sexuality purely in terms of their specific genre (painting, film, pornography) and to insist that they are part of a field within which women have been consistently subordinated. This should certainly transform the whole debate within art history over images of women within realist painting and avant-garde art. The whole

233

development of avant-gardist painting and sculpture has been bound up with sexualised definitions of the female body – involving women's fragmented forms, an obsessive focus around the sexual organs, or explorations of sadomasochism organised around female images (for example the work of Hans Bellmer, or the new acquisition by Allen Jones in the Tate).[11] Surrealism and pop art have actively consolidated their progressive and ruptural stance through a focus on female sexuality. The point to bear in mind is that these supposedly progressivist forms have often had the most profoundly reactionary implications for women.

In a different though related sense, the intersection of a range of official knowledges with forms of official photography reveals how visual material has worked to define meanings around sexual difference and sexual deviance. In the nineteenth century, medical journals such as *The Lancet* and the *British Medical Journal*, and medical textbooks, were quick to see the scientific value of visual illustrations, after the development of a series of technical processes which made possible the mass reproduction of photographic images. As *The Lancet* commented in 1859: 'Photography is so essentially the art of Truth – that it would seem to be the essential means of reproducing all forms and structures which science seeks for delineation.'[12]

This was the emergence of photography as evidence across a whole range of official discourses – legal, medical, psychiatric, anthropological. Photographic illustrations became significant for a variety of medical and biological sciences precisely because of the increasing scrutiny of the body and its normal and pathological characteristics. This was part of the more general shift away from environmental medicine to the study of the physical and mental health of individuals. Early theories of criminality, insanity and deviancy, such as those in Lombroso and Ferrero's *The Female Offender* (1893) or in Havelock Ellis' *The Criminal* (1890), defined a range of criminal or deviant types or characters through a biological or anthropological framework. Deviance and criminality were located in a pathological or aberrant anatomy. For example, female insanity was consistently defined in terms of the physical malfunctioning of the reproductive system, or through an arrested human evolutionary development – as an atavistic throwback to primitive man. These types could be identified because their characteristics were represented in physical and anatomical abnormalities, which could be precisely measured. As Lombroso and Ferrero commented: 'The anomalies in female criminals and prostitutes are: very heavy lower jaw, enormous nasal spine, simplicity of sutures, narrow or receding forehead . . . prominent cheek bones.'[13] Havelock Ellis classified criminal types according to a similar range of biological or physiological elements: cranial and cerebral characteristics, the face, anomalies of the hair, the body and physical sensibility.[14] Both accounts drew heavily on photography to secure the visual proof of their theories, through realist codes and conventions whereby the signifiers in the photograph pointed to signifieds in the real.

234

A GROUP OF SEXUAL PERVERTS (ELMIRA).

Figure 13.3 A group of sexual perverts from Havelock Ellis' *The Criminal*
Source: Havelock Ellis, *The Criminal*, Schribner & Welford, New York, 1890

But this development was not merely the use of a pre-established tradition of realist photography to reproduce certain medical and biological norms; the relation between photography and official discourse was reciprocal and mutually reinforcing. Photography's intersection with other disciplines which relied on methods of empirical proof worked to promote the authority of the photograph as a transparent guide to scientific truth. Realist photography as well as the human sciences gained by the exchange. From that perspective we can begin to see that we are dealing with the multiple intersection of a range of discourses, not with something designated as visual material in its interiority and a series of objects external to it.

The organisation of visual representations of sexuality and sexual difference has extensive continuities into our own political present – not only in medical textbooks and in textbooks on school biology, but also in the forms of reportage of popular journalism. Biological and anatomical definitions of sex and gender have achieved a powerful and sustained hegemony within public debate and at the level of popular culture. They are often secured through common-sense visual distinctions between male and female, and between normality and deviancy, in the mass of realist photographic images in the popular press. In the recent coverage of the 'Ripper' trial of Peter Sutcliffe, visual significations worked to reinforce the distinction between the normal family man (with recurrent photos from the family snapshot album and of Sutcliffe's wedding), and legal and psychiatric definitions of the monster or madman. Sutcliffe was both a normal man and an evil or pathological killer. These polarised representations structured out any discussion of the case in terms of the general problem of violent male sexuality. Similarly, visual representations of the Ripper's victims grouped the respectable women apart from and above the prostitutes, and thereby

confirmed the dominant definitions of female sexuality in play around the respectable/promiscuous woman dichotomy.

HISTORIES OF THE PRESENT

Both of those examples demonstrate how work on visual material must be seen as integral to the functioning of forms of cultural power. But dominant orthodoxies consistently define visual material not only in terms of the aesthetic and cultural norms of art, but through a highly particularised and discrete notion of history. The couplet is art/history. The assumed relevance and importance of history here needs as much interrogation as the object-centred norms we have discussed. It brings us to a wider set of questions which need to be foregrounded in all forms of socialist and feminist intellectual projects. Namely, what is the relevance of historical forms of analysis; what relation do histories of culture have to cultural politics in the present? Can history inform the types of political demands and choices we make in the field of cultural struggle? We should say immediately that to justify histories of culture solely in terms of their socialist and feminist content or perspective is simply not enough. This approach has made a series of effective interventions into the professionalised world of teaching within higher education over the last decade, and within that sphere it has fought effective and necessary battles. But the project cannot remain fixed at that level. The dangers of a purely professional radicalism are highly significant here. Socialism and feminism are ongoing political traditions, and the relevance of historical work does need to be thought through in relation to a wider spectrum of struggles than those within higher education. The reinterrogation of history has clearly played an important part in the formation of a distinctive political culture within the contemporary women's movement and the gay movement. As Bea Campbell and Anna Coote point out, a sense of history in broad terms – of perceived points of interconnection between past and present struggles – is vitally necessary if women are to transmit their politics to a new generation and so consolidate their gains.[15]

What we ask of the past should depend on the political present. In many respects that type of insistence can work to deconstruct the categories of past and present, and reveal them as the products of professional history. Historical work on cultural formations needs to be conceived as an attempt to understand the conditions of formation of our own historical present in the cultural domain. Practices which construct the category 'woman' in a subordinate set of relations, or the norms which consistently hierarchise particular cultural forms, are themselves part of the complex historical organisation of class and gender hegemonies. What, for example, is the relation between the formation of certain artistic codes in the sphere of cultural production and the relative marginalisation of women practitioners? What range of strategies have worked to define particular artefacts as forms of art

within the national culture and heritage? Historical understanding of these issues can enable us to consider more adequately the alternatives around specific cultural struggles – to supplement forms of political calculation by a historical perspective.

Yet that should not be a blank cheque for any and every type of historical analysis. Current debates and struggles do need to set the broad terms for the types of historical projects or research we undertake, and need to inform the type of archival work we embark on. There must, in short, be a set of political criteria and questions defining the parameters of where to begin and where to stop. Otherwise we are still inevitably caught up in a narrow discourse of academic history – where historical adequacy is an internal and professional question, and where any field or area is seen to be potentially relevant. It is clear that many socialist, and feminist, historians still have a remarkable allegiance to those academic norms. Historiography is a highly professionalised discipline, with an elaborately codified language which works, behind our backs, to present material and to construct audiences in a particular way. We urgently need to develop a language of historical writing and a mode of presentation which can foreground current political problems and debates through forms of historical narrative and analysis.

CULTURAL POLITICS:
REPRESENTATION AND PLEASURE

In what ways can the work we have developed be applied to the current debates and struggles which address those areas of culture designed as art, entertainment and leisure? Our work on the specificity of representations and the production of cultural meanings reinforces one important political point – that meaning and representation is itself a site of struggle. It is not enough to work to undermine the centrality of key institutions like the National Gallery, the Tate and the Arts Council, to shift their education and exhibition programmes and to expose their lack of accountability and élitism. These initiatives must go hand in hand with the deconstruction of the language and norms which give the field of art meaning. Particular political projects, such as Mary Kelly's *Post-Partum Document* series or Stuart Brisley's performances, can be appropriated for aesthetics and high culture once inside an Arts Council or commercial gallery space. The spatial lay-out of the institutions, the selective audience to which they speak, the pre-structured appreciative responses produced by the presentation format are part of a circuit which radical art objects and activities in themselves find it difficult to break. We must formulate a more sensitive cultural politics, which takes into account the level of signification. Similarly, as Rosalind Coward has consistently argued, feminist challenges to pornography need to be attentive to practices of signification through which degrading

237

representations of women are produced across a range of fields (e.g. advertising, film, television).[16] Struggles over the content of sexual representations and the definition of sexual meanings are central to current feminist politics. Let it be clear what we are saying here: it is not that struggles around institutions and apparatuses are not significant, but that the issue of representation and meaning (what it is, how it works, what effects it produces) must form part of a socialist and feminist politics which is committed to the transformation of attitudes, beliefs and behaviours.

A related issue concerns the question of pleasure itself. Definitions of pleasure, personal gratification and sensuous enjoyment, which revolve around aesthetics and creativity, have been crucial to the development of art history and are deeply embedded in the aims and practices of art institutions.[17] In the post-war period there has been a significant relation between pleasure and aesthetic enjoyment, as defined within the field of art, and social concerns within leisure, private life and civilised living, which were put forward as part of a social democratic programme. For Labour politicians Crossman, Crosland and Jenkins in the 1960s, art held out the potential, along with urban planning, green belts, consumer protection and sexual reform, to improve an increasingly consumerist and technological society.[18] In part, this programme drew out the implication of Keynes' own project for a society in which economic struggle would eventually cease to be the central concern for politics and would be replaced by the real issues, namely leisure and civilisation.[19] At the same time, the radical countercultural programmes of the 1960s developed around Marcuse produced similar, though more radical, alliances between aesthetics and individual expression – combining avant-garde art with sexual libertarianism.[20] For a variety of political positions, sensuality and aesthetic creativity were dominant in defining the nature of pleasure. Unevenly and contradictorily, these cultural definitions formed part of the norms of a social democratic, classless society. Likewise, libertarian definitions of sensuous pleasure in the area of sexuality were implicitly male defined – women were more tightly inscribed within heterosexuality.[21]

In the last decade, a variety of forms of cultural politics, in particular feminist projects and community arts, have challenged many key artistic assumptions: the notion of creativity as male, the importance of aesthetic excellence, the emphasis on individual producers. What they do not challenge are those definitions of pleasure which are bound up with the creative activities they are concerned to preserve. Although much feminist theatre and writing and community arts activity remains ambivalent about definitions of their work as art, their involvement with the creative/expressive act itself, often superimposed onto a new set of objects, smuggles back in aesthetic pleasure.[22] So what is the problem? To put it baldly, these definitions of cultural pleasure occupy a particular and privileged place in the cultural dimension of class hegemonies. In terms of the current hegemony of power

and the relations between the classes, aesthetic and creative pleasure continues to be promoted as more valid than other forms of leisure activity – football, ballroom dancing, etc. Or, popular practices come to be redefined in terms of those aesthetic and creative norms. There is no genuine cultural pluralism, as social democratic commentators would have us believe, but a ranking and hierarchisation of discourses around pleasure.

If pleasure is to form part of a socialist and feminist cultural politics, then we cannot be content to adopt and reproduce dominant definitions. This must inevitably point us towards a reconsideration of popular practices and popular pleasures. That does not mean we should work to reinstate and celebrate popular pleasures as against those aesthetic norms. Popular culture, as we know, is shot through with pleasure as defined for a white and male audience. But we urgently need to formulate a language which addresses popular pleasures, while being aware of their contradictory and ambivalent definitions and effects. Moral critiques of sexism and racism in popular activities are not enough, if they lost sight of the fact that pleasure is a central part of the experience of particular individuals and social groups – youth, gay men, etc. Work on culture must identify the historically specific forms of the pleasure/power couplet, as part of the efforts to shift representations and behaviours.

Nicholas Green was a lecturer in art and cultural history in the School of Art History and Music at the University of East Anglia from 1978 until his death in 1989. His principal area of research was on the cultural formation of the nineteenth-century Parisian bourgeoisie, and the role played by representations of the urban and the natural world in shaping the cohesiveness of this social group. The results of his work were published as *The Spectacle of Nature: Landscape and Bourgeois Culture in Nineteenth-century France* (Manchester University Press, 1990). In addition to a number of book articles, Nicholas also contributed to *Art History* and *New Formations*, as well as to *BLOCK*, on a wide variety of topics, from the nineteenth-century art market in Paris to contemporary versions of tourism and cultural politics. Throughout his career he was concerned to develop a theoretical framework for the analysis of visual culture which was differentiated both from traditional connoisseurial methods and from a number of the protocols of what has come to characterise the new art history. His approach was strongly influenced by the work of Michel Foucault, in particular Foucault's own efforts to produce a historically grounded map of the social field, associated with the formation of modernity. At the time of his death, Nicholas was beginning to turn his attention to a different aspect of French culture: the meanings carried by Frenchness for English audiences in the 1950s and 1960s.

NOTES

1 See, for example, N. Hadjinicolaou, *Art History and Class Struggle* (trans. L. Asmal), Pluto Press, London, 1978; J. Barrell, *The Dark Side of the Landscape: The Rural Poor in English Painting, 1730–1840*, Cambridge University Press, Cambridge, 1980; T. Clark, *Image of the People: Gustave Courbet and the 1848 Revolution*, Thames & Hudson, London, 1973.

2 G. Pollock, 'Vision, Voice and Power: Feminist Art History and Marxism', *BLOCK*, no. 6, 1982, pp. 2–21.

3 See M. Foucault, *The Archaeology of Knowledge* (trans. A. Sheridan Smith), Tavistock, London, 1972; *The Birth of the Clinic: An Archaeology of Medical Perception* (trans. A. Sheridan), Tavistock, London, 1977; *Discipline and Punish: The Birth of the Prison* (trans. A. Sheridan), Allen Lane, London, 1977; *The History of Sexuality: Volume 1, An Introduction* (trans. R. Hurley), Penguin, Harmondsworth, 1981.

4 See L. Daubanton, 'Rapport relatif aux entreprises de construction dans Paris, de 1821 à 1826', in *Recherches statistiques sur la ville de Paris*, IV, Paris, 1829, and *Mémoire adressé par une réunion de propriétaires, architectes et contracteurs de la Ville de Paris à MM les membres de la commission d'enquête*, 7 juillet 1828; A. Luchet, *Paris: Esquisses dédiées au peuple parisien*, Paris, 1830; *Les Français peints par eux mêmes*, Paris, 1840.

5 See, for example, T. Thoré, *La Recherche de la Liberté*, Paris, 1845; J. Taylor, C. Nodier and A. de Cailleux, *Voyages pittoresques et romantiques dans l'ancienne France*, 19 vols, Paris, 1820–78; E. Jamin, *Quatre promenades dans et la forêt de Fontainebleau*, Paris, 1837; C. Denecourt, *Guide du voyageur dans le palais et la forêt de Fontainebleu*, Paris; A. Castellan, *Fontainebleau: études pittoresques et historiques sur ce château*, Paris, 1840.

6 P. Valenciennes, *Eléments de perspective practique à l'usage des artistes. Suivis de réflexions et conseils à une élève sur la peinture et particulièrement sur le paysage*, Paris, an VIII, 1800; second edition, Paris, 1820. Valenciennes played an important role in setting up the Grand Prix du Paysage Historique in 1816.

7 *L'Artiste*, a general magazine on the arts, began publication in 1831. *Le Magasin Pittoresque* was a popular and encyclopaedic information periodical, which began in 1833. *L'Illustration* was an illustrated weekly news journal started in 1843.

8 See, for example, *Copies of Certain Papers relating to Cholera together with the Report of the Central Board of Health thereupon*, 1832, Great Britain Parliamentary Papers (GBPP), 1831–2, XXVI; *Report from the Poor Law Commissioners into the Sanitary Condition of the Labouring Population of Great Britain*, 1842, House of Lords Sessional Papers, XXVI–XXVIII; Children's Employment Commission, *First Report. Mines*, 1842, GBPP, 1842, XV–XVII; *Fourth Annual Report of the Registrar-General of Births, Deaths and Marriages, 1842*, GBPP, 1842, XIX.

9 See, for example, the pornographic extracts in S. Marcus, *The Other Victorians: A Study of Sexuality and Pornography in Mid-nineteenth Century England*, London, Weidenfeld & Nicolson, 1966 and G. Grimley (ed.), *My Secret Life*, Granada, London, 1972.

10 See P. Willis, *Learning to Labour: How Working Class Kids Get Working Class Jobs*, Saxon House, Farnborough, 1977.

11 Allen Jones, *Chair*, 1969, one of the acquisitions bought by the Tate Gallery in 1981.

12 *The Lancet*, 22 January 1859, vol. 1, p. 89. For the relation between official photography and social power in the mid-nineteenth century see J. Tagg, 'Power and Photography: Part One. A Means of Surveillance: The Photograph as Evidence in Law', *Screen Education*, no. 36, 1980, pp. 17–55.

13 C. Lombroso and W. Ferrero, *The Female Offender*, T. Fisher Unwin, London, 1895, p. 28.

14 Havelock Ellis, *The Criminal*, Schribner & Welford, New York, 1890.

15 A. Coote and B. Campbell, *Sweet Freedom: The Struggle for Women's Liberation*, Pan, London, 1982, p. 11.

16 See R. Coward, 'What is Pornography?', *Spare Rib*, no. 119, June 1982, p. 52.

17 See, for example, B. Berenson, *The Florentine Painters of the Renaissance*, Putnam's and Sons, New York, 1896; *The Italian Painters of the Renaissance*, revised edition, Clarendon Press, Oxford, 1930.

18 See, for example, C. Crosland, *The Future of Socialism*, abridged and revised edition, Jonathan Cape, London, 1964, especially the conclusion; *The Conservative Enemy: A Programme of Radical Reform for the 1960s*, Jonathan Cape, London, 1962, especially part 3; R. Jenkins, *The Labour Case*, Penguin, Harmondsworth, 1959.

19 J. Keynes, 'The Economic Possibilities for our Grandchildren', in *Essays in Persuasion*, Macmillan, London, 1931.

20 H. Marcuse, *Eros and Civilization: A Philosophical Inquiry into Freud*, Routledge & Kegan Paul, London, 1956; *One Dimensional Man: Studies in the Ideology of Advanced Industrial Society*, Routledge & Kegan Paul, London, 1964; *The Aesthetic Dimension: Towards a Critique of Marxist Aesthetics* (trans. H. Marcuse and E. Sherover), Macmillan, London, 1979. Peter Fuller's *Beyond the Crisis in Art*, Writers and Readers, London, 1980, represents an attempt to revive a humanist Marxism, drawing on Marcuse, which stresses the expressive nature of art.

21 For feminist critiques of sexual liberalism and libertarianism, see R. Coward, 'Sexual Liberation and the Family', *m/f*, no. 1, 1978; B. Campbell, 'A Feminist Sexual Politics', *Feminist Review*, no. 5, 1980.

22 Much feminist writing has broken with aesthetic norms, by using literary genres, such as autobiography, to explore the subjective dimensions of experience and oppression. See, for example, E. Wilson, *Mirror Writing: An Autobiography*, Virago, London, 1982.

14

REPRESENTATION, THE HAREM AND THE DESPOT

Olivier Richon

(*From*: Issue 10, 1985)

INTRODUCTION

Taking as a starting point a nineteenth-century Orientalist academic painting by Lecomte du Nouÿ, this paper will discuss instances where the Western surveying gaze is turned upon the Orient, holding it at a distance, the distance of a steady observation which positions the Occident as subject and the Orient as object of representation. My aim is to show to what extent Western representations of the Orient address the West itself, as if the Occident attempted to project itself and look at itself from an imaginary vanishing point, represented by the Orient.

Rhameses in his Harem, a painting where the despot melancholically plays chess, surrounded by his concubines or slaves, is located within the space of the Exotic. 'Exo' means from abroad, at a distance. 'Exotic': that which is brought back from abroad, back to the mother country, from outside the limits of what is called the West, Europe, the Occident. When viewed from a Western vantage point, the Orient becomes exotic as its image is brought back to the mother country.

The Orient and the Occident are then not just words, but names, proper names constructing identities which become territories. The Orient becomes what lies east of the dividing line. It is a differential term which defines what is not Western. It defines the West negatively, so that the Occident as a category cannot exist without the Orient. Inversely, the Orient will then only exist from a Western vantage point. The Western surveying gaze somehow constitutes itself as Western when looking at the Orient, at the other.

Thus The Explorer, The Conqueror, is an emblem of this Western look. Such an emblem can be found in the mythical figure of Amerigo Vespucci, The Discoverer, as pictured by Jan Van der Straet and described by Michel de Certeau:

242

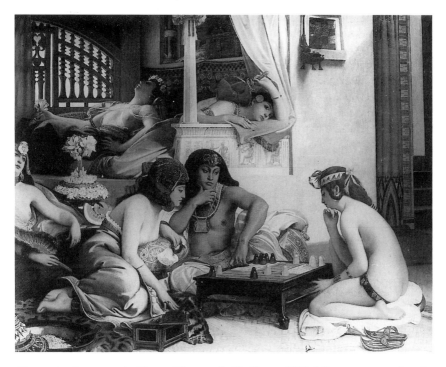

Figure 14.1 Lecomte du Nouÿ, *Rhameses in his Harem*, 1855 (oil on canvas, triptych, centre panel 114 × 146cm/45 × 57½ in)

Source: Courtesy of the Fine Art Society Plc

Standing up, dressed, armoured, wearing a cross, he bears the European's emblems of meaning. Behind him stand the vessels which will bring back to the Occident the treasures of Paradise. In front of him lies stretched the Indian America, a naked woman, unnamed presence of difference, a body which will wake among exotic plants and animals. An inaugural scene. After a moment of astonishment upon this threshold delineated by a colonnade of trees, the conqueror will write the body of the other and inscribe upon it his own history.[1]

A MYTH OF ORIGIN

As Michel Thévoz has shown,[2] what one calls Orientalist painting is primarily a nineteenth-century phenomenon. It is contemporary with colonial conquests and tied up with their ideology. The main initiator of Orientalism in France is the painter Gros, who was commissioned to glorify the Egyptian expedition of Bonaparte. He created for one century the

prototypes of Oriental landscapes, costumes and faces, without having set foot in Egypt. Using props and artefacts brought back from the East to his studio, Gros was nevertheless convinced that he painted from direct observation. Similarly, the English painter Bonington can be considered as one of the first specialists of Odalisques and harem scenes. He never travelled further afield than Italy.

From the outset, Gros and Bonington determine two points – the colonial and the libidinal. All subsequent Orientalist painters can be seen to oscillate between these two poles until the end of the nineteenth century. So, when countless painters actually went to the Middle East, North Africa and Egypt, in order to paint from direct observation, they started to look for models conforming to those of their predecessors. Needless to say such models were not to be located in empirical reality and had eventually to be fantasised, illustrating once again that representations refer to other representations and not to the truth of the represented.

The promise of the Orient as a natural stage set was therefore problematic. When he was in Algiers, Delacroix reported in the magazine L'Artiste in 1839 his difficulties in painting from direct observation. He complained of being constantly surrounded by a crowd of onlookers insulting him, laughing, throwing stones and firing gunshots at him. However, the difficulties of painting from observation were more imaginary than real, not only because painting from observation amounts to constructing an imaginary, but also because the difficulty consisted in finding an image which would conform to a pictorial model formed in the mother country.

After having taken everything they could from Greek and Roman antiquity, painters found in the Orient a new myth of origin: a new model in an older civilisation. As Michel Thévoz points out, one can read in L'Artiste that the Orient becomes like an exaggerated Italy. Fromentin, writing from Algeria, sees greatness and antique beauty everywhere. 'The Greek and the Roman are here, at the tip of my fingers' writes Delacroix from Tangiers, and adds:

> Rome is no longer in Rome. . . . Imagine, my friend, what it is to see figures of the age of the Consuls, Catos, Brutuses seated in the sun, walking in the streets, mending old shoes. . . . The Antique has nothing that is more beautiful.[3]

The Orient is processed and recycled through a Greek and Roman mould in order to become a prehistorical antiquity, closer, that is, to the origins of Western civilisation. All these references to an immutable past, frozen in the eternity of marble-like figures, build up representations of an harmonious beginning. Following Michel Thévoz, one can mention a similarity of form between the atemporality and ahistoricality of Orientalist painting and nineteenth-century bourgeois ideology.

Antiquity, greatness, beauty and perfection become the backdrop against which the myth of the origin of the rising bourgeoisie can take place: it

'originates' the bourgeoisie's power, fixing it to a point of origin whilst negating and concealing its historical and social relativity, that is, the possibility of its own death. This negation takes the form of a natural, universal and definitively harmonious system, which has finally been realised, and whose model of origin was already present in a mythical antiquity. The antique past is reconstituted in the light of the present, the theatrical and museum-like light of academic painting.

Similarly, Walter Benjamin writes in *Paris, Capital of the Nineteenth Century*, that with the beginning of iron constructions – arcades, railway stations, exhibition halls – a new technique of construction attempts to renew architecture in the form of a reactualisation of a mythical past. Arcades and other iron structures are designed to resemble Greek temples and Pompeiian columns:

> to the form of the new means of production (Marx), which to begin with is still dominated by the old, there correspond images in the collective consciousness in which the new and old are intermingled. . . . In the dream in which every epoch sees in images the epoch which is to succeed it, the latter appears coupled with elements of prehistory – that is to say of a classless society.[4]

Representations of the origin may be said to be mythical, not because they are delusions or false representations, but because they provide an explanation and, in the case of images, a muted narration or visualisation which rationalises a present state of affairs by confronting it with an origin, a point of departure, just as primitive myths were, and still are, the production of stories which put into play the confrontation of the present of a community to its origins.[5] If with the naturalisation of history and the negation of class divisions, the nineteenth-century bourgeoisie may represent itself as the achievement of a classless society, it is by the negation of its historical relativity, a posture which can be articulated as: 'I am determined by what I deny, that is, the possibility of my own death.' References to antiquity, to an harmonious origin, become the mark of a beginning which is unlikely to be fully rediscovered, just as it is to be forgotten. The origin is like a vanishing point and consists of the forgetting of the negation which is constitutive of its very existence. The formation of a myth of origin can be compared to the formation of childhood memories.[6] Freud shows that the individual, just as the collective past, is fantasmatically constituted rather than simply remembered. Freud establishes that early childhood memories are composed from indifferent scenes, seemingly irrelevant memories. It is as though important affective impressions have left no trace. These indifferent memories are in effect the result of a process of displacement. They are substitutes for impressions whose direct access to memory is repressed. Indifferent memories are conserved because of their associative relationship with other repressed memories.

This process of formation and fixation of *screen memories* can be extended to childhood memories as a whole. There is no guarantee that such memories are accurately remembered. They are mostly falsified, incomplete fragments displaced in space and time. Childhood memories are then traces deprived of a fixed origin, whose formation is due to the influence of psychic forces which intervene at a later date. They are post-rationalisations of previous experiences, originary deformations which are the only formations which inform us about the past. In this sense, childhood memories are not innocent, or rather, the supposed innocence of childhood designates a privileged time and place whose assumed purity serves as a disguise for the sexual content of the fantasies.

Childhood memories are then a complex process of rationalisation, secondary revision and deferred action; a process which is analogous to the one which takes place in the formation of hysterical symptoms. As Thévoz reminds us, Freud first related the neuroses of hysterics to his patients' account of a seduction which had occurred in their childhood. The frequency of such explanations, which would account for the origin of the neurosis, brought Freud to discover, around 1897, that such stories of seduction were fantasised by his patients. Such fantasies were constructed afterwards, sometimes during the course of the treatment. The seduction fantasy was a means by which infantile auto-erotic activities were displaced and explained in terms of an archaic event, which presented itself as the origin of the seduction. As Sarah Kofman puts it,

> the common point between memory, hysteria, and the work of art, is that all three are fantasmatic constructions endowed with a plastic or theatrical form and drawn from mnemic traces. All three put into play the past while deforming it.[7]

It is a constitutive deformation as a pure access to the past is utopian. The past is a utopia, in Thomas More's sense of the word: a good place (eutopia) which has no place (outopia). The taste for far away places in space and time is the nostalgic image of a fantasised golden age, as if one kept on being under the spell of childhood, the charm of a trouble-free land of felicity and harmony.

We may compare the ideology of academic painting with this process of memory formations. If, as Thévoz argues,

> it is true that a neurotic fantasy is given an origin retrospectively and that art can represent the monumental form of this retrospective construction, one can then conceive that the new dominant class in search of legitimacy will assign to the neurotic artist the ideological function of generalising at a historical level this subjective process of rationalisation of the psychic past.[8]

The ideological message is by no means reduced to the 'content' of the image, but is the effect of the means of representation and signification at work in the specular realism of academic painting.

RHAMESES IN HIS HAREM

Rhameses in his Harem can be taken as an emblem for the exotic. It is an academic painting which represents the most repeated theme of Orientalism: the despot and his harem, set in a mythological antiquity, more antique than Greece and Rome, and which is nothing else than the ancient civilisation of Egypt. It is dated 1885, and was painted by a pupil of Gérôme, Lecomte du Nouÿ, whose work was enthusiastically received in the French salons in the mid to late nineteenth century.

Rhameses in his Harem refers to a novel by Gautier,[9] *Le Roman de la Mômie*. The painting is a condensation of several scenes in which the despot and his harem are described. In one of these scenes, the concubines lasciviously attempt to catch the attention of the master, who, melancholically absorbed in daydreams, thinks of a young Christian woman he fell in love with at first sight.

Gautier's novel can be read as an example of romantic irony, mixing mythology and melodrama, high and low art. Du Nouÿ's painting, however, proudly declares itself as high art and history painting. Against the backdrop of the Orient, the values of classicism are reiterated, following the example of Gérôme and Ingres. It is along these lines that his work was received in the salons. In 1887, a critic wrote that it is 'a work . . . so perfectly accomplished . . . that I do not hesitate to say that a great Renaissance master would have been happy to sign it'.[10]

By 1900 *Rhameses in his Harem* was described as 'one of the most celebrated works of the Master, the chess game with pharaoh, which will certainly one day occupy a place of honour in one of the galleries of French painters at the Louvre'.[11]

One of the referents of the painting is thus a novel. Gautier describes a fresco on the walls of the palace:

> On the walls, large tableaux in flat bas reliefs coloured with the most brilliant tints described the everyday activities of the harem and scenes of its hidden life. There was the Pharaoh upon his throne, gravely engaged in a game of chess with one of his concubines who stood naked before him, her head in a large band from which blossomed a spray of lotus flowers.

For his descriptions, Gautier relied on archaeological documents, and particularly engravings which one would find in books on Egyptology. Whereas Gautier does nothing other than describe an image, the painter Lecomte du Nouÿ does the reverse: he makes a depiction of a description. Painting and literature are in this instance interdependent and echo each other. Barthes, in his exhaustive analysis of a realist short story by Balzac in *S/Z*, theorises the intertext between writing and image. He argues that the code of reference of nineteenth-century realist literature is the *mise-en-*

247

scène of a discourse. This means that the literary description is a view, as if the writer first has to transform the real into a painted and framed object in order to depict it. Inversely, it can be said that the code of reference of academic painting is literary. What is being noted is that specular realism by no means refers to something out there in the world. We do not have a relation between a sign and its referent in the real but, as Barthes puts it, a relation of one code to another code. Thus the idea of a referent which would guarantee a sort of empirical origin to meanings, disappears. Instead what takes place is reference to other discourses. Representation, then, is not the copy of an original model, but is always already a copy of another copy. Specular realism consists of the copy of a code. The code is that which is responsible for the operation by which the artefact achieves verisimilitude.

Verisimilitude demands immediacy and transparency. At first glance, the painting seems to be as seamless as a photograph: the image seems to 'speak for itself', as if it were a surface freed from the marks of its construction. In this respect, academic painting echoes photography and vice versa. To claim that academic painting is endowed with photographic precision is a paradox. It amounts to saying that the accuracy of photography is not objective, but academic. In this respect, photography is not a 'pencil of Nature', as Fox Talbot put it; its nature is to be faithful to a simplified Renaissance space inherited from painting. Academic pictorial representation and photographic representation echo each other tautologically. One cannot, as Thévoz puts it, 'pretend to demonstrate the fidelity of traditional figuration by its conformity to a photographic image which itself is based on that figuration'.[12]

Specular realism conforms to norms of visibility which are contingent and historical. It refers to a normative figurative logic inscribed in the code of monocular perspective. Such a code of visibility resembles the Cyclops' vision; it offers a monocular view of the world. The transparency and objectivity of academic painting is then mythological, but a myth which is not deprived of logic. Such logic postulates an immobile spectator, looking with one eye at a frozen scene. The eye looks through the surface of the image, towards the vanishing point of perspective, in order to be seduced by the illusion of depth. The depth of the image, and, by extension, the depth of meaning, depends on the flatness of its surface. It depends on its mirror-like surface in order to reveal depth. The meanings of academic paintings seem profound and immediate.

In this sense, such a structure of representation is fetishistic in that it presents itself as a surface which dissimulates its own lack, that is, which dissimulates itself. With this code of resemblance between the thing and its image, the artist becomes, as Julia Kristeva suggests, the 'servant of the maternal phallus'.[13] He will develop an art of reproducing body and space as objects the eye can master. It is a child's eye, positioned at the universal centre. Thus the divine point of view that perspective is said to offer does not come from above but from below: a point of view of indecency

characteristic of fetishistic disavowal. To look from below, behind the veils, for a stable world to hold on to.

Rhameses in his Harem appears to be at once a frozen scene and a posed tableau, at once metonymical and metaphorical. As metonymy, the painting is grasped as a fragment, an arrested motion which implies a before and an after, that is, an element of time prior to, and beyond the frame, yet contiguous with it: an anecdotal slice of life – 'once upon a time' in Egypt. As a posed tableau, the image shifts to the metaphorical register and becomes an allegory of the exotic, despotism and sensuality. The tableau is spatially arranged so as to feature the figure of the despot at the centre of the image, the frontal pose standing for the fixity and uniqueness of his essence. In opposition, the female figures structure the pictorial space in terms of depth and occupy diverse positions between foreground and background: a moving plurality of female existences which surround, frame, and enhance the permanence and singularity of a male essence.

The various props – fruits, flowers, drapes and architectural details – are anecdotal signs adding to the veracity of the scene and anchoring the picture in the realm of the exotic. As an object erected according to the rules of specular realism, the painting is on the side of a fetishistic scenario. For instance, the representation of the body conforms to an academic style which prescribes perfection and truth: the figures must be idealised, but convincing, so that they oscillate between an idealised nature and a naturalised ideal.

In du Nouÿ's painting, there is a definite similarity between the male and female figures. Sexual difference is signified by an opposition of tones and colours: dark for the despot and light for the concubines. The chromatic treatment of the bodies is under control and subordinated to drawing and line. Consequently, difference is acknowledged by tones and colour, but disavowed by line. The framing of the male face by the two females suggests a single portrait presented from three different angles. Constructing a seamless shape, line and drawing have priority over colour, reflecting an ideological priority of the masculine over the feminine, the control of the former over the latter. As quoted by Michel Thévoz, in 1867, in his *Grammaire du Dessin*, Charles Blanc wrote that 'drawing is the masculine gender of Art, colour its feminine one. . . . Painting courts its own destruction and will be corrupted by colour just as humanity was corrupted by Eve.'[14]

The line of drawing erects the figures into complete and closed bodies. Perfect shapes which are not lacking. Like statues, these bodies are petrified into marble-like representations of an ideal nature. As a monument to the memory of lost civilisations and of a body which is not lacking, it can be suggested that the painting shifts from the side of the fetish to that of the relic. It enters the time of reverie, of mourning and melancholia.[15] In this sense the obsession of specular realism to make things 'true to life' can be taken as a negation: in order to look alive according to the canon of

verisimilitude, bodies are erected into petrified poses and are made to resemble marble-like figures, marble being the metaphor for a timeless, that is, lifeless substance. In this respect, the *tableaux vivants* of academicism could be more appropriately called *natures mortes*.

As relic of a golden age, orientalised antiquity constructs a monumental reminder of times that have died away. The tableau as relic maintains in a visible state the memory of what has disappeared. Such a nostalgia relies on a split between a knowledge of separation and a belief that something still exists. The petrified bodies of academic painting and the visibility achieved by specular realism consolidate the belief against an anguish of destruction which would amount to the annihilation of specular representation: the decomposition of the body in death. Thus bodies are constantly redeemed, being at once a reminder of death and a protection against it. A mummification which, in Gautier's *Roman*, pays comical homage to classical art:

> The last impediments removed, the young woman was revealed in all the chaste nudity of her beautiful body, which had retained, despite the passing of so many centuries, all its shapely contours, all the lissom grace of its pure lines. Her attitude, rarely seen in a mummy, was like that of the Venus of Medicis, as if the embalmers had wanted to remove from this charming body the sad appearance of death, and to soften the corpse's unyielding rigidity.[16]

To the visibility and immediacy of the fetish, just as that of the relic,[17] one may add the immediacy and transparency of meanings of academic style. As Thévoz argues,[18] such a style attempts to purify all forms from any element which would resist and unfix the intentional message. Everything must signify, so that details which are neither descriptive nor symbolic must be avoided like the plague. No interference should occur between the plastic signifier (the brush strokes and the technique of illusionist realism) and the iconic signified (the figure which is represented). Such a style attempts to repress what Barthes calls the 'obtuse meaning', that is, all those elements which subvert and threaten to displace meaning. Thus the image seems to over-exist, to be utterly significant: more real than real, that is, hyper-real. This nineteenth-century hyper-realism allows the image to be identified without ambiguity, in one glance, and to reveal its tautological truth: a harem is a harem, a despot is a despot, the Orient is the Orient.

With all its hyper-realism, *Rhameses in his Harem* is a *mise-en-scène* of a fantasy, in the psychoanalytical sense of the term. It is the fulfilment of a wish which makes use of an imaginary scenario – the power of the despot over his slaves, and the power of man over women. At the same time, it represents that which cannot be seen, as the harem prohibits any foreign look. The depiction of the harem, like the unveiling of an enigma, attempts to make visible what is hidden.

The despot surrounded by his women is not just an academic fantasy. It is a theme, and more than a theme, a concept which predates nineteenth-century colonialism and Orientalism. It is, as Alain Grosrichard puts it, the concept of a fantasy.[19]

IT IS RUMOURED

In his brilliant study, Grosrichard shows that from the end of the seventeenth century until the eighteenth century, the figure of the despot is a spectre which haunts the Western world. At this time, rumours about the Orient are brought back to the West by travellers, writers and diplomatic circles. Whether they are true or false does not matter. What matters is that they construct knowledge about the Orient, what E. Said has called a 'textual attitude'.

In the seventeenth century a French writer like Chardin reports what it is to be an Oriental master. To be a master is to have the privilege of sight: the despot can be stupid, mad, ignorant, drunk or ill – all this does not matter as long as he sees. To be blind, in a despotic regime, is to be condemned to obey. In the Orient, one can only obey blindly.

In France, the word *despotism* is found in the authorised dictionaries around the eighteenth century. It denotes absolute power and authority. It refers to the arbitrariness of power and to a form of government in which the sovereign is the absolute master. The examples which are given are from Turkey, Japan, Persia and almost the whole of Asia. In France, the term is theoretically introduced by Montesquieu in 1748.

The adjective *despotic*, though, was already used to qualify and denounce the abuse of power of Louis XIV. The term despotic, then, calls into question the essence of monarchy. Briefly, the principle of monarchy is that the king is named the Father of the People. To denounce the power of the king as being despotic amounts to saying that the king confuses his people, that is, his children, with slaves. He is then a father against nature. However the despot, in Greek antiquity and as theorised by Aristotle, means precisely the father of the family; it denotes the power of the father over his slaves, but not over his children and wife. Thus a term – despotism – which denotes in Aristotle a domestic power, comes to designate, in the seventeenth century, the sphere of political power. It is as if the Eye of Asia, whose emblem for the West is the despot, was looking back at the West, contaminating the power of the monarch.

Addressing the question – What is a master? – Aristotle distinguishes between the political and the domestic field: the former being the power of the magistrate and of the king, while the latter denotes the power of the father over his family and his slaves. The authority of the king over his subjects can then be compared to the authority of the father over his

children: the reason of the people, just as the reason of children, is still imperfect and needs a guiding hand. As husband, the power of the father resembles the power of the magistrate. The wife is thus compared to the magistrate's fellow citizen whose reason and will are impotent as they need a superior authority to represent them. Finally, as master of his slaves, the power of the father is despotic.

If the political power of the monarch and that of the magistrate, just like the domestic power of the father, must serve in the last instance the common interest of all, the despotic authority does not. Aristotle argues that despotic authority requires no knowledge; it merely serves the interest of the master as the slave is nothing but a separated, yet living part of the master.

Whereas political power has authority over free citizens, despotic power is the unique and absolute authority of a master over his slaves. Political power can by no means be called despotic. A despotic policy would be an aberration, a monstrosity. This monster has a name: the tyrant. Unlike the magistrate or the king, who represent the common interest of all, the tyrant seeks his own pleasure. The tyrant upsets the regime of representation. For Aristotle, the aim of the tyrant is pleasure, whereas the aim of the king is beauty. Pleasure means disorder, beauty order. Beauty, the law, must exclude the imperfection of man, that is, passion. The law, then, is defined as reason freed from desire.

Nevertheless, Aristotle takes as examples of despotic regimes the governments of Asia, countries where people are said to be slaves by nature. It follows, therefore, that the Greek has a right to command the barbarian, just as the political is superior to the domestic.

Asia becomes the site of pure despotism, as if it were unable to ascend to the political, forever remaining at the level of the domestic. The only fate of Asia is thus to surrender to the Greek master, just as the domestic must surrender to the political.

In Aristotle's notion of Asia, we can thus recognise the Orient which will be reinvented by Europe during the classical age and at the beginning of colonialism: the idea that the Orient cannot represent itself.

The harem is a place which excludes any foreign look. Western representations of the harem are then the fulfilment of the wish to uncover what is hidden. If the depicted is orientalised, the depicting activity is obviously Western. The harem can be considered as a *mise-en-scène*, displaced on to the Orient, of the metaphysics of man and woman: a machinery producing an ontology of the Western concept of man and woman.

The harem is the exclusive domain of one being, the despot. The order of the harem is organised around the limitless pleasure of the master, and above all his sexual pleasure, which starts with his scopic privilege. The harem is a solitary confinement for all and is a delicious place for one person only – the master.

The master's primal object of enjoyment and possession is not so much woman as women. With polygamy, he does not possess the other sex but its multiplicity. Multiplicity characterises inferiority, an inferiority in respect of the uniqueness of the despot: the amount of women will never match the uniqueness of the master.

At the classical age, Muslim polygamy is thus received as a scandal, a temptation and a threat. A threat in the sense that polygamy and the emblematic figure of the harem can be conceived as the logical consequence of Western metaphysical principles concerning man and woman.

As Grosrichard puts it, Western lawyers, philosophers, and doctors have done nothing other than define 'woman-as-being' as a minor being compared with man. Metaphysically, she is an existence deprived of an essence, a form deprived of content, or a male essence whose actualisation is prevented from taking place. As only the male subject is said to be able to actualise all the virtualities of human essence, a woman can only be thought of as defective in relation to this essence. She is ontologically devaluated, thus inferior. The relationship of the superior to the inferior is given as the relationship between the one, the unique, and multiplicity.

If man exists, that is, if one can formulate an ontological concept of man, then he must be polygamous, just as one unique God must reign over a multitude of souls, just as one unique master must reign over a multiplicity of slaves.

Such principles are developed by St Augustine in the fifth century, in order to justify and rationalise the polygamy of the ancient patriarchs of the Bible. This text, as Alain Grosrichard notes, is again in fashion at the end of the eighteenth century.

Augustine's argument also relies on the relation between uniqueness and multiplicity, between essence and existence. Augustine argues that a man can have several wives when the state of society allows it, and the spirit of the time recommends it. The ontological principle of the status of man and woman is based upon the reproduction of human beings, as if the biological would justify the metaphysical principles. So unlike woman, man can make several children in one year. Several women can be made pregnant by one man whereas one woman cannot be made pregnant by several men at a time; a soul who fornicates with a multitude of false gods, cannot be made fertile. If such principles may justify the polygamy of the ancient patriarchs, Augustine adds that their reproductive mission, religiously assumed, is over. There are enough Christians and they can now behave according to monogamistic principles.

What is noted, then, is that the metaphysics of man and woman, and the construction of the ontological superiority of the former over the latter, is at work in the representation of the harem.

The harem makes us imagine an indefinite plurality grouped around the unity, uniqueness and transcendence of the one for whom and by whom women exist.

253

'YOU THINK YOU COULD BE THERE INSTEAD OF BEING HERE'[20]

For nineteenth-century academic painting and literature, Egypt is used as a reservoir of archaeological information, providing the necessary factual details for a *mise-en-scène* of an Orient. Factual details about costumes, architecture and design were necessary in order to legitimise the fantasy of a Western Orient; fact could then slide at ease towards the factitious, as long as the latter was based on factual information: archaeological documents, engravings, photographs.

Indeed, photography, in the nineteenth-century framework of positivism, was considered as the privileged machine for the collection of fact and documentary evidence. Photographic documents of the Orient were a standard against which the accuracy of academic depiction and literary descriptions could be assessed. A standard constructing an idealisation: a view of the Orient as an archaeological field; a museum in nature, nature as a museum offered to Western scrutiny. Thus Ernest Lacan looking at photographs:

> Take a magnifying glass and you read the inscriptions left upon these monuments through the millennia by forgotten generations, challenging science across the centuries. It is Egypt, Palestine, Nubia that you have beneath your eyes, and which appear, as in a fanciful tale, to display themselves to your gaze.[21]

The use of the present tense translates the wish for the immediacy of the photographic document just as the verb *to be* invests the photograph with ontological pretensions: it is Egypt, it is the Orient. Ruins, temples and inscriptions become the privileged signifier of an essential Orient, of the Orient as image. Each place is 'presented to us reflected from the very face of Nature itself, owing nothing indeed to picturesque arrangements . . . but free from the error . . . incidental to artistic treatment'.[22]

The photograph is denied the status of image: it is not picturesque, it is not a picture. A negation which gives to the photograph the status of a pure trace, an indexical fragment, a metonymical clue brought back to the mother country where it could be endowed with metaphorical value: this is the Orient, bare, untouched and deserted. Photography could then join the 'civilising missions' and 'peaceful conquests' of nineteenth-century Western cultural politics.[23]

Photography collaborates with the construction of academic painting: a foreign agent, an informer, a valet providing documents for academic representation. Photography remains at the threshold of the harem. It remains outside, leaving the inside to academic painting. A similarity of form was noted between the structure of academic representation and that of photography.

The spatial organisation of a photograph is dependent upon monocular perspective, which implies a single viewpoint for an abstract spectator, a spectator-as-I; as Benjamin noted, identification in film (and this is also true of photography) is primarily determined by the camera's point of view: 'the audience's identification with the actor is really an identification with the camera. Consequently, the audience takes the position of the camera.'[24]

Academic representation, as is the case with *Rhameses in his Harem*, can very well be constructed according to several points of view. One can briefly indicate these different viewpoints: from the bottom left, looking towards the despot, and from the bottom right of the picture. Both construct a low viewpoint, positioning us at ground level, lying down on furs and fabrics, just as the two women on the foreground. The niche on the wall above the woman playing chess is drawn from her point of view, from below. The space above the tapestry, at the top centre, seems to have been drawn from the point of view of someone standing up.

I do not want to emphasise the accuracy of such viewpoints but only their plurality. It begs the question of who is looking, of who is allowed to cast a gaze upon the closed space of the harem, so that the eye loses itself in far away perspectives.

In the logic of the harem, two categories of subjects are allowed to share the space of the despot: the women and the eunuchs. The spectators' iden- tification could be said to oscillate between these two categories; to be with the women I must be one of them, and to be next to them I must be the one who keeps them in place.

Rhameses in his Harem would then be a frozen peepshow offering ambiva- lent identifications: to the surveilling gaze of the eunuch and to the lascivious postures of the women. Control and idleness.

Now there is a third character who is introduced to the scenario of du Nouÿ's visual fantasy: the eunuch, the absent other, implicated in the scene by his absence.

As was mentioned earlier, polygamy should make a decent Christian wife according to St Augustine. The place of the eunuch may well be that of the perfect Christian husband. As Grosrichard[25] remarks, with the category of the eunuch, Christian marriage can at last reach the perfect union of souls, a perfection guaranteed by a strict observance of chastity, something St Augustine would highly recommend. Two souls will be capable of being related in order to make one, something which would never be attained by the union of the flesh. If the eunuch is the model of the Christian husband as saint, he is as well the worst of all Christian husbands: a true pervert, one for whom desire is not limited to the conjugal duty of reproduction. In his treatise on eunuchs, written in 1701, Ancillon is particularly worried. His question is, are eunuchs to be allowed to get married? What to think of a woman who desires one of them and what to think of men if eunuchs are desired by women?

255

The eunuch would be a saint respected by all and a pervert desired by all. At this point, the role of the eunuch may be displaced. He would not only be the invisible spectator of the harem but the one upon whom all places depend: he is a semblance, a seducer, a simulacrum. His place cannot be understood as being determined by one sex or the other. The eunuch is not to be found in between two sexes. What if sexual difference was secondary and castration primary, so that it is from the eunuch that the two sexes can be allocated a place? As Grosrichard puts it, the eunuch would then be the emblem of alterity:

> the Other who arouses all others, the instigator of their desires, the bar or the split which sets a relation between the sexes, and which makes this relation at once necessary and impossible because the eunuch is always (isn't that his function?) between one and the other, and, so to speak, in the middle of the bed, even and especially when one is certain that he is not there.[26]

In the context of academic representation, one could then place the eunuch as that which representation attempts to repress and disguise: the founding absence upon which it is based.

The eunuch as a semblance, master in the art of mimicry, could then be an emblem for the image. An emblem which is good at being nothing, that is, good at pointing at this nothing, this void upon which the image relies in order to exist as the presence of an absence.

In this sense, the image 'speaks to us of less than the thing, but of us, and in connection with us, of less than us, of that less than nothing which remains when there is nothing.'[27]

NOTES

1 Michel de Certeau, 'Avant Propos', p. 3 (my translation) in *L'Ecriture de l'Histoire*, Gallimard, Paris, 1975.
2 Michel Thévoz, *L'Académisme et ses Fantasmes*, Minuit, Paris, 1980. See chapter 'L'Orient: Réalité et Fantasme'. My paper is mainly informed by this work.
3 Quoted by MaryAnne Stevens, *The Orientalists*, Royal Academy Catalogue, 1984, p. 19.
4 Walter Benjamin, *Baudelaire*, New Left Books, London, 1973, p. 159.
5 De Certeau, op. cit., pp. 57–62.
6 Sarah Kofman, *L'Enfance de L'Art, souvenir et fantasme*, Payot, 1970.
7 Ibid., p. 86 (my translation).
8 M. Thévoz, op. cit., p. 34 (my translation), Introduction.
9 T. Gautier, *Le Roman de la Mômie*, Flammarion, Paris (first published in 1858).
10 *Eastern Encounters*, The Fine Art Society, London, 1978, p. 66.
11 Ibid.
12 Michel Thévoz, 'Painting and Ideology', *BLOCK*, no. 6, 1982.
13 Julia Kristeva, *Desire in Language*, Blackwell, Oxford, 1981, p. 246.
14 Quoted by Thévoz, *L'Académisme et ses Fantasmes*, p. 99.

15 P. Fedida, 'La relique et le travail de deuil', *Nouvelle Revue de Psychoanalyse*, no. 2, Gallimard, Paris.
16 Gautier, op. cit.
17 Although the fetish and the relic do not operate in the same register. The former belongs to perversions and the latter to neuroses. What is being noted is that both are at work in academic representation.
18 Thévoz, 'Painting and Ideology'.
19 Alain Grosrichard, *Structure du Serail*, Editions du Seuil, Paris, 1979. What follows is a brief summary of some topics analysed by Grosrichard.
20 Ernest Lacan, *Esquisses Photographiques*, Paris, 1856.
21 Ibid.
22 *The Holy Land, Egypt, Constantinople and Athens*, W.M. Thompson, 1866.
23 See Abigail Solomon Godeau, 'A Photographer in Jerusalem, 1855', *October*, no. 18.
24 W. Benjamin, 'The Work of Art in the Age of Mechanical Reproduction', *Illuminations*, Jonathan Cape, London, 1970.
25 Grosrichard, op. cit., pp. 183–206.
26 Ibid, p. 201 (my translation).
27 Maurice Blanchot, 'Two Versions of the Imaginary', in *The Gaze of Orpheus and Literary Essays*, Station Hill Press, New York, 1981, p. 79.

15

VIDEO: SHEDDING THE
UTOPIAN MOMENT

Martha Rosler

(*From*: Issue 11, 1985/6)

What we have come to know as 'video art' experienced a 'utopian moment' in its early period of development, encouraged by the events of the 1960s. Attention to the conduct of social life, including a questioning of its ultimate aims, had inevitable effects on intellectual and artistic pursuits. Communications and systems theories of art making, based partly on the visionary theories of Marshall McLuhan and Buckminster Fuller, as well as on the structuralism of Claude Lévi-Strauss – to mention only a few representative figures – displaced the expressive models of art that had held sway in the West since the early post-war period. Artists looked to a new shaping and interventionist self-image (if not a shamanistic-magical one), seeking yet another route to power for art, in counterpoint – whether discordant or harmonious – to the shaping power of the mass media over Western culture.

Regardless of the intentions (which were heterogeneous) of artists who turned to television technologies, especially the portable equipment introduced into North America in the late 1960s, these artists' use of the media necessarily occurred in relation to the parent technology: broadcast television and the structures of celebrity it locked into place. Many of these early users saw themselves as carrying out an act of profound social criticism, criticism specifically directed at the domination of groups and individuals epitomised by broadcast television and perhaps all of mainstream Western industrial and technological culture. This act of criticism was carried out itself through a technological medium, one whose potential for interactive and multi-sided communication ironically appeared boundless. Artists were responding not only to the positioning of the mass audience but also to the particular silencing or muting of *artists* as producers of living culture in the face of the vast mass-media industries: the culture industry versus the consciousness industry.

As a reflection of this second, perhaps more immediate motivation, the early uses of portable video technology represented a critique of the institutions of art in Western culture, regarded as another structure of domination. Thus, video posed a challenge to the sites of art production in society,

258

to the forms and 'channels' of delivery, and to the passivity of reception built into them. Not only a systemic but also a utopian critique was implicit in video's early use, for the effort was not to enter the system but to transform every aspect of it and – legacy of the revolutionary avant-garde project – to redefine the system out of existence by merging art with social life and making 'audience' and 'producer' interchangeable.

The attempt to use the premier vernacular and popular medium had several streams. The surrealist-inspired or -influenced effort meant to develop a new poetry from this everyday 'language' of television, to insert aesthetic pleasure into a mass form and to provide the utopic glimpse afforded by 'liberated' sensibilities. This was meant not merely as a hedonic–aesthetic respite from instrumental 'reality' but as a liberatory manoeuvre. Another stream was more interested in information than in poetry, less interested in spiritual transcendence but equally or more interested in social transformation. Its political dimension was arguably more collective, less visionary, in its effort to open up a space in which the voices of the voiceless might be articulated.

That the first of these 'streams' rested on the sensibility and positioning of the individual meant, of course, that the possibilities for the use of video as a 'theatre of the self', as a narcissistic and *self*-referential medium, constantly presented themselves. And, indeed, the position of the individual and the world of the 'private' over and against the 'public' space of the mass is constantly in question in modern culture. Yet this emphasis on the experience and sensibilities of the individual, and therefore upon 'expression' as emblematic of personal freedom and as an end in itself, provided an opening for the assimilation of video – as 'video art' – into existing art-world structures.

A main effort of the institutionalised art-delivery structures (museums, galleries, and so on) has been to tame video, ignoring or exorcising the elements of implicit critique. As with earlier modern movements, video art has had to position itself in relation to 'the machine' – to the apparatuses of technological society, in this case, electronic broadcasting. Yet the museumisation of video has meant the consistent neglect by art-world writers and supporters of the relation between 'video art' and broadcasting, in favour of a concentration on a distinctly modernist concern with the 'essentials' of the 'medium'. This paper, in Part 1, attempts to trace some basic threads of artists' reactions to nascent technological society and marketplace values in the nineteenth century, using photography as the main example. The discussion invokes the dialectic of science and technology, on one side, and myth and magic, on the other. In considering the strategies of early twentieth-century avant-gardes with respect to the now well-entrenched technological–consumerist society, it asks the question: movement toward liberation or toward accommodation? Part 2 considers historiography and the interests of the sponsoring institutions, with video history in mind. Part

3 considers the role of myth in relation to technology, with a look at the shaping effects of the post-war US avant-garde and of Marshall McLuhan on the formation and reception of 'video art' practices.

PART 1: PREHISTORY

Video is new, a practice that depends on technologies of reproduction late on the scene. Still, 'video art' has been, is being, forced into patterns laid down in the last century. In that century, science and 'the machine' – that is, technology – began to appear as a means for the education of the new classes as well as to the rationalisation of industrial and agricultural production, which had given impetus to their development. Although the engineering wonders of the age were proudly displayed in great exhibitions and fairs for all to admire, the consensus on the shaping effect that these forces, and their attendant values, had on society was by no means clear. Commentators of both Left and Right looked on the centrality of the machine as meaning the decline of cultural values in the West. Industrialisation, technology's master, seemed to many to rend the social fabric, destroying rural life and traditional values of social cohesiveness and hard work that had heretofore given life meaning.

Central to the growing hegemony of the newly ascendant middle classes, bearers of materialist values and beneficiaries of these new social dislocations, were the media of communication – not railroads, which welded communities together with bands of steel and incidentally added to the repertoire of perceptual effects. Although the new mass press aided communication among classes and factions vying for social power, its overweening function was the continuous propagation of bourgeois ideology among members of the still-developing middle classes and, beyond them, to the rest of society. And it was this ideology that accorded 'science' a central position. 'Science', as sociologist Alvin Gouldner has noted, 'became the prestigious and focally visible paradigm of the new mode of discourse'.[1] One need hardly add that this focus on science and technology incorporated the implicit goals of conquest, mastery and instrumentalism responsible for the degradation of work and the destruction of community.

The new technologies of reproduction, from the early nineteenth century on, were not segregated for the use or consumption of ruling élites but soon became embedded in cultural life. Perhaps the most public examples are the growth of the mass press, as previously noted, and the invention of photography, both before mid-century. The birth of the press in the previous century has been identified with the tremendous expansion of the 'public' sphere, inhabited by the cultured, including the cultured bourgeois tradesman alongside the literate aristocrat. The growth of the mass press coincided with the pressure for broader democratic participation, to include the uncultured and unpropertied as well. The erosion of traditional authority,

which had emanated from the aristocracy, helped bring the previous ruling ideologies into crisis.

Thus, conflict over cultural values and the machine stemmed from the aristocracy and from the newly proletarianised 'masses', as well as from traditional craftspeople, tradespeople and artists. Artists' revolts against the technologisation and commodification of 'culture', and its ghettoisation as a private preserve of the ebullient middle classes, took place in the context of the artists' own immersion in the same 'free-market system' that characterised those classes. Thus, opposition to technological optimism was located in diverse social selectors, and for diverse reasons. Both cultural conservatives, such as John Ruskin, and political progressives, such as his former student William Morris, sought to find a synthesis of modern conditions and earlier social values. It might not be stretching a point too far to remark that the centrality of instrumental reason over intellectual (and spiritual) life is what motivated the search of these figures and others for countervailing values. The Romantic movement, in both its backward-looking and forward-looking aspects, incorporates this perspective.

> The world is too much with us; late and soon,
> Getting and spending, we lay waste our powers:
> Little we see in Nature that is ours
>
> William Wordsworth (1806)

To some, the political struggles of the day, the growth of turbulent metropolises housing the ever-burgeoning working classes, and the attendant depletion of rural life, were the worst aspects of nineteenth-century society. To others, like Morris, the worst aspect was the situation of those new classes, their immiseration of material and cultural life, and its deleterious effect on all of society, which he came to see as a matter of political power. Technological pessimism and an attempt to create a new 'humanist', anti-technological culture marked the efforts of these latter critics.

The American history of responses to technology differs, if only at first. Initially mistrustful of technology, American thinkers by mid-century looked to technological innovation to improve the labour process and develop American industry, while safeguarding the moral development of women and children. The American transcendentalist poet and minister Ralph Waldo Emerson was initially one of the supreme optimists, but even he had turned pessimist by the 1860s.

Despite the doubts, stresses and strains, there was, of course, no turning back. In cultural circles even those most suspicious of technological optimism and machine-age values incorporated a response to – and often some acceptance of – science and the technologies of mass reproduction in their work. The Impressionist painters, for example, placed optical theories drawn from scientific and technical endeavours (such as the weaving of tapestries) at the centre of their work, while keeping photography at bay by emphasising

colour. They also turned away from the visible traces of industrialism on the landscape, in a nostalgic pastoralism. Photography itself quickly forced the other visual (and poetic!) practices to take account of it, but strove in its aesthetic practices to ape the traditional arts.

As Richard Rudisill has demonstrated,[2] visual images, which were a mania with Americans even before the invention of daguerreotype, went straight to the heart of the American culture as soon as the processes of reproduction became available. Rudisill notes that Emerson had referred to himself as a great eyeball looking out during his moments of greatest insight. As John Kasson observes, Emerson was 'most concerned with the possibilities of the imagination in a democracy' and 'devoted himself not so much to politics directly as to "the politics of vision." . . . For Emerson, political democracy was incomplete unless it led to full human freedom in a state of illuminated consciousness and perception.'[3] The identification of the closely observed details of the external object world with the contents of interiority, landscape with inscape, and with the ethical and intellectual demands of democratic participation, provided a motif for American cultural metaphysics that we retain.

Just before photography appeared, the popularity of American art with Americans reached a zenith with the 'art clubs', in which ordinary people, through subscription or lottery, received American art works, most of which were carefully described in the popular press. The decline of these clubs coincided with the rise of the new photo technologies, which rested far closer to the heart of private life than paintings and graphics. Artists took note.

It is worth noting that the person who introduced photography to America was not only a painter but was the inventor of the telegraph, Samuel F.B. Morse, who received the photographic processes from Daguerre himself. While they chatted in Morse's Paris lodgings, Daguerre's diorama theatre, based on the protofilmic illusions of backdrops, scrims and variable lighting, burned to the ground. This is the stuff of myth. Despite their conjuncture in Morse's person, it took close to one hundred years to get the technologies of sound and image reproduction together.

The subsequent history of Western high culture, which eventually included American high culture as well, included efforts to adapt to, subsume, and resist the new technologies. Although artists had had a history of alliance with science since the Enlightenment (and despite their market positioning vis-à-vis the middle classes, as previously described), even such technologically invested artists as the Impressionists, and even photographers, were likely to challenge the authority of scientists often by stressing magic, poetry, incommensurability.

The powers of 'imagination' were the centre of artists' claim to a new authority of their own, based on command of interiority and sensation or perception, notwithstanding the fact that the formulation of those powers

might be based on the methods and discoveries of the rival, science. Sectors of late nineteenth-century art practice, then, pressed occultist, primitivist, sexist, and other irrationalist sources of knowledge and authority, spiritual insights often based not on sight *per se* but on interpretation and synaesthesia, and a rejection of 'feminine' Nature. The dialectic of these impulses is the familiar one of modern culture, as Nietzsche suggested.

John Fekete, in *The Critical Twilight*, has called symbolism, whose genesis occurred during this period, 'aesthetics in crisis, protesting hysterically against commodity pressures'.[4] Fekete refers to its attempt to shut out all of history and the social world as 'the sheer despair of total frustration and impotence'.[5] Wordsworth's lament about 'getting and spending' is transformed into aesthetic inversion and mysticism. Fekete notes, significantly, the transformation from the formalism of Rimbaud's the 'disordering of all the the senses' to that of more modern versions of formalised aestheticism, which 'make a fetish of language and (embrace) its principles of order',[6] promoting 'the unity characteristic of the contemporary ideologies of order'.[7] Including social order.

The capitulation to modernity is associated with Cubism, which identified rationalised sight with inhuman culture. We should note that rejecting realism, as Cubism did, allowed painting to continue to compete with photography, partly by including in a visual art analogies to the rest of the sensorium, and partly by opposing simultaneity to the photographic presentation of the moment. The sensorium and its relation to form remained at the centre of artists' attention. Futurism's apologia for the least salutary shocks of modernity and urbanism featured a disjointed simultaneity that abolished time and space, history and tradition. Its perceptual effects were composed into a formal whole in which figure and ground were indistinguishable and ideological meaning suppressed. Although Futurism handled modernity through abstraction and condensation, Picasso's Cubism incorporated African and other 'primitive' imagery as a technique of transgression and interruption, signifying, one may speculate, incommensurability and mystery, a break in bourgeois rationality. Both Cubism and Futurism rejected photographic space.

So far I have cast photography in the role of rational and rationalising handmaiden of bourgeois technological domination. There is another side to it. By the turn of the twentieth century, photography was well established as a rational and representational form, not only of private life and public spectacles of every type, but as implicated in official and unofficial technologies of social control: police photography, anthropometry, urban documentation, and time-and-motion study, for example. Photographs were commodities, available to the millions by the millions. But, as previously noted, aesthetic practice in photography was interested in the model provided by the other arts. European aesthetic photography after the middle of the nineteenth century was associated both with the self-image of the

intellectual and social élite (through the work of Julia Margaret Cameron), and with an appreciation of the premises of painterly realism, though in coolly distanced form (P.H. Emerson).

The first important art-photographic practice in the United States, Alfred Stieglitz' Photo-Secession, was modelled after the European *fin-de-siècle* secession movements, with which he had had some first-hand experience. Stieglitz melded symbolist notions with the aestheticised pictorial 'realism' of his mentor Emerson. The sensory simultaneity of symbolist synaesthesia appealed to this former engineering student, who also revealed his enthusiasm for the mechanical reproduction of sound offered by the wireless and the player piano.[8]

The photographic example provides an insight into the choices and silences of aestheticism with respect to technology. Aside from the use of a camera – a still-confusing mechanical intrusion – this new art photography depended for its influence on the latest technologies of mass reproduction. In Stieglitz' publication *Camera Work*, which helped create a nationwide, or worldwide, art-photography canon, current and 'historical' photographs appeared as gravures and half-tones, the products of processes only recently developed for the mass press. Thus, an art apparently hostile and antithetical to mass culture, preserving craft values and arguing against 'labour consciousness', in fact depended on its technologies: a seeming paradox worth keeping in mind. The camera and print technologies were perceived as neutral, tool-like machines to be subsumed under the superior understandings of an aesthetic élite. The aesthetic sensibility was an alchemical crucible that effected a magical transformation.

Still, by 1916 Stieglitz had so thoroughly conceded to the photographic modernism of Paul Strand that he devoted the last two issues of the moribund *Camera Work*, specially resurrected for this purpose, to his work. After Strand, the camera apparatus and its 'properties' prevailed, displacing the negative-to-print handiwork at the centre of art-photographic practice. For Strand and others, the camera was an instrument of conscious seeing that allowed for a politicised 'cut' into, say, urban microcosms, peasant counter-examples, and the structures of nature. Photography was, for them, mediation *toward*, not away from, social meaning. For others, of course, photographic modernism meant a new abstract formalism or, through the rapid growth of product photography, a corporate symbolism of commodities.

Thus, photographic modernism accepted science and rationality but also allowed for an updated symbolism of the object in a commodified world, a transformation that advertising made into its credo. Whereas photographic pictorialism had suggested a predictable alliance of aestheticism and élitism as a noble bulwark against the monetary measure of the marketplace and sold proletarian labour, formalist modernism united the high arts with the mass culture of modern entertainment forms and commodity culture. Modernism, in Kantian fashion, favoured the material art work while

remaining vague about the meaning it was supposed to produce. Formalist ideologies were furthered by such Bauhaus figures as Laszlo Moholy-Nagy, who propagated a scientific vocabulary of research and development, therapeutic pedagogy and experimentation. In art and architecture, formalist modernism promised a healthier, more efficient and adaptive – and liberatory – way of life, for all classes. The possibly revolutionary intent, to pave the way for democratic participation, could quickly turn into accommodation to new – technocratic – élites.

It has been observed that post-war American modernism, despite its strict separation of the arts from each other as well as from the social world, and with its fetishisation of materials, nevertheless institutionalised the avant-garde. To discover what this represents for our concerns, we must look at the aims of the 'classic' twentieth-century avant-garde movements, Dada and Surrealism, which appeared in the 1920s and 1930s, when modern technological society was already firmly established. The use of, or transgression against, the media of communication and reproduction was on their agenda, for the avant-garde saw art institutions as integrated into oppressive society but as ideally positioned nonetheless to effect revolutionary social change; this was a reworking of the Symbolist effort to disorder the senses, perhaps, but with new political intentions. The aim of Dada and Surrealism was to destroy art as an institution by merging it with everyday life, transforming it and rupturing the now well-established technological rationalism of mass society and its capacity for manufacturing consent to wage enslavement and rationalised mass killing. Peter Bürger has described the activity of the avant-garde as the self-criticism of art as an institution, turning against both 'the distribution apparatus on which the work of art depends, and the status of art in bourgeois society as defined by the concept of autonomy'.[9] Thus, Duchamp's 'Readymades', which, through their validation of despised objects by the agency of the artist's signature, 'exposed' the real operations of the art-distribution apparatus. Bürger writes:

> the intention of the avant-gardists may be defined as the attempt to direct toward the practical the aesthetic experience (which rebels against the praxis of life) that Aestheticism developed. What most strongly conflicts with the means–end rationalist of bourgeois society is to become life's organizing principle.[10]

The disruptive efforts of Expressionism, Dada and Surrealism intended to transgress against not just the art world but conventional social 'reality' and thereby become an instrument of liberation. As Bürger suggests, the avant-garde intended on the one hand to replace individualised production with a more collectivised and anonymous practice, and on the other to get away from the individualised address and restricted reception of art. But, as Bürger concludes, the avant-garde movements failed. Instead of destroying the art world, the art world swelled to take them in, and their techniques

of shock and transgression were absorbed as the production of refreshing new effects. 'Anti-art' became Art, to use the terms set in opposition by Allan Kaprow in the early 1970s. Kaprow – himself a representative post-war US 'avant-gardist', student of John Cage – had helped devise a temporarily unassimilable form, the 'Happening', a decade or so earlier. Kaprow wrote, in 'The Education of the Un-Artist, Part I':

> At this stage of consciousness, the sociology of culture emerges as an in-group 'dumb show'. Its sole audience is a roster of the creative and performing professions, watching itself, as if in a mirror, enact a struggle between self-appointed priests and a cadre of equally self-appointed commandos, jokers, gutter-snipers, and triple agents who seem to be attempting to destroy the priests' church. But everyone knows how it all ends: in church, of course.[11]

As Kaprow plainly realised, the projected destruction of art as a separate sphere was accomplished, if anywhere, in the marketplace, which meant a thwarting of avant-gardist desires. But nothing succeeds like failure, and in this case failure meant that the avant-garde became the academy of the post-war world. The post-war American scene presented a picture of ebullient hegemony over the Western art world. Stability and order seemed to have been successfully erected on an art of alienation and isolation. High culture appeared to have conquered the 'negative' influences of both politics and mass culture by rigorously excluding, or digesting and trans-forming, both through a now thoroughly familiar radical aestheticism. Art discourse made updated use of the dialectic of scientific experimentation on technique and magical transformation through aestheticism and primitivism, veering toward an avant-garde of technical expertise. This hegemonic con-dition lasted about as long as 'the American century' it seemed to accompany – that is, until the new decade of the 1960s. The rapid growth of television and the cybernetic technologies, which had gotten a big boost from the war and American militarisation, hastened the crisis. Television had no difficulty building on the structure and format of radio, with pictures added. Radio had established itself in a manner like that of the mass press and photog-raphy in the previous century and had played a vital role in disseminating the new ideologies of consumerism, Americanism, and the State. Like photography, radio depended on action at a distance, but with the added fact of simultaneity. It appeared to be a gift, free as air. The only direct sales came through hardware – which took on the fanciful forms of furni-ture, sky-scraping architecture, cathedrals, and the hearth, the mantelpiece, and the piano, all in one, with echoes of the steamship. Bought time appeared as free time, and absence appeared as presence. Radio had the legitimacy of science (and nature) and the fascination of magic.

Television was able to incorporate into this all the accommodations of photography and film, though in degraded form. As with advertising, the

all-important text was held together with images of the object world, plus the spectacle of the State and the chaos of the street, and voyeuristic intrusions into the private lives of the high and the low, the celebrity and the anonymous. Television was like an animated mass magazine and more. As commentators from Dwight MacDonald and Marshall McLuhan to Guy Debord and Jean Baudrillard have observed, the totalising, ever-whirling and spinning microcosm of television supplanted the more ambiguous experience of the real world.

Alvin Gouldner comments on the war between the 'cultural apparatus' (using C. Wright Mills' term) and the consciousness industry (Hans Magnus Enzensberger's term). Gouldner quotes Herbert Gans' essay of 1972 that 'the most interesting phenomenon in America . . . is the political struggle between taste cultures over whose culture is to predominate in the mass media, and over whose culture will provide society with its symbols, values, and world view'. This struggle, the reader will immediately recognise, is the continuation of that of the previous century, which appeared at that juncture as that between the culture based on aristocratic values, and that based on new, middle-class centred, scientistic values. Abstract Expressionism had followed the path of an impoverished bohemian avant-garde with strong aestheticist elements, but neither as dismissive of proletarian sympathies as the Stieglitz set, nor as comfortably situated. With relative speed, Abstract Expressionism found itself blessed with success – or cursed. Suddenly these artists, used to a marginal and secessionist existence, were producing extremely expensive commodities and bearing highly fetishised biographies. Jackson Pollock appeared on the cover of *Life* and was shown in poses bearing some similarity to James Dean, another rebel figure and beloved prodigal son. Artists' enshrinement as mass-media celebrities inverted their 'meaning'. The dominance of the distribution system over the artists who stocked it was proved again to those who cared to see. Others have also demonstrated the way in which this élite art, an art that suggested doubt and abstraction, freedom and impoverishment, an art that dismayed populists of the Right and the Left, become the ambassador of the American empire.[12]

Pop Art followed a logical next step, a public and ritualised acceptance of the power of mass culture through an emphasis on passivity and a renunciation of patriarchy, high-culture aura, and autonomy. It was mass culture and the State, after all, that had made Abstract Expressionism a 'success', made it a *product* bearing the stamp 'Made in the USA' much like any other product. Warhol's Pop was a multi-faceted and intricate 'confession' of powerlessness, accomplished through production, entourages, modes of production, and poses, that mimicked, degraded, fetishised, and misconstrued, in slave fashion, the slick, seamless productions of corporate mass culture, especially those of the technologies of reproduction. The slave's ironic take on the relation between art and technology was to retain the older, craft-oriented media of oil paint and silk screen, but to use them to

copy or reorder the reified icons of the photographic mass media. The apotheosis of the avant-garde was its transmutation into the servant of mass culture. Aura had passed to the copy.

As Kaprow wrote about the social context and 'art consciousness', as he termed it, of the period:

> it is hard not to assert as matters of fact:
> that the LM (Lunar Module) mooncraft is patently superior to all contemporary sculptural efforts;
> that the broadcast verbal exchange between Houston's Manned Spacecraft Center and Apollo 11 astronauts was better than contemporary poetry;
> that, with its sound distortions, beeps, static and communication breaks, such exchanges also surpassed the electronic music of the concert halls;
> that certain remote-control video tapes of the lives of ghetto families recorded (with their permission) by anthropologists, are more fascinating than the celebrated slice-of-life underground films;
> that not a few of those brightly-lit, plastic and stainless-steel gas stations of say, Las Vegas, are the most extraordinary architecture to date;
> that the random trancelike movements of shoppers in a supermarket are richer than anything done in modern dance;
> that the lint under beds and the debris of industrial dumps are more engaging than the recent rash of exhibitions of scattered waste matter;
> that the vapor trails left by rocket tests – motionless, rainbow colored, sky-filling scribbles – are unequalled by artists exploring gaseous mediums;
> that the Southeast Asian theater of war in Viet Nam, or the trial of the 'Chicago Eight', while indefensible, is better than any play;
> that ... etc, etc, non-art is more art than ART-art.[13]

Apprehending the collapses of public and private spaces, Kaprow, too, representing the aesthetic consciousness, could only bow before the class of science, technology, the State, and the ephemera of modern urban-suburbanism, especially as orchestrated through television. The 'antihegemonic' 1960s also brought a different relation to issues of power and freedom, more populist than avant-gardist, more political than aestheticist. Students rebelled against the construction of what Marcuse termed one-dimensional culture and its mass subject, while the politically excluded struggled against the conditions and groups enforcing their own powerlessness. The iron hand of science and technology became a focus of agitation, particularly in relation to militarism and the threat of total war. The twin critique of technological and political domination helped beget a communitarian, utopic, populist, irrationalist, anti-urban, anti-industrial, anti-élitist, anti-intellectual, anti-militarist, communitarian counterculture, centred on

youth. Hedonic, progressive, rationalist, anti-sexist, anti-racist, anti-imperialist and ecological strains also appeared. The severe stress on the reigning ideologies also put models of high culture in doubt, not least among its own younger practitioners. Artists looked to science, social science and cultural theory – anywhere but to dealers, critics, or aesthetics – for leads. New forms attacked head-on the commodity status of art. 'Objecthood' was an issue not only because art objects were commodities but because they seemed insignificant and inert next to the electronic and mass-produced offerings of the mass media.

PART 2: HISTORY

At last, video. This is well-worked territory. In fact, video's past is the ground not so much of history as of myth. Some look to the substantive use of a television set or sets in altered or damaged form in art settings in the late 1950s or early 1960s. Others prefer the sudden availability of the Sony Portapak in the mid-1960s, or the push supplied by Rockefeller capital to artists' use of this new scaled-down technology. But the consensus appears to be that there is a history of video to be written – and soon. I would like to consider the nature of such histories, and their possible significance for us.

Historical accounts are intent on establishing the legitimacy of a claim to public history. Such a history would follow a pattern of a quasi-interpretive account of a broad trend activated by significant occurrences, which, on the one side, are brought about by powerful figures and, on the other side, determine or affect what follows. Video's history is not to be a *social* history but an *art* history, one related to, but separate from, that of the other forms of art. Video, in addition, wants to be a major, not a minor, art.

Why histories now? Is it just time, or are the guardians of video reading the graffiti on the gallery wall, which proclaims the death or demotion of photographic media? (Like those of colour photos, video's keeping, 'archival', qualities seem dismal, and the two are liable to vanish together without a trace.) If video loses credibility, it might collapse as a curated field. Or perhaps the growth of home video and music television has made the construction of a codified chain of *art*-video causation and influence interesting and imperative.

Some fear that if histories are written by others, important issues and events will be left out. Others realise the importance of a history in keeping money flowing in. The naturalisation of video in mass culture puts the pressure on to produce a history of 'art video', or 'video art', that belongs in the art world and that was authored by people with definable styles and intentions, all recognisable in relation to the principles of construction of the other modern art histories.

Sometimes this effort to follow a pattern appears silly. For example, one well-placed US curator made the following remarks in the far-away days of 1974:

The idea of the video screen as a window is ... opposite from the truth in the use of video by the best people. Video in the hands of Bruce Nauman, or in the hands of Richard Serra, is opaque as opposed to transparent. It's an extension of a conceptual idea in art. It enables the audience – again on a very subliminal and intuitive level – to return to painting, to look at painting again, in a renewed way.

... In the future, most of us who have been watching video with any amount of attentiveness are going to be able to recognize the hand of the artist in the use of the camera. It's possible to know a Van Gogh as not a fake ... by a certain kind of brush-stroking; very soon we're going to know the difference between Diane Graham (*sic?*) and Bruce Nauman and Vito Acconci because of the way the camera is held or not held. Style in video, that kind of personal marking, is going to become an issue. And it's going to subsume information theory with old-fashioned esthetic concepts.[14]

Ouch! I suppose it is not Jane Livingstone's fault that in 1974 video editing had not yet imposed itself as the style marker she thought would be the analogue of the 'brush-stroking' manoeuvre. As absurd as her remarks (should) sound, she was right about the role of 'old-fashioned esthetic concepts', for aestheticism has been busily at work trying to reclaim video from 'information' ever since. It is the self-imposed mission of the art world to tie video into its boundaries and cut out more than passing reference to film, photography and broadcast television, as the art world's competition, and to quash questions of reception, praxis and meaning in favour of the ordinary questions of 'originality' and 'touch'.

Historiography is not only an ordering and selecting process, it is also a process of simplification. Walter Hines Page, editor of the turn-of-the-century magazine *The World's Work*, liked to tell writers that 'the creation of the world has been told in a single paragraph'.[15] Video histories are now produced not by or for scholars but for potential funders, for the museum-going public, and for others professionally involved in the field, as well as to form the basis for collections and shows. The history of video becomes a pop history, a pantheon, a chronicle. Most important, the history becomes an *incorporative* rather than a transgressive one. And the names populating the slots for the early years are likely to be those of artists known for work not in video or those of people who remained in the system, producing museum-able work over a period of years or at the present. And, of course, they are likely to be New Yorkers, not Detroiters, or even Los Angelenos or San Franciscans, not to mention San Diegans. Some histories do recognise the contribution of Europeans – perhaps mostly those histories produced in Europe – or Canadians, or even Japanese – always assuming they have entered the Western art world. Finally, the genres of production are likely to fit those of film and sculpture. Codification belies open-endedness and

'experimentation', creating reified forms where they were not, perhaps, intended. This even happens when the intent of the history is to preserve the record of open-endedness. And so forth.

Thus, museumisation – which some might point to as the best hope of video at present for it to retain its relative autonomy from the marketplace – contains and minimises the *social negativity* that was the matrix for the early uses of video.

PART 3: MYTH

At the head of virtually every video history is the name Nam June Paik. Martha Gever, in her definitive article on the subject in *Afterimage* magazine upon the occasion of his unprecedented exhibition at New York's Whitney Museum of American Art, referred to Paik's 'coronation'.[16] I prefer the word 'sanctification'; for Paik, it would appear, was born to absolve video of sin. The myths of Paik suggest that he had laid all the ground work, touched every base, in freeing video from the domination of corporate TV, and video can now go on to other things. Paik also frees video history from boring complexity but allows for a less ordered present. By putting the prophet at the front, we need not squabble over doctrine now, nor anoint another towering figure, since the video-art industry still needs lots and lots of new and different production.

The myth of Paik begins with his sudden enlightenment in Germany – the site of technical superiority – through John Cage, the archetypal modernist avant-gardist, at a meeting in 1958. Martha Gever relates that Paik writes to Cage in 1972, 'I think that my past 14 years is nothing but an extension of one memorable evening at Darmstadt in 58'.[17] Paik comes to America around 1960, affiliated, more or less, with the Fluxus movement. Fluxus was a typical avant-garde in its desire to deflate art institutions, its use of mixed media, urban detritus, and language; the pursuit of pretension-puncturing fun; its de-emphasis of authorship, preciousness and domination. Paik participates in some events and, we are told, shows his first tape at a Flux event. Again showing the rest of us the way, this time to funding, Paik supposedly makes this tape with some of the first portable equipment to reach US shores, equipment he buys with a grant from the John D. Rockefeller the Third Fund. According to the myth, the tape was of the Pope (!).

The elements of the myth thus include an Eastern visitor from a country ravaged by war (our war) who is inoculated by the leading US avant-garde master while in technology heaven (Germany), who once in the States repeatedly violates the central shrine, TV, and then faces the representative of God on earth, capturing his image to bring to the avant-garde, and who then goes out from it to pull together the two ends of the American cultural spectrum by symbolically incorporating the consciousness industry into the

methods and ideas of the cultural apparatus – always with foundation, government, gallery, museum, broadcast and other institutional support.

And – oh yes! – he is a man. The hero stands up for masculine mastery and bows to patriarchy, if only in representation. The thread of his work includes the fetishisation of a female body as an instrument that plays itself, and the complementary thread of homage to other famous male artist-magicians or seers (quintessentially, Cage). The mythic figure Paik has done all the bad and disrespectful things to television that the art world's collective imaginary might wish to do. He has mutilated, defiled and fetishised the TV set, reduplicated it, symbolically defecated on it by filling it with dirt, confronted its time-boundedness and thoughtlessness by putting it in prox-imity with the eternal mind in the form of the Buddha, in proximity with natural time by growing plants in it, in proximity with architecture and interior design by making it an element of furniture, and finally turned its signal into colourful and musical noise.

Paik's interference with TV's inviolability, its air of non-materiality, over-whelmed its single-minded instrumentality with an antic 'creativity'. Paik imported TV into art-world culture, identifying it as an element of daily life susceptible to symbolic, anti-aesthetic aestheticism, what Allan Kaprow called 'anti-art art'.

As Gever discusses, the effects of his museum installations are hypnotic. These effects formalise the TV signal and replicate viewer passivity, replacing messages of the State and the marketplace with entertainment. In some installations the viewer is required to lie flat. Paik neither analysed TV messages or effects, nor provided a counter-discourse based on rational exchange, nor made its technology available to others. He gave us an upscale symphony of the most pervasive cultural entity of everyday life, without giving us any conceptual or other means of coming to grips with it in anything other than a symbolically displaced form. Paik's playful poetry pins the person in place.

The figure of Paik in these mythic histories combines the now-familiar antinomies, magic and science, that help reinforce and perpetuate rather than effectively challenge the dominant social discourse. Why is this impor-tant? The historical avant-garde has shown a deep ambivalence towards the social power of science and technology. Surrealism and Dada attempted to counter and destroy the institutionalisation of art in society, to merge it with everyday life and transform both through liberation of the senses, unfreezing the power of dissent and revolt. Although this attempt certainly failed, subsequent avant-gardes, including those that begin to 'use' or address television technology, had similar aims.

Herbert Marcuse spelled this out back in 1937 in his essay 'The Affirmative Character of Culture'.[18] Marcuse traces the use of 'culture' by dominant élites to divert people's attention from collective struggles to change human life and toward individualised effort to 'cultivate' the soul

like a garden, with the reward being pie in the sky by and by – or, more contemporaneously, 'personal growth'. Succinctly put, Marcuse showed the idea of culture in the West to be the defusing of social activity and the enforcement of passive acceptance. In the Western tradition, form was identified as the means to actually affect an audience.

I would like to take a brief look at a sector of the US avant-garde and the attempt to contain the damage perceived to have been wrought on the cultural apparatuses by the mass media. Consider the notable influence of John Cage and the Black Mountaineers, which has deeply marked all the arts. Cage and company taught a quietist attention to the vernacular of everyday life, an attention to perception and sensibility that was inclusive rather than exclusive, but that made a radical closure when it came to divining the causes of what entered the perceptual field. This outlook bears some resemblance to American turn-of-the-century anti-modernism, such as the US version of the Arts and Crafts movement, which stressed the thera-peutic and spiritual importance of aesthetic experience.[19] In fact, however, it was a form of accommodation to it.

Cage's mid-1950s version, like Minor White's in photography, was marked by Eastern-derived mysticism; in Cage's case the anti-rational, anti-causative Zen Buddhism, which relied on sudden epiphany to provide instantaneous transcendence; transport from the stubbornly mundane to the sublime. Such an experience could be prepared for through the creation of a sensory ground, to be met with a meditative receptiveness, but could not be trans-lated into symbolic discourse. Cagean tactics relied on avant-garde shock, in always operating counter to received procedures or outside the bounds of a normative closure. Like playing the strings of the piano rather than the keys, or concentrating on the tuning before a concert or making a TV set into a musical instrument. As Kaprow complained, this idea was so powerful that soon 'non-art was more Art than Art-art'. Meaning that this supposedly challenging counter-artistic practice, this 'anti-aesthetic', this non-institutionalisable form of 'perceptual consciousness', was quickly and oppressively institutionalised, gobbled up by the ravenous institutions of official art (Art).

Many of the early users of video had similar strategies and similar outlooks. A number (Paik among them) have referred to the use of video as being against television. It was a counterpractice, making gestures and inroads against Big Brother. They decried the idea of making art – Douglas Davis called video art 'that loathsome term'. The scientist modernist term, exper-imentation, was to be understood in the context of the 1960s as an angry and political response. For others, the currency of theories of information in the art world and in cultural criticism made the rethinking of the video apparatus as a means for the multiple transmission of useful, socially empow-ering information rather than the individualised reception of disempowering ideology or sub-ideology, a vital necessity.

273

MARTHA ROSLER

Enter McLuhan. McLuhan began with a decided bias in favour of traditional literacy – reading – but shifted his approval to television. With a peremptory aphoristic style McLuhan simplified history to a succession of Technological First Causes. Many artists liked this because it was simple, and because it was formal. They loved the phrase 'The medium is the message' and loved McLuhan's identification of the artist as 'the antenna of the race'. McLuhan offered the counterculture the imaginary power of overcoming through understanding. Communitarians, both countercultural and leftist, were taken with another epithet, 'the global village', and the valorization of preliterate culture. The idea of simultaneity and a return to an Eden of sensory immediacy gave hippies and critics of the alienated and repressed one-dimensionality of industrial society a rosy, psychedelic, wet dream.

John Fekete notes that McLuhan opposed mythic and analogic structures of consciousness – made attractive also through the writings of Claude Lévi-Strauss – to logic and dialectic, a move that Fekete says 'opens the door to the displacement of attention from immanent connections whether social, political, economic or cultural, to transcendent unities formed outside human control'.[20] Fekete then rightly quotes Roland Barthes on myth (here slightly abbreviated):

> *myth is depoliticized speech.* One must naturally understand *political* in its deeper meaning, as describing the whole of human relations in their real, social structure, in their power of making the world; ... Myth does not deny things, on the contrary, its function is to talk about them; simply, it purifies them, it makes them innocent, it gives them a natural and eternal justification, it gives them a clarity which is not that of an explanation but that of a statement of fact. ... In passing from history to nature, myth acts economically: it abolishes the complexity of human acts, it gives them the simplicity of essence, it does away with all dialectics, with any going back beyond what is immediately visible, it organizes a world which is without contradictions because it is without depth, a world wide open and wallowing in the evident, it establishes a blissful clarity: things appear to mean something by themselves![21]

This is the modern artist's dream! McLuhan granted artists a shaman's role, with visionary, mythopoeic powers.

McLuhan writes that art's function is 'to make tangible and to subject to scrutiny the nameless psychic dimensions of new experience' and notes that, as much as science, art is 'a laboratory means of investigation'. He calls art 'an early warning system' and 'radar feedback' meant not to enable us to change but rather to 'maintain an even course'. Note the military talk! Art is to assist in our accommodation to the effects of a technology whose very appearance in world history creates it as a force above the humans who brought it into being.

McLuhan gave artists a mythic power in relation to form that fulfilled their impotent fantasies of conquering or neutralising the mass media. By accepting rather than analysing their power, by tracing their effects to physiology and biology rather than to social forces, artists could apply an old and familiar formula in new and exciting ways. The old formula involved the relation of the formalist avant-garde to the phenomena of everyday life and culture.

I do not intend to trace the actual effects of McLuhanism on video art, for I believe that artists, like other people, take what they need from the discourse around them and make of it what they can. Many progressive and anti-accommodationist people were spurred by the catchphrases and rumours of McLuhanism to try new ways to work with media, especially outside the gallery. Clearly, though, McLuhanism, like other familiar theories, offered artists a chance to shine in the reflected glory of the prepotent media and cash in on their power over others through formalised mimetic aestheticisation.

CONCLUSION

Some new histories of video have taken up this formalised approach and have portrayed artists in the act of objectifying their element, as though tinkering could provide a way out of the power relations structured into the apparatus. Reinforcing the formalist approach has brought them – inadvertently – to bow, as McLuhan had done, to the power of these media over everyday life. In separating out something called 'video art' from the other ways that people, including artists, are attempting to work with video technologies, they have tacitly accepted the idea that the transformations of art are formal, cognitive and perceptual. At the very least, this promotes a mystified relation to the question of how the means of production are structured, organised, legitimated and controlled, for the domestic market and the international one as well.

Video, it has been noted, is an art in which it is harder than usual to make money. Museums and granting agencies protect video from the marketplace, as I remarked earlier, but they exact a stiff price. Arts that are marginally saleable have shrunken or absent critical apparatuses, and video is not an exception. Video reviewing has been sparse and lacklustre in major publications. This leaves the theorising to people with other vested interests. In the absence of such critical supports, museumisation must involve the truncation of both practice and discourse to the pattern most familiar and most palatable to those notoriously conservative museum boards and funders – even when the institutions actually show work that goes beyond such a narrow compass.

To recapitulate, these histories seem to rely on *encompassable* (pseudo-) transgressions of the institutions of both television and the museum, formalist

rearrangements of what are uncritically called the 'capabilities' of the medium, as though these were God given, a technocratic scientism that replaces considerations of human use and social reception with highly abstracted discussions of 'time', 'space', cybernetic circuitry, and physiology: that is, a vocabulary straight out of old-fashioned discredited Formalist Modernism.

Museumisation has heightened the importance of installations which make video into sculpture, painting or still life, because installations can live only in museums – which display a modern high-tech expansiveness in their acceptance of mountains of obedient and glamorous hardware. Curatorial frameworks also like to differentiate genres, so that video has been forced into those old familiar forms: documentary, personal, travelogue, abstract-formal, image-processed – and now those horrors, dance and landscape (and music) video. And, of these, only the brave curator will show documentary regularly. Even interactive systems, a regular transgressive form of the early 1970s, appear far less often now. Perhaps the hardest consequence of museumisation is the 'professionalisation' of the field, with its inevitable worship of what are called 'production values'. These are nothing more than a set of stylistic changes rung on the givens of commercial broadcast tele-vision, at best the objective correlatives of the electronic universe. Nothing could better suit the consciousness industry than to have artists playing about its edges embroidering its forms and quite literally developing new strategies for adverts and graphics. The trouble is, 'production values' mean the expen-diture of huge amounts of money on production and post-production. And the costs of computerised video editing, quickly becoming the standard in video-art circles, surpass those of (personal) film editing in factors of ten.

Some of the most earnest producers of art videotapes imagine that condensation of the formal effects of this kindly technology will expose the manipulative intent of television. The history of the avant-gardes and their failure to make inroads into the power of either art institutions or the advancing technologies through these means suggests that these efforts cannot succeed.

Alvin Gouldner describes the relation between art and the media as follows:

> Both the cultural apparatus and the consciousness industry parallel the schismatic character of the modern consciousness; its highly unstable mixture of cultural pessimism and technological optimism. The cultural apparatus is more likely to be the bearer of the 'bad news' concerning – for example – ecological crisis, political corruption, class bias; while the consciousness industry becomes the purveyors of hope, the profes-sional lookers-on-the-bright-side. The very political impotence and isolation of the cadres of the cultural apparatus grounds their pessimism in their own everyday life, while the technicians of the consciousness

industry are surrounded by and have use of the most powerful, advanced, and expensive communications hardware, which is the everyday grounding of their own technological optimism.[22]

We may infer that American video artists' current craze for super high-tech production is a matter of envy. It would be a pity if the institutionalisation of 'video art' gave unwarranted impetus to artists' desires to conquer their pessimism by decking themselves out in these powerful and positivist technologies.

On the other hand, as the examination of the Paik myth suggests, it would be equally mistaken to think that the best path of 'transgression' is the destruction of the TV as a material object, the deflection of its signal, or other acts of the holy fool. The power of television relies on its ability to corner the market on messages, interesting messages, boring messages, instantly and endlessly repeating images. Surely we can offer an array of more socially invested, socially productive counterpractices, ones making a virtue of their person-centredness, origination with persons – rather than from industries or institutions. These, of course, will have to live more outside museums than in them. But it would be foolish to yield the territory of the museum, the easiest place to reach other producers and to challenge the impotence imposed by art's central institutions. Obviously the issue at hand as always is who controls the means of communication in the modern world and what are to be the forms of discourse countenanced and created.

NOTES

1 Alvin Gouldner, *The Dialectic of Ideology and Technology*, Seabury Press, New York, 1976, p. 7.
2 In *Mirror Image: The Influence of the Daguerreotype on American Society*, University of New Mexico Press, Albuquerque, 1971.
3 John Kasson, *Civilizing the Machine: Technology and Republican Values in America 1776–1900*, Penguin, Harmondsworth, 1976, p. 111.
4 John Fekete, *The Critical Twilight: Explorations in the Ideology of Anglo-American Literary Theory from Eliot to McLuhan*, Routledge & Kegan Paul, London, 1977, p. 15.
5 Ibid.
6 Ibid., p.16.
7 Ibid.
8 In *Camera Work*, cited by Sally Stein in 'Experiments with the Mechanical Palette', unpublished paper.
9 Peter Bürger, *Theory of the Avant-Garde* (trans. Michael Shaw), Manchester University Press, 1984, p. 34.
10 Ibid.
11 Alan Kaprow, 'The Education of the Un-Artist, Part I', *Art News*, February 1971.
12 See Max Kosloff's's mid-1970s article in *Artforum* on 'Abstract Expressionism and the Cold War', and Eva Cockcroft's subsequent re-reading of the situation in the same magazine. See also Serge Guilbaut, *How New York Stole the Idea of Modern Art: Abstract Expressionism, Freedom and the Cold War*, University of Chicago Press, 1983.

13 Kaprow, op. cit. Ellipsis in original.

14 Jane Livingstone, 'Panel Remarks', in *The New Television: A Public/Private Art* (ed. Douglas Davis and Allison Simmons), based on the conference 'Open Circuits', held in January 1974 in association with the Museum of Modern Art, MIT, Cambridge, Mass., 1977.

15 Christopher P. Wilson, 'The Rhetoric of Consumption', in *The Culture of Consumption* (eds Richard W. Fox & T.J. Jackson Lears), New York, Pantheon, 1983, p. 47.

16 Martha Gever, 'Pomp and Circumstance: The Coronation of Nam June Paik', *Afterimage*, vol.1.105, no. 3, October 1982, pp. 12–16.

17 Ibid.

18 *Zeitschrift für Sozialforschung*, vol. 1 VI. Reprinted in English translation in Herbert Marcuse, *Negations*, Beacon Press, Boston, 1968, pp. 88–133.

19 See T.J. Jackson Lears, *No Place of Grace: Anti-Modernism and the Transformation of American Culture 1880–1920*, Pantheon, New York, 1981.

20 Fekete, op. cit., p. 143.

21 Roland Barthes, 'Myth Today', in *Mythologies*, Hill & Wang, New York, 1972, p. 143.

22 Gouldner, op. cit., p. 175.

16

A REPORT
ON THE WESTERN FRONT

Post-modernism and the 'politics' of style

Dick Hebdige
Foreword by Ubik

(*From*: Issue 12, 1986/7)

FOREWORD – BRAND NAME: DICK

I am Ubik, before the universe was I am. I made the suns. I made the worlds. I created the lives and the places they inhabit: I move them here, I put them there. They go as I say, they do as I tell them. I am the brand name and my name is never spoken, the name which no one knows. I am called Ubik but that is not my name. I am. I shall always be.

> (Philip K. Dick, *Ubik* (the German edition in which the phrase 'I am the word' is mistranslated as 'I am the brand name')

The nature of things is in the habit of concealing itself.

> (Heraclitus, Fragment 54)

The problem is simply this: What does a science fiction writer know about? On what topic is he an authority?

> (Philip K. Dick)

When Dick was alive, he lived in Santa Ana, California, just a few miles from Disneyland. In fact he lived so close that when he was alive, he would sometimes describe himself in lectures and interviews as a spokesperson for Disneyland. One day he went there to meet his friend and fellow SF writer, Norman Spinrad. The two men talked about Watergate on the deck of Captain Hook's pirate ship. The same day Dick discussed the rise of fascism with Spinrad as they were spun round inside a giant teacup. (Elizabeth Entebi headed the crew that filmed these exchanges for Paris TV.) Dick used to think a lot about simulation then. He could never forget the fact that he knew how to get from his apartment to Disneyland and that Disneyland was in some strange way the home of the obsessions that drove him on to write. He used to worry a lot in those days about how to draw the line

between reality and fiction, copies and originals, the authentic and the inauthentic:

> Well, I will tell you what interests me, what I consider important. I can't claim to be an authority on anything, but I can honestly say that certain matters absolutely fascinate me, and that I write about them all the time. The two basic topics which fascinate me are 'what is reality?' and 'what constitutes the authentic human being?'

During his 27-year career as a science fiction writer, Dick explored these same two topics in over thirty novels and more than one hundred short stories. Towards the end of his life, he addressed himself again – and this time directly – to those questions in an essay entitled 'How to Build a Universe That Doesn't Fall Apart Two Days Later'. All the information about Dick you have just read came from that essay together with all the quotations (including the Heraclitus and the blurring of the brand name and the logos in the German edition of *Ubik*). In 'How to Build a Universe That Doesn't Fall Apart', Dick discusses his own work, the nature of 'coincidence', and the reversibility of time. He considers the viability of pre-Socratic thought, reflects on anamnesis, theology, the roots of his concern with simulation, his horror of the inauthentic. (When Dick was alive, this dread of the fake and the inauthentic formed at times his one stable point of orientation just as it did in the anti-authoritarian counterculture with which he was identified.) When dick read Dick's essay in October 1986, he found the correspondences between the arguments put forward by Dick and himself in this article simultaneously uncanny, unsettling and reassuring. Although dick wrote the rest of this article before he read Dick's essay, and although Dick wrote his essay before dick even thought of writing his, the two arguments unfold along broadly parallel lines. There are the same limited obsessions. There is the same underlying structure of preference and aversion, the same general drift – the scary, funny ride through 'Disneyland' and then the journey home. When Dick died, he was in fact – metaphorically speaking – still in transit between what he called 'home' and Disneyland. (The last short story he ever wrote was called 'I Hope I Shall Arrive Soon' . . .). What Dick used to refer to as Disneyland is what dick used to call the Western Front. . . .

<div align="right">Ubik
October 1986</div>

Post-modernism – we are told – is neither an homogeneous entity nor a consciously directed 'movement'. It is instead a space, a 'condition', a 'predicament', an *aporia*, an 'unpassable path' – where competing intentions, definitions and effects, diverse social and intellectual tendencies and lines of

force converge and clash. When it becomes possible for people to describe as 'post-modern' the decor of a room, the design of a building, the diegesis of a film, the construction of a record, or a scratch video, a television commercial, or an arts documentary, or the intertextual relations between them, the layout of a page in a fashion magazine or critical journal, an anti-teleological tendency within epistemology, the attack on the metaphysics of presence, a general attenuation of feeling, the collective chagrin and morbid projections of a post-war generation of baby-boomers confronting dis-illusioned middle age, the 'predicament' of reflexivity, a group of rhetorical tropes, a proliferation of surfaces, a new phase in commodity fetishism, a fascination for images, codes and styles, a process of cultural, political or existential fragmentation and/or crisis, the 'decentring' of the subject, an 'incredulity towards metanarratives', the replacement of unitary power axes by a plurality of power/discourse formations, the 'implosion of meaning', the collapse of cultural hierarchies, the dread engendered by the threat of nuclear self-destruction, the decline of the university, the functioning and effects of the new miniaturised technologies, broad societal and economic shifts into a 'media', 'consumer' or 'multinational' phase, a sense (depending on who you read) of placelessness (Jameson on the Bonnaventura Hotel) or the abandonment of placelessness (Kenneth Frampton's 'critical regionalism') or (even) a generalised substitution of spatial for temporal coordinates[1] – when it becomes possible to describe all these things as 'post-modern' (or more simply, using a current abbreviation, as 'post' or 'very post') then it is clear that we are in the presence of a buzzword.

That a single word should serve as the inflated focus for such a range of contradictory investments does not necessarily render it invalid or meaning-less. An ambivalent response to what Barthes might have called the 'happy Babel' of the post seems on the whole more honest and in the long run more productive than a simple either/or. Viewed benignly, the degree of semantic complexity surrounding the term might be seen to signal the fact that a significant number of people with conflicting interests and opinions feel that there is something sufficiently important at stake here to be worth struggling and arguing over. The substantive appeal of these debates consists in the degree to which within them a whole bunch of contemporary crises are being directly confronted, articulated, grappled with. In other moments, for me at least, an uneasiness concerning the rapidity and glee with which some intellectuals seem intent on abandoning earlier positions staked out in the pre-post-erous ground of older critical debates predominates: an uneasiness which is no doubt underpinned in this case by a squarer, more puritanical aversion to 'decadence', 'fatalism', 'fashion'. . . .

For example, one influential mapping of the post-modern – fatally inflected through the work of Georges Bataille – revolves around the 'death of the subject'. In the (ob)scenario sketched out by Jean Baudrillard, the vagina and the egg – the images compulsively reiterated in Bataille – give

281

way to the metaphor of television as nether-eye (never I): the 'empty' point of origin to which everything returns:

> It is well known how the simple presence of television changes the rest of the habitat into a kind of archaic envelope, a vestige of human relations whose very survival remains perplexing. As soon as this scene is no longer haunted by its actors and their fantasies, as soon as behaviour is crystallised on certain screens and operational terminals, what's left appears only as a large useless body, deserted and condemned. The real itself appears as a large useless body. . . . Thus the body, landscape, time all progressively disappear as scenes. And the same for public space: the theater of the social and the theater of politics are both reduced more and more to a large soft body with many heads.[2]

Sometimes this image of contemporary metropolitan existence as a kind of decentred, 'hyperreal' or technicolor version of Hobbes' Leviathan seems more clearly applicable to the term 'post-modernism' itself than to any hypothetical 'post-modern' ontology. The claims made on behalf of the post can appear grotesquely inflated. The putative signs and symptoms of a post-modern condition sometimes look too much like the morbid projections of a cohort of marginalised, liberally educated critics trapped in declining institutions – the academy, the gallery, the 'world' of art criticism – for them to be taken seriously at face value. The post becomes a monstrous phantasm: a shapeless body of ungrounded critique with countless tiny heads. We know from mythology that such a hideous apparition must be approached obliquely rather than directly. The monster must be read at an angle in the same way that the signal on a video tape is read diagonally by helical scan. It is this need for indirection that dictates the eccentric trajectory of the present report. What follows is an attempt to re-present my own ambivalence *vis-à-vis* the prospect(s) of the post: to engage with some of the issues raised in debates on post-modernism, to cruise the text of post-modernism without forfeiting the possibility of another place, other positions, other scenarios, different languages. In what I take to be the post-modern spirit, I shall try to reproduce on paper the flow and grain of television discourse, switching back and forth between different channels. In this way what follows is likely to induce in the reader that distracted, drifting state of mind we associate with watching television. I shall address the problematic of post-modernism then in the form in which I shall pose questions rather than in the arguments I shall incidentally invoke.

1.

Passing through Disneyland's turnstiles is like boarding a revolving restaurant. Disney's ambition to seamlessly graft the crowds onto an animated environment succeeds at the expense of immobilising them. The loony sidewalks turn into vicious circles and, though they are

always shuffling round and round on maximum rotation, the masses become as frozen and unchanging as the rings of Saturn. The parks are no kind of place for functioning flesh and blood bodies. The publicists proudly describe EPCOT (the new Disney theme park) as the best equipped city on earth for the handicapped, which only means, however, that it's as dynamically demanding as a hospital corridor. Taking its cue from the TV show, Disneyland mutates from the rugged to the precious, from Adventureland and Frontierland to Tomorrowland and Fantasyland, from Tom Sawyer's Island to Tinkerbell's Toy Shop. . . . Freedom of movement is purely illusory; the visitor is trapped in the spectacle's theatricality. In Disneyland, critic Louis Marin claims, 'the visitor is on stage; he performs the play and is alienated by the part without being aware of performing.' But the French critic missed a crucial point during his American vacation. What he calls alienation is here called great fun.

(Paul Taylor, 'The Disney State', *Art and Text*, no. 22, and *FILE*, no. 25, joint issue, 1986)

2.

Post-modernism resembles modernism in that it needs to be thought in the plural.[3] Not only do different writers define it differently but a single writer can talk at different times about different posts. Thus, for instance, Jean-François Lyotard has recently used the term to refer to three separate tendencies: (1) a trend within architecture away from the Modern Movement's project 'of a last rebuilding of the whole space occupied by humanity', (2) a decay of confidence in the idea of progress and modernisation ('there is a sort of sorrow in the Zeitgeist') and (3) a recognition that it is no longer appropriate to employ the metaphor of the 'avant-garde' as if modern artists were soldiers fighting on the borders of knowledge and the visible, prefiguring in their art some sort of collective global future.[4] To pick through some of these definitions, there is, first and most obviously, post-modernism in architecture though even here there are conservative, conservationist and critical regional conjugations. There is post-modernism as a descriptive category within literature and the visual arts where the term is used to refer to a tendency towards stylistic pluralism, the crisis of the avant-garde as idea and as institution, and the blurring on an allegedly unparalleled scale of the categories of 'high' and 'low' forms, idioms and contents. There have also been attempts to describe as post-modern the emergent cultures and sub-cultures associated with the new user-friendly communication technologies (VCRs, home computers, synthesisers, beat boxes, portable and 'personal' audio cassette machines, etc.) and to place these emergent forms within the context of a general shift into a new 'consumer' or 'media' phase in capitalist development. Here there is much talk of bricolage, creative consumption,

the decentring and de-professionalisation of knowledge and technical expertise, the production of meaning in use. There is talk, too, of a general breakdown of social and cultural distinctions: an end not only to the 'outmoded' fantasy of the (suffering) 'masses' and their corollary in the market (the 'mass' in 'mass culture', 'mass media', etc.) but also of the historically grounded 'communities' of the industrial period: end of existing subjectivities, existing collectivities. These fragmentations in their turn are sometimes linked to the erosion of the boundaries *between* production and consumption, between different media, and the incommensurable 'times' and unsynchronised rhythms of different processes, experiences, actions. It is sometimes suggested that together these blurrings and mergers have led to the collapse of the hierarchies which kept apart the competing definitions of culture – high culture, low culture, mass culture, popular culture, culture as a whole way of life – in such a way that these categories and their contents can no longer be regarded as separate, distinct and vertically ranked.

To introduce another though related nexus of concerns, Hal Foster in his Preface to *Postmodern Culture* distinguishes between neo-conservative, anti-modernist and critical post-modernisms and points out that whereas some critics and practitioners seek to extend and revitalise the modernist project(s), others condemn modernist objectives and set out to remedy the imputed effects of modernism on family life, moral values, etc.; while still others, work-ing in a spirit of ludic and/or critical pluralism endeavour to open up new discursive spaces and subject positions outside the confines of established practices, the art market and the modernist orthodoxy. In this latter 'critical' alternative (the one favoured by Foster) post-modernism is defined as a positive critical advance which fractures through negation (1) the petrified hegemony of an earlier corpus of 'radical aesthetic' strategies and proscriptions, and/ or (2) the pre-Freudian unitary subject which formed the hub of the 'pro-gressive' wheel of modernisation and which functioned in the modern period as the regulated focus for a range of 'disciplinary' scientific, literary, legal, medical and bureaucratic discourses. In this positive 'anti-aesthetic', the critical post-modernists are said to challenge the validity of the kind of global, unilinear version of artistic and economic–technological development which a term like modernism implies, and to concentrate instead on what gets left out, marginalised, repressed or buried underneath that term. The selective tradition is here seen in terms of exclusion and violence. As an initial counter-move, modernism is discarded by some critical post-modernists as a Eurocentric and phallocentric category which involves a systematic prefer-ence for certain forms and voices over others. What is recommended in its place is an inversion of the modernist hierarchy – a hierarchy which, since its inception in the eighteenth, nineteenth and early twentieth centuries (depending on your periodisation),[5] consistently places the metropolitan centre over the 'underdeveloped' periphery. Western art forms over Third World ones, men's art over women's art, or, alternatively, in less anatomical

terms, 'masculine' or 'masculinist' forms, institutions and practices over 'feminine', feminist, or 'femineist' ones.[6] Here the term 'post-modernism' is used to cover all those strategies which set out to dismantle the power of the white, male author as privileged source of meaning and value.

'People are afraid to merge . . . '

Many of these diagnoses of the post-modern condition cluster round the threat or the promise of various kinds of merger. As we have seen, a number of immanent mergers have been identified: the coming together of different literary, televisual, and musical styles and genres, the mergers of subjects and objects, originals and copies, hosts and parasites, of 'critical' and 'creative' discourses, of criticism and paracriticism, fiction and metafiction. This tendency is signalled at one level in the much vaunted contemporary preference in art, literature, film, TV and popular music for parody, pastiche, simulation and allegory – the figures which have risen like ghosts from the grave of the fatally afflicted author. Epistemologically, the shift towards these tropes is rooted in deconstructionism, in the abandonment of the pursuit of origins and the post-structuralist attack on the metaphysics of presence. From the academy to Academy One, from Jacques Derrida to *Blade Runner*, there is the same cultivation of postures of confusion or distress around the un-decidability of origins, there is the same blurring of the line(s) between shadows and substances, metaphors and substantive truths, the same questioning of the validity of all such binaries.

Somewhere in the middle, between the seminar and the cinema, sits the work of Jean Baudrillard (the rhyme seminar/cinema/Baudrillard is an irritating if apposite coincidence . . .). Baudrillard has introduced Philip K. Dick into the body of 'serious' social and critical theory rather like a mad or malevolent scientist might assist the *Invasion of the Bodysnatchers* by intro-ducing a pod from outer space into a small, quiet midwestern town. Resorting to the hyperbaton – the rhetorical strategy favoured by the sophists – Baudrillard presents a heretical 'history' of the simulacrum in which, in a progression ('precession') leading from the religious icon to computational simulation, the model is seen gradually to precede and generate the real rather than vice versa. Through this radical in-turning or implosion of sense, Baudrillard attempts to evacuate not only Plato, the Western philosophical inheritance, and any untheorised belief in space–time oppositions but also the Enlightenment achievement/legacy, the dual drives towards universal liberation and social engineering which underpin that achievement/legacy, and any notion of history, progressive or otherwise, which might be used to clarify or valorise the experience of modernity.[7]

Behind this erosion of the twin epistemic faiths of the modern epoch – positivism and Marxism – a question is being posed. The question is: if the fictionalising prepositional copula 'as if' has been allowed into the 'hard'

sciences along with the theory of relativity, catastrophe theory, recursive computational logics and a recognition of the limits of controls, then on what grounds is it to be excluded from social critique and critical theory, from the descriptive, interpretive and predictive discourses of the soft social sciences? The question is: if the Abraham Lincoln Simulacrum in Disneyland can give the Gettysburg address several times a day thanks to robotics and a computer programme then why not take simulation seriously, why not Disneyfy the sober body of 'serious' critique?

> People are afraid to merge on freeways in Los Angeles. This is the first thing I hear when I come back to the city. Blair picks me up from LAX and mutters this under her breath as her car drives up the onramp. She says, 'People are afraid to merge on freeways in Los Angeles'. Though that sentence shouldn't bother me, it stays in my mind for an uncomfortably long time. . . . Nothing else seems to matter to me but those ten words. Not the warm winds which seem to propel the car down the empty asphalt freeway, or the faded smell of marijuana which still faintly permeates Blair's car. All it comes down to is that I'm a boy coming home for a month and meeting someone whom I haven't seen for four months and people are afraid to merge.
>
> (Brett Easton Ellis, *Less Than Zero*)

3.

Post-modernism in architecture is identified with the end of the European modernist hegemony imposed with growing conviction and on a global scale from the 1920s onwards through what became known as the International style. The reaction against International style architecture was pioneered in Britain by people like Edwin Lutyens and has been taken up by a whole generation of British architects from the neo-classicists like Quinlan Terry to the bricolage builders like Terence Farrell and Piers Gough and community architects like Rod Hackney.

What this generation have renounced is the rationalist theology of high modernism with its puritanical (some have called it 'totalitarian') insistence on clean, uncluttered lines – a theology framed by the programmatic utterances of le Corbusier and Mies van der Rohe and realised throughout the world with varying degrees of finesse, varying degrees of brutalism, in countless skyscrapers, office blocks, and tower blocks from Brazilia to British council housing estates. Modernism in architecture is identified with the abolition of the particular, the irrational, the anachronistic and with the more or less intentional destruction of the coordinates through which communities orient themselves in space and time: the destruction, that is, of history-as-a-lived dimension and of neighbourhood as socially inhabited space.

In the 1980s, the Great British Tower Block collapses along with the

exhausted rhetoric of post-war optimism, welfarism, bureaucratic collectivism and the related cults of industrial expansion and mechanical progress – all of which it uniquely is seen to symbolise. Typically, modernist architecture and architects are linked (at least by their neo-conservative opponents) to the discredited ideals and objectives of Planning with a capital 'p' – that means – obviously in this context – town planning but also, by association, economic planning, and, by extension, social planning of any kind. The reaction is fuelled partly by the observation – which is, after all, pretty hard to refute – that the apocalypse when realised in concrete begins to look decidedly seedy 20 years on when covered in English drizzle, cracks, obscene graffiti and pigeon shit. For many opponents of architectural modernism, the decline of the tower block coincides with the decline of what it stands for in Britain. The tower block's collapse serves as a ghostly reminder of the weaknesses of that other larger edifice – the post-war corporate State with its mixed economy, its embattled health services, its strained, unlikely and ultimately illusory social and political consensus forged in the white heat of Harold Wilson's modernising techno-jargon. In architectural journals and books, the post-modernist putsch can be heard in the following keywords: 'value', 'classical proportion', or alternatively 'community', 'heterogeneous', 'diverse', 'choice', 'conservation', 'neo-Georgian', and in the substitution of organic metaphors for the more mechanical analogies of high modernism. No more futurist manifestos. No more Spaceship Earth. No more talk about houses being 'factories for living'. To borrow Alexei Sayle's words, 'No more living 200 feet up in the air in a thing that looks like an off-set lathe or a baked bean canner.'[8]

Instead we get the reaffirmation of either or all of the following: the particular, the vernacular, the sanctity of regional or national materials, styles, methods and traditions; the desirability of maintaining continuity with the past. The architect-as-surgeon has been replaced by the holistic practitioner, the architect-as-homeopath, in some cases, on some severely under-financed community housing schemes, by the architect-as-faith-healer.

Architecture is a relatively independent and isolable field but none the less there are definite links that can be made with other post-modernisms. There is the assertion, at least in the literature, of the legitimacy of ordinary people's desires and aspirations if not always an unqualified endorsement of their tastes. Here we find a theme common to all the radical post-modernisms: the articulation – in this case quite literally – of a horizontal rather than a vertical aesthetic: a flat-spread aesthetic rather than a trian-gular figure with the élite, the expert at its apex and the masses at the base. An emphasis on difference and diversity replaces the stress on system, order, hierarchy (though this does not apply to Quinlan Terry who believes that the laws of both architecture and social structure were laid down in the time of Solomon).[9] But more importantly, what links the architecture of the post to its artistic, critical and more purely philosophical and speculative

equivalents is the shrinkage in the aspirations of the intellectual practitioner him/herself. It is there in the questioning of the god-like role and absolute rights of the enlightened expert-as-engineer-of-the-future. It is there in the preference for structural, holistic or ecological models of the field over dynamic, teleological or modernising ones.

4.

For the term 'post-modernism', if it signifies at all, announces at the very least a certain degree of scepticism concerning the transformative and critical powers of art, aesthetics, knowledge. In its critical inflections, it announces the end of any simple faith in what have sometimes been called the 'grand metanarratives' – the Great Stories which for thousands of years the cultures of the West have been telling themselves in order to keep the dread prospect of otherness at bay. The term post-modernism marks the decline of the Great Stories the West has told itself in order to sustain itself as the West *against* the Rest, in order to place itself as Master and as Hero at the centre of the stage of world history. Those great stories, those metanarratives have many different titles, many different names. Here are just a few:

> divine revelation, the unfolding Word, the shadowing of History by the Logos, the Enlightenment project, the belief in progress, the belief in Reason, the belief in Science, modernisation, development, salvation, redemption, the perfectibility of man, the transcendence of history through divine intervention, the transcendence of history through the class struggle, Utopia, subtitled End of History. . . .

These stories – who knows? – may have functioned in the past as forms of reassurance like the first stories which John Berger talks about[10] – stories perhaps designed by men – for this is the gender which constitutes itself as *the* subject of history. Berger imagines the first men crouching round their fires at night telling stories – perhaps dreams, embellished or idealised biographies, perhaps boasts intended to amplify the storyteller's power or the power of the storyteller's tribe to keep the fear of ghosts and wolves at bay. Each story represents a ring of fire and light, lit to pierce the ambient darkness. To chase it back forever. . . . And we today, crouching on our haunches centred round the dying embers of so many great stories, so many heroic, epic master-narratives – stories which have lost their light and lustre, their power and their plausibility – we, today, may have to learn to live without their solace and their comfort in a world where nothing – not even the survival of the world itself as something to wake up to in the morning – is any longer certain.

If post-modernism means anything at all, it means an end to a belief in coherence and continuity as givens, an end to the metaphysic of narrative closure (and in this it goes no further than the modernism it claims to super-sede). Post-modernism may mean what Paul Virilio calls (in a phrase that

echoes Benjamin) the 'triumph of the art of the fragment':[11] a loss of totality, a necessary and therapeutic loss of wholeness.[12]

It may mean recognising in ways that were prefigured years ago in Einstein's physics that subjects can merge with objects, that discontinuities are as significant, as productive as continuities, that observer effects and random factors must be taken into account in understanding or re-presenting any process whatsoever, however material the process, however 'materialist' the account.[13] It may mean at worst substituting history as a game of chance for the older, positivist models of productive causality. Less fatalistically, it may mean substituting a history without guarantees for the older models of mechanical and 'necessary' progress. The choice is still there even in the nuclear age: history as a sound and fury signifying nothing or history as a desperate struggle to snatch back reason with a small 'r' from the jaws of desperation.

But if this still sounds too grandiose and pretentious and far too close to the modernist project it claims to displace, we can cut post-modernism down to size by reducing its terms of reference. There are plenty of signs of the post on the frantic surfaces of style and 'lifestyle' in the mid to late 1980s.

Post-modernism could certainly be used to loosely designate that range of symptoms which announce a break with traditional cultural and aesthetic forms and experiences: the break, for instance, with traditional notions of authorship and originality. Post-modernism has been used as a shorthand term to reference certain qualities and tendencies which characterise the contemporary (Western) metropolitan milieu: a growing public familiarity with formal and representational codes, a profusion of consumption 'lifestyles', cultures, subcultures; a generalised sensitivity to style (as language, as option, as game) and to difference – ethnic, gender, regional and local difference: what Fredric Jameson has called 'heterogeneity without norms'.[14]

For it is not all dark Wagnerian brooding, this post-modern thing. In fact, it often gets depicted (in a spirit which can be hostile or approving) as quite the opposite – as a celebration of what is there and what is possible rather than what might be there, what might be hypothetically possible.

The switch from the austere and critical negations (of the sensuous, of the doxa) which marked the counter-cinema, 'anti-art' and the conceptualism of the late 1960s and 1970s into 1980s eclecticism, bricolage and play etc. indicates not so much a lowering of expectations as a shift in the register of aspirations: from the drive towards a total transformation in historical time (May 1968 and all that) to the piecemeal habitation of finite space – the space in which we live. If we were to talk in terms of master-disciplines the shift would be from sociology to architecture.

While some artists and critics (e.g. Fuller) denounce post-modernism as a flatulent retreat from the sacred responsibility of the artist to bear critical witness for the times in which we live,[15] others (e.g. Owens and Kruger) stress the extent to which the sacerdotal postures and 'duties' of the artist

must themselves be questioned and dismantled insofar as they serve to amplify and duplicate the voice of the Father.[16]

5.

Clearly, there are many good things to be grown in the autumn of the patriarch, many good things to be found in the ruins, in the collapse of the older explanatory systems. The unfreezing of the rigid postures of the past – the postures of the hero, the critic, the spokesman – may merely signal the long awaited eclipse of many oppressive powers in our world – the power, for instance, of the white male middle-class pundit. It may open things up so that sense may begin to flow with less alarming gusto through more varied and more winding channels. Such a dispersion of sense might lead to a loosening of the bonds that bind us to the single and the singular track, to a paranoid obsession with certitude and fixed and single destinations.

6. AS IF (i): LOONEY TUNES

What's up doc?

(Bugs Bunny)

The drift of some post-modernist accounts implies that the modernist avant-garde constituted itself through what amounted to an imaginary and paranoid projection of absolute otherness on to an idealised, non-existent bourgeois 'norm'. The unitary subject which is incessantly attacked, distressed, deconstructed in modernist art and literature and modernist criticism becomes the imaginary subject of both economic/political and cultural/symbolic power: the absolute Father. The avant-garde – were it to exist today – could no longer feasibly counterpose itself against such a clearly phantasmagoric, literally fantastic projection. In the days of *Dallas* and Princess Di we find it hard to pin down the contemporary correlative of anything so coherent and stable as a unitary bourgeois 'norm'.

In some declensions of the post, the unitary subject as the principal target of radical modernist avant-garde practice has been revealed as a straw man in the late twentieth century because capitalism these days has absolutely no stake whatsoever in the idea of individuals being tied to fixed and stable identities. The ideal consumer of the late 1980s is a bundle of contradictions: monstrous, brindled, hybrid. The ideal consumer as deduced from contemporary advertisements is not a 'he' or a 'she' but an 'it'. At the moment (November 1985) it is a young but powerful (i.e. solvent) Porsche-owning gender bender who wears Katherine Hamnet skirts and Gucci loafers, watches *Dallas* on air and *Eastenders* on video, drinks lager, white wine or Grolsch and Cointreau, uses tampons, smokes St. Bruno pipe tobacco, and uses Glintz hair colour, cooks nouvelle cuisine and eats out at McDonald's,

is an international jetsetter who holidays in the Caribbean and lives in a mock-Georgian mansion in Milton Keynes with an MFI self-assembled kitchen unit, an Amstrad computer and a custom-built Jacuzzi. The ideal consumer is not the ideal productive worker of an earlier epoch – a sexually repressed nobody, alienated from sensual pleasure, subjected to the turgid, life-denying disciplines of the working week and the nuclear family. Instead the ideal consumer – It: enemy of the personal pronouns – is a complete social and psychological mess. The ideal consumer as extrapolated from the barrage of contradictory interpellations from advertising billboards to magazine spreads to TV commercials is a bundle of conflicting drives, desires, fantasies, appetites. What advertising conceived as a system offers is not a sanctuary from conflict and necessity, not a 'magical' refuge from the quotidian grind. It does not address or constitute a subject so much as promise an infinite series of potentially inhabitable (and just as easily relinquished) subject positions. What capitalism these days wants is a world full of loaded drunken boats – *bateaux ivres* loaded down with loot. The subject of advertising is not the rational sovereign subject of Descartes, the subject of 'consumer sovereignty'. Nor is it the manipulated dupe of some 'critical' analyses of advertising signs: the malleable wax to the thumbprint of either commerce or the law. Rather it is Deleuze and Guattari's 'body without organs'[17] – the absolute decentred subject, the irresponsible, unanchored subject: the psychotic consumer, the schizophrenic consumer.[18]

Donald Duck goes shopping!

This disruption of the relative certainties and stabilities of high modernism takes place within the transfigured social/informational space opened up by electronic communications. In a world of instantaneous communication, multi-user systems, electronic polylogue, the artist and the critic pale even further than before into impotence and insignificance. The intellectual, the critic, the artist can no longer claim to have privileged access to the truth or even to knowledge, at least to the knowledge that counts. What artist can compete with advertising when it comes to visual impact, ubiquity, effect and general exposure? What use is a critical interpretation of a text or a semiotic reading of an image in a world where information never stays in place, where information, communication, images are instantly produced, transformed, discarded in a process of endless complexification, polyphony, supersession and flux?

But all is not lost. We may have lost the Big Theories, the Big Stories, but post-modernism has helped us rediscover the power that resides in little things, in disregarded details, in aphorism (miniaturised truths), in metaphor, allusion, in images and image-streams. It has led to a rediscovery of the ancient power of the parable and the allegory, for the 'allegorical impulse' is everywhere in evidence.

291

7. AS IF (ii): ORBIS TERTIUS

The Argentinian writer Jorge Luis Borges once wrote a story about an imaginary world called Tlön.[19] This world has its own science, its own languages, its own religions and philosophies – all based on premises totally alien to Western traditions of thought – premises most especially inimical to the materialist tradition. Tlön is the invention of a satanic American millionaire who has secretly commissioned a group of experts to compile a multi-volume encyclopaedia detailing every aspect of life on this fictional planet. Thousands of pages are devoted to the geography, history, the social and cultural institutions of the imaginary world. As the years go by, the narrator, a specialist in esoteric literature, becomes intrigued by the mystery of Tlön and tracks down successive volumes of the encyclopaedia in obscure antiquarian bookshops dotted around the genteel suburbs and bohemian quarters of various European and South American cities.

The fine details of a highly complex but entirely imaginary order are thus gradually disclosed to him – the intricate details of an invented, invisible world parallel but totally alien to our own. The fantastic essence of this alternative world system is most clearly embodied in a special category of ideal objects called the hrön which are literally dreamt into being. The hrön are ideas in three dimensions which do not obey the laws of normal matter: they have a palpable existence but proceed directly from consciousness and depend upon consciousness for their survival. Borges mentions hrön ruins sited in neglected landscapes which continue to exist solely because of an occasional visit from a few birds or a horse. They persist because they are seen to persist – they exist through the gaze of others.

The story ends with the discovery, on a rainy night in a remote village in the heart of the Argentinian pampas, of a small, impossibly heavy conical object – an object composed of matter of such density that it defies the laws of physics. The boy who finds this cursed object is driven mad by his discovery and the next morning, the writer stumbles across the boy's corpse outside his bedroom door. The implication of Borges' story is that the fragile shell that separates the real world from the ideal world of Tlön has broken down. The shadow of Tlön may fall at any time across the face of our familiar primary universe and with the appearance of that shadow a kind of doom is pronounced upon us all, an end to the prospect of repose. The boy's death is the first sentence in a new parodic Bible: the beginning of a travesty of history. Humanity folds back upon itself condemned to endless repetition, endless simulation – life without substance, world without end. The imaginary is become the symbolic; the symbolic closes over the real: the hrön are upon us. . . .

Borges' story plays on taboos deeply embedded in occidental mythology – taboos concerning the dangers of unrestrained hypothesis – the tragic consequences which flow from the exercise of an overambitious imagina-

tion. These fears have been embodied down the centuries in a succession of mythical types: in Lucifer, who challenged God as author of the world, in Mary Shelley's Dr Frankenstein, and Rabbi Loew who moulded the Golem, a humanlike figure in clay and brought it to life by breathing the secret name of God into its mouth, in Faust, and Daedalus and Icarus who perished by flying too high, by seeking godlike mastery over natural mysteries. The diabolical nature of the conspiracy of Tlön masterminded by the shadowy millionaire who imposes one condition on his encyclopaedists – that they 'make no mention of that "false impostor" Jesus Christ'[20] – the diabolical nature of that conspiracy is signalled by the boy's death. The hrön are the embodiment in form of the tragically inflated aspirations of that doomed or doom-bringing lineage that leads from Lucifer to Oppenheimer – the lineage of those who have sought to snatch away the veil, to know everything, to exhaust the earth's resources, to manipulate and hence to obliterate the transcendental mysteries. The hrön come into this world like black holes engendering chaos and darkness around themselves. They arrive wrapped in an aura of dread. . . .

Borges' story ends with a postscript in which the narrator explains how some 7 years after the publication of his original article on the Tlön conspiracy, published initially in a small, specialist journal, a hideous inter-national cult has grown up around the hermetic world which he described in its pages. This cult, claims 'Borges', is threatening the entire world:

> Contact with Tlön and the ways of Tlön have disintegrated this world. Captivated by its discipline, humanity forgets and goes on forgetting that this is the discipline of chess, not of angels. Now the conjectural 'primitive language' of Tlön has found its way into the schools. . . . A scattered dynasty of solitaries has changed the face of the world. If our foresight is not mistaken, a hundred years from now . . . the world will be Tlön.[21]

8. AS IF (iii): THE ENCYCLOPAEDIA OF TLÖN: AN I-D FOR THE 1980s

Today we have our own encyclopaedias of Tlön: perfect worlds untouched by time, grime and history. Our encyclopaedias of Tlön are science fiction, video games, computer programmes, the popular press, advertisements, TV commercials, pop promo videos, first strike capabilities, the 4-minute warning, and Star Wars laser defence systems. These are some of today's perfect (i.e. self-referential, self-generating, recursive) fictions. Internally consistent, entirely hypothetical, they remain hermetically sealed against contact with the brute lack of physical, material and human limitation. These are the encyclopaedias of Tlön and they flicker in the libraries which face out towards the Enemy all along the disintegrating line of the Western

Front like the neon signs in West Berlin blinking out towards the East across the Berlin Wall.

Volume one: stylish simulacra

Two advertisements for Harrods' Way In Clothes boutique appeared in 1986 on the back covers of *I-D* and *The Face*. The style of these ads was a pastiche of mid-1960s modern graphics. There were nudging references to Op Art: the black and white, high-contrast images, the self-consciously dated fore-grounding of bold, black 1960s type. The Way In – as the name suggests – opened up in the late 1960s but rather than play down the dated 'swinging sixties' connotations of their client's name, the agency which handles the Harrods account have decided to camp it up, to cash in on the look. As the new becomes discarded as an outmoded category and the invention

Figure 16.1 Advertisement for the Way In, 1986

Source: Reproduced courtesy of Harrods

Figure 16.2 Advertisement for the Way In, 1986
Source: Reproduced courtesy of Harrods

of the new is abandoned as an anachronistic presumption, the past becomes a repertoire of retrievable signifiers and style itself is defined as a reworking of the antecedent. Just as the Grey agency working for Brylcreem decided to re-run re-edited versions of 1960s TV adverts with an unobtrusively updated soundtrack, so these Way In ads invoke an only slightly skewed sense of the recent past. The putative appeal of both Brylcreem and the Way In adverts is based on retrochic – the paradox of the old-fashioned, smart young modern look. In the 20 years or so that separate the image and its echo, social and moral values may have changed along with the political mood, school-leavers' expectations, prospects, aspirations, but the look, the haircuts, the tailored profiles remain constant – transmitted down the line of the video generations as constant and invariable as a prayer or incantation.

However in order to mark the product as upmarket, the advertisers have contrived to signal to the sign-conscious constituency towards which these adverts are targeted, that the advertisers know that times have changed by using obscure quotations from esoteric texts. (After all, this is 1980s narrow-casting: advertisers nowadays address a tightly defined demographic – a specific segment of the market not the classless teen mass implied in 1960s adverts.) From *The Face*, a caption beneath the silhouette of someone sitting on a chair reads: 'you are tired of provincial boutique Sundays, you want the mythical New York and the Champs Elysées'. A credit in fine print informs us that these words are taken from *Julie Christie* by Stephen Duffy. Not the real Julie Christie, icon to a generation of iconoclasts, the archetype of the British 'dolly bird' in the 1960s, of the politically committed campaigner and protester in the 1970s and 1980s, but rather something *called* 'Julie Christie': Julie Christie in inverted commas.

The authenticity of the quote from the *I-D* advert is, if anything, even more uncertain. It is framed within a frame. In a two-page spread, below a heading 'Double Identity', a photo graphic of an eye and a fingerprint, we read the following words:

> The type of consciousness the photograph involves is indeed truly unprecedented, since it establishes not a consciousness of the being-there of the thing (which any [*sic*] could provoke) but an awareness of its having been there.

This quotation is attributed to 'Roland Brown' although it seems likely that Roland Barthes is intended here (the quote is from 'The Rhetoric of the Image'). Alternatively (and this would be appropriate) it may be that the quote is being attributed to a fictional blend of Barthes and James Brown, Godfathers respectively of the sign and soul music. Such a condensation of black funk and Parisian intellectual chic would represent the perfect dream amalgam of the two elements that dominate the international high-gloss style purveyed by *I-D* and *The Face*: sex and text, somatic rhythm and Continental theory – the point where the Sorbonne meets the South Bronx: an 'erotics' not of reading but of skimming.

What these adverts represent is the coming out of what Barthes called the 'second degree' in a world where we are invited to live our whole lives out inside someone else's borrowed frames, in a world which becomes bounded by the body where the body becomes first and foremost an attractive setting for the eyes – something to be looked at and looked after. The social collective, the larger collective interest, the social body, the body politic, can no longer be either dressed or addressed within this discourse as it dissolves – this larger body – into a series of narrowly defined markets, targets, consumption, taste and status groups. No boundaries left within this discourse of the Look, no far perimeter, no limits to consumption, no limits to the spirals of desire, no distinction between use value and exchange value, no distinction between truth and lies, structure and appearance, reality and the will. The banal consequence of all these collapses along the disintegrating line of the Western Front is this: there is nothing better anywhere: nothing but individual bodies bent on having a wild time until the lights go out.

Within such a discourse it is difficult if not structurally impossible to make plausible appeals to larger social unities and interests, to larger communities, to social and identity formations larger than those inscribed within consumption. Now, in 1986, with the steady erosion of social, political and ideological alternatives, with the ascendancy of the stunted logic of the market, the implication is that there is nowhere else to go but to the shops even if all you have to go to the shops with is a bottle and a petrol bomb when you go shopping at midnight for the only things that lift you up and give you value: clothes, videos, records, tapes, consumption: high-gloss i-d, high-gloss identity . . .

9.

Volume two: a monetarist imaginary

Levi's are aiming red tag 501's at the *Miami Vice* dole queue cowboys.

(Kevin Foreman)

This shrinkage of the imaginative horizons can be linked in part to wider cultural shifts associated with the consolidation of monetarist policies and agendas throughout much of north-western Europe and North America. During the 1980s we have seen the establishment throughout much of the Western world of a 'New Realism' based around a primitive version of political economy and a Hobbesian view of society as an atomised mass of individual units (families) driven by self-interest and 'natural' appetites – which are regulated and satisfied by the free play of market forces and proscribed in the last instance by the law. This 'New Realism' in its turn has facilitated a number of cultural developments.

It could be said, for instance, to underwrite the formulation of a new consumption ethic – unconstrained by the puritanical residues of the dissenting tradition – and a corresponding consumer aesthetic which privileges the criterion of looking good, of style – a theology of appearances – over virtually everything else. On the one hand there are the *Miami Vice* cowboys of the dole queue and the black economy. But at the same time, the prioritisation of market criteria of value serves to naturalise entrenched status and income differentials so that existing social and economic inequalities are exacerbated. The consumption ethic/aesthetic is most clearly in play at the point where commodities are mediated to the public; at the point where future markets are invited to meet existing products, where the two converge in the dreamscapes of glossy magazines, commercials and mail order catalogues.

Here on the boundaries of the real, the hrön of the late 1980s are silently gathering.

Habitat catalogues provide a paradigm case. For 20 years, Habitat have pioneered the idea of pre-selected shopping in Great Britain. They have pioneered the notion of the totally designed or integrated package where the consumer buys a whole ensemble rather than a single item. The assumption is that one purchase will drag the rest of the (matching/complementary) ensemble behind it in a process we could call 'syntax selling'. In the last few years syntax selling has been directed at a much wider variety of social groups. Customers are now invited to buy their way into the particular package most suited to their aspirations, means and preferences instead of being subjected to one (stripped pine) house style. In this way Terence Conran's selection of designs for Habitat are being used to shape and frame what Pierre Bourdieu calls the 'habitus' – the internalised system of socially structured, class specific gestures, tastes, aspirations, dispositions which can dictate everything from

297

an individual's 'body hexis' to her/his educational performance, speech, dress and perception of life opportunities.[22] The Conran intervention in the habitus/Habitat aims to generate profits, to educate the public and to raise the general standard of design in Britain. It may also incidentally lead to the development of the 'cultivated habitus', a 'semi-learned grammar'[23] of good taste which would serve to perpetuate a hierarchy of taste by establishing a scale ranging from 'excellence (mastery of the code), the rule converted into a habitus capable of playing with the rule of the game, through the strict conformity of those condemned merely to *execute*, to the dispossession of the layman'.[24]

The syntax of the package offers the consumer the security and imaginary coherence of pre-scripted lifestyle sequences (institutionalised therapy for the psychotic consumer): this is the chair to sit in, the food to eat, the plates to eat it off, the table settings to place it in, the cutlery to eat it with. This is the wine to drink with it. These are the glasses to drink the wine in, the clothes to wear, the books to decorate the bookshelves with. . . . Now that Conran has taken over Mothercare, you can colour-coordinate your entire life from the cradle to the grave.

There is nothing unique to the 1980s in syntax selling, the cultivated habitus, or the mail order mode of address. What is perhaps new in Britain is the diversity of the packages on offer, the increased sensitivity on the part of manufacturers and retailers to regional and temporal fluctuations in market taste and the lack of local resistance to such strategies on the part of consumers. As resistance to market pressures, to market definitions of reality and worth are actively eroded with the spread and penetration of market values, so previously repressed or occluded social aspirations can emerge to find the appropriate cultural register and to find, too, the kind of legitimacy which has generally been withheld from such aspirations since at least World War Two. On the pages of the current Habitat catalogue, the service industries receive an unexpected boost in a happy gathering. The aspiring consumer of kitchenware is invited to dream of having servants: for what else can all these individuals be doing standing in the kitchen? The poses, the lighting, the setting all invoke an echo of the code of those *Sunday Times* colour supplement profiles of up-and-coming restaurants. Here are the staff of El Pastos, as open, warm and willing to be photographed as they are friendly, efficient and eager to please when you sit down to dine. The paradigm of service: one of the most significant looks this season.

Of course the *Tatler* – the magazine which ran a campaign in which a photograph of the 'beautiful rich' sporting on a yacht was displayed beneath the line: '*The Tatler*: the magazine for the other boat people' – can go one better in the offensive stakes. The removal of the old restraints – conscience, compassion, a sense of fair play, of *noblesse oblige* – all the old aristocratic virtues which were the sentimental remnants of an older, more organic and

Figure 16.3 Cover of the *Tatler*, October 1985

Source: Reproduced by permission of *Tatler* magazine

feudal relation to 'the people' displaced by Thatcherism and the New (suburban) Right are here annulled in the name of the nouveau aristocracy.

Recently the *Tatler* urged its readers to think pink: to return not (it goes without saying) to the tiresome old dreary dogmas of the Left but back to riding pink. The blatant assertion of privilege is here disguised or euphemised by irony. It is, after all, just an image, just a joke because nobody really believes in much more than images and jokes these days.

In these adverts, we encounter the return of the milk-white English rose, of the beautiful blonde bully: a kind of proto-fascist narcissism in this obsession – increasingly marked in the fashion pages of so many magazines since 1979 – with Aryan ideals of beauty: the unadulterated 'look', uncontaminated by the indigestible multi-cultural stew which – it is perhaps implied – 'They' are trying to serve us up from the sidelines. . . .

299

The miracle of the (English) rose

Victoria likes the culture shock of East End shopping (Halal goats' heads, compasses to point you in the direction of Mecca, black light bulbs, Huguenot-style singing birds, and the best smoked salmon in London). 'Shopkeepers here are not smarmy the way they are to customers in gentrified parts of London, but refreshingly direct.' She has brought up three daughters in the East End, all with the proper English roseness you might find in Cheltenham. 'As the girls get older they become a bit impatient with Georgian authenticity. They would like Laura Ashley wallpaper in their rooms and fitted carpets, but you can't really stick wallpaper on top of panelling. The eldest girl's dream is to have a modern flat in the Barbican with mix 'n' match fabrics. Just as we reacted against our parents' taste, our children will react against us.'

(Victoria Cruickshank, from an article on the New Georgians, 'Home is where the Art is' by Alexandra Artley, *Sunday Times* Colour Magazine, 27 October 1985)

The terrain on which all these different but related imaginaries are built is the terrain of advertising, the imaginary of Tlön, a world which has surrendered to the simulacrum – the image which bears no relation to a pre-existent real but which nonetheless can have real effects – a world where reality is nothing more than an incessant staging of events to be framed, recorded, relayed, screened: a world where people's lives simply unravel in the blank, empty spaces of the now. We are in danger of being rolled flat beneath the weight of all this imaging. People with real bodies and real minds have become, within today's encyclopaedias of Tlön, the dreadful excess; the non-necessary, embarrassing surplus of the sign.

The passive half of humanity (will be increasingly consigned) to a second hand world, a ghost world in which everyone lives a second hand and derivative life.

(Lewis Mumford)

So what's new, doc? Aaagh, quit beefin', will ya?

(Bugs Bunny)

11. A NEW CONVICTION POLITICS

Mirror, mirror on the wall
Who's the fairest of them all?

(Snow White's wicked step-mother)

Finally, we come to the *Daily Mirror*, the comic book of Tlön. At the climax of a 'mega-charity event' organised by Jasper Conran, heir to the Habitat-

Heals-and-Mothercare millions, a television personality called Selina Scott pretends to marry another television personality called Charles Villiers. And this is front page news in Mr Maxwell's new look *Mirror* in 1985. Selina Scott is a presenter; Charles Villiers is an actor, but these fine distinctions are neither here nor there. They pale into insignificance in the luminosity of televisual fame – the condition these two share – a luminosity which unites this charmed duo and glows over their heads with all the radiance of D.H. Lawrence's rainbow. The marriage in inverted commas is consecrated in celebrity.

But of course this is just make-believe. It didn't *really* happen. They aren't really getting married. The 'scandal' of 'our Selina' marrying an already married man is just a counterfeit manufactured for the worthiest of causes: to help to feed the world. For this is Fashion Aid. The mock marriage ceremony is a fairy tale. Its fairy tale character is confirmed by the proximity of the adjacent item on the withdrawal of Janet Street-Porter, yet another TV personality, from the event on the grounds that she would not do it unless she got paid or received some material recompense (literally 'material' in this case: apparently she asked to keep the dress). We even have the Ugly Sister to Selina's Cinderella.

The fantasy appeal of a union between Charles and Selina was no doubt enhanced for the *Mirror* editor by the often remarked resemblance between Selina Scott and the Princess of Wales. The prospect of watching Selina, the image of Lady Di (the fantasy stand-in from the telly: more common than the original commoner), the prospect of watching the Princess Diana Simulacrum sweeping up the aisle on the arm of another well-bred Charles in a reprise of the original performance – this was just too good to miss. In fact, there was no chance of it's being missed. This was a marriage made not in heaven but on a PR person's desk. It was made to make a splash. It was literally *designed* to be front page news in 1985.

Any vague misgivings we may have about the 'status' or the 'meaning' of this 'mega-event' are ruled out of court by the proviso that, after all, this is . . . all for charity. After the phenomenal success of Band Aid and Live Aid, after the phenomenal impact of Bob Geldof on the popular imagination, how could we even think to question the value or the virtue of an event that calls itself 'Fashion Aid' and which manages to raise another much needed million for the starving people of Africa? This event might be make-believe but it is make-believe with a conscience; if it is vanity then it is vanity in the service of a higher ideal. The Royal Wedding is simply being playfully quoted in order to generate more cash and more interest in the stars who stood in at the Albert Hall for all of those who care about starvation in Africa and for the cameras which were present on the day to relay the event to the rest of the world.

And yet that quotation is not innocent. The Royal Wedding is not just any old event. It was a key event in the consolidation of the new mood of

national pride and the new authoritarian populism which has characterised British popular culture in the 1980s. It was, after all, the Royal Wedding which – just days after the inner-city riots of 1981 – marked the magical renewal of the ideal of one nation welded together through its common history and pledged to uphold the time-honoured British traditions of Caste, the Christian Creed, the Family, Democracy and Due Ceremonial Process. The Royal Wedding – together with the electoral victory 2 years earlier of Mrs Thatcher – marked the real beginning of the 1980s. For what came in on Mrs Thatcher's train, what came swirling in on the silken hem of Princess Di's interminable wedding dress was Romance, Resolve, Retrenchment: the 3 r's for the 1980s. Iron resolve from the Falklands to Orgreave, retrenchment of some pretty primitive ethical, social and economic values and, most significantly in this particular context, romance – the word which must surely be the heading in italics over the decade – romance from the New Romantics to the New Georgians, from *Brideshead Revisited* to *Chariots of Fire*: romance – an alternative, softer synonym for that other 1980s keyword – 'STYLE' ('style' would be etched out in hard edged, hi-tech no-nonsense bold . . .).

So Selina and her beau act out a respectful and affectionate parody of the Royal Wedding for the cameras as part of a fashion show attended by similar media and fashion 'mega-personalities' in an event which took place in order to be recorded by the cameras so that funds could be generated for a campaign to 'Feed the World' – a campaign which, to complete the circle, was started when another media mega-personality, Bob Geldof, was moved one night by what he saw when watching a TV documentary about famine in Ethiopia.

To close the strange loops (the Disneyride) across the terrain of the post-modern sketched out in this report, we are back where we started with simulacra, hermetic systems, back beneath the shadow of Tlön. For sometimes the media's sole source of power, their entire fascination in the age of what Eco calls 'neo- (as opposed to 'paleo') TV' appears to consist in the relations which pertain between them, in the energy generated within their own field rather than in any putative links we might superstitiously or sentimentally believe they retain with a reality outside themselves, with what we might call the 'extra-textual' world. But in the case of the Aid phenomenon, the post-modern 'explanation' seems barely adequate or plausible. A post-modern *langueur* is simply not appropriate in this case. For the image of hermetic systems shatters with the assertion of a categorical imperative that seems to be irrefutable, when the prospect of the Real comes crashing in through the television screens in the shape of babies with distended stomachs, demanding to be fed.

For the fact is that the chain of events that leads from Geldof watching TV in his living room to Selina, Charles and a line of Tina Turner look-alikes dressing up for a good cause was triggered off precisely because of just such a superstitious, sentimental conviction – precisely *because* enough

people felt that something real and something terrible – the two ideas are related – was happening *somewhere else* and that we – all the rest of us were directly connected to and in some ways responsible for that terrible though physically remote reality.

Whatever else we may feel about the Band Aid phenomenon, about what occurs around its edges in the *Mirror* piece for example, I do not think that anyone would deny the strength and the importance of that other conviction. In a sense, I think, everything hangs upon the survival of the capacity of ordinary people to identify, to bond together and to act constructively in concert to make things better; the capacity of ordinary people to discriminate when it really matters between what is real and what is not, to decide what the real priorities are. I do not think anyone in their right mind would deny that real and vitally important moral resources were relocated and effectively deployed on a massive, international scale by Geldof and the people working with him. It may indeed be possible that what we are just glimpsing here in the Band Aid phenomenon is the formulation of a new set of moral imperatives, a new kind of eco-politics in which 'resolve' and 'conviction' – keywords in the Thatcherite discourse, terms which were given a definite authoritarian gloss as they were persistently invoked to counteract appeals from all sides for a U-turn away from monetarist policies – were themselves turned in a new and startlingly different way by 'Saint Bob' and his colleagues. After Geldof, the dishevelled, sometimes less than civil Irishman who spoke up on behalf of conscience – the *real* Enemy Within, the repressed term in the monetarist discourse – Thatcher could no longer claim to have a monopoly on either resolve or conviction.

The possibility of emerging eco-perspectives simultaneously developed through and bound into global communications networks is an important if problematic one and it goes directly against the dark, fatal grain of much post-modern prophecy. Such eco-perspectives will be articulated differently in different national–political contexts as they combine and are combined with, inform and are informed by, existing political–discursive formations. (Here in Britain Geldof mobilised an alternative 'decent' British common sense against Thatcher's 'little Englandism'.) There are of course no guarantees. There is no *telos* impelling humanity towards greater co-operation and mutual understanding in McLuhan's 'global village'. But there are vital lessons to be learned from Band Aid and the Geldof intervention concerning the mobilisation of affect, the, as yet, barely explored potentialities for organising and redirecting material and immaterial resources through affective networks opened up within transnational communication systems.[25]

That is what I meant earlier when I referred to reason with a small 'r' snatched from the jaws of desperation. The potentialities sketched out around the edges of the Aid phenomenon can be glimpsed on the other side, as it were, of the morbid discourse of the post. . . .

And if it does (end), the rides at Disneyland are never going to be the same again. Because when time ends, the birds and hippos and lions and deer at Disneyland will no longer be simulations, and, for the first time, a real bird will sing.[26]

(Philip K. Dick, 'How to Build a Universe . . . ')

This chapter was originally given as the Bill Chaitken Memorial Lecture at Central School of Art, 1985.

NOTES

1 See, for instance, Hal Foster (ed.), *Postmodern Culture*, Pluto, London, 1985; Lisa Appignanesi and Geoff Bennington (eds), *Postmodernism. ICA Documents 4*, Institute of Contemporary Arts, London, 1986; Jean-François Lyotard, *The Postmodern Condition*, University of Manchester Press, 1984; *New German Critique: Modernity and Postmodernism Debate*, no. 33, Fall 1984; Fredric Jameson, 'Postmodernism or the Cultural Logic of Late Capitalism', *New Left Review*, no. 146, July–August 1984; Hilary Lawson, *Reflexivity: The Post-Modern Predicament*, Hutchinson, London, 1985. For a more developed and conventional critique of post-modernism than the one presented in this report, see Dick Hebdige, *Hiding in the Light: On Images and Things*, Routledge, London, 1988.
2 Jean Baudrillard, 'The Ecstasy of Communication', in Foster, op. cit.
3 See, for instance, Michael Newman, 'Revising Modernism, Representing Postmodernism', in Appignanesi and Bennington, op. cit. Newman posits two distinct modernist traditions, one centring on an 'autonomous' fixation on 'honesty', 'purity' and reflexivity' (from Kant to Greenberg), the other focused round a 'heteronomous' aspiration to dissolve art into everyday life (from Hegel to the surrealists). Any simplistic model of a single modernist movement unfolding globally in time to the rhythm of 'development' is effectively dismantled by Perry Anderson in his response to Marshall Berman's book, *All that's Solid Melts into Air*. See P. Anderson, 'Modernity and Revolution', *New Left Review*, no. 144, March–April 1984.
4 Jean-François Lyotard, 'Defining the Postmodern', in Appignanesi and Bennington, op. cit.
5 For problems of periodisation, see Foster, op. cit., especially Foster, 'Postmodernism: A Preface', pp. ix–xvi, J. Habermas, 'Modernity – An Incomplete Project', pp. 3–15, F. Jameson, 'Postmodernism and Consumer Society', pp. 111–25. Also P. Anderson, op. cit. and Newman, op. cit.
6 For a discussion of these categories see Shirley Ardener, *Perceiving Women*, Malaby Press, 1975; Annette Kuhn, *Women's Pictures: Feminism and Cinema*, Routledge & Kegan Paul, London, 1982.
7 See Jean Baudrillard, 'The Precession of Simulacra', in *Art & Text*, no.11, Spring 1983. Also *Simulations*, Semiotext(e), New York, 1983. Paul Virilio explores similar themes in 'The Overexposed City', in *Zone 1/2 – The City*, Zone Books, New York, 1986.
8 Alexei Sayle, *Train to Nowhere*, Methuen, London, 1983.
9 See Patrick Wright, 'Ideal Homes', in *New Socialist*, no. 31, October 1985.
10 John Berger in conversation with Susan Sontag on the TV discussion programme *Voices*.
11 Paul Virilio and Sylvere Lotringer, *Pure War*, Semiotext(e), New York, 1983.
12 The most extreme formulation of the 'postmodern ontology' thesis has been put

forward by Baudrillard who argues that the 'space of the subject' (interiority, psychological 'depth', motivations etc.) is being 'imploded' and destroyed by the new communication technologies. See Baudrillard, 'The Precession of Simulacra', op. cit., and 'The Ecstasy of Communication', op. cit.

13 See Jean-François Lyotard, 'Les Immateriaux' in *Art & Text*, no. 17, Expressionism, April 1985. This article is a translation of a document written by Lyotard as an accompanying gloss to the exhibition of the same name organised by Lyotard at the Pompidou Centre in Paris from 28 March to 15 July 1985. The mixed media installations which formed a series of nodal points through which the spectator/auditor was invited to 'drift' were designed to force modifications to existing models of aesthetics, knowledge and communications by exploring/exposing the epistemological implications of the new technologies. The installations were designed to stand as analogues of/catalysts for the new 'postmodern sensorium' – a sensorium constituted in part directly through exposure to the new technologies (understood first and foremost as the bearers of the next phase in human evolution: the era of the Simulacra). This new sensorium, it is argued, can only be properly understood/inaugurated if we 'move beyond' the post-Socratic distinctions between, for instance, mind and matter, body and spirit, subject and object which formed and go on forming the founding 'moment' of so much of what we call 'Western' thought and culture.

14 Jameson, op. cit.

15 See for instance, Peter Fuller, *Aesthetics After Modernism*, Writers and Readers, London and New York, 1983; *Beyond the Crisis in Art*, Writers and Readers, London and New York, 1980.

16 See Barbara Kruger, *We Won't Play Nature to your Culture*, Institute of Contemporary Arts, London, 1983, and Craig Owens, 'The Medusa Effect; or, The Spectacular Ruse', in Kruger, ibid. Also Craig Owens, 'The Discourse of Others: Feminists and Postmodernism', in Foster, op. cit.

17 Gilles Deleuze and Felix Guattari, *The Anti-Oedipus: Capitalism and Schizophrenia*, University of Minnesota Press, 1983.

18 Ibid. and Jameson, 'Postmodernism or the Cultural Logic', op. cit., and 'Postmodernism and Consumer', op. cit. Also Baudrillard, 'The Ecstasy of Communication', op. cit. For a more critical engagement with the post-modernist 'appropriation' of schizophrenia see D. Hebdige, 'Staking out the Posts', in *Hiding in the Light: On Images and Things*, Routledge, London, 1988 and 'Postmodernism and The Other Side', in *Journal of Communication Inquiry*, vol. 10, part 2, Summer 1986, pp. 78–98.

19 Jorge Luis Borges, 'Tlön, Uqbar and Orbis Tertius', in *Labyrinths*, Penguin, Harmondsworth, 1969.

20 Ibid.

21 Ibid.

22 See Pierre Bourdieu, *Outline of a Theory of Practice*, Cambridge University Press, 1977, also *Distinction: A Social Critique of the Judgement of Taste*, Routledge & Kegan Paul, London, 1984.

23 Bourdieu, ibid.

24 Ibid.

25 For a more developed version of these arguments, see 'Vital Strategies', in *Hiding in the Light: On Images and Things*, Routledge, London, 1988.

26 Philip K. Dick, 'How to Build a Universe That Doesn't Fall Apart Two Days Later', in *I Hope I Shall Arrive Soon*, Victor Gollancz, London, 1985.

17

AN INTERVIEW WITH JEAN BAUDRILLARD

Judith Williamson
Translated by Brand Thumim

(*From*: Issue 3, 1980)

This interview took place in London on 18 November 1988. Our intention has been to keep the flavour of Baudrillard's speaking style and to use his own terminology as far as possible. This is the complete version of the interview from which an extract, with an introductory essay, was published in *City Limits* no. 375.

JW: *You've said that theory should be rigorous enough to cut itself off from any system of reference (*Forget Foucault*). If you still think that, then what is the status of your theories – what do they explain?*

JB: Yes, it's still true, more and more so in fact: in a way, theory has moved further and further from having a system of reference, which is the same as a critical system. What I mean is that traditionally, critical thought, analytical thought, has always needed a system of reference, and I had some for a long time – Marx, Freud and so on, like many others, and I had older references like Nietzsche, Holderlin – then after a while I thought that one had to jump, to pass over to the other side of the line and lose a sense of reference in order for one's thought to be more a projection, an anticipation. And at that point theory gives way entirely to its object, to its object in a pure state. The subject of theory or of knowledge no longer seeks to interpret; we move away from interpretation and we come much closer to fiction. We have something which is more like a fiction-theory. So we have a theory which is no longer referenced; but of course, it's a paradox because there is always a kind of actuality, a reality, so we're talking about the reference being actuality, or even an anticipation of actuality: but it would come from the object itself, the events themselves, from situations themselves – so you have a kind of situationism.

The term 'reference' bothers me because if you mean authors, theoreticians and so on, of course there are lots, there's been Sartre, Barthes, Marcuse, people like that, but that's something else. For myself, I'm talking not so much in terms of references, but in terms of the object. I think that

theory is not so much a kind of lineage of references, a continuity, but rather a confrontation, an antagonism, a kind of duel between the object and theory, between the real and theory. So it's no longer so much the real or reality as a reference, but rather the reference would be the confrontation itself, the antagonism between the object and the theory. I don't think that the purpose of theory is to reflect reality, nor do I think its reference should be the history of ideas. We need something more adventurous, more direct, more aggressive if you like.

You characterise systems of signification in our culture as circuits of signifiers with no referent. That seems very accurately to describe certain forms of imagery which endlessly refer to one another, like TV and advertising. But do you believe that holds true for all forms of signification, including writing, and in that case how do you see the function of writing?

Yes, it is also true for a system of writing, for a theoretical system. All signs enter into such circuits, none escape – even theory itself becomes on some level a flow of signifiers with no referent. And this can be seen as negative in relation to classical theory, but it can be a very original situation. Theory then speaks of simulation but also offers itself *as* a system of simulation; and theory like mine doesn't claim to be anything more than *one* of the possible systems of simulation of something. I don't know what this theory signifies but there is an act by which it retraces its own object, it attempts to be an analogue, or a homologue, of that object. So if you're speaking of simulation you have to hold a discourse *of* simulation. If you're speaking of seduction, you have to hold a discourse *of* seduction, and so on. There is a kind of osmosis, almost a resemblance, an identification of theory with its object. Which means that it becomes its own reference. It becomes a kind of pure object or a pure event. Writing remains this kind of pure event, something like an act. And I don't just mean the workings of language, there is something more in the fact of writing: there is no difference today between the state of things and the state of theory. There is a kind of short circuit, an implosion between the two. Whereas in critical theory there is a distance between discourse and reality.

You've shown how Marx privileges use-value in the same way that theories of signification privilege the referent. But challenging that privilege is not necessarily the same as denying that there is any use-value or referent, i.e. the material world.

My criticism of use-value or of the referent is of course a challenge to reference, a challenge to the material world, or rather, a challenge to the *principle* of reality, because the reality principle is at some level a principle of reference. In order for there to be a reality, there has to be a principle of reference, a principle of signification, a principle of reality. Yes. I do

contest it. There is a challenge there [in my work] to all that, including in the use of language: in a way I'm also doing a critique of the use-value of language. So in this case theory no longer aims solely to signify something, or certainly it doesn't exhaust itself in the process of signification, it has to invent another object, it has to invent another world as it were; it does have a kind of strength, a power which is almost utopian, or maybe it's more the power of paradox, a position of paradox that we're talking about. And in the paradox there is the fact that reality becomes ambiguous, paradoxical, certainly undecidable – so it no longer has a functional use-value, one can no longer say, 'this is real, this is rational, this is true'. So then theory is forced to evolve in a universe of contingency – which is a universe of simulation and so on. So it's a big game, isn't it – a gamble. It's a game, but there are rules.

Your writing suggests that there is no space outside the hyperreal but you say that 'it's essential today to evaluate the double challenge of the masses and their silence, and of the media' (The Masses, 1985). What do you see as the space from which such an evaluation might take place?

It's no longer the traditional space, no longer the critical space where there would be a historical contradiction, a contradiction of meaning. This hyper-real space which has no depth – which is therefore superficial – it's no longer a mirror: it's a screen. It's the space of the screen. And the masses them-selves are a screen. Their answer, their silence, their reverberation of all the messages, the media and so on, has the function of a screen. But it's the function of an opaque screen whereas that whole system [of the media etc.] aims at a transparency of things. So the masses are a kind of opaque screen which no longer returns meaning – which absorbs meanings and no longer throws them back. It's a screen-space we're talking about, I can't put it any other way. A screen is a pure surface and at the same time it's a space. To look at it in different terms, in America you have the desert; the desert is also a pure space but completely superficial and it no longer sends back meaning. So there a circuit of meaning does indeed get cut.

So of course there is no longer any possibility of evaluation. It's an operation that's taking place, a kind of implosion of meaning. There isn't any point of view from which to criticise it external to that space. There's a kind of immanence of the hyperreal and we are all caught in it: there's a kind of confusion of the negative and positive poles, there are no longer any intellectual positions in the traditional sense. There are no longer any positions of knowledge or evaluation which are outside the hyperreal, and it's that fact which constitutes the end of critical analysis. It's not possible to make a judgement. When I describe hyperreality or the media or what-ever, there is no positive or negative judgement – well, maybe from time to time! – but in principle, there is no judgement, neither of morality nor of

truth. I remain in the same ambivalence, if you like, as that space itself. So when people say to me, this work is pessimistic or it's optimistic, no, it's neither optimistic nor pessimistic but I myself am making a hyperreal theory, about the hyperreal space.

But in America *you say, for example, of Reaganism, 'This consensus around simulation is much less fragile than is commonly thought since it is far less exposed to any testing against political truth'. What do you see as a political truth against which a simulation might be tested?*

Well, I mean 'political truth' in inverted commas, because it's what one imagines to be political reality, political contradictions, conflicts, etc. And simulation manages to neutralise conflicts. It manages to neutralise this political reality – the word reality isn't perhaps very appropriate – but in the universe of simulation there are no longer any contradictions. It's not a dialectical superseding, of course, but a neutralisation by means of simulation. So that's the problem. In the beginning I, too, made an analysis of simulation which was still a critical analysis, saying that this universe of simulation is a mystifying universe, an alienating universe – it's still alienation through the sign. But later, no, I don't think so, simulation is no longer alienation, we pass into something else and from there on one is no longer confronted by the political state of things. We are in a universe of simulation . . . it's the smile of Reagan – it can also be the cancer of Reagan! Because the cancer of Reagan is as simulated, in the theoretical sense of the term, as the smile of Reagan. It's the same thing.

So do you see any possibility for a strategy that could oppose the system of capital?

I'm not a strategist, I don't hold out any political alternatives. I no longer see any political alternatives. The alternative – I've already described it – is a kind of strategy of indifference. The universe of simulation is an indifferent universe, a neutralised one: and it's the same strategy on the other side, on the side of the masses. People do in fact defend themselves, they have defensive and even offensive strategies; but this time, through indifference. Which is to say, they don't fight any more through difference, through demands, through struggle and conflict, but on the contrary, they turn the system back on itself according to its own weapons, its own logic, they fight with the same weapons as the system itself. And therefore we're no longer in the same political universe, we are in a universe I call transpolitical, or something like that. There is still something at stake, there is still an antagonism, there is certainly a struggle between the strategy of simulation at the level of political power or what is left of political power, and a strategy of indifference, which is to say that the masses also manage to neutralise power, but by their silence, by their indifference. It's no longer a strategy of subversion.

But you're not silent.

No. (laughs) That's paradox. (laughs) The strategy is no longer, as it was in the classical political world, the strategy of negativity – for example – of subversion, the negativity of revolution; the transpolitical world is more analogous to a game of poker, if you like, where there is a raising of the stakes: where you outbid indifference with indifference. You up a bid of neutralisation with more neutralisation. So it becomes a game, at this point, it's become something else. It is no longer exactly a historical or political space.

How do you place your theoretical development in relation to the political movements of the sixties? You mentioned situationism. How do you see your work in relation to it, and has that relationship changed?

My work really has its roots in the movements of the sixties. In France there were lots: there were the Situationists, there was Socialism or Barbarism, we ourselves had started a journal called *Utopias* – there were all those movements. For my part I'd say it's very definitely from the sixties that this kind of theory was born, and '68 was absolutely determining, it was crucial for the position of theory. For me particularly, I was very, very attracted by Situationism. I wasn't part of the movement but yes, Situationism is like a kind of primitive theoretical scene, a radical one. And even if today Situationism is past, there remains a kind of radicality to which I have always been faithful. There is a kind of obsession, a kind of counterculture, which is still there. Something that has really stayed with me . . . and that's why I am not at bottom a philosopher, it's because I have always had a kind of radical suspicion towards culture, or even towards ideas – a kind of barbarism, in fact. A barbarian position. (laughs).

You say in your latest book that America is 'suffering from the disappearance of ideologies that might contest its power'. Do you think that your work is symptomatic of that situation?

Yes, I think there is a kind of homology with the American situation, the American state of things. In fact since the sixties I have thought that it was at bottom the American reality, or the American hyperreality, which was the model, the anticipation, the fiction of our own ideas; and it's true that what I've done is a little bit the same. Which is to say that in the same way that America ultimately takes European utopias or European ideas to the end of their logic, realises them, materialises them, and by the same token neutralises them, that's a little of what I do in the field of theory. To take concepts all the way to their limits, to their extremities and even beyond their limits. So I try to realise them, and thereby I make them pass into

fiction. I create a void, in a sense. And for me America is to some extent a strategy of the void, of emptiness, the desert. But not in a depressive way, not at all depressive – on the contrary, in a very prodigious way. So in the field of theory I have tried also to preserve this energy of the void, this energy of the realised utopia, an energy of something which passes into its own hyperlogic. For me, America is in fact a hyperlogical world; hyperreal because hyperlogical. The Americans did everything: what the Europeans thought, the Americans did. It's a kind of radical pragmatism, which forces one to throw into question anew all the ideas, all European idealism. So I too did that for theory. I think it's exactly the same thing.

You say that the work of Marx fits perfectly the capitalist system which is its object, it colludes or collaborates with that system. Do you see your work as in some way symptomatic of and collaborative with late twentieth-century consumer capitalism?

Yes, I think so, but this may be a pretension on my part. There is indeed a strong coincidence between the work of Marx and a certain state of capitalism, and I hope there is the same coincidence between my theories, if you like, and the post-Marxist state of things . . . I'm not sure what to call it . . . the state of things . . . I'm not sure if it's still capitalism but in any case, the contemporary state of things. But it is symptomatic in the ambiguous sense of the word symptom, which is to say, a symptom is at the same time something which translates a pathology – it produces a sign, it's the sign of a pathology, of a conflict – and at the same time it's a kind of . . . sublimation of the pathology, it's also a kind of neurosis. A symptom is in the end a small neurosis which acts . . . not as a therapy, but all the same, it's an event which contributes to precipitate the situation – not to find a solution but to go further in the situation. The symptom isn't just a sign which reflects an illness but it is an event *in* the illness. So theory would in that sense be symptomatic. It is ambivalent. It's negative inasmuch as it participates in a kind of pathology of reality and it's positive inasmuch as it tries to turn this reality into something else. So yes, in that sense symptomatic could be the right word.

At one point when we were talking earlier you said that in America you were trying to explain something. Do you see your writing as interpretation, or seduction (to use your own terms)?

Yes, more like a seduction. It's not an interpretation inasmuch as there isn't a meaning. I don't think of myself as a subject capable of interpreting America. America is an object which is too immense . . . it's beyond interpretation. On the other hand, and precisely because it's beyond interpretation, there is a fascination; fascination is a passion which remains beyond interpretation. It's not exactly seduction, it's more fascination.

America is more fascinating than seductive. Seduction is . . . something else. And in describing America – well it's not a description, but in my sort of camera-movement over America – what I wanted to preserve was this fascination. Which remains always enigmatic. Interpretation seeks to be no longer enigmatic, to resolve the enigma. Whereas I seek to preserve the enigma – the enigma of America. And the enigma is seductive. It's fascinating, and seductive.

What do you make of the cult status of your work, particularly among young people, in Britain, North America and Australia?

I am a little surprised because you speak of a cult, which suggests that people are very interested in this – or perhaps fascinated – while on the other hand I have noticed that the critics, journalists and so on are almost all negative, they come up with negative criticisms. The official reaction of 'thinking people' or 'cultured people' is very often defensive, reticent – in short negative in one way or another. When it comes down to it, they can't bear this exposé of surface-ness, of non-reference and so on – they just can't bear it. I suppose there's nothing to be done about that. But maybe indeed young people are less concerned with questions of truth and criticism, they are more directly sensitive to this kind of writing which is . . . fragmented, maybe also to the kind of game with superficiality – which is not necessarily a superficial game. It is a game with superficiality. Perhaps young people are more immediately sensitive to that, they haven't a defensive system of prejudices – so maybe it goes down better with them. But when I'm told this I find it very problematic, because it means, ultimately, that young people are ready to become fans like that . . . whereas what I speak about, I do claim that it is serious. It doesn't try to be deep . . . but still, there is at some level a kind of depth to it all. So for me it does remain enigmatic, why it should be so successful in that way. And it's often surprising that, in New York for example, the success is not with university students and academics but with artists and all that New York scene. I'm very pleased about that, it's rather nice, because I never particularly courted the university world . . . but I would have thought there could possibly be an acknowledgement from the field of philosophy, from the direction of the universities and so on, a little more recognition, and that it wouldn't just be a cultural or countercultural special effect. It's something else than that. But there it is, you can't control things.

But perhaps the fatalism in your work corresponds to something – a political depression – that here, for example, under Thatcher, people actually feel? A desperation?

Ah yes, here you have Thatcher. But I think that the atmosphere, the state of things, is somewhat the same in France, even if we have a kind of socialist

government ... I think the problem of political despair is everywhere. And of course, there is a correspondence between what I speak about and this situation which is depressive, but what I am saying is not depressive; I try to cross over to the other side of this political depression through a kind of transpolitical analysis which would be, OK, not optimistic, definitely not optimistic, which would be – I'm not sure how to put it – fatal, but it's not fatalism in the passive sense: it's the idea that there is the possibility of another game. Another set of rules. You have to search for it of course ... it's precisely *not* despair – it's not hope but it's not despair either. Things are already happening differently now, there's definitely something else than the classic history of the political scene, because that is indeed in a bad way, it's depressive. But beyond this line of depression I think there is something else going on, something else is possible. Basically one must not obstinately try to regenerate the political scene because I think that *is* without hope. In reality it's true my work reflects a kind of ... yes, a kind of depression, of disappearance, and at the same time it's an attempt to transfigure all that in an energetic way, in a fictional way. To say, well, if it's another game, then let's play the other game. What I'm trying to say, in a nutshell, is if the work testifies to the disappearance of something, the loss of something, to a depression, I think that there is an energy of disappearance and this energy must be found. It's a bit like that. We're going to have to stop because I have to make a phone call.

APPENDIX:
BACK ISSUES OF *BLOCK*
AND THEIR CONTENTS

Towards a Theory of Consumption:
 Tu – a Cosmetic Case Study Kathy Myers
Visual Representation and Cultural Politics Nicholas Green and Frank
 Mort
Cultural Package Judith Rugg

Issue 8 1983

The Possessed: Harold Rosenberg and the Roger Cranshaw
 American Artist
From the Margins: Modernity and the Case Terry Smith
 of Frida Kahlo
The Production of Meaning: Karl Beveridge Martha Fleming
 and Carole Condé
Centre pages by Victor Burgin
No Particular Thing to Mean Adrian Rifkin
New York, New York Barry Curtis
In Poor Taste: Notes on Pop Dick Hebdige

Issue 9 1983

Structure and Pleasure Claire Pajaczkowska
Further Thoughts on the Production of Meaning Carole Condé and Karl
 Beveridge
Lévi-Strauss, Feminism and the Politics of Lon Fleming
 Representation
The Object of the Centrefold Roger Cranshaw
Further Thoughts on Frida Kahlo Terry Smith
Centre pages by Marie Yates
Cultural Politics, Design and Representation Tony Fry
Design and Gender Phil Goodall
The Debate at the Salon of 1831 Nicos Hadjinicolaou
Beyond the Purloined Image Mary Kelly
The Value of a General Model of the Production, John A. Walker
 Distribution and Consumption of Artistic Signs
 for the Discipline of Art History

Issue 10 1985

Strategies of Vigilance: an Interview with Angela McRobbie
 Gayatri Chakravorti Spivak
Pictures and Parables David McNeill
Correct Distance Mitra Tabrizian
Centre Pages by Barbara Kruger
Representation, the Harem and the Despot Olivier Richon
The Grand Tour (photowork) Olivier Richon
Art History and Difference John Tagg
The Myth of the Independent Group Anne Massey and Penny
 Sparke

316

INDEX

319

INDEX

Joachimides, Christos 73
Johns, Jasper 4, 87–114
Jones, Allen 234
Journal des demoiselles 118
Journal of Design History 4
journals xii, xiii, 5; medical 234;
 popular 231
Judd, Donald 37

Kahlo, Frida 4
Kahnweiler, Daniel Henry 58
Kant, Immanuel 264
Kaprow, 268, 272
Kasson, John 262
Kelly, Mary 28, 60, 61, 62, 237
Kerouac, Jack 101
Keynes, J.M. 238
King, David xi
Klein, Melanie 38
knowledge 52–3, 158, 174, 201; arenas
 for relations of power and 224–5;
 collective nature 159; decentring and
 de-professionalisation of 284; design
 as a form of 159; design processes
 and transforms 159; different forms
 149; divulging 196; fields produce
 and reproduce themselves 77;
 general 63; higher level of 78;
 historical 160, 212; histories which
 have become established as 135;
 irrationalist sources 263; new 213,
 228; power exercised through 159;
 practical 136; production of 69;
 recognition of orders of visuality as
 forms of 225; regimes of xiii; social
 division of 141, 143; strategic
 collaboration of power and 163;
 uncertainties within the institutions
 of xiv; usable 65
Koch, Janice and Kenneth 102
Kofman, Sarah 246
Kohl, Helmut 72
Kolbowski, Silvia 61
Korea 8
Kristeva, Julia 33, 38, 40, 42, 43–4,
 46–7, 75, 78, 248
Kruger, Barbara 16, 61, 289

labour: domestic 168; exchange value a
 measure invested in a commodity
 170; female, traditional areas 190;
 hard, reduction of 199; housewives
 do not appear to sell 168; immanent

process 215; intellectual and manual,
 reorganisation of 198; most
 concentrated processes 197; paid
 188, 192, 193, 195; partial
 reorganisation of 192; personal 174;
 personalised 183; power 9;
 productive 168, 170; professional
 forms of 183; redesigning the
 process 205; redistribution of 198;
 securing returns for investments
 and 163; separation of mental
 from manual 150; shedding on a
 massive scale 189; 'useful' 170;
 women's 202
labouring classes 232–3
Labowitz, Leslie 16
Lacan, Ernest 117, 121, 122, 254
Lacan, Jacques 5, 34, 38
La Citoyenne (suffrage newspaper) 120
Laclau, Ernesto 77
Lacy, Suzanne 16
La Gaulois 118, 119
laissez-faire 207, 214, 217
Lancet, The 234
landscape 232; imagery 230; space and
 status allotted to 231; visible traces
 of industrialism on 262
language 33–48, 104, 308; analytical
 227; debates around 226; elaborately
 codified 237; functions 91;
 metonymy accords a kind of privacy
 to 92; poetic and playful uses of
 225; recovery of a possible operation
 of the feminine in 117; rhetorical
 and figurative aspects 91;
 social/symbolic system of 59;
 theories about 65; use-value 308
Laplanche, J. 76
L'Artiste 231, 244
Laski, Marghanita 217
Las Vegas 268
Lawrence, D.H. 301
laws 252, 292; architecture and social
 structure 287; authoritative or true
 39–40; iron 163; paternal 39;
 patriarchal 78; symbolic 40
Lawson, Nigel (Lord Lawson of Blaby)
 133
Leavis, F.R. 75
Le Corbusier (Charles Edouard
 Jeanneret) 156, 286
Leeds City Art Gallery 52
Leeds University 65

161; study of 57; surplus value 168; terrain upon which capital organises relations of 202; transformation of the social relations of 205; visual properties essential to understanding 144; women's 168, 191
productivity 55, 56, 163
professionalisation 191
proletariat 261, 267
propaganda 16
Propp, Vladimir 33
prosody 47
prostitutes 234, 235; allusions to prostitution 117; child 233; depraved and sexualised 233; potential 233
pseudo-scientism 148
psychiatric definitions 235
psychic forces 246
psychic relations 43, 45
psychoanalysis 32, 39, 184; approaches to art 31; concepts xiii; intervention 59; Lacanian 42; post-Marxist theories 224; transition from linguistic theory to 38; used as a theory to implement semiotics 45
psychology 47, 96; childcare appropriation by 198
psychotic consumers 291, 298
public art 93
punk 7, 12; para 15; retro 13
Putnam, Tim 132

quality 185; élitism necessary to the survival of 11; 'high-art' world based on 18; product 198; quantity and 193–4
quasi-revolution 13

race 63, 65, 184, 206; hierarchical system of relations 54
racism/racists: blacks working against 14; institutional 75; moral critiques of 239; offensive words 14; practices and policies 53; struggles against 65
radicalism xi, 55; aestheticism 266; pragmatism 311; purely professional 236; war 218
radio 266
Ramsden, Mel 4
Raphael, Max xii
'rational' activity 167
rationalisation 168, 246, 260
rationalism 265

rationality: bourgeois 263; photographic modernism accepted 264
Rauschenberg, Robert 98, 99, 104, 105
Read, Herbert 216
'Readymades' 265
Reaganism 309
realism 37; aestheticised pictorial 264; classical, analysis of 38; debates around 118; epistemological 79; hyper 250; illusionist 250; New 297; painterly 264; post-war 72; rejecting 263; social, 'space age' 13; specular 246, 248, 249, 250
realist painting 233
reality: challenge to the principle of 307; complex and contradictory 162; different levels 149; dividing, classifying, ordering and transforming 159; fiction and 280; institutions which control 158; instrumental 259; knowledge of 158; market definitions of 298; material, practical appropriation and transformation of 158; neglect of one significant part 151; perceiving, analysing, evaluating, studying and teaching 160; political 309; predicating a world of 77; represented, medium may impose upon 161; social 16, 265; socio-economic 149; virtual 224
reason: from desire 252; instrumental 261
rebelliousness 17
reception theory xiii
Red Letters (journal) xii
reductionism 80
Reed, Evelyn 23
Regency style 216
Regional Arts Associations 74
Reilly, Paul 215
religion 39, 45
Renaissance 36, 45, 248; nationalisation of 218
repetition 34, 37, 39, 42; playful 117
representation 8, 242–57, 272; classical monocular perspectival system 37; critique of 224; crucial role played by 75; 'design' in 142; distortion of understanding of 36; female body 100; 'femininity' 122; filmic 182; index of consent to a body of sexual